EDDIE AND TH

SUB

THE MINUTE M

AT

THE MIX

CAGE

STARWO

8151 sant

STUEiON

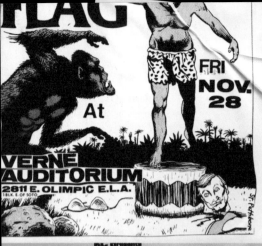

FRI NOV. 28

At

VERNE AUDITORIUM
2811 E. OLIMPIC E.L.A.
1BLK. E. OF SOTO

BLACK FLAG IIII
ADOLESCENTS

$7.50

CHANNEL 3

BLACK FLAG IIII

MINUTEMEN
plus
TRAGICOMEDY
and
Special Guest

Friday, Jan. 7, 1983 8:00 p.m.
LA CASA DE LA RAZA
601 East Montecito St.
Santa Barbara

Limited Tickets
$8.00 on Sale
Dec. 17th at
Rockpile, Turning Point

THIS IS THE PUNCH LINE

ART: Raymond Pe

RC presents

BLACK FLAG IIII

FEAR
STAINS
YOUTH GONE MAD
CaUsTIc caUsE

GOLDENVOICE PRESENTS

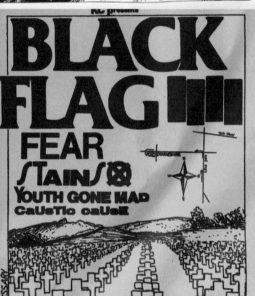

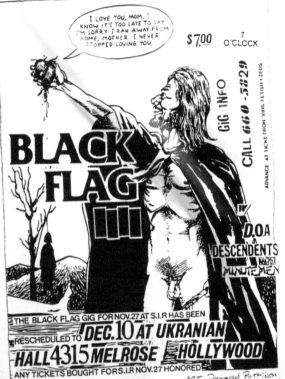

I LOVE YOU, MOM. I KNOW IT'S TOO LATE TO SAY I'M SORRY I RAN AWAY FROM HOME, MOTHER. I NEVER STOPPED LOVING YOU.

$7.00 7 O'CLOCK

GIG INFO CALL 660-5829

ADVANCE AT TICKET FROM VINIL FETISH + ZEDS

BLACK FLAG IIII

D.O.A
DESCENDENTS
MINUTEMEN

THE BLACK FLAG GIG FOR NOV. 27 AT S.I.R HAS BEEN RESCHEDULED TO **DEC. 10 AT UKRANIAN HALL 4315 MELROSE HOLLYWOOD**

ANY TICKETS BOUGHT FOR S.I.R NOV. 27 HONORED

ART: Raymond Pettibon

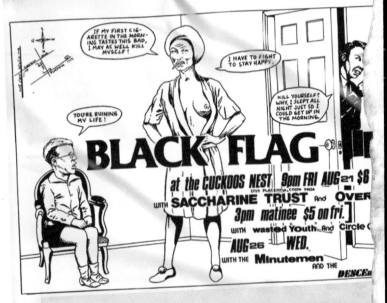

IF MY FIRST CIGARETTE IN THE MORNING TASTES THIS BAD, I MAY AS WELL KILL MYSELF!

I HAVE TO FIGHT TO STAY HAPPY.

KILL YOURSELF? WHY, I SLEPT ALL NIGHT JUST SO I COULD GET UP IN THE MORNING.

YOU'RE RUINING MY LIFE!

BLACK FLAG IIII

at the CUCKOOS NEST 9pm FRI AUG 21 $6
1714 PLACENTIA, COSTA MESA
with SACCHARINE TRUST and OVER
3pm matinee $5 on fri.
with wasted Youth and Circle
AUG 26 WED.
WITH THE Minutemen AND THE

DESCE

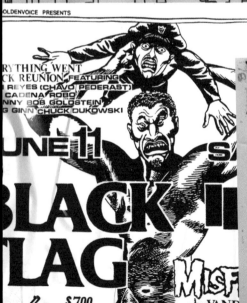

RYTHING WENT
K REUNION FEATURING
REYES (CHAVO (PEDERAST)
CADENA (ROBO
NNY BOB GOLDSTEIN
G GINN) CHUCK DUKOWSKI

UNE 11

BLACK FLAG II

MISFI
VAND

$7.00

CLIMAX PRESENTS

BLACK FLAG

For more information call

SDAY FEB. 11
DUST BALLROOM
5612 Sunset blvd
462-1111

BLACK FLAG IIII

Tues WITH THE MiDDle Class

TASTE TH MOMENT!

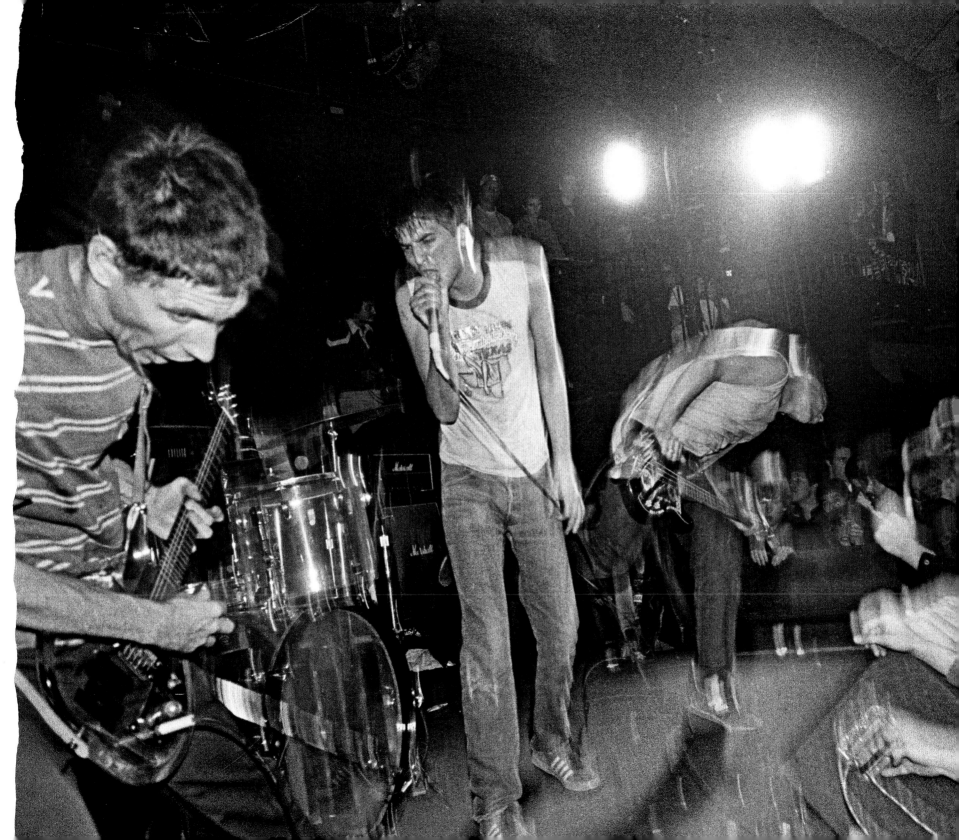

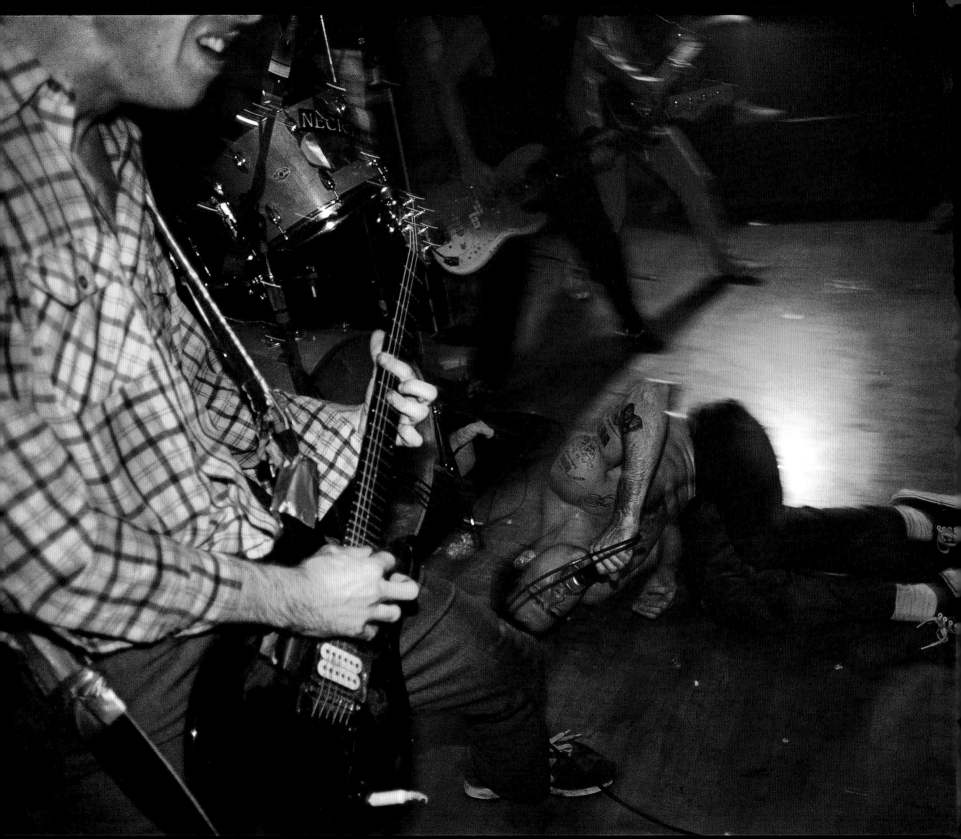

what I see

the BLACK FLAG photographs

glen E. friedman

what I see
the BLACK FLAG photographs
glen E. friedman

First Edition

Published by Akashic Books
Copyright © 2022 Glen E. Friedman
ISBN: 978-1-63614-036-0
Library of Congress Control Number: 2021945447
Printed in China

All photographs by Glen E. Friedman
Foreword by Chuck Dukowski

This book was edited and designed by Glen E. Friedman, with Sohrab Habibion
Editorial assistance by Ian MacKaye

Special thanks to Astrida Valigorsky, Guy Picciotto, Scott Martin, Henry Rollins,
Raymond Pettibon, Ric Clayton, Jaime Sciarappa, Joe Carducci, Doug Linde, and Bryan Ray Turcotte

Akashic Books, Brooklyn, New York, USA
info@akashicbooks.com, www.akashicbooks.com

Burning Flags Press
PO Box 69, New York, NY 10276
www.BurningFlags.com

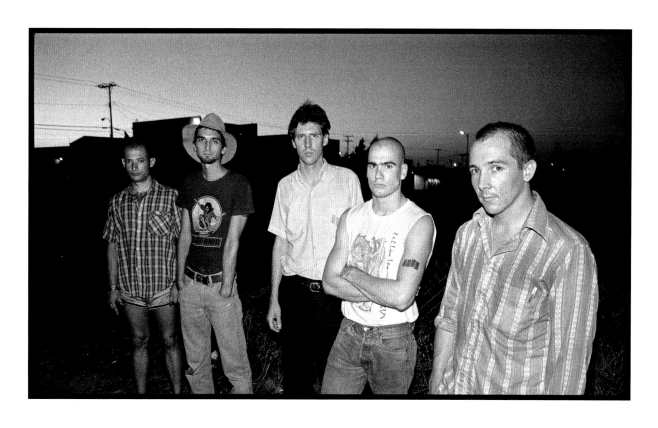

table of contents

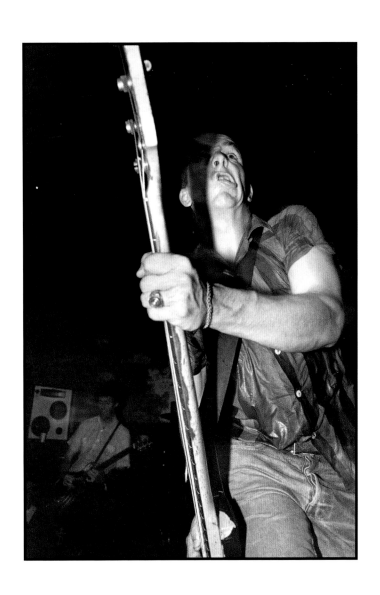

What I See

The title of this book is taken from a song I wrote for Black Flag. "This feeling haunts me . . ." the song begins. Looking at these photographs, I am haunted by a different feeling, the icy touch of the ghosts of yesterday.

These photos encapsulate performances I will always remember and shows I have forgotten, their memory lost in a blur of gear loaded in and out of vans in nightclub alleys, thousands of times over. We worked like our lives depended on it and that tension, energy, and drama played itself out in our live shows.

I'm a bass player and a songwriter but through my drive to share music I became other things—record label owner, agent, tour manager, graphic designer, band promoter, and janitor! In the true DIY spirit of the day, I did every job that needed to be done. Looking back, I think one of the things I did best was choosing people to work with, and one of the best people I chose was Glen E. Friedman.

When you think of an image of Black Flag you are probably thinking of one of Glen's photographs. And that photograph is, more likely than not, an intense action shot.

When I met Glen at a show we were playing in East LA, just as our second EP was released, in nineteen hundred and a million years ago, what intrigued me was that he was a photographer for *SkateBoarder* magazine. Not only was skateboarding part of my culture as a Southern Californian but I knew that the energy and intensity of punk rock and the energy and intensity of skateboarding were, at their core, the same thing. Glen captured and framed that perfectly.

It is deceptively difficult to photograph the zeitgeist of a musical performance. So few of the iconic images of musicians are of them actually performing. Glen brought his experience as a skateboarder-cum-photographer to the action of punk rock and he made it *fine art* by showing the emotion of the music. His shots compose and expose the cathartic expression of the moment. I tried to give Glen access to the stage as much as I could so he had the opportunity to create. He rewarded us by doing some of his best work.

Early in the career of Black Flag, before Henry Rollins, when Dez Cadena was our singer, we had some of our worst problems with the local police. I remember a show at the Stardust Ballroom in Hollywood, early 1981. There are some photos of it in this book. The show was memorable to me because it was the first gig in a long stretch of planned shows that we actually got to play. Over and over we would arrive at the venue to find that the LAPD had shut down the show before it even started. It became a joke that our real job as musicians was just to load and unload our gear, never to play. For some reason the police had fixated on us at this time. Amazingly, they tapped our phones, which I know, because I once picked up the receiver and instead of a dial tone I heard men speaking about their surveillance of us. Shortly after that our place was raided. They tore our space apart and found nothing—but our landlord evicted us anyway.

One of the performances depicted here is of a show in front of the Federal Building in Westwood, near UCLA. I arranged the show with a political group that advocated for marijuana legalization. I'm not sure how they got permission or if they even had permission for the show. There was just the hope that federal officers wouldn't deign to bust it. We brought generators for electricity and weren't bothered by an officer of any stripe, though there were men with telephoto lenses looking down at us. I guess Glen wasn't the only photographer that day. Today marijuana is legal in California and the Federal Building is surrounded by large pylons, the front lawn unavailable for protests.

For me, all the photos in this book invoke a personal nostalgia, but for everyone, including me, they have, with time, developed a new layer of meaning. They are evocative of a lost era. I am strangely reminded of Dorothea Lange's famous Depression-era photo of the migrant mother. Her face in that moment is shorthand for understanding the struggles and deprivation of the Great Depression. I look at Glen's photos of my own face, twisted and raw, pushed to the edge. What do they say about that time?

2020 is heavy on my mind as I write this; the summer protesters marched in the street in front of my house. "BLACK LIVES MATTER!" they shouted. My family and I went outside and shouted with them. "SAY HER NAME! BREONNA TAYLOR!" we screamed. The upwelling of emotion was almost unbearable. Police cars formed a phalanx at the end of my block, officers waiting with their guns out. I thought of the "riots" at Black Flag shows, which weren't really riots at all, just the LAPD deciding some kinds of music are a threat. Back then we had a truly evil police chief, Daryl Gates, who talked about "breaking" young people like horses. Regarding deaths from choke holds, Gates once said, "We may be finding that in some Blacks when it is applied, the veins and arteries do not open up as fast as they do in normal people."

Normal people. Sit with that for a second.

Thirty years later, George Floyd called for his mother as a police officer choked him to death.
I want to believe we can get better.

My heart aches to believe
I'm cheated from what I see

I wrote those words so long ago but the feeling, the frustration, is still there. I was aware at the time that the persecution we experienced from the LAPD was mitigated by the fact that we were white suburban kids. If our band had been Black, I don't think it's hyperbole to say that the police would have killed someone. As it was, we felt bold enough to play "Police Story" and create mocking radio ads that made the riots seem like a part of the show. It was all so toy by comparison to the deaths in the streets today . . . but then again, billy clubs always hurt.

My heart still aches to believe and I'm going to let it. I'm going to let my heart believe that the future will be better. I'm going to let my heart believe that we still have a chance to right so many wrongs, that at least we will try. I'm going to let my heart believe in a just future for my children, and someday my grandchildren.

— Chuck Dukowski

Inspiration & the context.

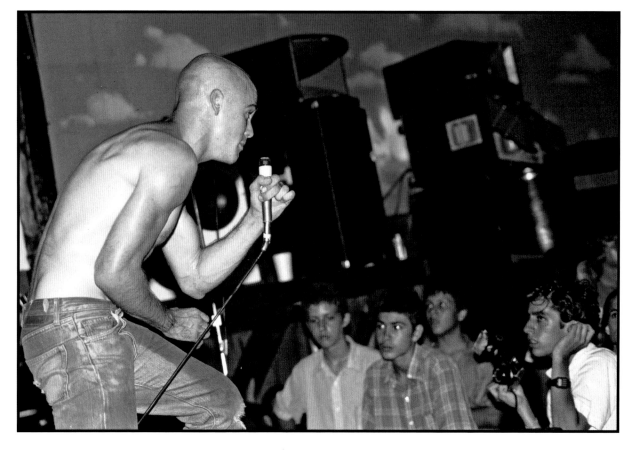

In front, shooting what many people believe was Henry's first official show with Black Flag. *Photo by Brian Tucker - Fer Youz.*

Rise Above

Music was the story of our angst as teenagers, and we lived for it, as much as we lived for our skateboards and the new lifestyle that had never existed before. Punk rock was very similar, but in the beginning more elusive than skateboarding, it was weird and even scary. The style was unlike anything! I mean the clothes, the sound, the outlook on the world, the awareness of things outside of our normal circles were expanded incredibly by punk rock. Its rebelliousness, intellectualism, and creativity in the early years were something to behold.

By 1978 my friends and I had begun the migration from the hard rock of Ted Nugent, Led Zeppelin, Aerosmith, and Jimi Hendrix to the likes of the Ramones, the Damned, Devo, Sex Pistols, Buzzcocks, and others, then came the Germs, Dead Kennedys, the Weirdos, and more. The prior music was loved for its energy, the highest of the era, but punk rock had ten times more and spoke of things we could relate to more closely. In 1979 I had heard of the band Black Flag but I had not yet heard their music. Obviously you could not go online to look them up, you couldn't even go to the radio and listen for them. There were only a few radio shows around *the world* that would play punk rock at all, they were very obscure and you had to listen at weird hours of the night, at most once a week or even once a month, if you could even find them. To say they were few and far between is an understatement. You had to know where you could buy independent and imported records to get to hear most of these bands.

Why did we do it? you may be asking. What drove us? What made us so hungry or interested? Well, for one thing, we did not have the world at our fingertips, we were not bored of life because there was just too much going on in the world that we had no access to, as far away as any dream we could imagine. But music, that was our escape, that was our release.

Back in the early days, if you were into punk you were usually ridiculed by classmates and only accepted by your closest peers, if any. It was a place for outcasts, those considered weird, artsy, nerdy, or just different. We were encouraged to express ourselves freely in any and every way. It was liberating for the post–baby boomer generation that did not participate or want to be a part of the "normal" sports/cheerleading "popular kid" stuff. We relished being outsiders and would even have to fight for that privilege we gave ourselves. Hated by most and only respected by the more open-minded folks who could see we were doing something unique and NEW. Of course there were nihilists and drunks and brawlers, like in all other social circles, but for the most part, the punks of my day were free thinkers, people who really cared for others and the world at large. We knew there were other ways of looking at things besides what was taught in schools, portrayed on TV, or espoused by our parents.

Being a punk rocker—getting threatened by people who were scared of us because of how we looked, what we were thinking, what we were doing, how we protested, or what we were listening to—was a badge of honor for us mostly skinny runts and peculiar-styled kids.

Alternative thinking: that's where the cleaned-up, more-inclusive-of-other-musical-styles-and-perspectives music category of "alternative" came from a decade later. If it wasn't so sterile, I think I would have liked it as a category of music, but it came to mean almost nothing compared to what we were exposed to and inspired by in the late 1970s and early '80s.

Rodney Bingenheimer,
Starwood.

I remember very clearly the first time I heard BLACK FLAG. We were at Rodney Bingenheimer's "New Wave Disco" at the Starwood nightclub in West Hollywood. Rodney had been a Hollywood fixture since the '60s and a radio maverick who introduced the United States to countless new acts—both local and from the UK—that were on independent or foreign record labels and would not get played on any other commercial radio stations. These Tuesday and Wednesday nights they had punk shows (probably because normally people wouldn't go to a club in the middle of the week). Punks had so few places to see shows, and it was great for the time. We were there to see the Alley Cats and the Crowd, I believe it was late 1979. Between bands we went into Rodney's area, and while the dance floor was mostly empty, people would hang out, socialize, and listen to what he was playing. The most abrasive, raw, underproduced, almost broken sound I had ever heard was coming out of the super-loud speakers. It was actually almost abusive to the ear, relative to any other "music" recording I had ever heard. I fucking loved it. I asked my friend if he knew what it was, who it was. Of course, because I mostly hung out with people who were tuned in, he knew and said, "That's Black Flag." It was their first record, it hadn't been out long, and Rodney may have even had an early copy of the very first small pressing. The song was "Nervous Breakdown," it was truly awesome, thundering, distorted, and loud, never mind the volume. I needed to have that record, I was on a mission, but alas, I could not find it before I had to head back to the East Coast after my school break visiting my mom.

It was months later that I got a cassette from a friend with this hard-to-find record on it. The tape also had X, Dead Kennedys, the Germs, the Weirdos, and others at the tail end of the '70s, mostly bands that didn't have full albums out yet. I loved them and was thrilled by all of them, but that Black Flag sound was just fucked up beyond anything else up to that time. It wasn't just punk rock, it was hard-core punk rock. I was inspired by it.

Next time I was back in California, punk was getting a bit more popular but still a real fringe culture with no more than a hundred or two hundred people at the biggest shows. Another skateboarding friend of mine who lived in Redondo Beach told me he had heard that Black Flag was playing nearby at an old abandoned church that

had become a kind of community center. We went to see them play, it was at the Church where some members of the band were living, and Ron Reyes was the singer (I never got to see their original singer Keith Morris play with them back then). It was sparsely attended, not well lit, kind of a derelict party more than a show, but it was good and loud.

By the time I moved back to California for college in the summer of 1980, punk rock shows were getting bigger, but they were still limited to just a few hundred people. Maybe the biggest show I saw next was Black Flag playing at a place called the Hideaway in Downtown LA in September of 1980. The Pettibon flyer was ominous with the huge shearing blades and the title *Everything Went Black*. We got there, and the street in front of the warehouse was crowded. Everyone was trying to fit through one small door between two big gates, and eventually we got in. The place was packed but people were still trying to get in. Finally a bunch of kids just pushed a car into one of the huge gates and were able to break it open, and everyone just rushed through . . . I can't remember if Black Flag even got to play, but I believe we saw a few songs and then were forced out. Before I knew it, we were all back out on the streets, hanging out, surrounding the place . . . then suddenly we see a phalanx of at least fifty helmeted police marching toward us! Like, what the fuck is this about? We're trying to see a band play and there are police in riot gear waiting for us when we are leaving? At the time it made no sense, it was even absurd. It was in a dead-quiet industrial area of Downtown and we scurried to our vehicles to get the fuck outta there ASAP. The next day I told my stepfather, who was a criminal lawyer, and he could barely believe me. He advised me to get badge numbers next time, but I told him they had them covered. I never saw anything like that in my life up to that point, it was like a full-on army battalion . . . for a bunch of punk rock kids! WHAT THE FUCK?

I went to try and see them again. Black Flag had two shows on a Wednesday night just a few weeks later at the infamous Whisky a Go Go and it turned out to be a real riot on the Sunset Strip. As the crowd was gathering and growing on this stretch of the strip known for its world-famous music venues, someone threw a glass bottle at a police car driving by, smashing against its windshield. Within minutes, dozens of police units

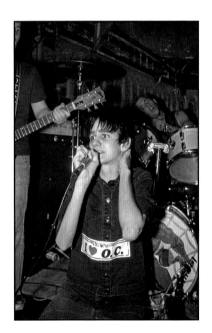

Adolescents, Baces Hall.

showed up and chased everyone away and closed down the club for the night. Neither of the shows got to happen.

The next Black Flag show in LA was just a few weeks later, on Friday, October 24, 1980, deep in Hollywood, closer to Los Feliz, on Vermont Avenue. It was in a busy area with a kind of strip mall across the street, near a huge lighted intersection, just a block north of Sunset Boulevard. This venue, Baces Hall, actually had a stage, and there were a ton of kids there. Black Flag was getting more popular by the day and the crowds were increasing dramatically as people found out about their shows via the *LA Weekly*, Rodney on KROQ, or most impactfully from Black Flag's own DIY Raymond Pettibon flyer and poster campaigns. With the added mayhem created by the insane police presence at their shows, there was palpable excitement in the air. We were participating in something that warranted helicopters, SWAT teams, and police cruisers too numerous to count. The large numbers of cops baffled us at first. We weren't doing anything illegal or wrong. Their presence was often blamed on promoters being scared by the overwhelming crowds that were showing up that often looked threatening to them, with leather jackets, spiked wristbands, and unusual haircuts. In hindsight some pointed out that perhaps even the police officers felt threatened by this "uniformed" uncontrollable presence, while others postulated that it was the LAPD gearing up for the 1984 Olympic Games in LA and the powers that be didn't want visitors to see anything but pretty stereotypes.

The Baces Hall show was monumental to me for several reasons, mostly because the bands were great and so many of my friends were there. UXA played, with pro skater Kent Senatore on bass for them, and Jim "Red Dog" Muir was onstage helping out. The Adolescents had their biggest audience to date, and I made photos of them at this show that appeared in the liner notes of their first album (which was my first album cover too).

By the time Black Flag were to come onstage and play, the police were getting ready to invade and shut the place down. There were multiple helicopters circling overhead, and well over a hundred cops in helmets and riot gear. The promoters pleaded with the cops

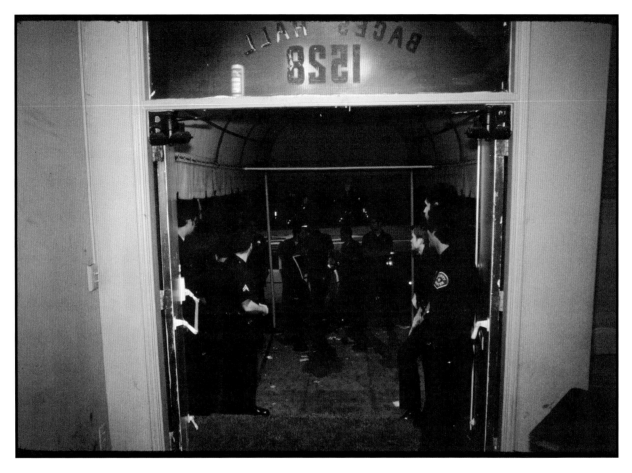

LAPD, Baces Hall.

not to shut it down in fear that kids would destroy the place if Black Flag did not get to play. Black Flag were rushing to get onstage, but the cops were not going to wait. I was in the middle of the room when the band went on, trapped as the cops were coming in the main door behind me, opposite the stage. As soon as they entered, they started to line up across the entire back of the venue, before pushing forward and swinging their billy clubs at anyone who stood in their way. Black Flag broke into "Police Story" . . . *Fuck this city, it's run by pigs, they take the rights away from all the kids* . . . as everyone was being forced out one tiny back exit to the left of the stage. I tried making some photos, though I can't find evidence in my archive that any came out from those few moments, but Black Flag linchpin Spot shot some where I can see myself up front trying. The gig was shut down before Black Flag barely got started.

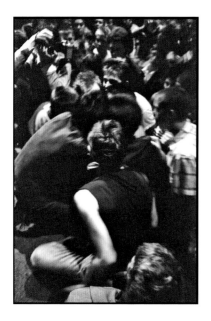 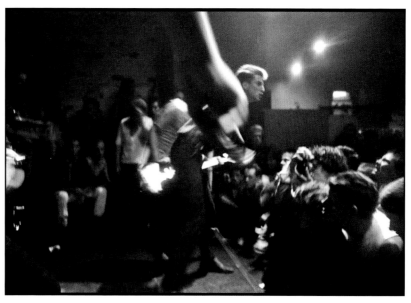

Baces Hall evidence. *Photos by SPOT.*

Before the place was emptied I managed to get up on the stage and was attempting to hide behind the drum kit as though I was working with them to take down the equipment, but by this time no member in the group was to be seen. A cop grabbed my camera like it was a leash to get me out; reluctantly, but due to force, I was out through the back door like everyone else. There was total pandemonium on the streets as everyone was trying to leave and cops were chasing us and swinging! This was not the first or last time that cops had broken up a show, forced kids to leave, and then as they were leaving, or trying to get in their vehicles, cops would beat them as if they were not moving quick enough. It was insane. I saw a woman get chased and whacked by an officer so hard that her leg broke. This was unfathomable in that moment in time, and if I hadn't seen it with my own eyes, I'd have a difficult time believing it actually happened.

The next Black Flag show I went to was November 28, just a month later. It was going to be in a more remote, less-cared-about section of town, with the hope that the cops or county sheriffs wouldn't be interested since it was East LA. The venue was the Vern Theatre, it had a proper stage and was pretty big. There must have been three hundred people, if not more, and there was quite a bit of the usual commotion. A bunch of weird things happened that night, but one of the more funny ones was that rather than a coat check, at this venue they checked everyone's chains! I never usually make pictures of the extraneous cultural shit of the moment, that was never my thing, but this was just ridiculous, I had to . . .

Later in the evening, Black Flag finally came on and for the first time in months they got to complete a full set within LA County. The show was blistering in its sound, spirit, aggression, speed, and most of all attitude. It was the first time I was able to finally make pictures of them. Dez Cadena was the lead singer, and it may have been one of his best shows. His voice was not totally shot yet, as it would become in the nights, weeks, and months to follow, until the next singer was found. But Dez's raw guttural vocals were perfect for that era. I think I shot part of a roll of color film and a full roll of black-and-white, I was stoked to finally be able to make pictures of this band.

After the show, somehow I met Spot, the band's producer and engineer. He was also a photographer and all-around enthusiastic nice guy. I introduced myself, and being a skater himself, he recognized me. Immediately he invited me to come out to the van as they were packing up the gear, and he wanted me to have a copy of the *Jealous Again* EP that had just been released. I promised him and Chuck Dukowski, who I had just met, that I would see if I could get the record reviewed in *SkateBoarder*'s *Action Now* magazine (the transition publication from the failing *SkateBoarder,* which no longer had an industry to support it, to a more diverse format that was to include music and other action sports). I got Black Flag the review in the next issue that went to print, written by the same friend who turned me on to them, Brian Schroeder, who would later become known for his incredible drawing skills as "Pushead." Dukowski once said that review got them exposure all over the world like no other press they'd ever had.

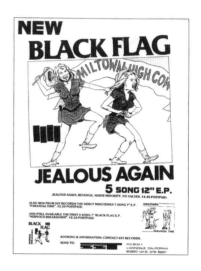

The next show was just after the new year. They were playing two nights, January 6 and 7, 1981, at the Starwood with various great opening bands. I sat on the front of the stage next to one of the sound monitors, staying low, and later also moved to the side of the stage and got some photos with Dez still getting out the vocals with his torn voice. After this show I grew more comfortable moving around, as did the band with me moving around them, while always trying to be inconspicuous. This show in the confines of the West Hollywood property went off pretty well. I got the editors from *Action Now* to come down, and after seeing what I had been telling them about, they promised an article in a future imprint (which would come about a year later with their final issue that included the Black Flag bars on the cover next to the skater Neil Blender).

Test pressing with hand-drawn
label by Chuck Dukowski.

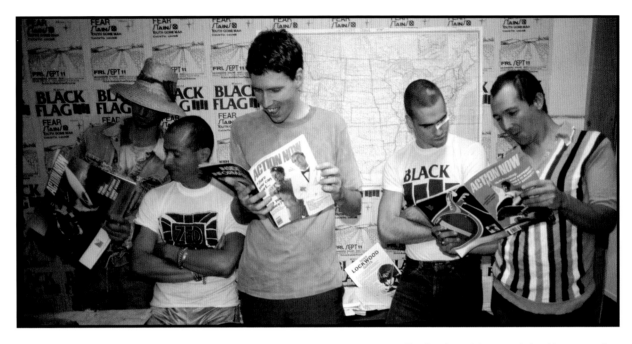

The band checking out *Action Now* magazine.

Things were really blowing up. It was an amazing period with the scene growing by leaps and bounds and the creativity really swelling. Records were being made by scores of new punk groups, and in retrospect, every month felt like a year, with so much going on all the time.

In early February there was the show at the Stardust Ballroom. There must have been a thousand people there. Circle Jerks, Fear, and China White were all on the bill too, and everyone I knew in the punk and skate worlds was there. Once again, I got onstage to make photos. Dez with a bandanna around his head, Dukowski with a *NO VALUES* T-shirt. This was also the night I shot the controversial live photo of the Circle Jerks that was used as the promo poster for their second album. The record company removed the swastika from the bass player's arm in the photo (he was Jewish no less).

There were a few more local gigs that winter and spring, but early in 1981 Black Flag took on a heavy-duty tour schedule that lasted till late July. Rumor had it they had found a new singer on the road. People close to the band knew that Dez wanted to play guitar more, and his voice was not holding up. It was a rougher, tougher sound compared to the two previous singers, Keith and Ron, but it was just not going to be able to last.

One night in mid-August, I was sitting out at Oki Dogs, the notorious punk after-show meet-up spot in Hollywood. I saw a guy there I had met in New York earlier in the summer at a show, the singer of the band S.O.A, up from DC. As a fellow skater, he knew me from *SkateBoarder* magazine and I convinced him to hook me up with a copy of the S.O.A record he was selling outside the gig for possible review in the magazine. Now hanging at Oki Dogs, I asked this tough-looking guy with the shaved head what he was doing out here in LA, and he calmly said he was Black Flag's new singer. Oh shit! We all figured they would have a new singer sooner or later, and damned if everyone didn't want that job, but this dude who I met in NY from DC, he was it! He handed me a flyer for two Black Flag shows on August 21, 1981. I told him I would be there with my camera, and he kept his cool.

By this time I had met all of the band and they were good with me shooting. Along with another of my all-time favorite images, the cover of this book was a photo I made that afternoon, generally thought of as Henry's first official show as the lead vocalist of Black Flag. After that matinee, I shot a few during sound check for the evening gig and a couple of group photos as the sun was setting outside the Cuckoo's Nest. Henry Garfield from Washington, DC, now Henry Rollins upon his arrival in Los Angeles, was a wrecking ball! He destroyed those songs he had loved as only a true fan could, it took no effort, it was all in his heart, he screamed every damned word like it was his last. As I've said many times since meeting Henry, some might think it's a facade, and sure, he can joke around with the best of them, but Hank is as serious as a heart attack. There is no such thing as fake around this guy. Shows down in Orange County, where the crowds were notoriously rough, were nothing difficult for him. He commanded the stage with his vocal strength and dedication. Respect was immediate from all those who didn't want to act too cool to give the new guy a chance. There was no fucking with this animal.

After Henry got in the band I became a bit closer with them. They started seeing my photos a few days after each show once the film was developed. I began hanging with them more and more, going down to the SST "office," which could more accurately be called a "base of operations," where they were all living in one room on the street

Original *Damaged* LP label
(unreleased).

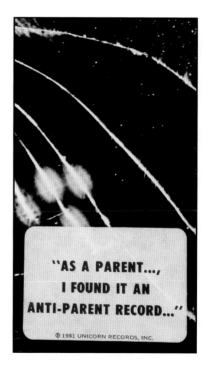

Sticker, back of first LP
pressing, *Damaged*.

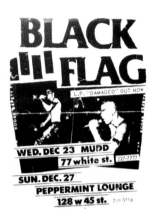

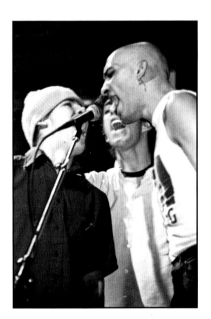

Mugger, Earl Liberty, and me
(in the middle) singing backups
live at the Peppermint Lounge.
Photo by Arabella Field.

level, sleeping on the floor and under desks in any makeshift space they could muster. I was a fan for sure, but I really felt a responsibility to be there and help if I could. I wanted everyone to know about this band and what they were doing, *I wanted everyone to be as inspired as I was.*

Coincidentally, they moved up to West Hollywood for several months to record their debut full-length album *Damaged* just as I was getting my first apartment at age nineteen a few blocks away, sharing it with my seventeen-year-old girlfriend who had run away from home and left high school to be with me. I came down to practices, sat in on a few recording sessions (where, embarrassingly, I even put down my vocal along with the crew on the song "TV Party," and joined in on gang backups on "Rise Above" and "Six Pack"), and made a few portraits of them on the street one night outside the studio.

I remember one afternoon during the *Damaged* sessions when Henry was getting his first *major* tattoo work done by the legendary Rick Spellman. The skull drama masks were so fucking cool that after seeing them I came minutes away from getting tattooed as well. I sketched out exactly what I wanted: the Black Flag bars logo of course, the words *MY RULES,* and then, with *INTEGRITY* below that, the skull drama masks, along with some other details. Someone teased me about how much thought I put into it. After rubbing my skinny arm, preparing for the needle, I backed out. No regrets, and to this day I never got inked. I figure if I could walk away from the afternoon when Henry got his skeleton drama masks, I'd never be tempted again.

When *Damaged* was released Black Flag went into overdrive. They personified DIY like no one else up to that time. Not only did they book their own shows, drive and move their own equipment in and out of gigs, spray-paint graffiti, paste up and hand out their own flyers, they also did their own publicity. They taught me about stuffing envelopes and getting editors' names from the newsstand magazines and newspapers and addressing envelopes with 8x10 prints to help them get press. But this time, with their first full album, they were pursuing a distribution deal with a major label. Not only was the album phenomenal but there was an alluring hook for the press to bite at—a record executive at the major label balked, calling it an "anti-parent" record!

This made no sense, but it certainly gave us a reason to pursue publicity in mainstream publications. I myself stuffed at least a dozen or two envelopes to the likes of *TIME, Newsweek, New York Times, Los Angeles Times, Village Voice, Boston Globe, Rolling Stone, Creem, NME,* etc., you name it. I got not one bite! Outside of fanzines and the skateboarding magazines I worked with, it would be years before the bigger press would ever mention Black Flag. It sucked.

The song "Rise Above" was an incredible anthem, my favorite of that moment, and it led off the new album. Newly recorded versions of "Depression," "Police Story," "Spray Paint," and "Gimmie Gimmie Gimmie" with Henry on vocals could not be denied. "What I See" and "Padded Cell" were mind-numbing, and the album-ending opus "Damaged," with Hank contributing his first lyrics to the band, was a monumental emotional earthquake. "Thirsty and Miserable," cowritten by Dez, is probably my all-time favorite. This LP inspired me and legions of others.

The *Damaged* LP got released and then all hell broke loose when the major label distribution deal officially fell through. It was a shame. After we did the photo for the "TV Party" single, nothing was happening beyond a heavy schedule of touring. One week during a short break we all piled in the van and drove up to San Francisco to do a video for the "TV Party" single with Target, the infamous punk rock video production company. They had no real plan, and I was probably the only one in the van who had even seen MTV at that time, so I put together an idea on the way up for what we would do, with some tinkering by Dukowski and Joe Rees at Target. The video got filmed in just a few hours, we had a laugh, and making it was about as much of a goof as the song itself. It was a commentary, but mostly a joke, at least to me (and as Chuck used to say back then, "If they can't take a joke, then fuck 'em!").

And then came the legal mess. It all went sour, and "Everything Went Black" for real. Because of a record contract, the band was not allowed to release the new material they wanted. They went to court and got thrown in the slammer! This essay isn't an attempt to offer a complete history of the band but more just a reflection on my time with Black Flag and the inspiration that helped me make my photographs. You can read all the

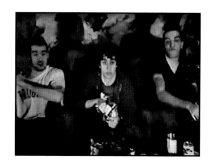

Frame from "TV Party" video: Henry, Glen, and Earl.

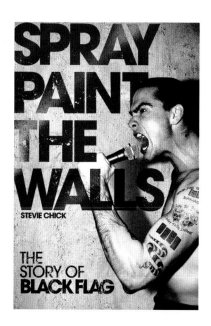

Stevie Chick's tome.

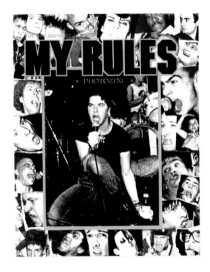

My Rules photozine
front cover, November 1982.

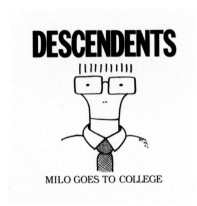

First Descendents album,
September 1982.

inner workings of what happened with the lawsuit in the great book *Spray Paint the Walls* by Stevie Chick (with my photos gracing the covers, I'm proud to say). I believe Chuck and Greg Ginn were the first musicians ever to do jail time for fighting a music contract. It wasn't a long time, but it had a major impact on them, exposing them even further to the adversity of the system, legal and penal. That shit was fucked up.

I became a part of their crew in some ways, though not 100 percent. I was out wheat-pasting posters at night with them and handing out flyers at shows, shooting group shots that were needed for press, both for Black Flag and even some of their labelmates. Within California, I drove to many shows with a few of the guys in my car, usually *without* my camera in hand. The camera gear was cumbersome, fragile for punk gigs, and expensive—who wants to worry about that? And I didn't want to be seen as the camera nerd. But of course I was so inspired that sometimes I just *had* to make photos while I was getting out angst, head banging or slam dancing to my favorite band on the planet. Often I would just kneel by Greg's guitar amp with the sound blasting just inches from my ear for most of the set. I got a more full dose of that insanity than just about ANYONE. And I'd get some photos too! But the fact is, I saw Black Flag play many more times without my camera than I did with it.

I drove up to SF on August 12, 1982, with Dez, Henry, and label guy Joe Carducci all in my little Honda, for a gig that was in the back of a theater. They actually played off the back of the stage and the audience was hanging in basically the loading area. At this point Chuck Biscuits was the drummer in the band. I had volunteered to go up to visit my recently exed girlfriend and stay the night as she was visiting from NY. It wasn't a good rendezvous, but Black Flag was playing and it was probably one of the best shows that they had ever done. I had so much frustration about what I was dealing with that I couldn't stop slamming, even with my camera in hand, only on occasion passing it to my friend to hold, then I'd grab it back and push unabashedly to the front and shoot some pictures. It was more intense for me than ever because of my personal stuff, so not only was I slamming with total abandon when on the dance floor, but when I was making photos I was as intense as ever, making sure to get the goods.

The gig ended, I drove my friend to the place she was staying, and I realized I would not be spending the night. I went back to the venue where the band was still loading out. Henry said he would drive back down to LA with me. I took the first shift so he could rest after the show, he took the second. We drove up, had the show, then drove back, all in less than eighteen hours. Henry dealt with my sob story and I eventually fell asleep. About an hour away from SST, I took the wheel again and Henry started to write some early rudimentary lyrics for Black Flag, or perhaps it was just poetry.

Word got out to Bill Stevenson of the Descendents, who was good friends with the Black Flag crew, that I had a pretty sad breakup situation I was dealing with. Since Milo, their singer, was going to college (as their debut LP stated on its cover), they needed a new singer, and Bill asked me to try out. He thought that all the emotional stuff I was going through would help me be a great singer. I practiced with them about three times, but in the end they got another guy who also played guitar. So I didn't get to actually ever perform as a lead vocalist in a band, but I came that close!

Instead, I created and self-published my own zine. I had been in the dark room one night in late September of 1982 making prints from 7 p.m. to 7 a.m. for a book that was slated to come out on California punk. After I finished and looked at all this work I printed, I *knew* that the publishers would not use everything I wanted them to. I *knew* it would not be as great as it should be. To be more honest, I *knew* it would suck. I called my friend, and the first editor of *Thrasher* magazine at the time, Kevin Thatcher, and asked him what it would cost for me to make a zine with the same quality as *Thrasher*. I wanted to make it a one-time thing, exclusively photos of all the bands I had taken across the country that were worthwhile. Later, I decided to add short essays in the back from the main movers in each part of the country that I knew. I named it after the Black Flag song "My Rules," and it was not a "fanzine"—it was going to be the first ever "photozine"! I laid out the whole thing myself with some help from K.T. on the mechanicals, and the local typesetter for the text bits I didn't make myself with Letraset rub-off type lettering. I collected ads from all my record label friends to get the cash to do it and traded space with others. *Thrasher* got their ad for letting me use their facilities in the Hunters Point Shipyard to put the layouts together with K.T.

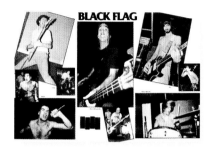

My Rules photozine center spread.

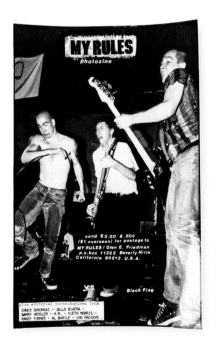

Original mail order ad, master, sent to fanzines.

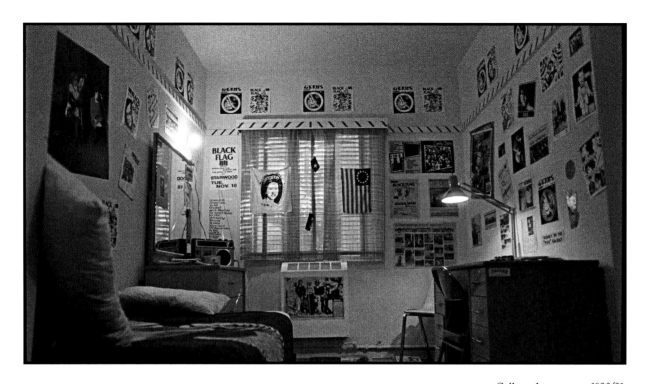

College dorm room, 1980/81.

Black Flag and SST Records got their ad for being the transportation for ten thousand zines we had to move from Northern California back down to LA in their tour van. Davo, Black Flag's roadie, and I moved them all from the bindery up north, down to LA—the exhaust leaking from the engine block into the van while we were driving back and forth for sixteen hours straight definitely fucked up some of my brain cells. The zine turned out to be a huge success, selling over eight thousand in the first two years. I sold it directly to record stores, magazine stands, and independent record distributors around the country. I also put ads in the biggest fanzines at the time, *Flip Side* and *Maximum Rocknroll*. I had lunch money coming into my p.o. box from around the world for years.

The Black Flag show at the Ukrainian Cultural Center in East Hollywood on December 10, 1982, was another one of the greatest I ever saw. Biscuits was on drums, and no one could deny that whenever he was practically standing up behind any band smashing his kit, it was gonna be great. The band was beginning to bring out post-*Damaged* songs, only a couple, so they were still taking no prisoners and destroying the auditorium with power and emotion like no other band you would ever see. I shot a roll of B&W and a roll of color this evening and got that shot of Henry that

was on the cover of the original *FUCK YOU HEROES* book. I love that image since you can also see everyone behind Hank in the shadows or in silhouette while he's just killing himself for each lyric of "Damaged." As usual, heavy as a ton of bricks.

The opportunities I had to work with other bands and be more involved in the production and promotion of music were a direct outgrowth of my experiences with Black Flag. I was in school at UCLA by this time, after a year at Santa Monica College where I got my GPA up enough to be able to transfer over. I met Mike Muir (my good friend Jim "Red Dog" Muir's younger brother) while there and we became friends. He gave me his band's demo and I loved it. Unfortunately for them, no one else outside of Venice and West LA really did. Now let's not kid ourselves, it wasn't because of the music so much as the rabid insane fans his band Suicidal Tendencies had. They were considered a nuisance by most of the scene in LA—they were hated! Super rowdy and out of control, they took the DogTown skate attitude and brought it to punk, and the rest of the city was not feeling it, but we sure didn't care. I loved their mix of '70s metal sensibility and hard-core punk rock of the beginning of the '80s. I told Mike I would help get them a record deal and do all their photography, and I also ended up being the producer of the album. Hanging with Black Flag and other bands in the studio over the last couple of years, I thought I knew what needed to be done.

Greg Ginn offered me my own record label to release the album, one that would be under an umbrella of other labels he would also form with his independent distributor, but something didn't quite work out. We still did a four-song demo with Spot, Black Flag's producer, that came out pretty cool, but not something to release to the public. So I went to my good friend Lisa Fancher of Frontier Records, the woman who gave me my first album-cover shoot for the debut Adolescents LP. She was a powerhouse at the time, having released first albums for the Adolescents, T.S.O.L., Circle Jerks, and China White, to name a few. She and her label were well respected and, most importantly, trustworthy. Eventually I was able to convince her to take on the project. I got the guys to practice in the drummer Amery's garage every day for a month until they were so tight we'd go in the studio and finish the album in three days! But then I had this idea for the cover. No punk rock group at the time would have the audacity to

First pressing of *TV Party* 7" single.

Hand-drawn S.T. fan shirts.

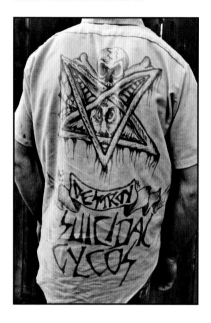

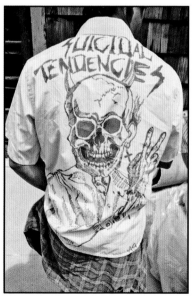

put themselves on their record cover, but since I was their de facto manager/producer/photographer, I figured a way we could make a photo of them that could work and still be "punk"—I had them hanging upside down! And I wanted to play up the idea of their wild following that often wore their own hand-drawn shirts to gigs. I wanted to get photos of all these shirts for the cover too, so I asked Black Flag if they would play a garage party with Suicidal to draw all their fans *without a doubt* to come out on a Saturday afternoon in West LA. Because they were always up for a challenge and would practice every day anyhow, they were all in as a favor to me.

This gig and party were in the backyard and garage of the grandmother of one of Suicidal's most dedicated roadies, Albert. You needed to be wearing your own hand-drawn S.T. shirt in order to gain entry. Black Flag went on first, they were playing as loud and hard as ever (can you imagine that in your grandma's garage?). Since there was daylight coming in from the window that faced the yard, I decided to use my fish-eye lens. Because we were so cramped in the space, I probably would not have been able to see more than one person at a time if I used any of my other lenses. The environment, as when shooting a pool in skating, was as important as the subjects, and it turned out to be perfect for the space. Black Flag's set was melting the walls. I would go off "dancing" for a few songs, then pick up my crazy camera setup for a few minutes here and there, and shoot. Another one of my favorite Black Flag images comes from this day. But truth be told, the Suicidal kids were not really loving Black Flag. In fact, it was probably Davo, Spot, and myself who enjoyed them the most. Henry almost got into a beef since one of the girls was getting too close and fell on the floor with him. Some thought he provoked it and a boyfriend was not happy, but out of respect held off, though it was a close call. There's some video of this day floating around if you want to look for it, I can be seen going off like a fool in front, while the band is giving it their all. Once it was time for Suicidal to play, their rabid fans who were all wearing their shirts (that I had photographed out in the yard) were so outta control, the band could not even finish a song without having to stop due to equipment being knocked down. I was not even able to shoot a single S.T. photo while they were playing. That was one for the books. It was also the last time Dez would officially perform with Black Flag, before going exclusive with his own band, DC3.

A few months later, on June 11, 1983, Black Flag was set to play at the huge Santa Monica Civic Auditorium (same place we'd see surf films in the '70s). It was billed as the "Everything Went Black" reunion because they would bring back Ron and Dez to sing songs they made famous, before Henry would come out and do his usual set. At the time there was serious bad blood between them and their original first singer, Keith Morris, so Black Flag had one of their ever-enthusiastic friends pretend to be Keith, using the moniker "Johnny Bob Goldstein." Merrill Ward from the band Overkill came out with a typical Keith headband and beer in hand and mocked him a bit, before Ron came out. Some interesting photos came from this show, even if a bit sterile because of the big venue. Some stuff I shot backstage in the huge well-lit dressing room while they rehearsed a set before going out onstage. It was pretty unbelievable how hard these guys ALWAYS practiced. A warm-up is one thing, but practically a whole set in your dressing room before you go out onstage? These guys were no joke at this time. Practice was life.

On July 4 in 1983 there was the last-minute outdoor show at the Federal Building in Westwood that was walking distance from my new apartment. Since it was 100 percent outdoors I brought down my fish-eye and motor drive in case there was some good action to catch. This was my main camera equipment for skate contests, where you may want to catch detailed specifics of a new trick, but it's rare that you'd have the ability to shoot live-action motor-drive sequences of a band playing. Still, I thought I'd try to do something different. Not as great as I had wanted, I realized that the lights and the dark background at normal indoor shows helped not only the audience focus on the subjects but also the vision and composition through my lens onto film. But I did what I could to make the scene look interesting and centered on the band.

In just a few more months a major change would come to Black Flag. Greg asked Chuck, one of the core founders (and to me the heart and soul of the band), to move over to band responsibilities other than playing the music, and have Kira Roessler take his place on the bass. It was devastating news to us die-hard fans (and friends of his) who loved to watch Chuck play and talk from the stage and in interviews. He was a major inspiration to many of us back then. He was not only cool, but more intelligent

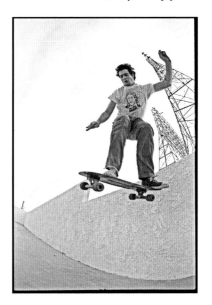

"H" off the wall before we shot a new band publicity photo.

Ad we did to get Henry hooked up with free skate equipment.

yeah, I ride 'em

27

than almost anyone in the room. At first Chuck seemed enthusiastic and okay with this, but years later, looking back, even he admitted it was some bullshit . . . But we all went forward.

They were back down to a four-piece with Bill Stevenson on drums and Kira on bass, Henry on vocals of course, and Greg leading on guitar and otherwise. It was weird. Kira was a badass. I probably knew her before any of the guys in the band as she used to date my friend Wally Hollyday (at that time the premier skate park designer in the world). Wally, as a hobby, used to make punk-style clothes, and back in 1979 he made me some "bondage" pants which I thought were cool at the time. When I picked them up from Wally, Kira gave me a hard time . . . Her boyfriend had made them and she was poking fun at me for wearing them! In fact, she was an insider on the early LA punk scene in Hollywood, more than anyone else in the band. Her older brother Paul had played keyboards in the seminal LA band the Screamers. She was righteous and tough, and could play incredibly, but that didn't matter to me. Chuck was the coolest, and the music changed a lot. Even so, Chuck arranged for me to shoot some publicity photos after I watched them practice one day early on. We went down to the beach and made some with Kira wearing a Dead Boys shirt, but apparently someone didn't like it after the fact, so it wasn't used for a publicity shot. A couple of months later we did some in my friend "King James" Cassimus's studio, because they thought they needed a "studio shot." I never like working in a studio, ever, and I can count the days I've shot in a studio in my life on one hand. In these last studio shots, Kira is looking a bit more dressy and Henry is looking like he's on another planet and disinterested or depressed. It was the last time I shot them.

Fast-forward several years and I am in Tower Records on 4th and Broadway in New York, thumbing through the rack, and I come across my favorite album of all time, *Damaged,* as a compact disk. CDs, as they came to be known in the following years, were a new format, so a new cover template of art had to be created for the new size. The photo on the cover wasn't mine, never was. (Truth be told, I was bummed when I found out back then that they used another photographer for the shoot. I was told after it was done that they didn't think I'd want to do something so "set up.") But this format

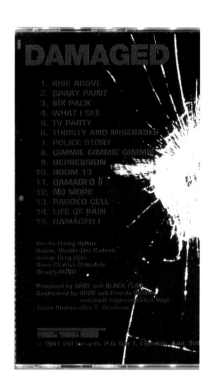

Miscredited initial printing of *Damaged* compact disk.

of the album made some eight years after its original release, when I flipped it over, lo and behold, on the back it said, *Cover photo: Glen E. Friedman.* OH SHIT! I had to get a copy, here's my (incorrect) photo credit on my favorite album, that's one for the collection. I tracked down Chuck to let him know. We hadn't talked in a year or so, and he actually *argued* with me about it: "No, Glen, you shot that, I know you did." I said, "Chuck, I wish I had!" To put it politely, I would have done it much differently. Eventually he relented, and I asked him to send me a copy for fun to keep in my archive, and to be *sure* to fix it on the next printing.

Punk rock was fun. Punk rock was arty. Punk rock was political. Punk rock was new. Punk rock was about being original, and doing it yourself, but not selfishly. In my idealistic view, punk rock was passionate about changing the world through our art and actions. The nihilistic and violent aspects that came in later had nothing to do with why I became a punk rocker, enthusiast, supporter, propagandist, and proliferator. Black Flag didn't play "hardcore," but they were indeed a hard-core punk band. They were at their best in those years when I worked with them, and those records and shows will live in infamy, as will these photographs. I hope they inspire, and that you enjoy them as much as I do.

— glen E. friedman

Dez Cadena, Chuck Dukowski, Greg Ginn, Robo

Vern Theatre, East Los Angeles, November 28, 1980

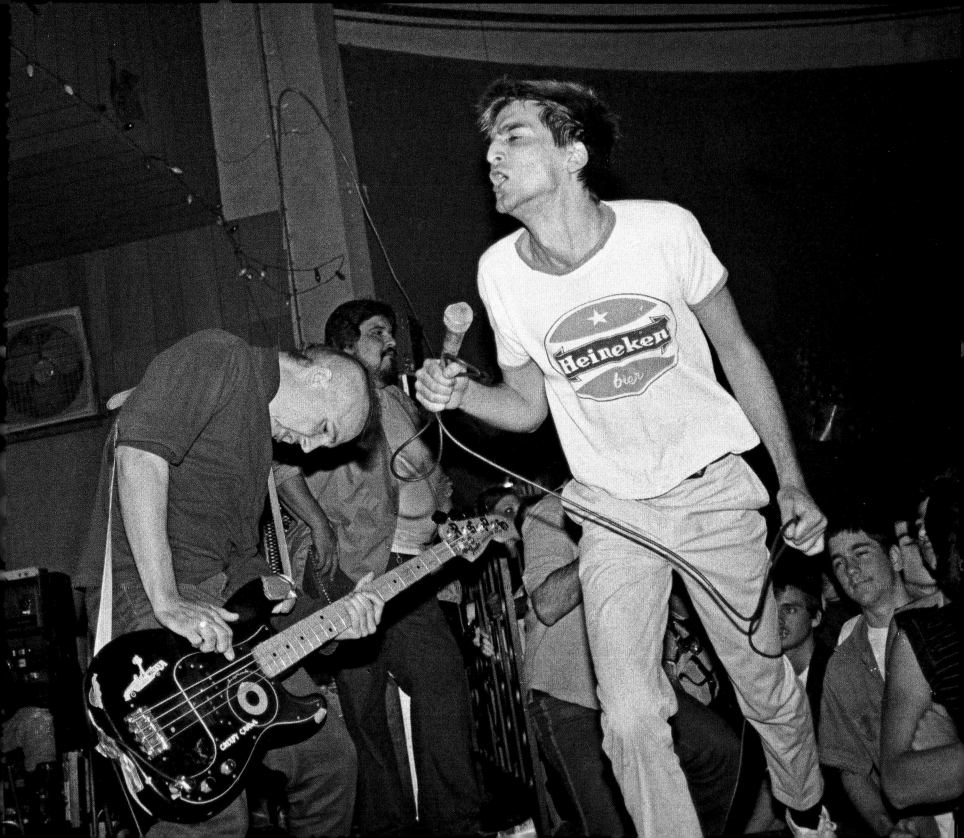

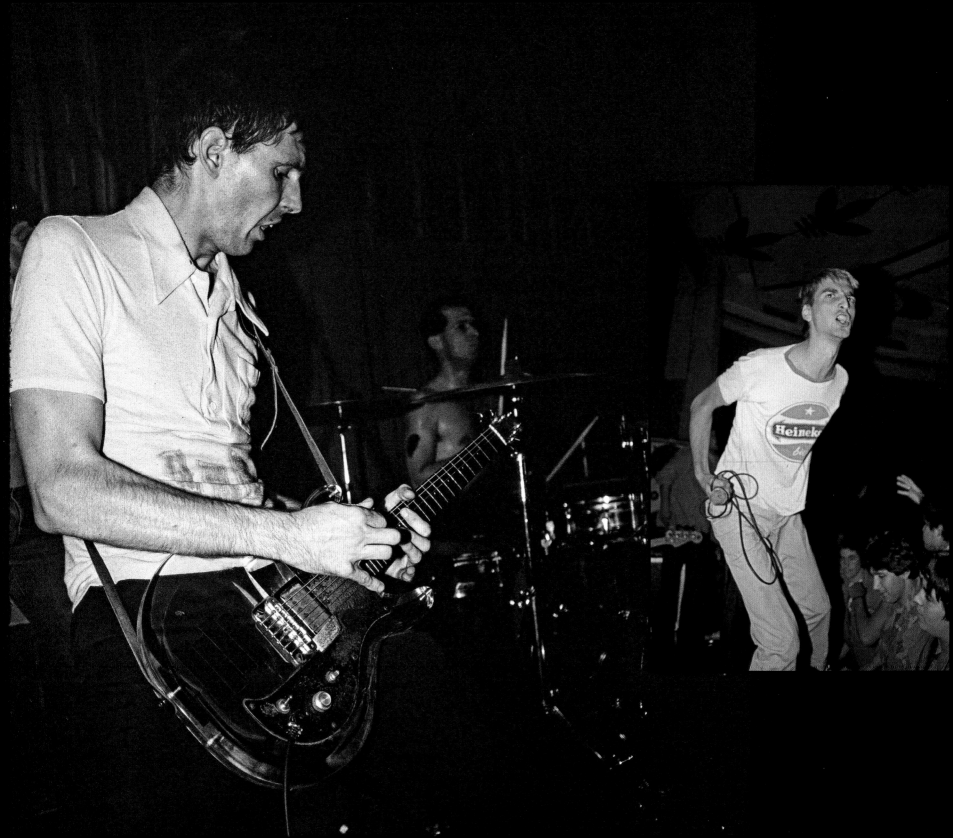

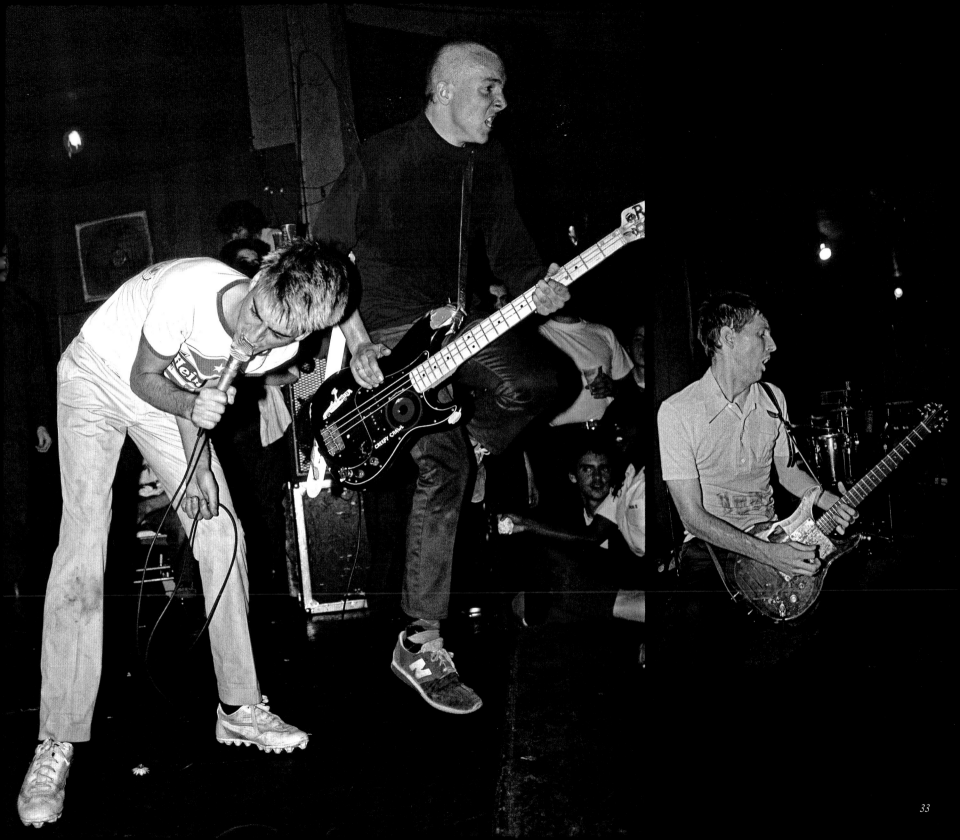

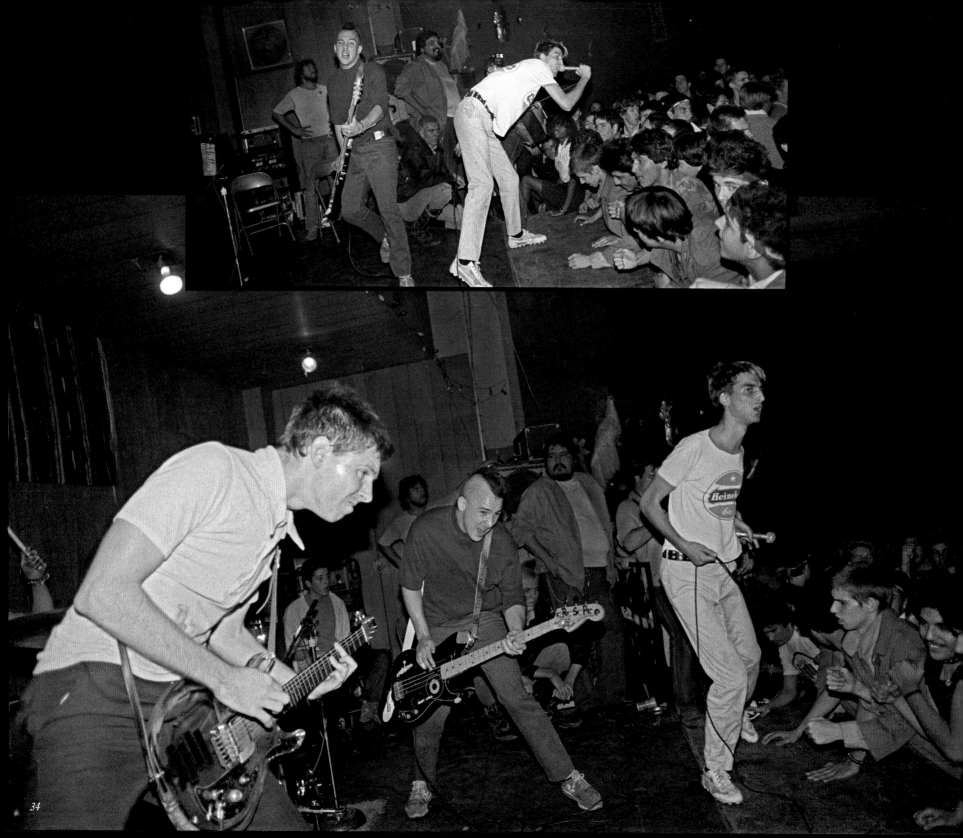

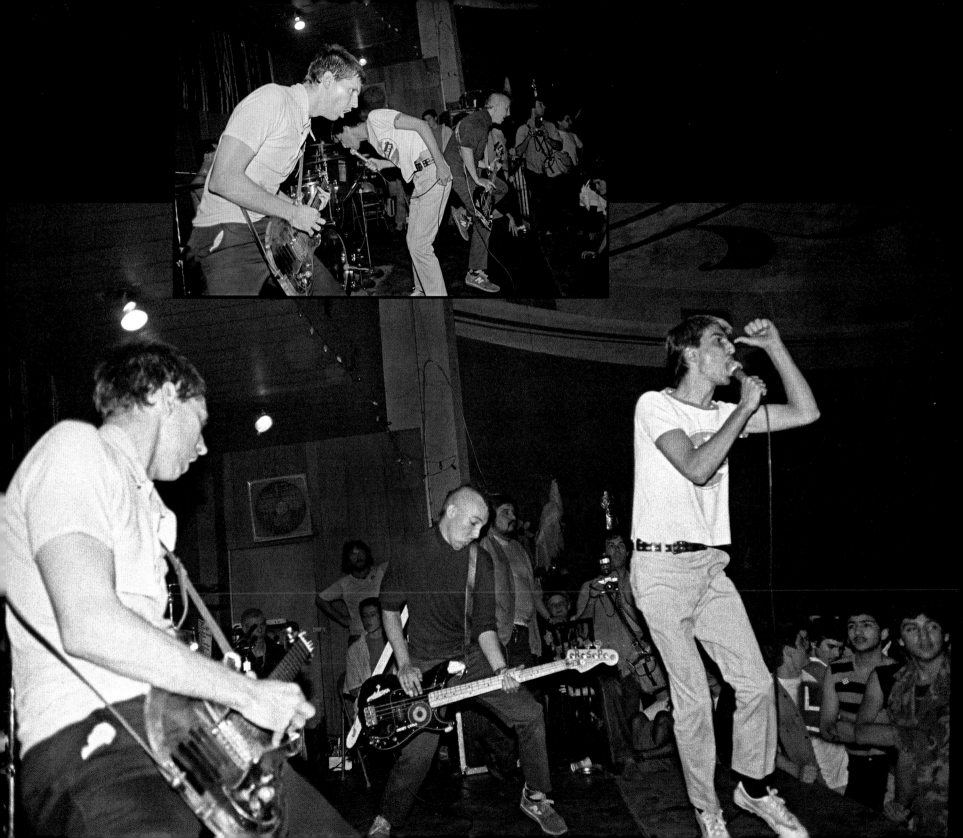

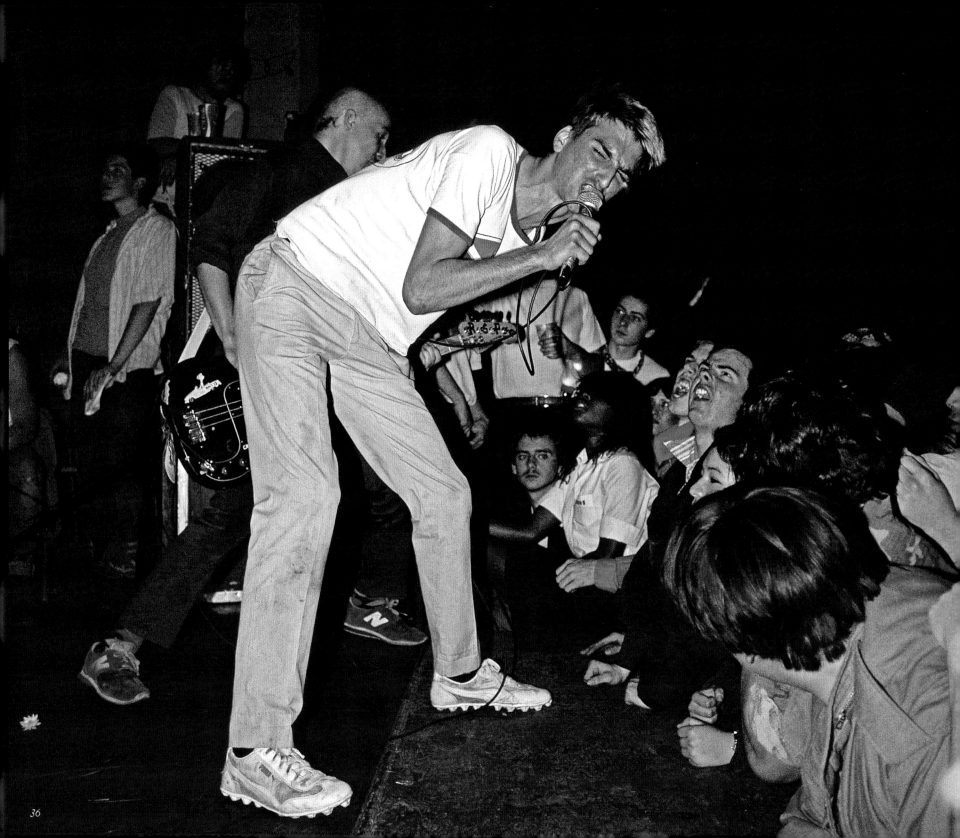

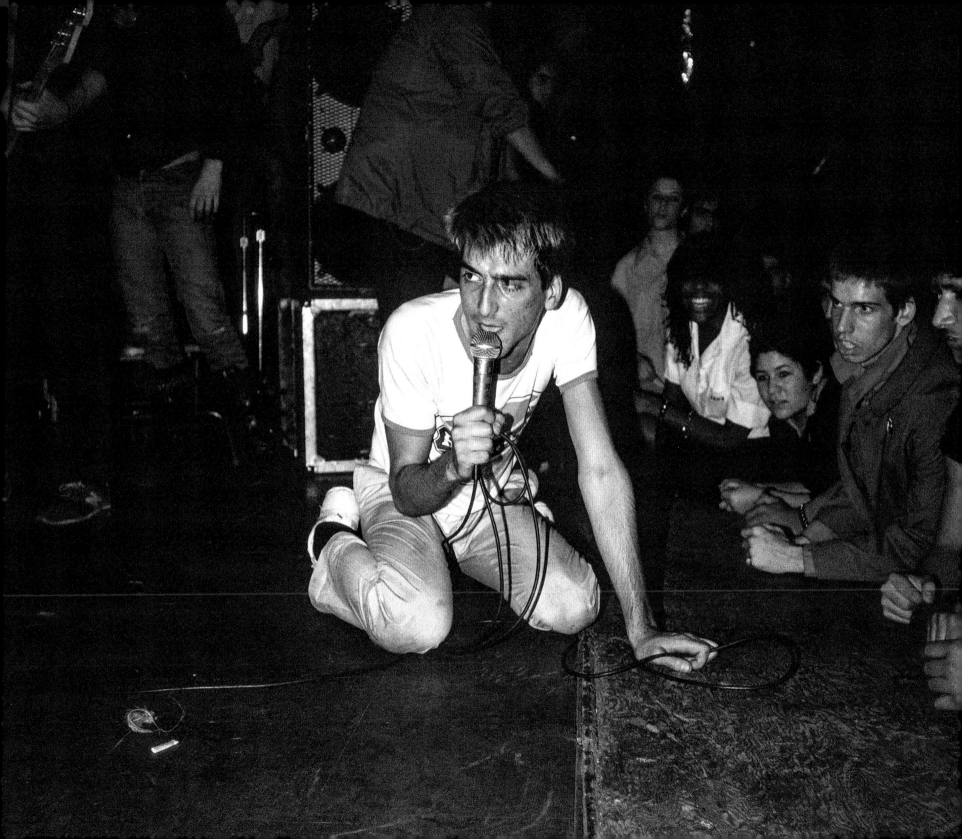

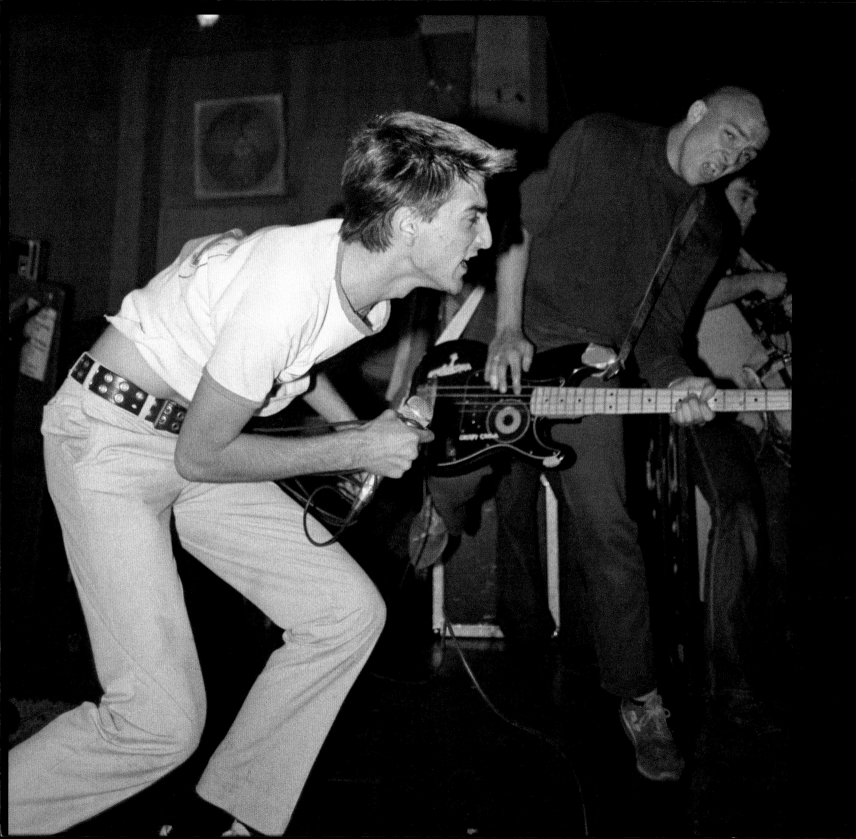

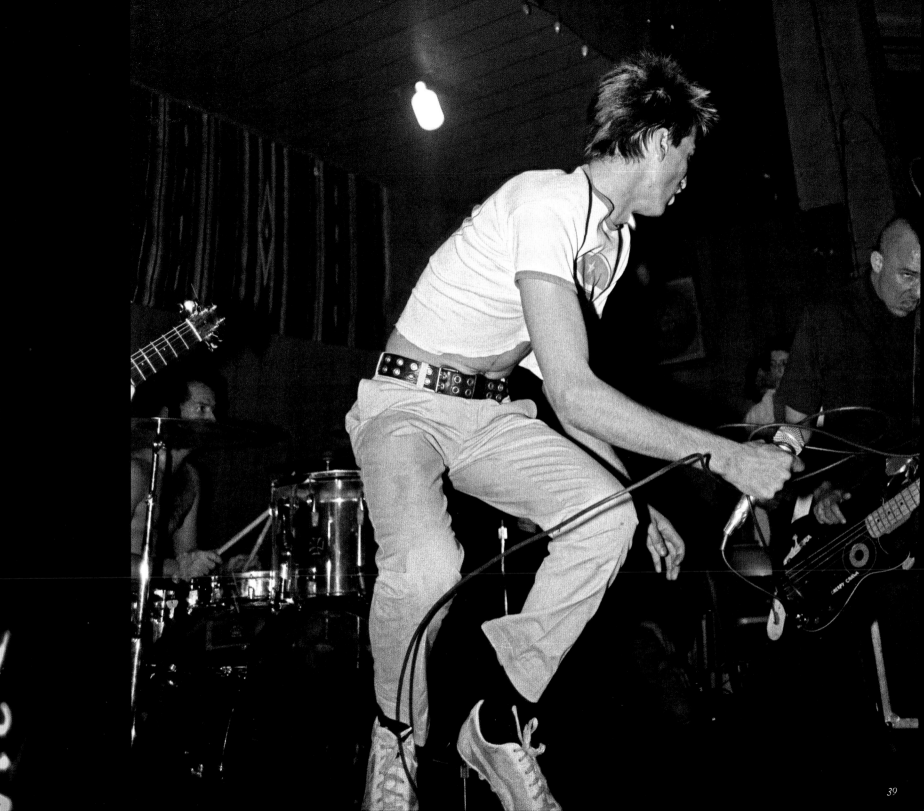

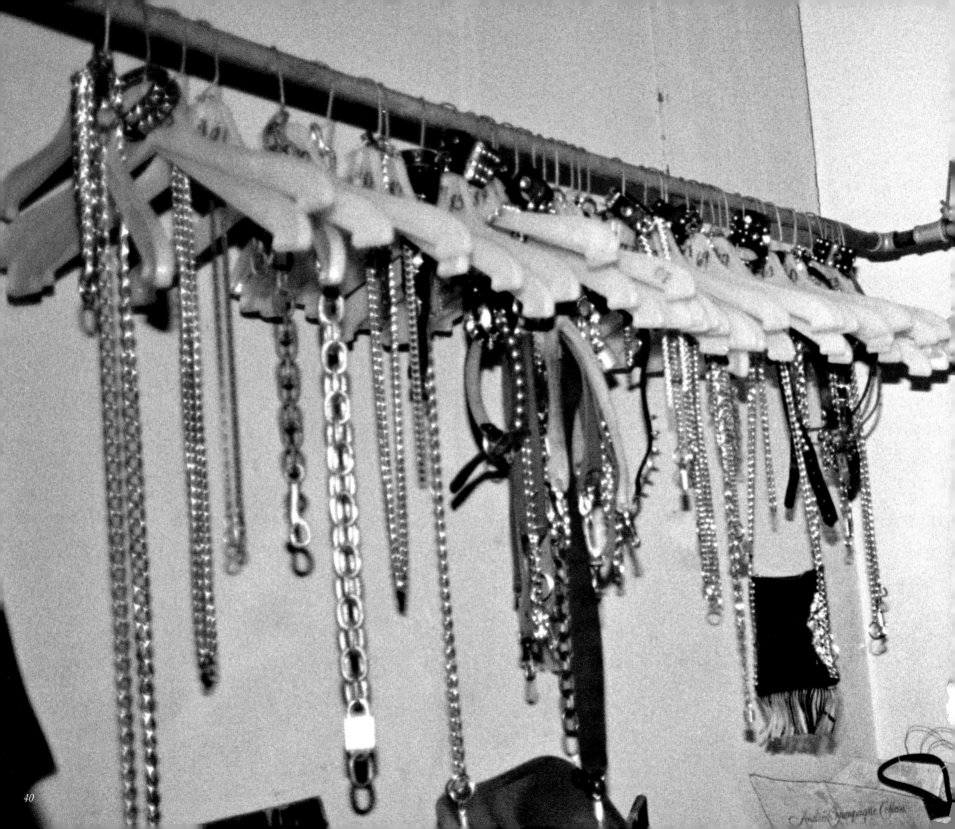

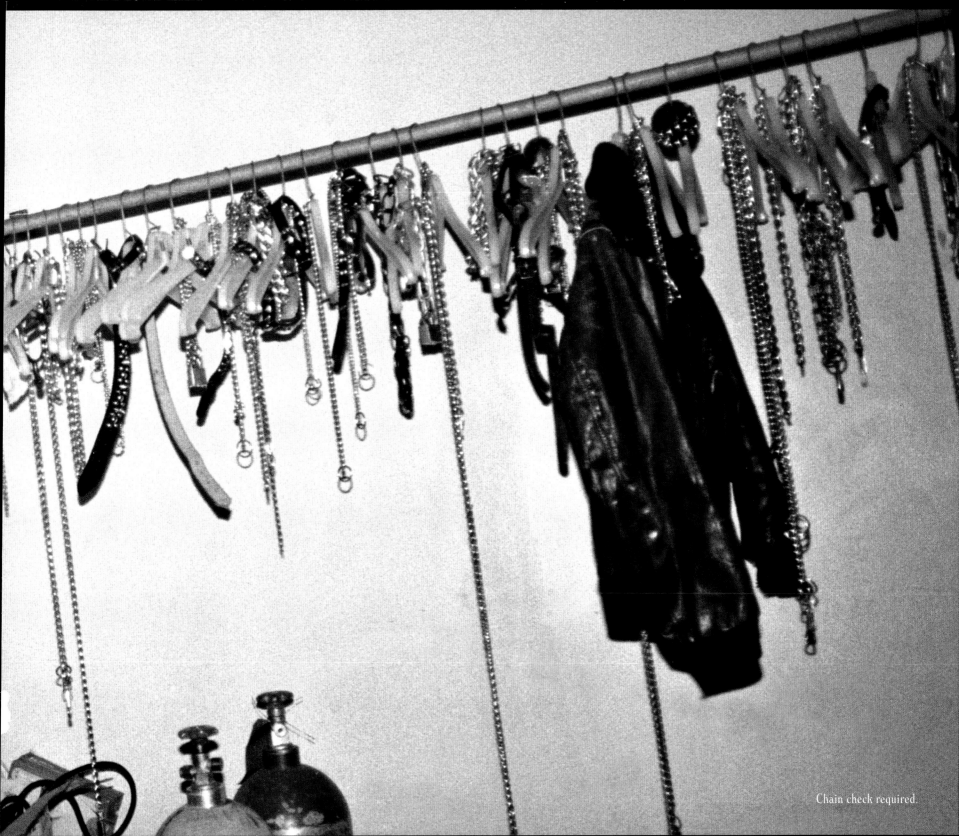

Chain check required.

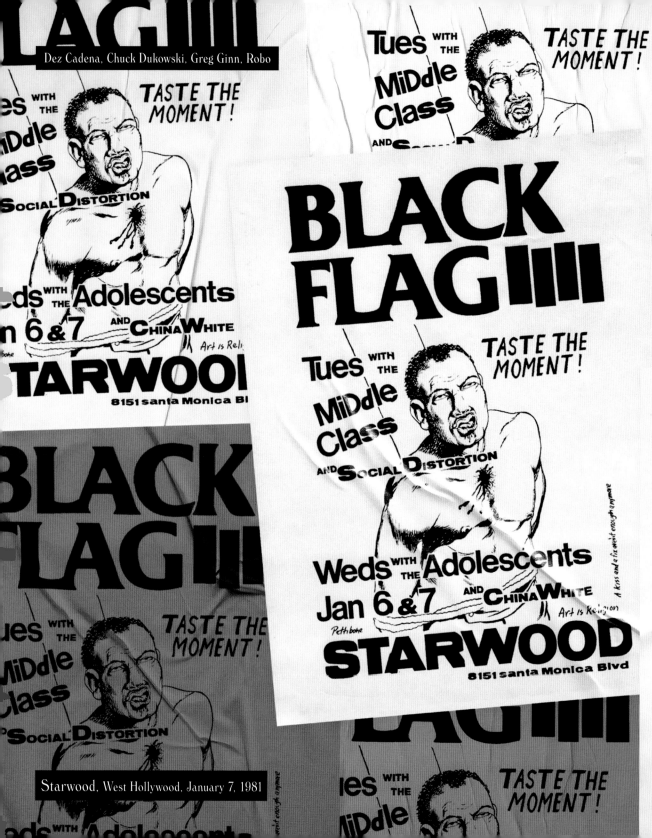

Dez Cadena, Chuck Dukowski, Greg Ginn, Robo

Starwood, West Hollywood, January 7, 1981

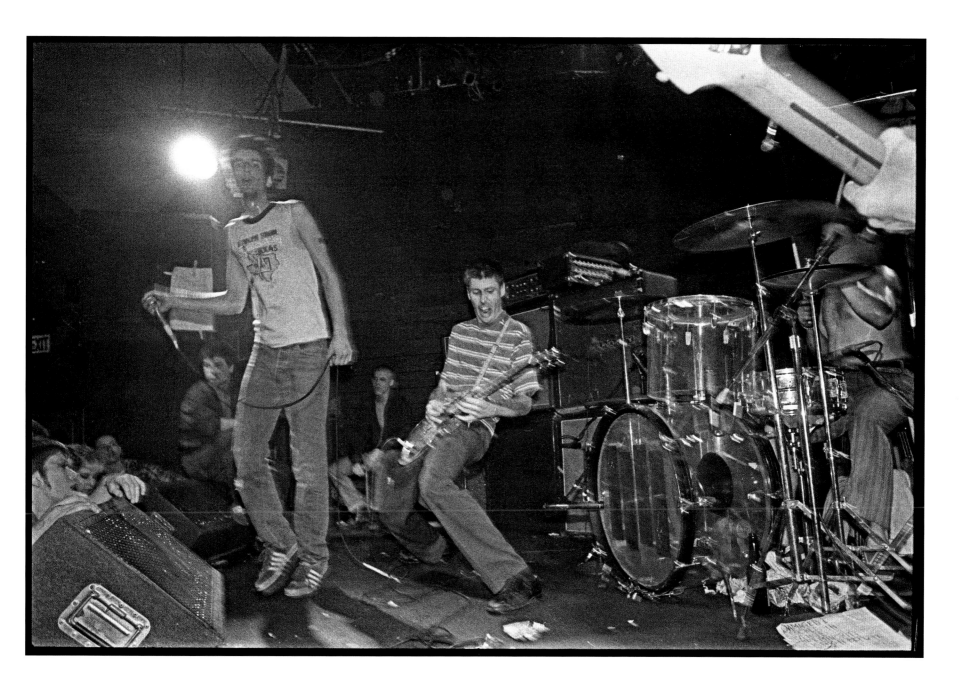

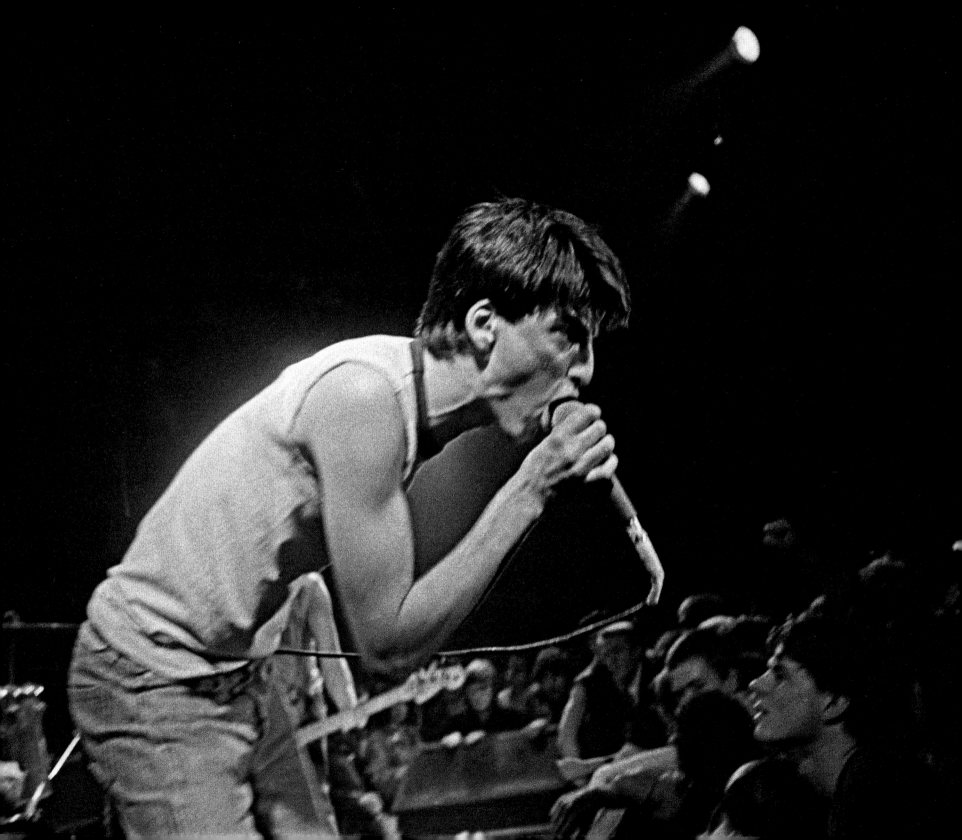

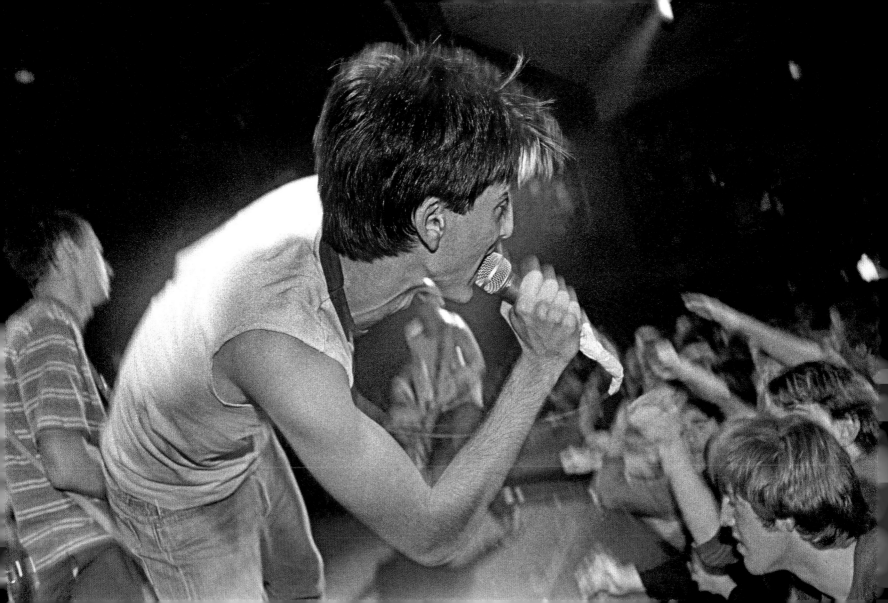

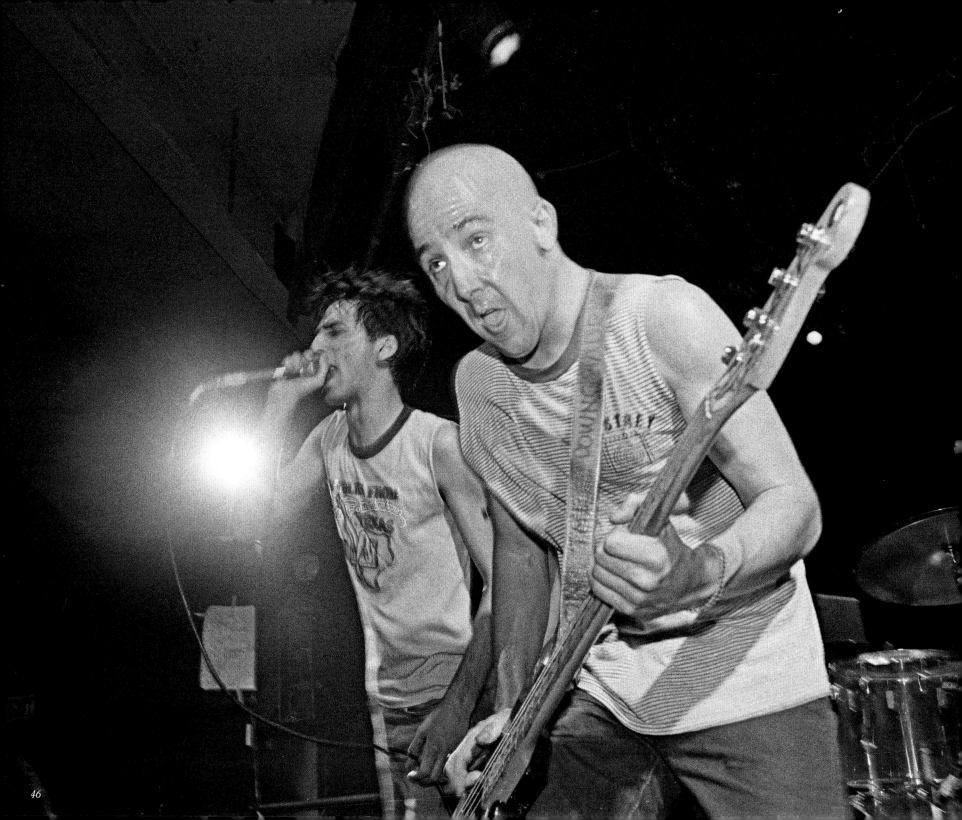

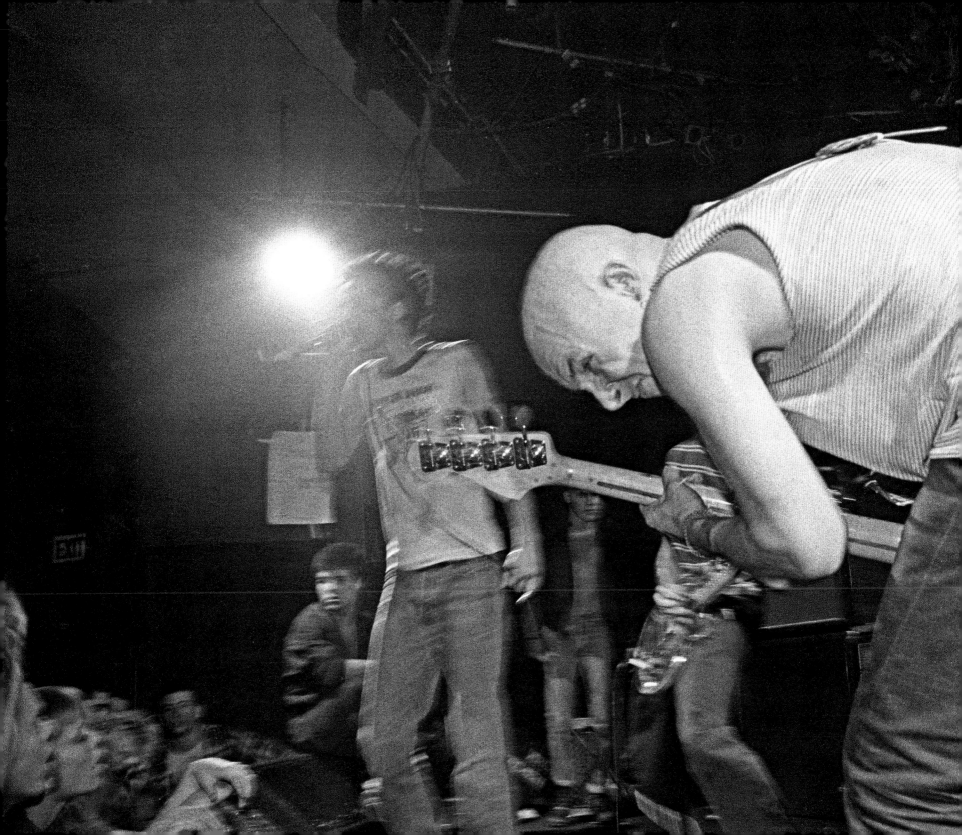

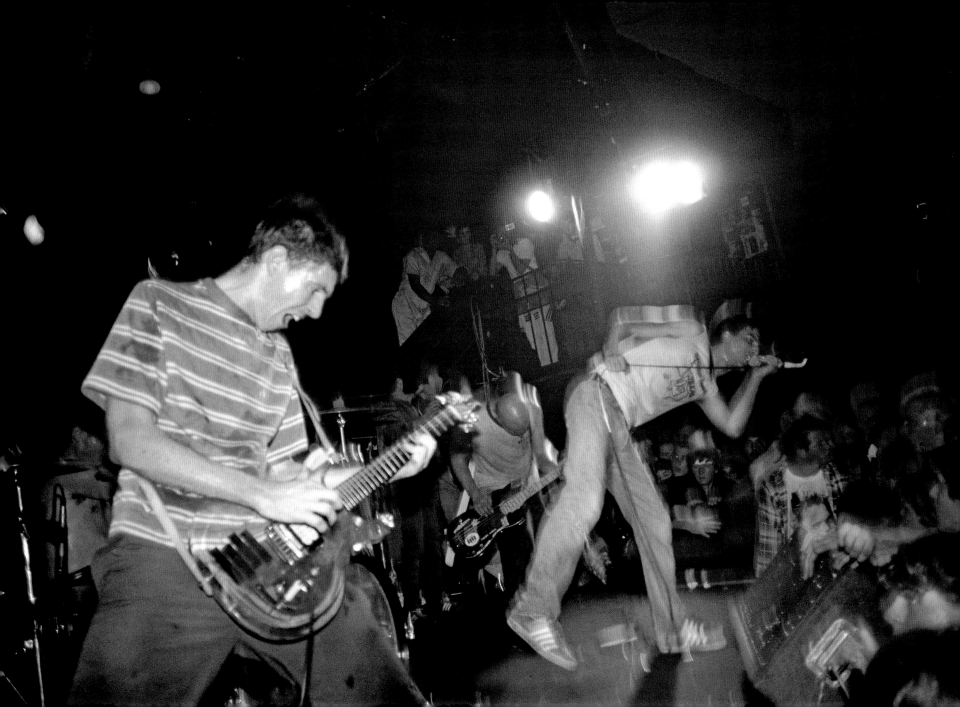

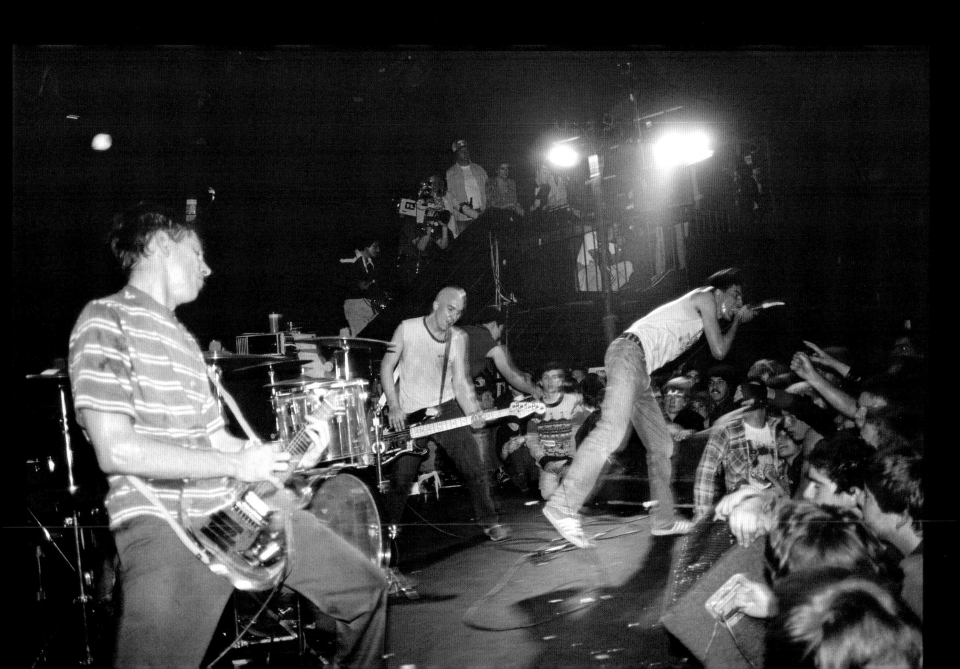

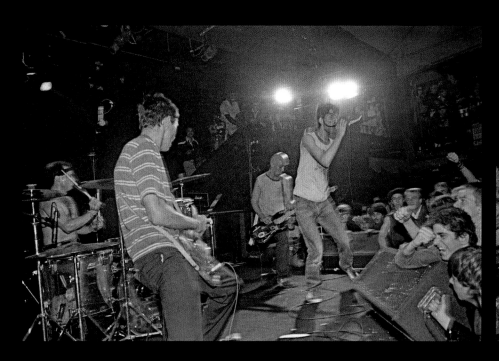
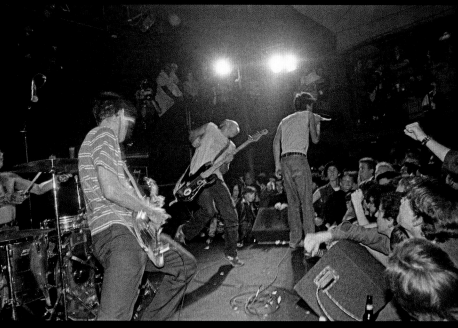
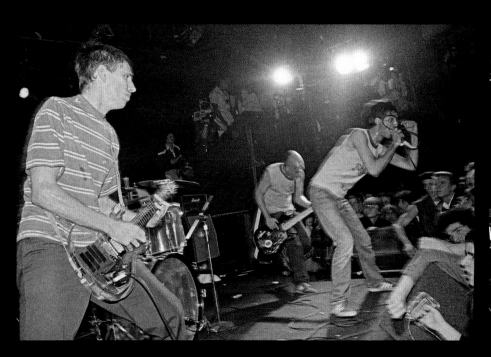
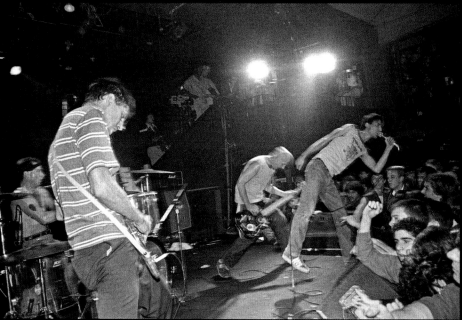

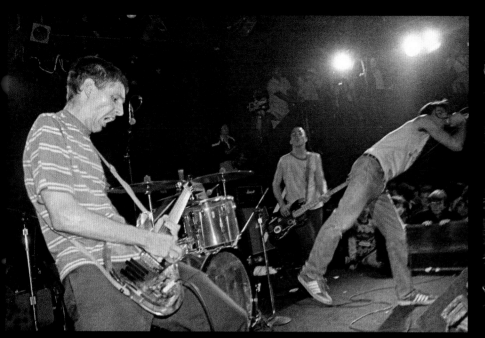
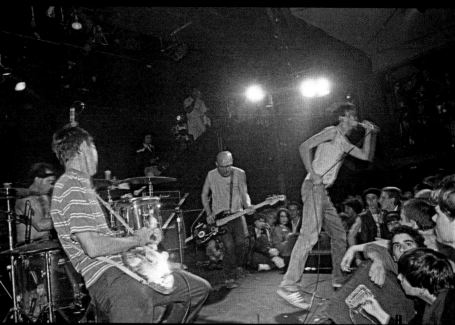
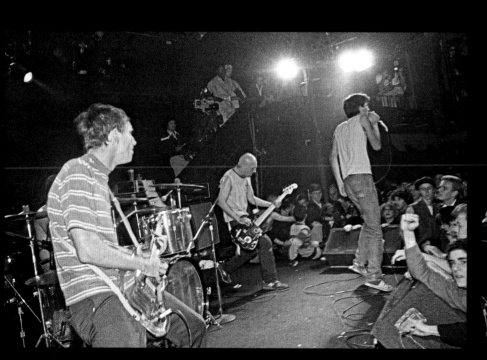
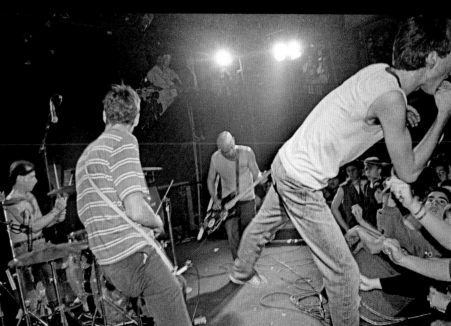

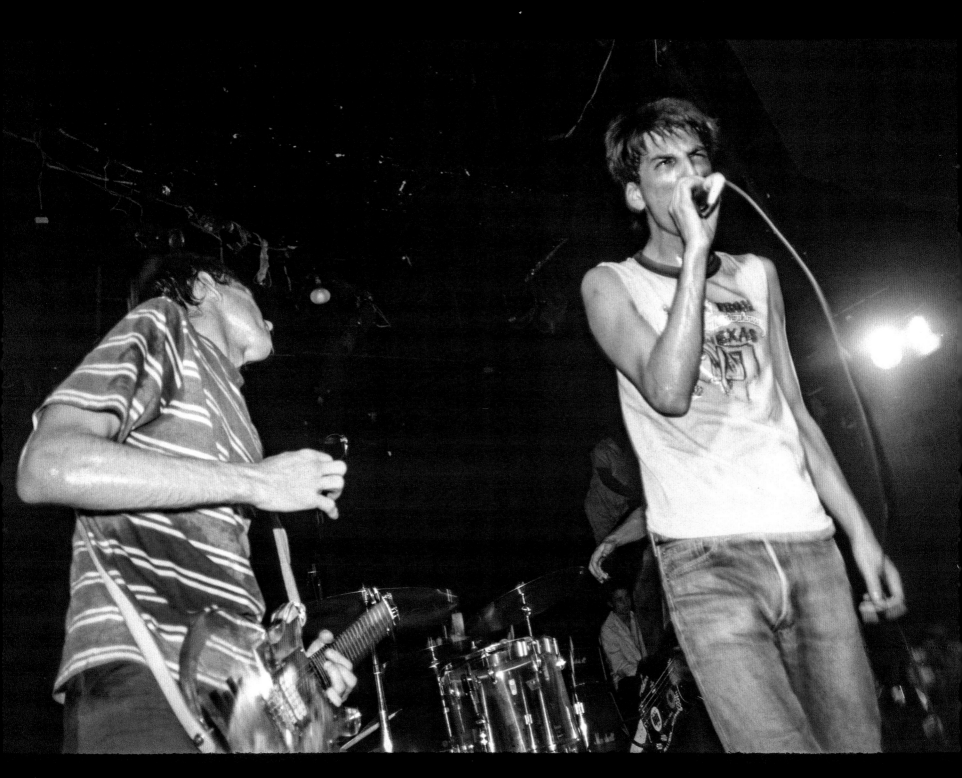

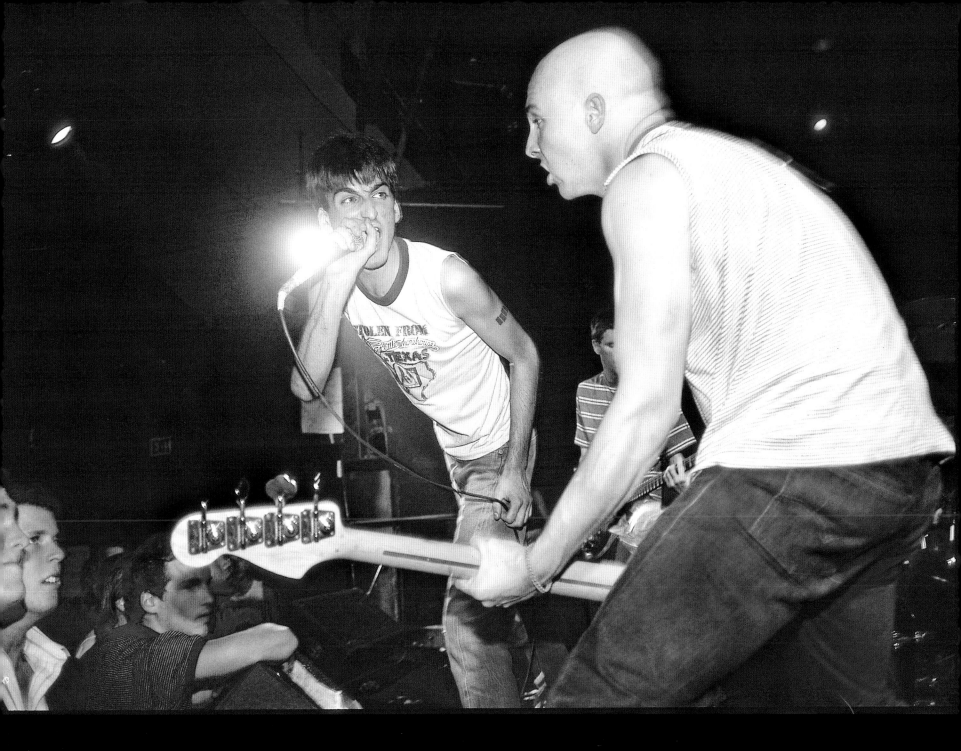

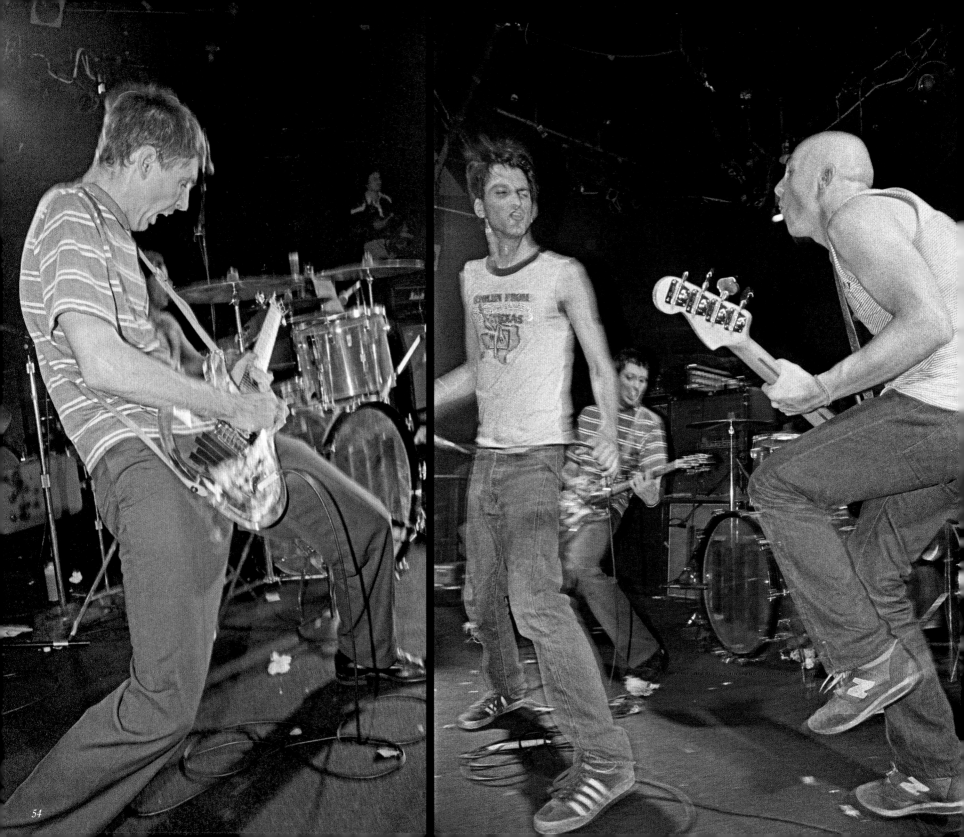

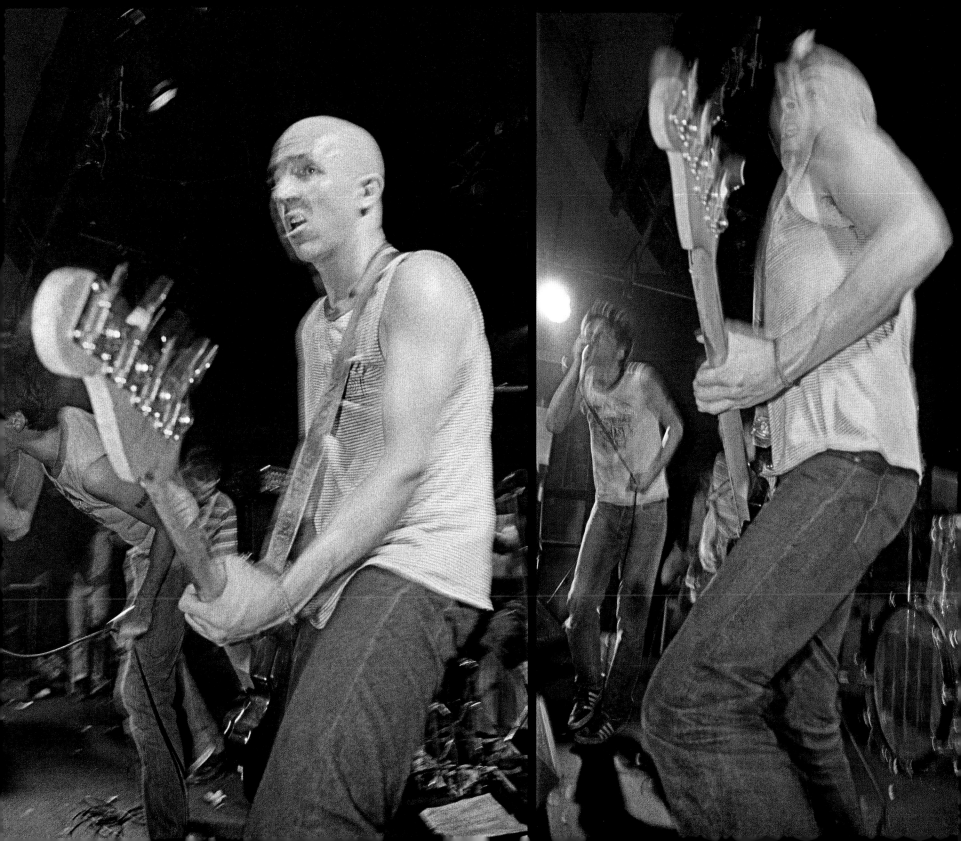

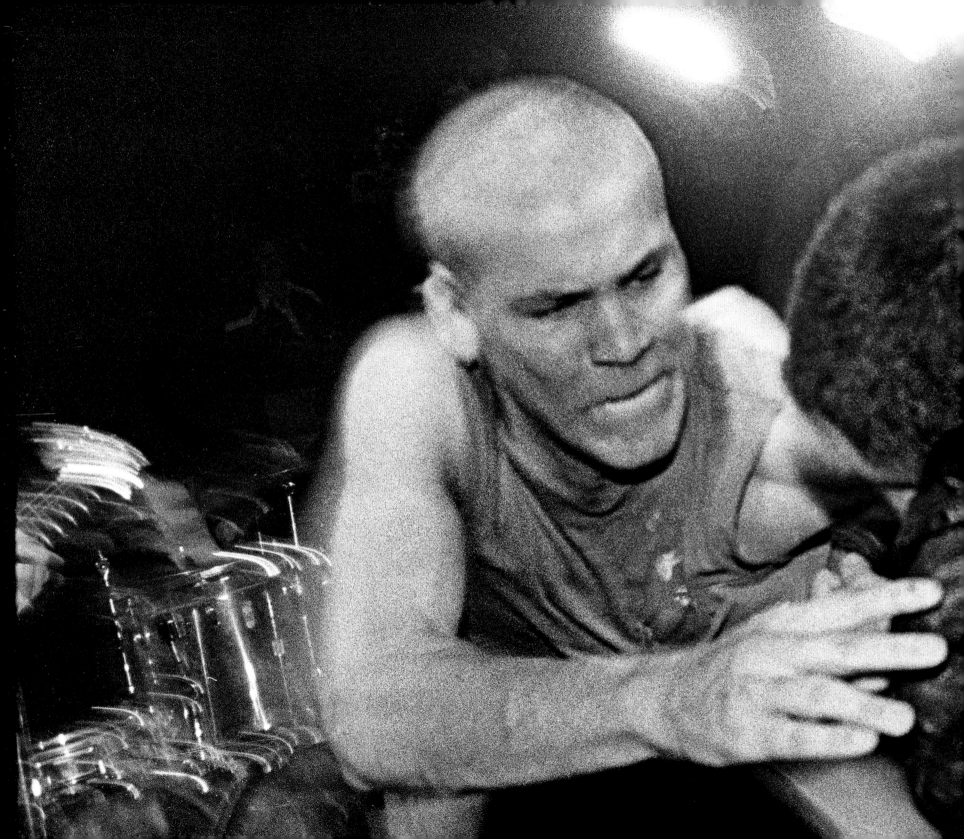

Mugger, the roadie, taking care of business.

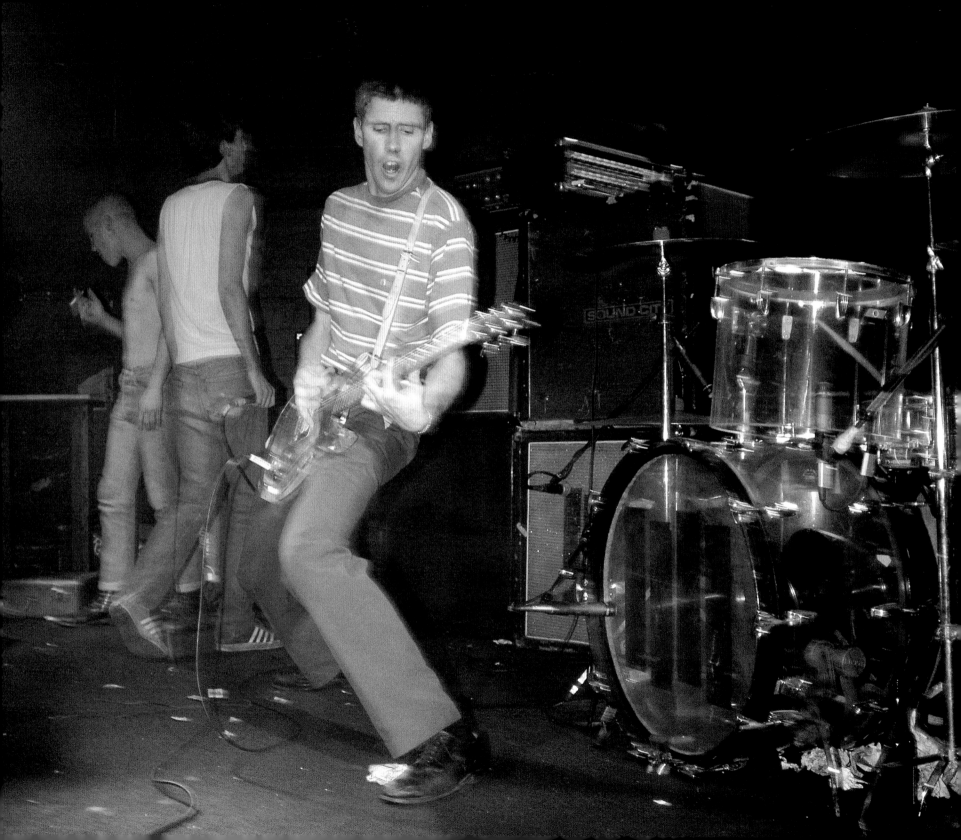

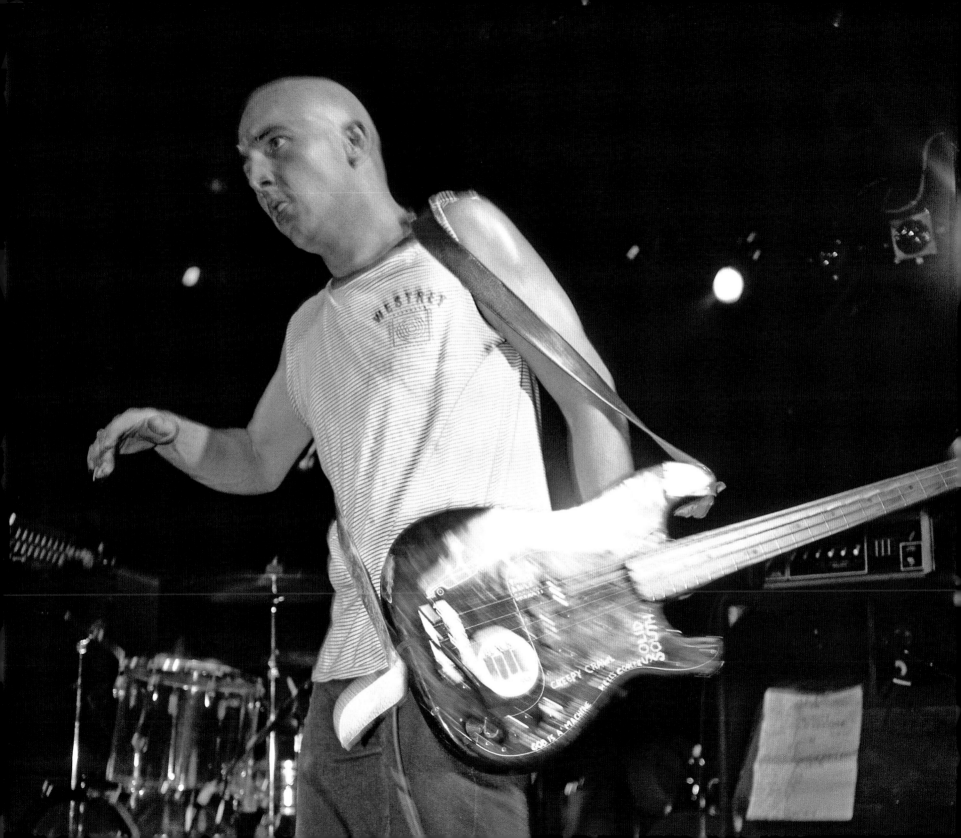

Dez Cadena, Chuck Dukowski, Greg Ginn, Robo

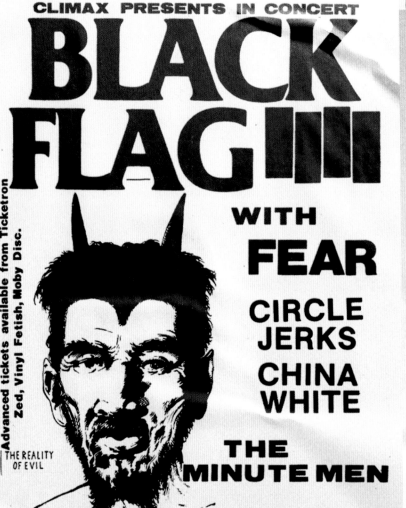

CLIMAX PRESENTS IN CONCERT

BLACK FLAG ||||

WITH

FEAR

CIRCLE JERKS

CHINA WHITE

THE MINUTE MEN

THE REALITY OF EVIL

Advanced tickets available from Ticketron Zed, Vinyl Fetish, Moby Disc.

WED. FEB. 11
STARDUST BALLROOM

5612 Sunset Blvd. $6 for more info call-462-1111

Stardust Ballroom, Hollywood, February 11, 1981

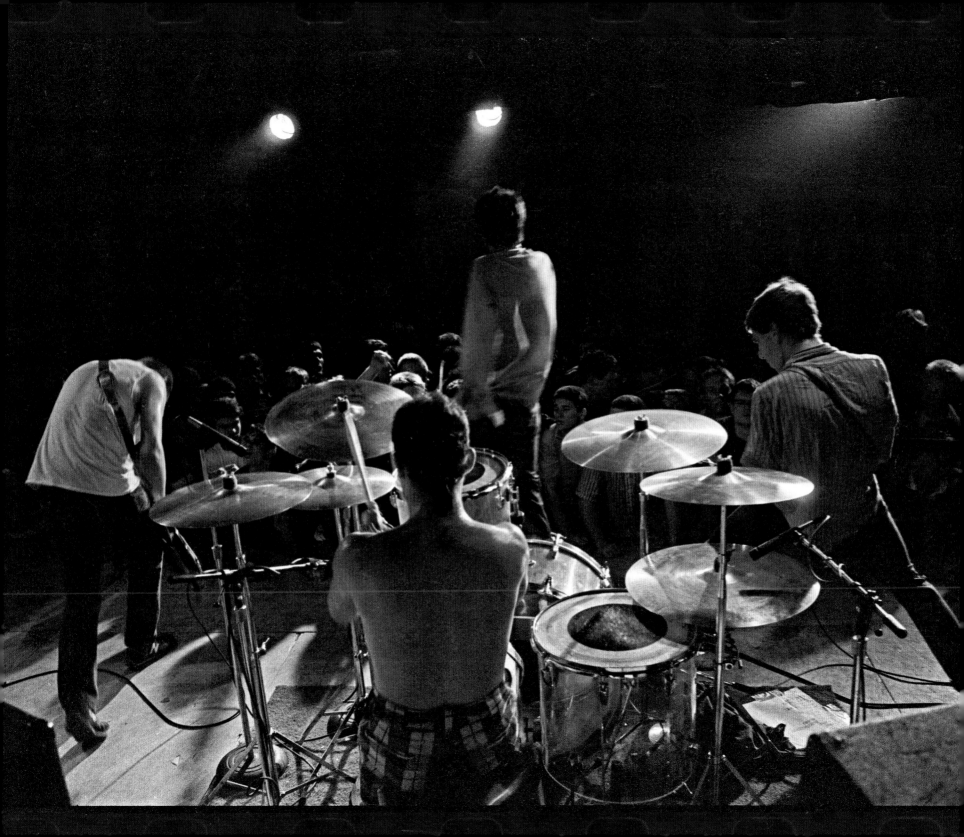

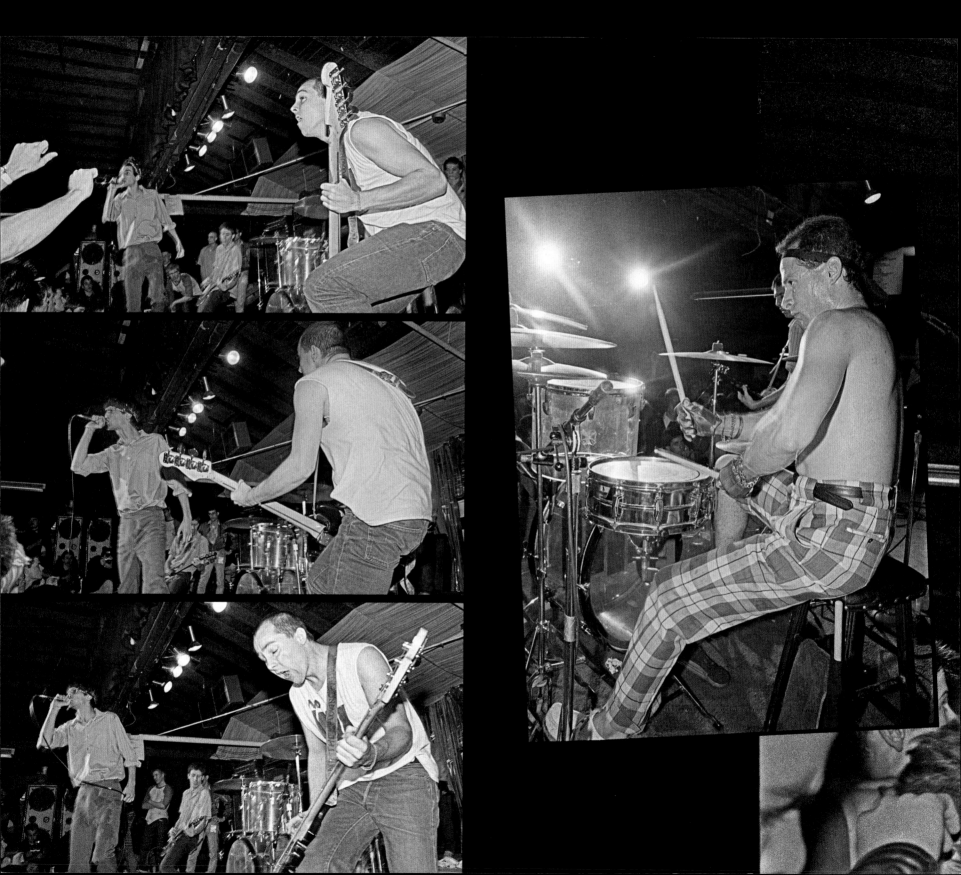

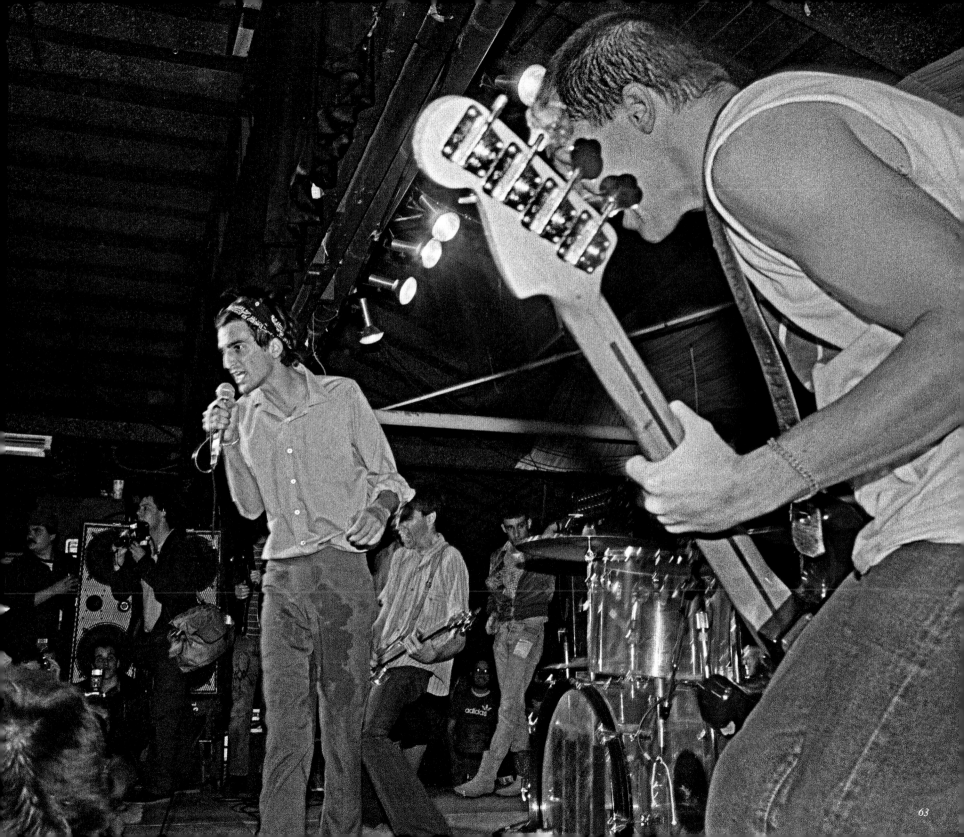

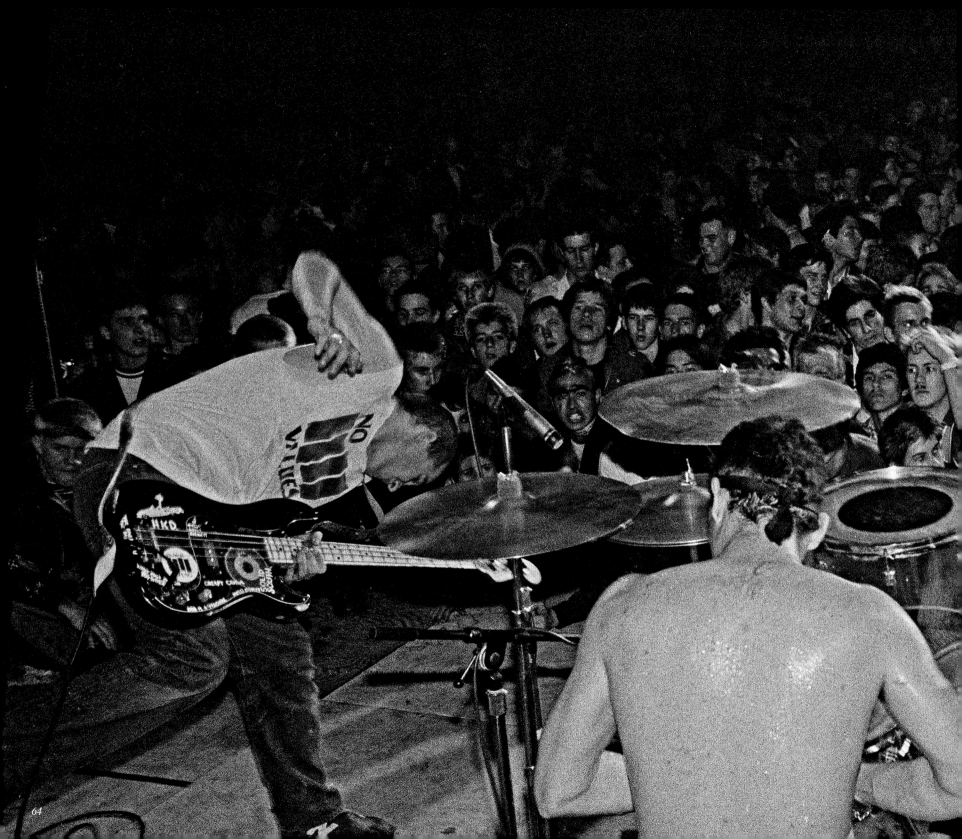

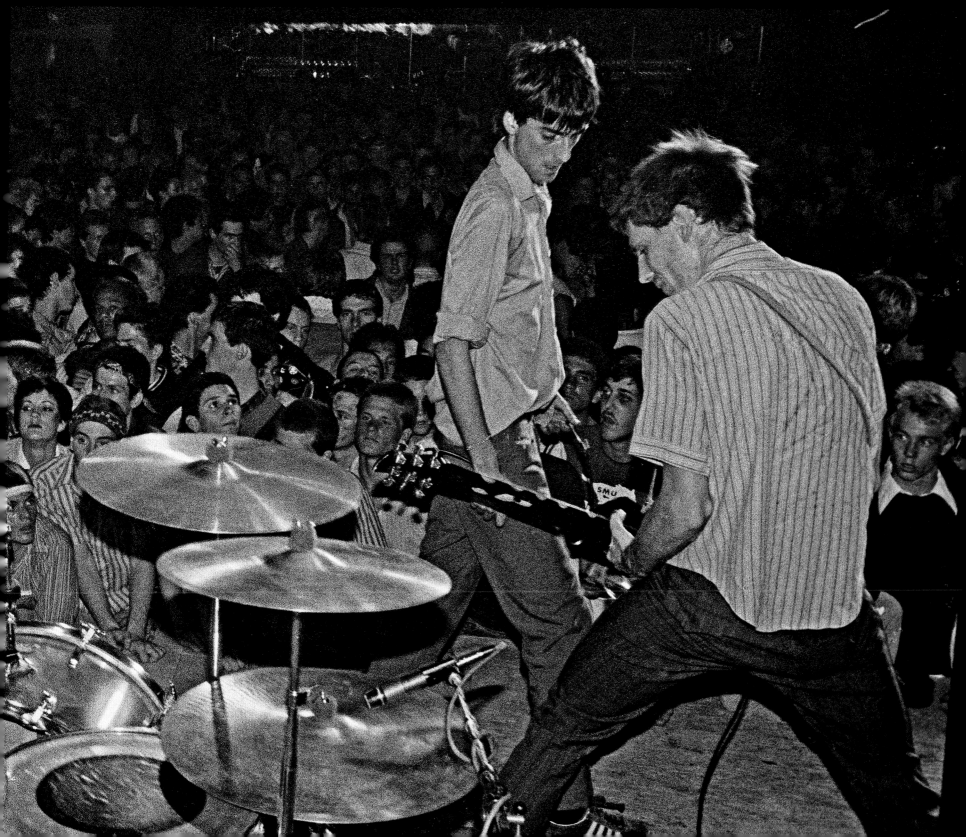

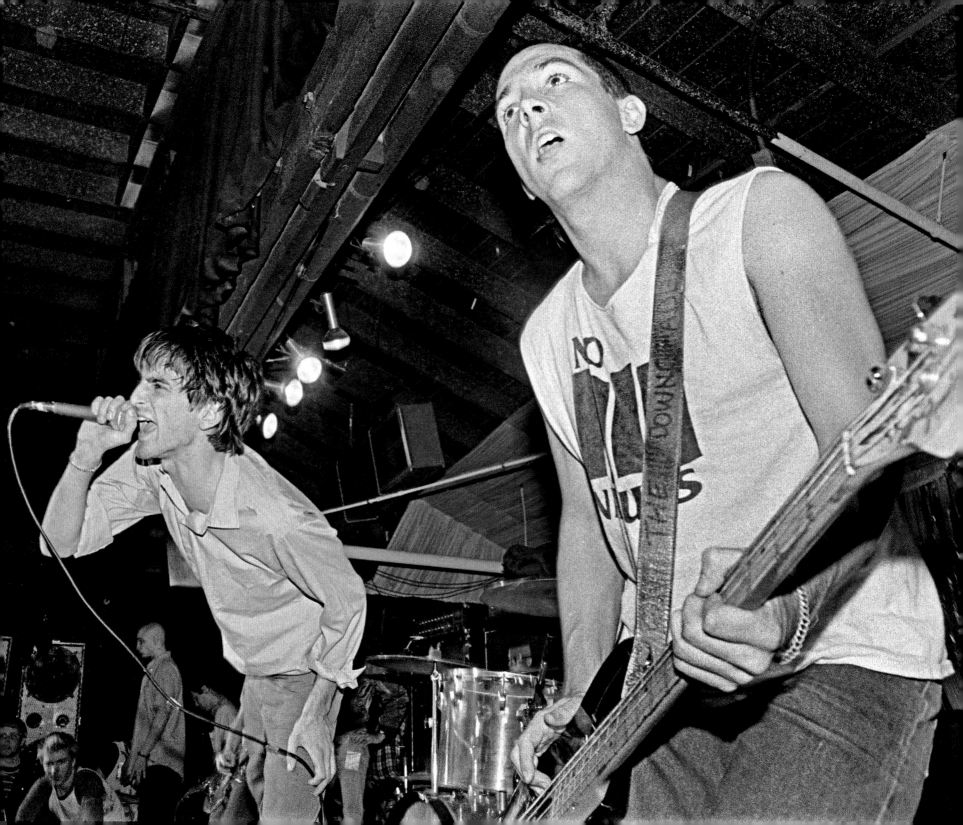

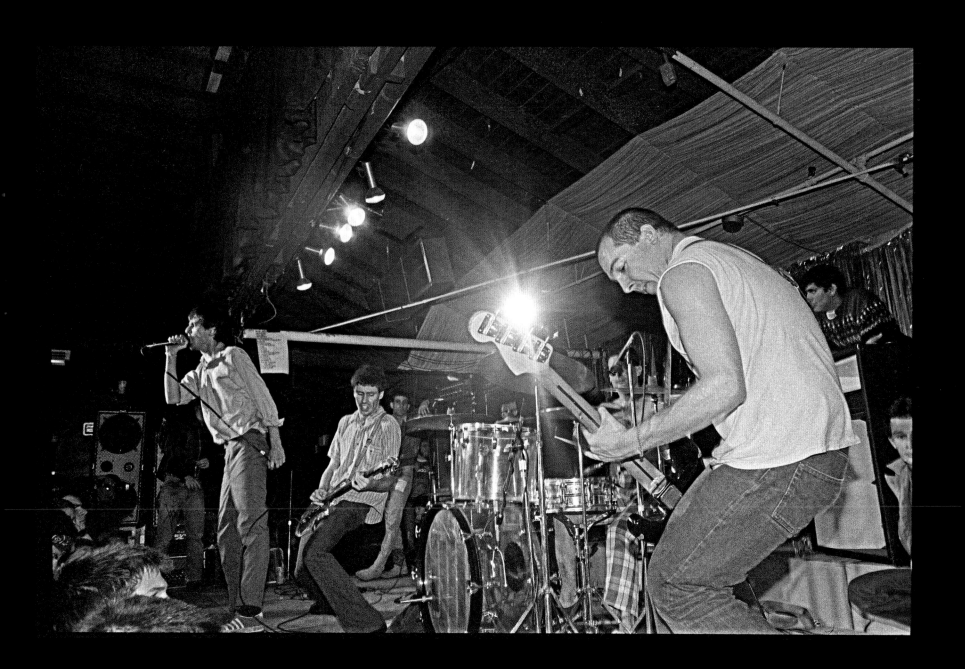

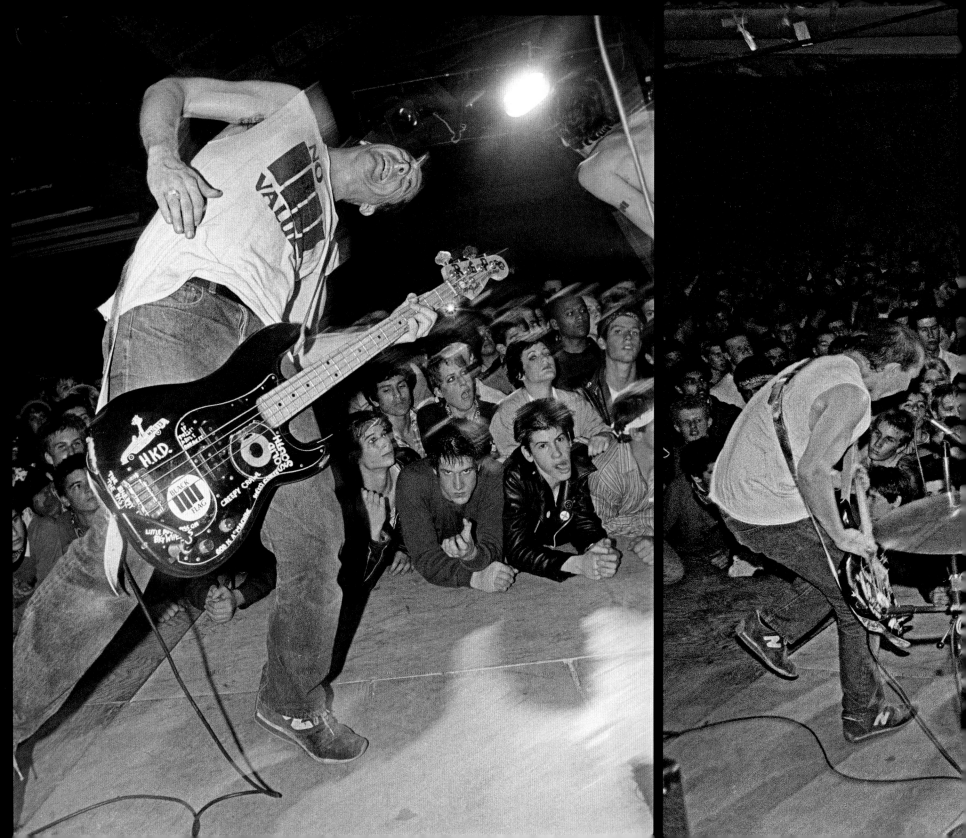

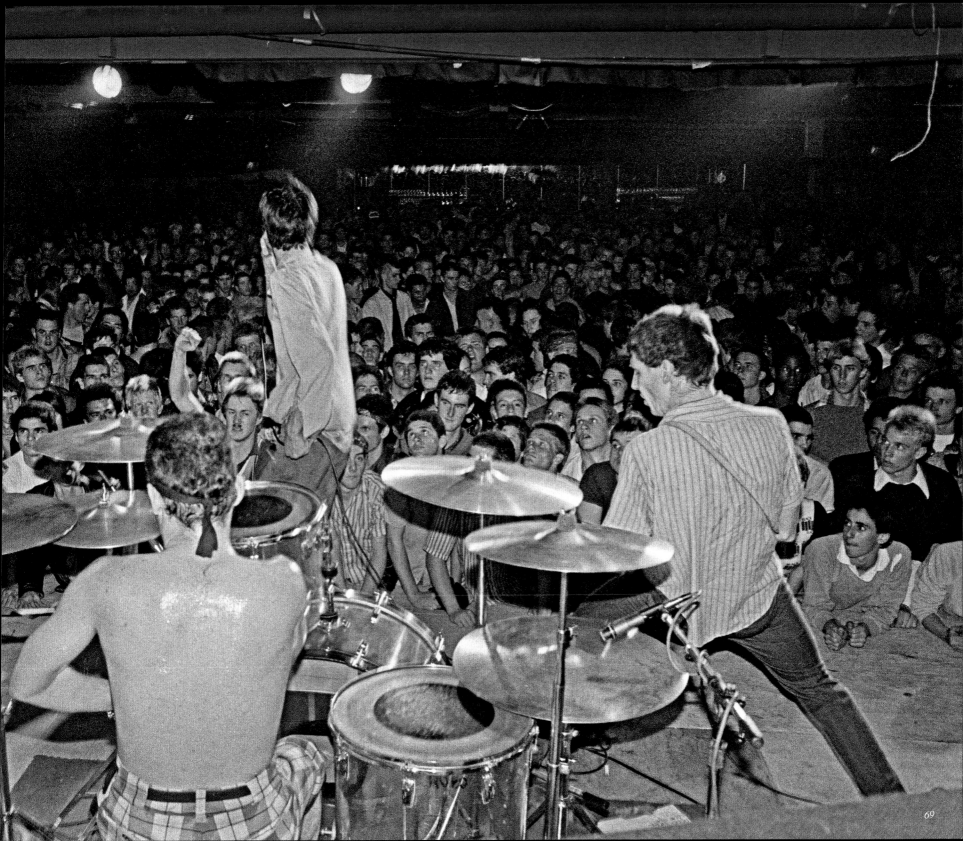

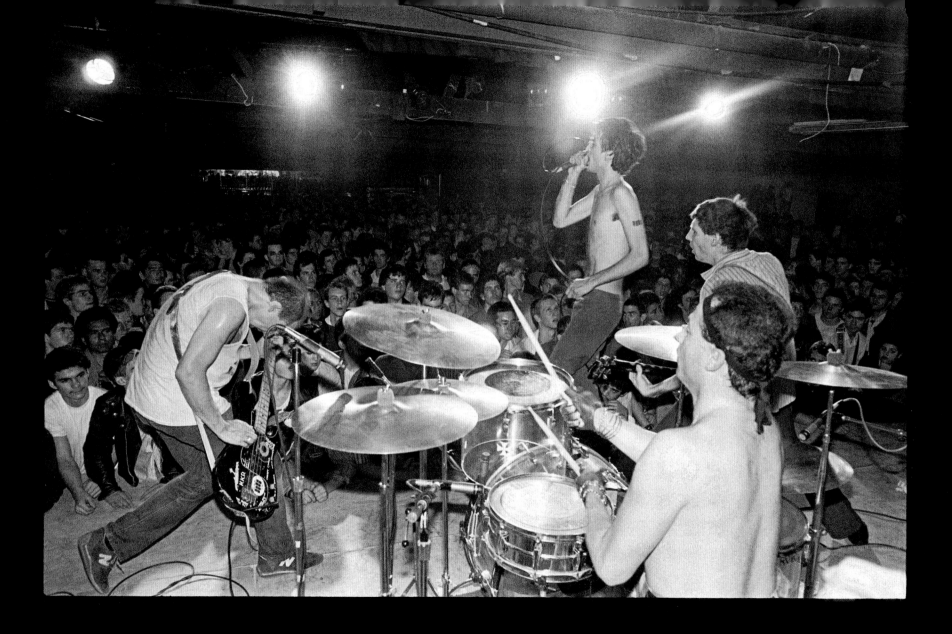

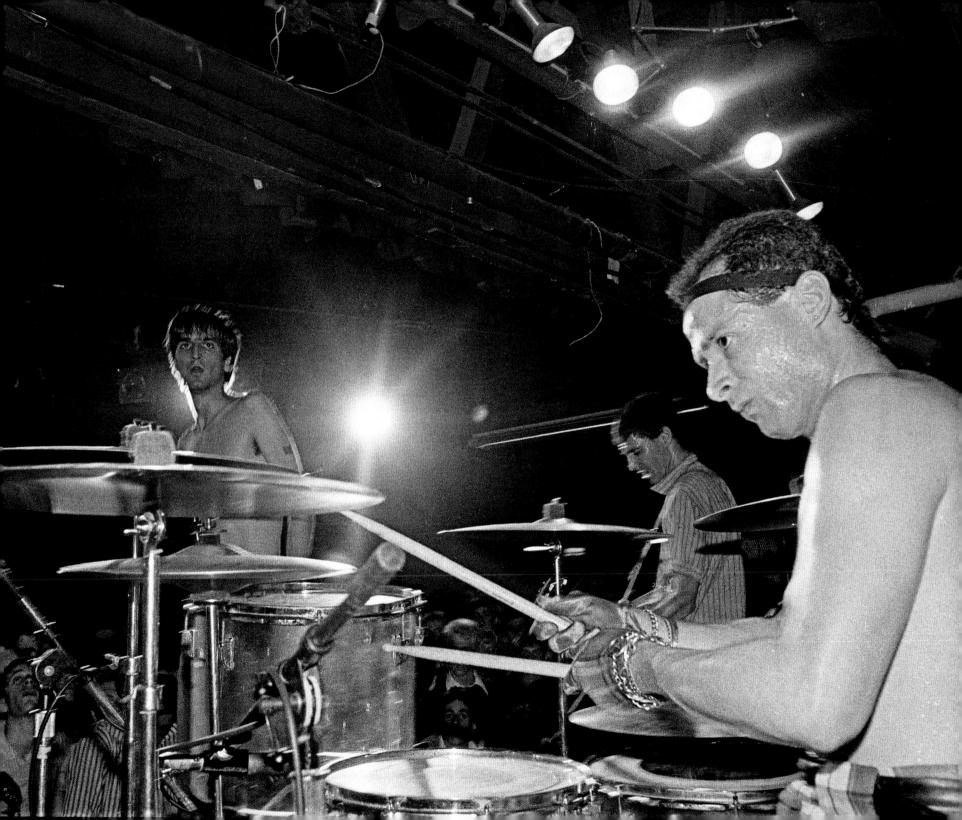

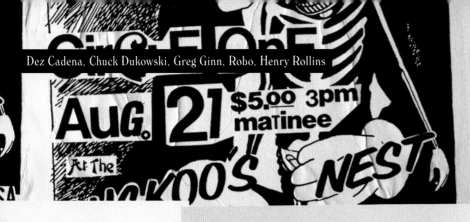
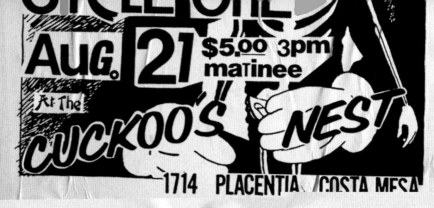

Dez Cadena, Chuck Dukowski, Greg Ginn, Robo, Henry Rollins

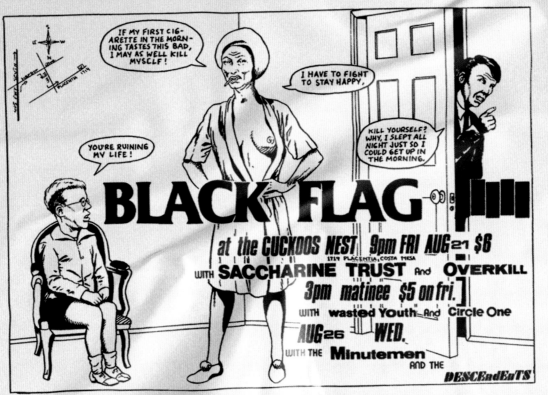

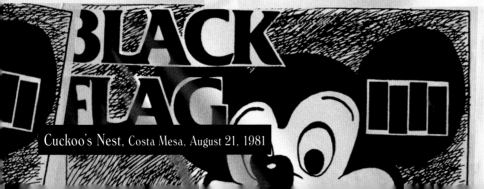

Cuckoo's Nest, Costa Mesa, August 21, 1981

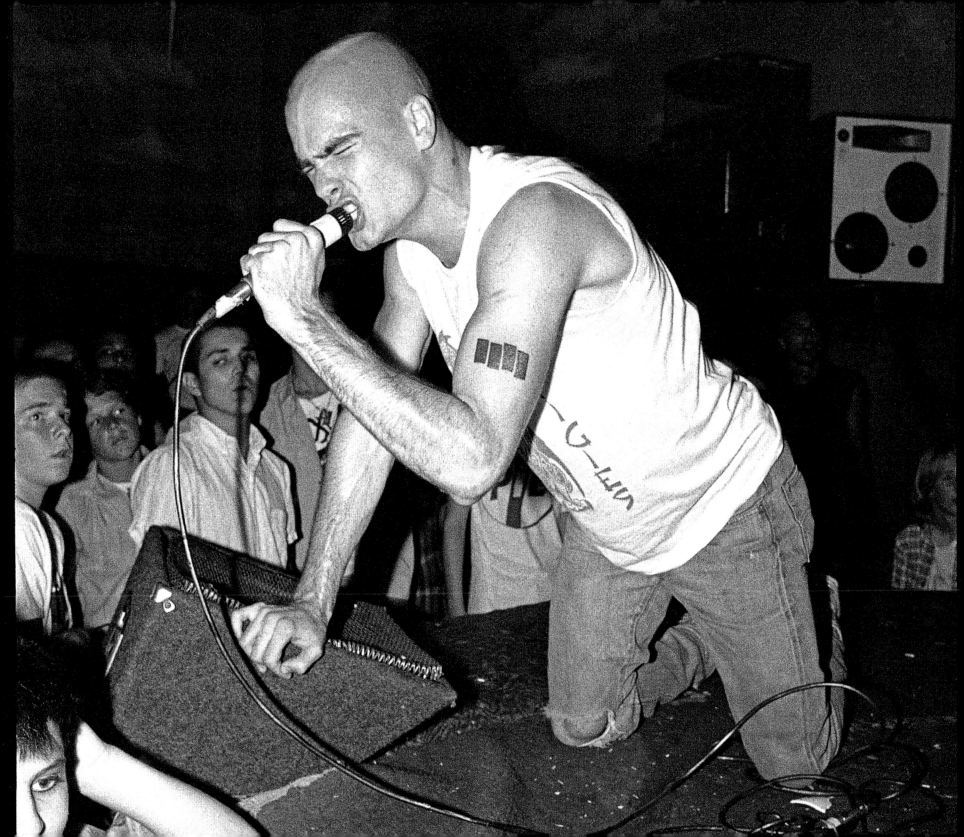

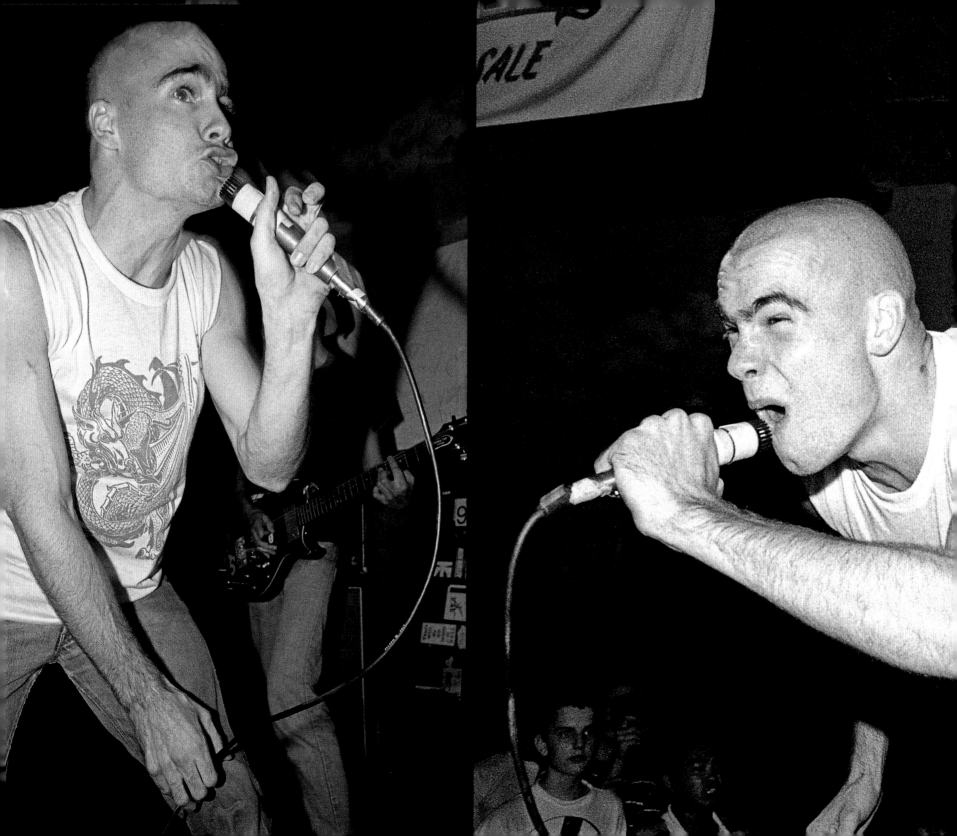

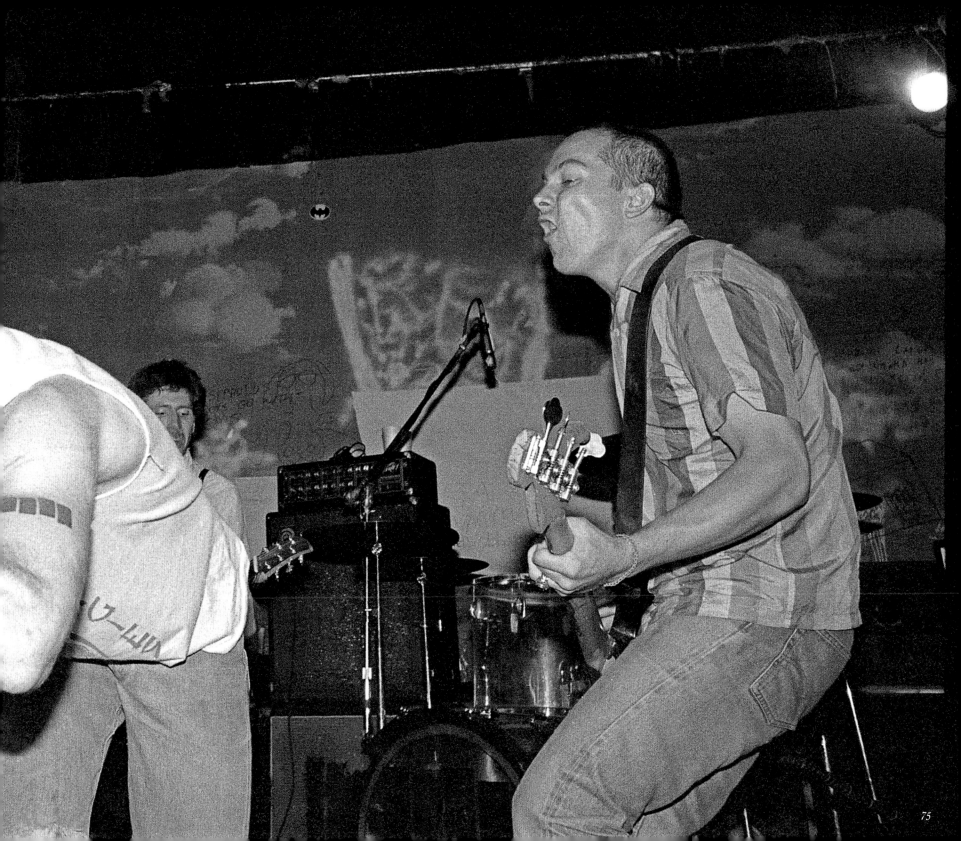

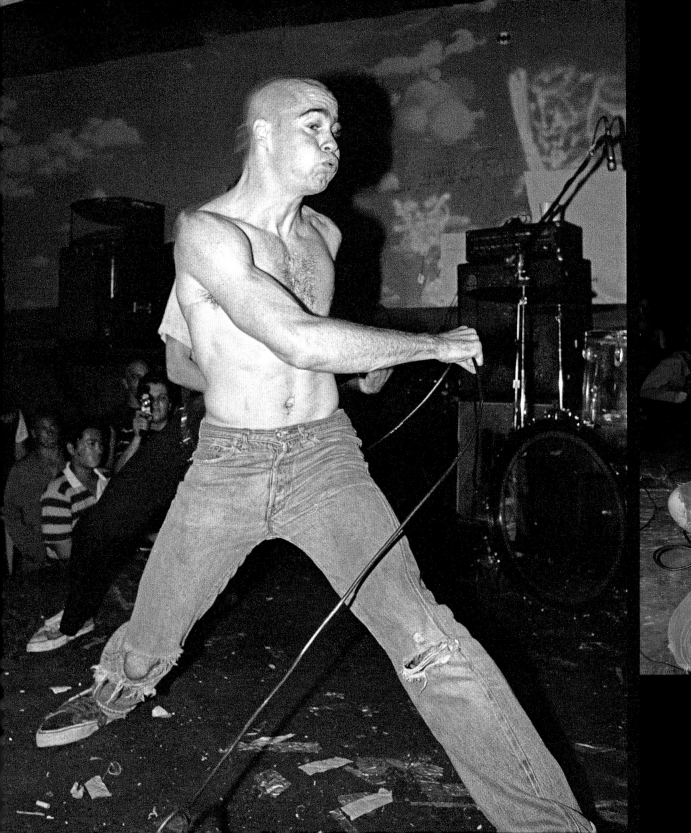
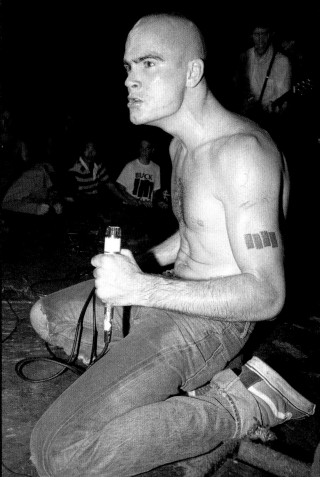

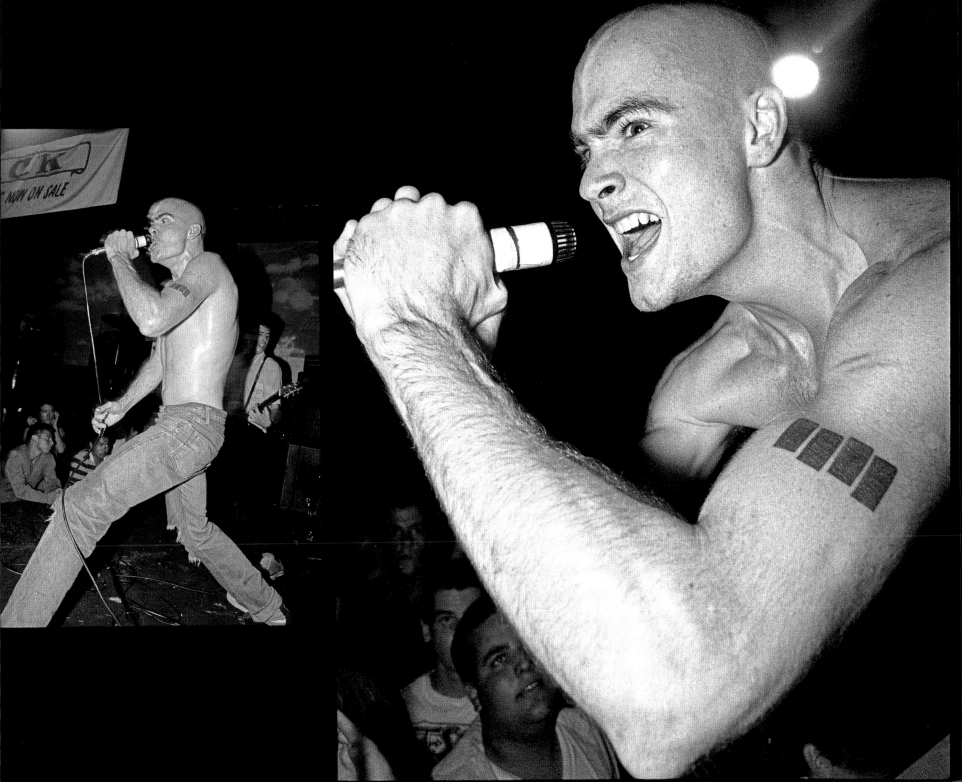

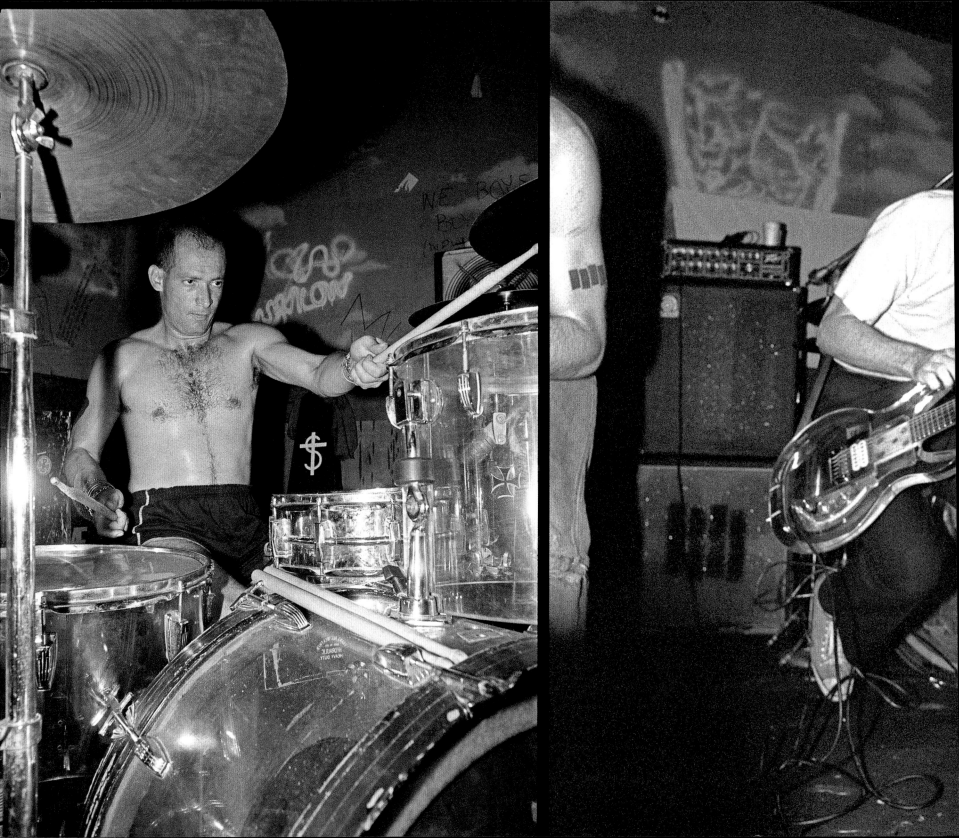

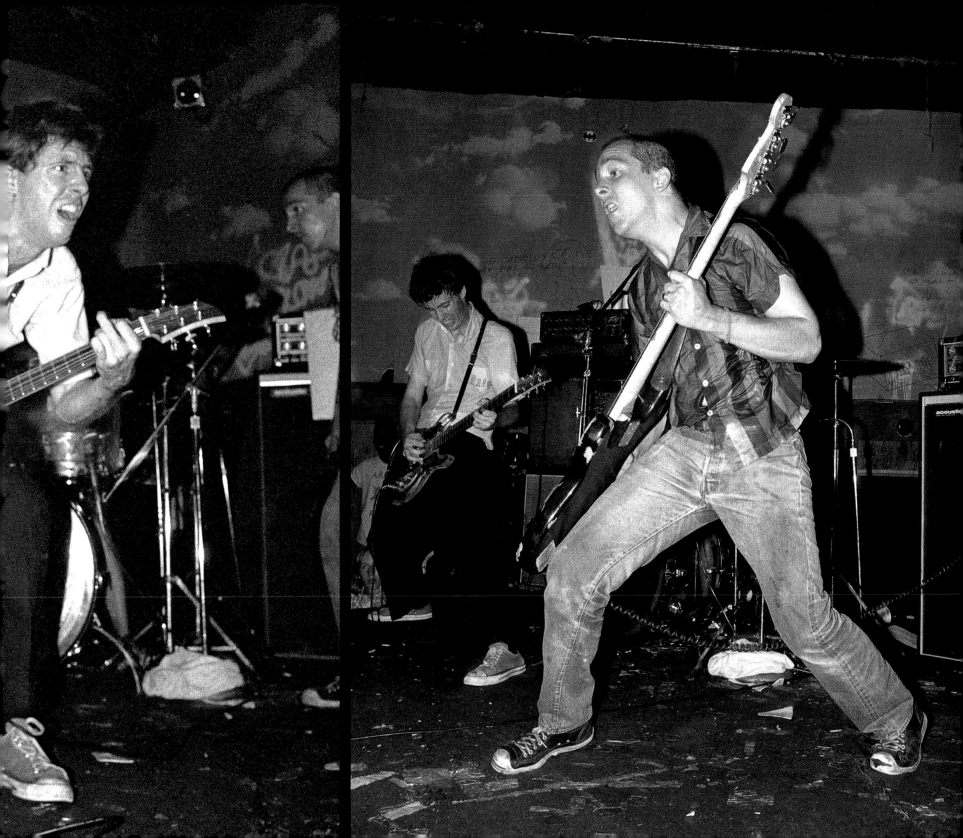

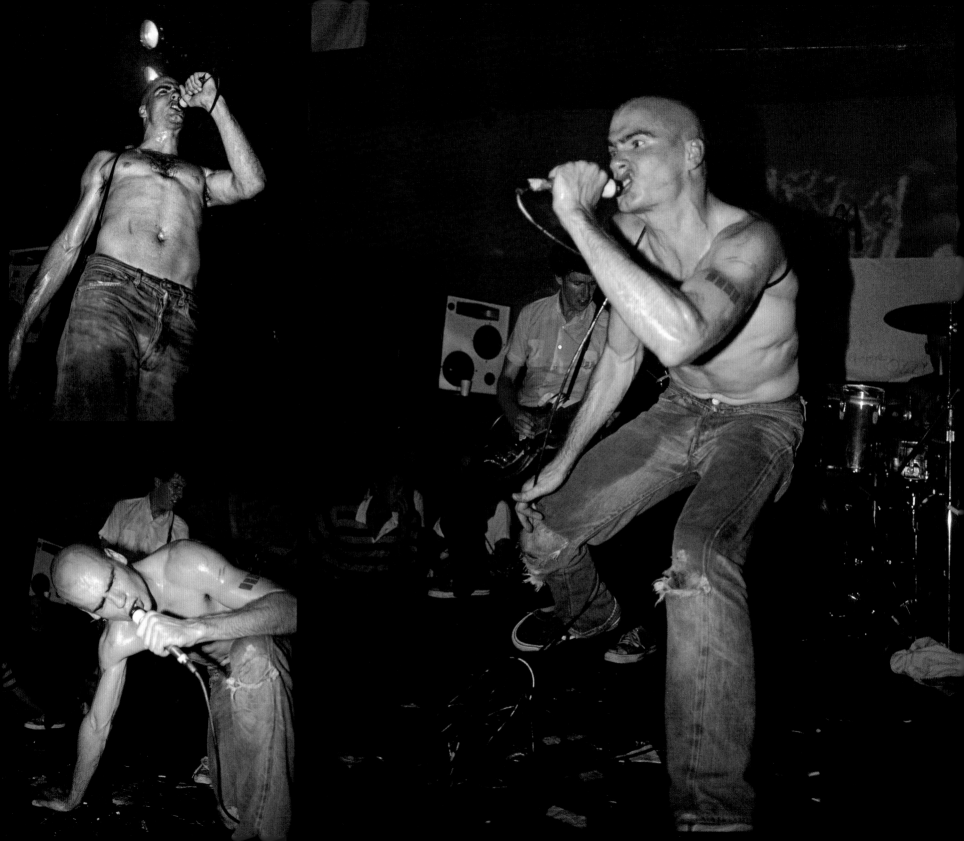

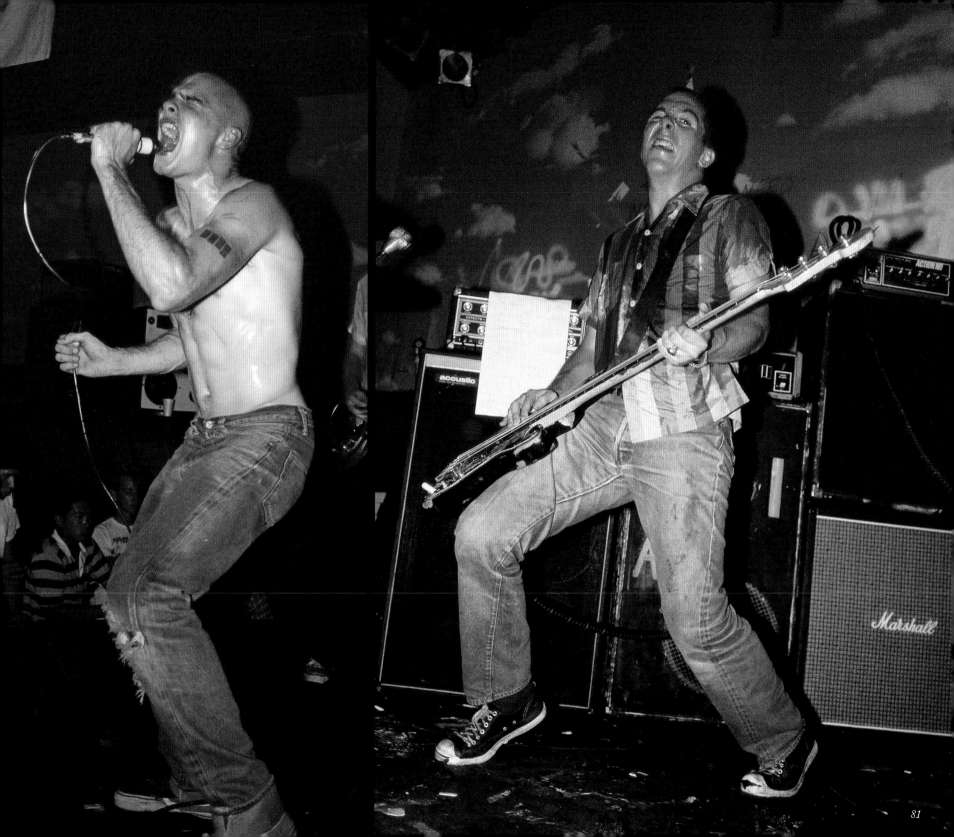

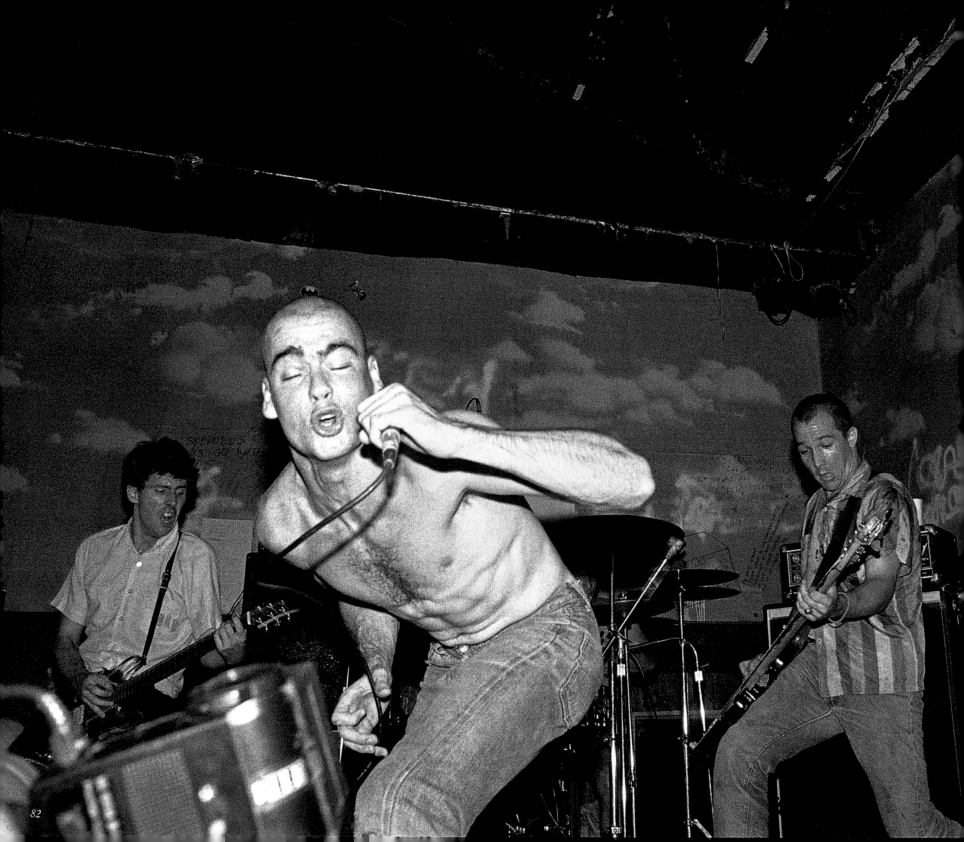

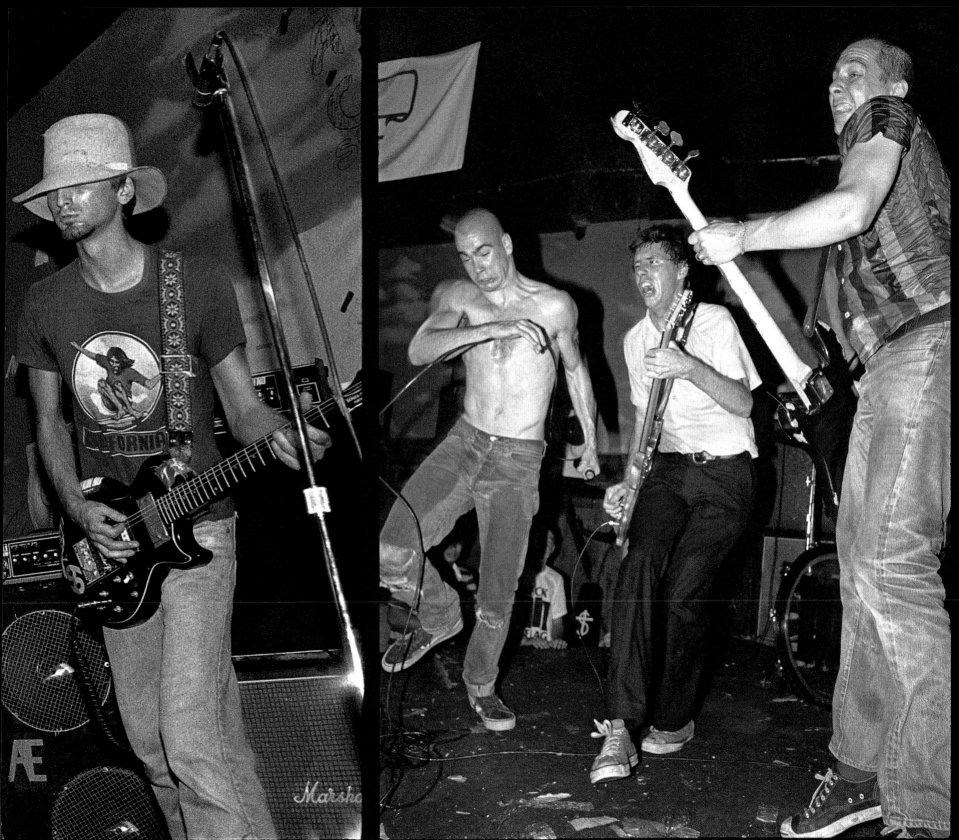

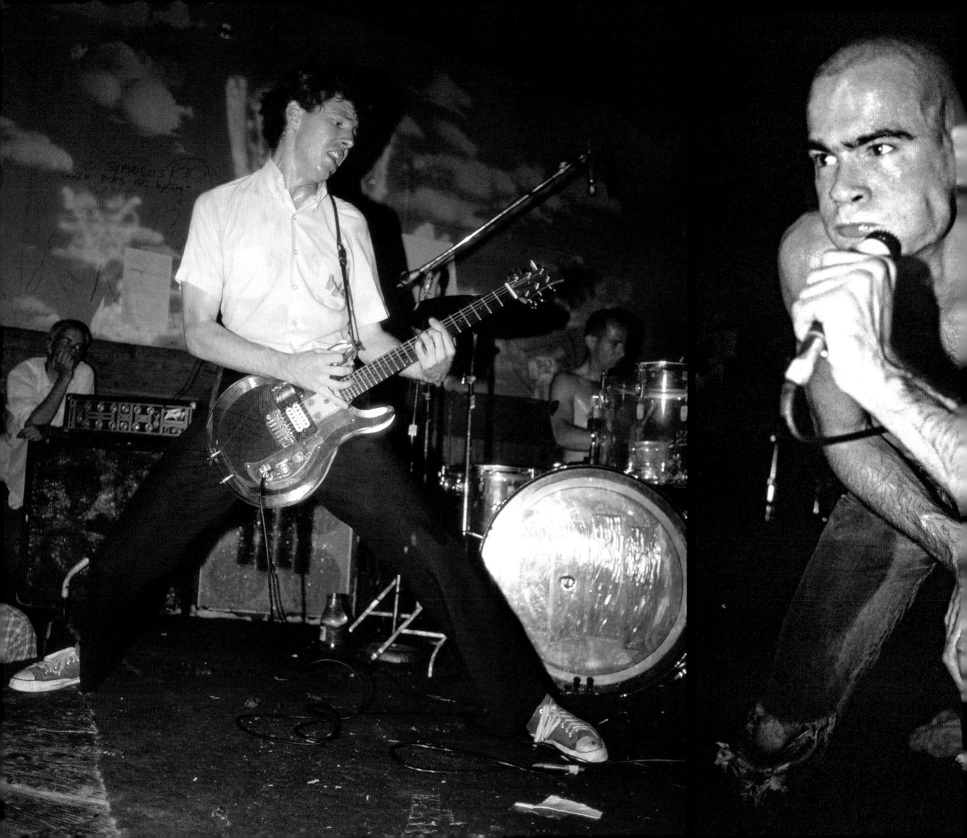

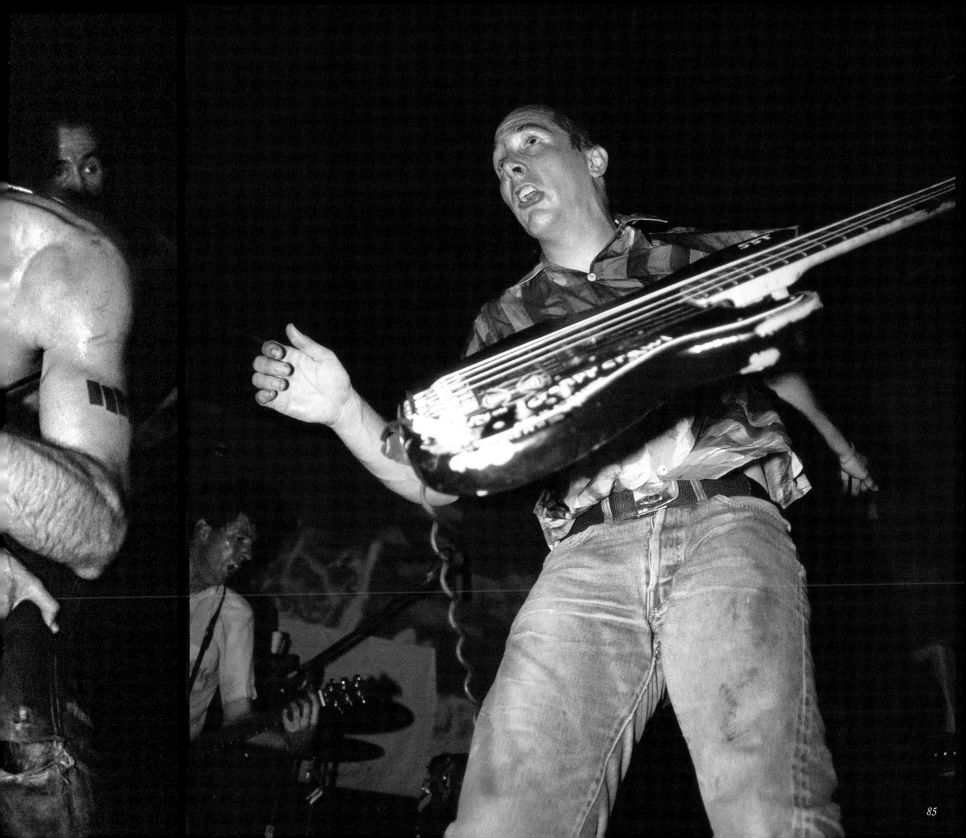

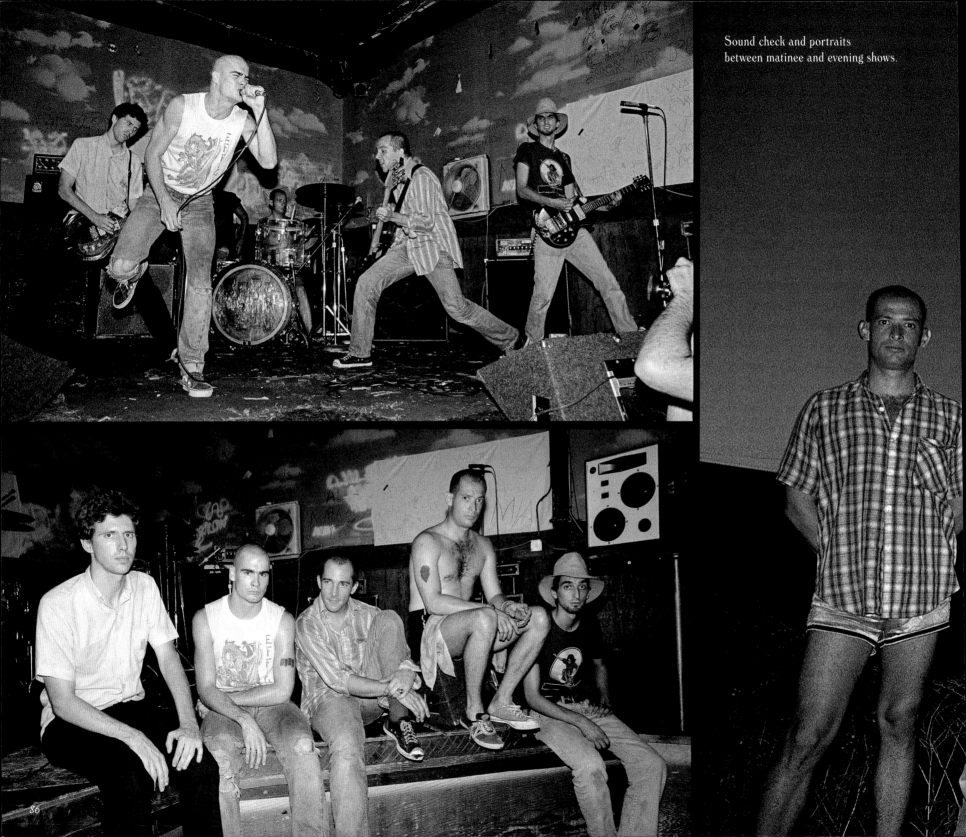

Sound check and portraits between matinee and evening shows.

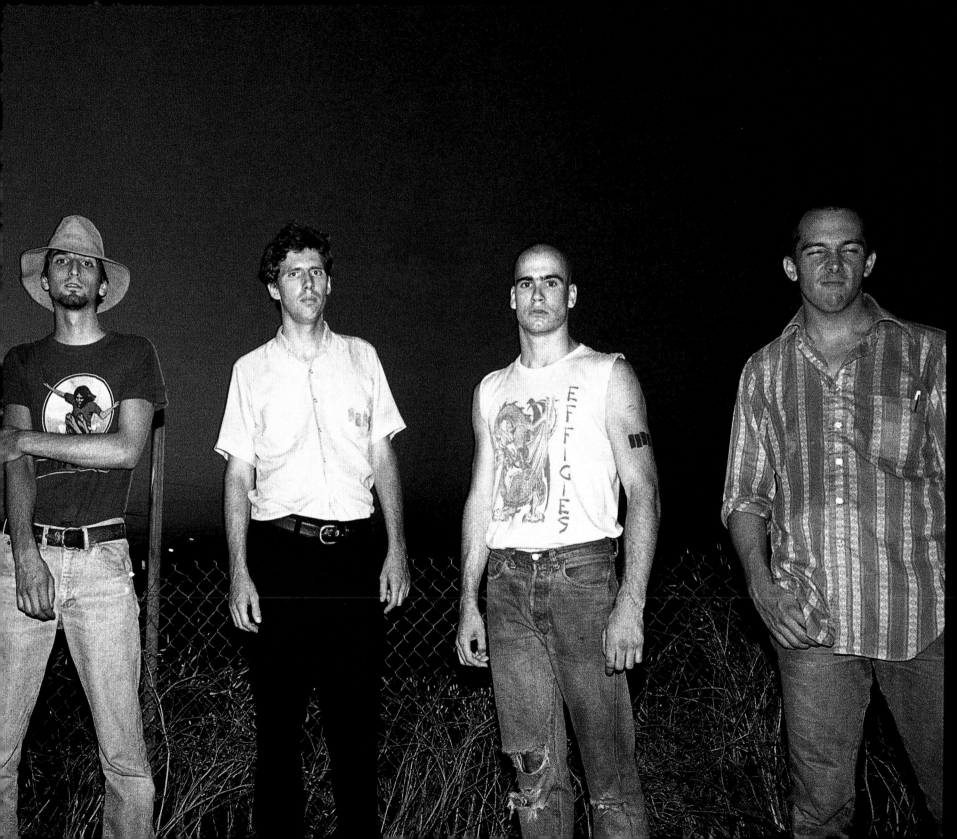

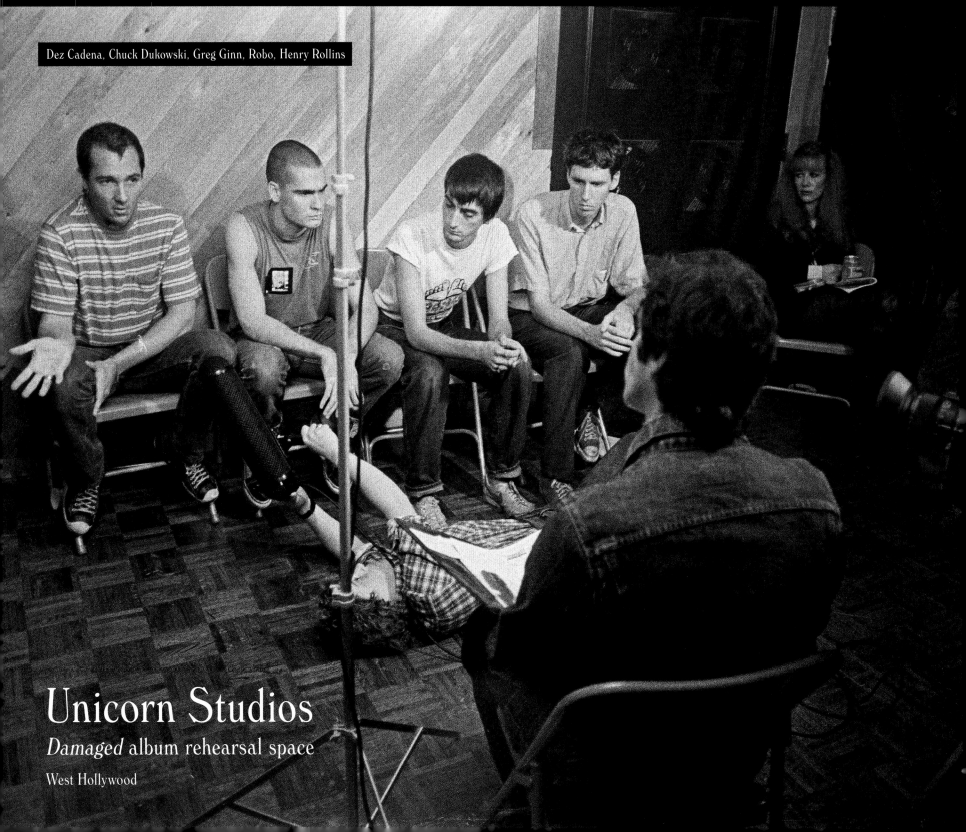

Dez Cadena, Chuck Dukowski, Greg Ginn, Robo, Henry Rollins

Unicorn Studios

Damaged album rehearsal space

West Hollywood

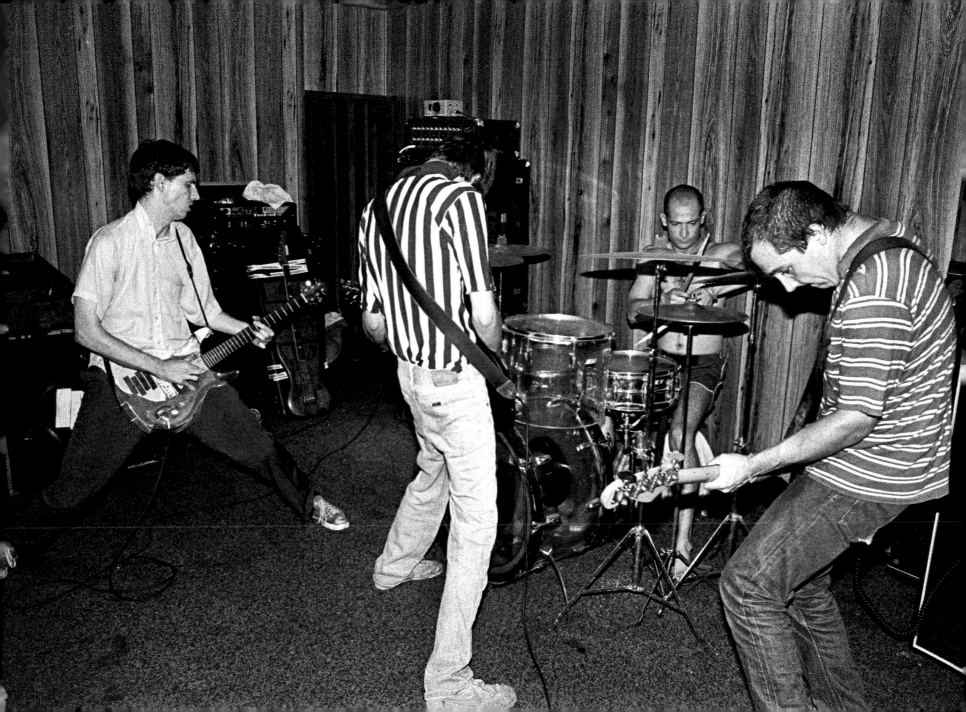

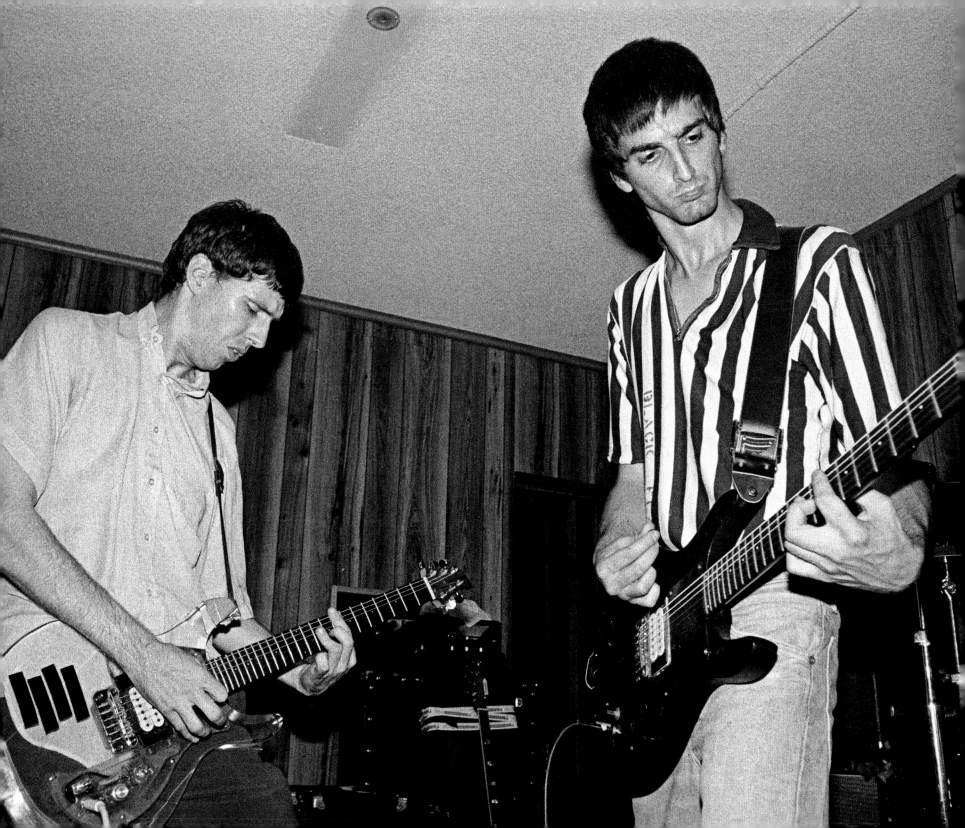

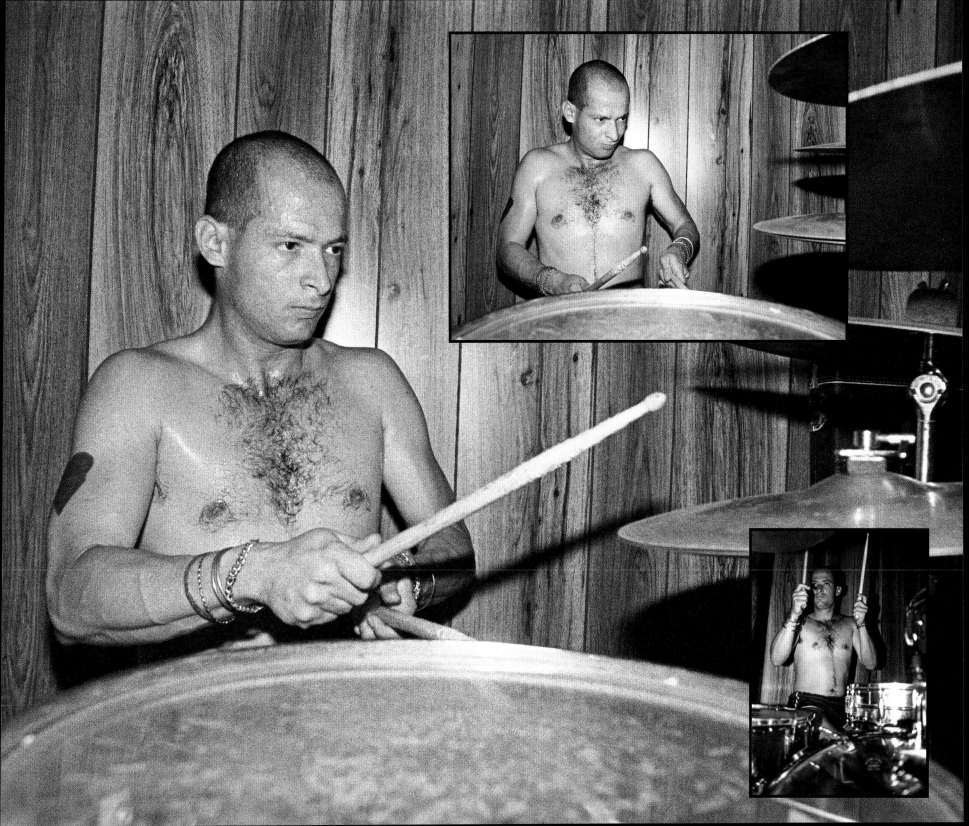

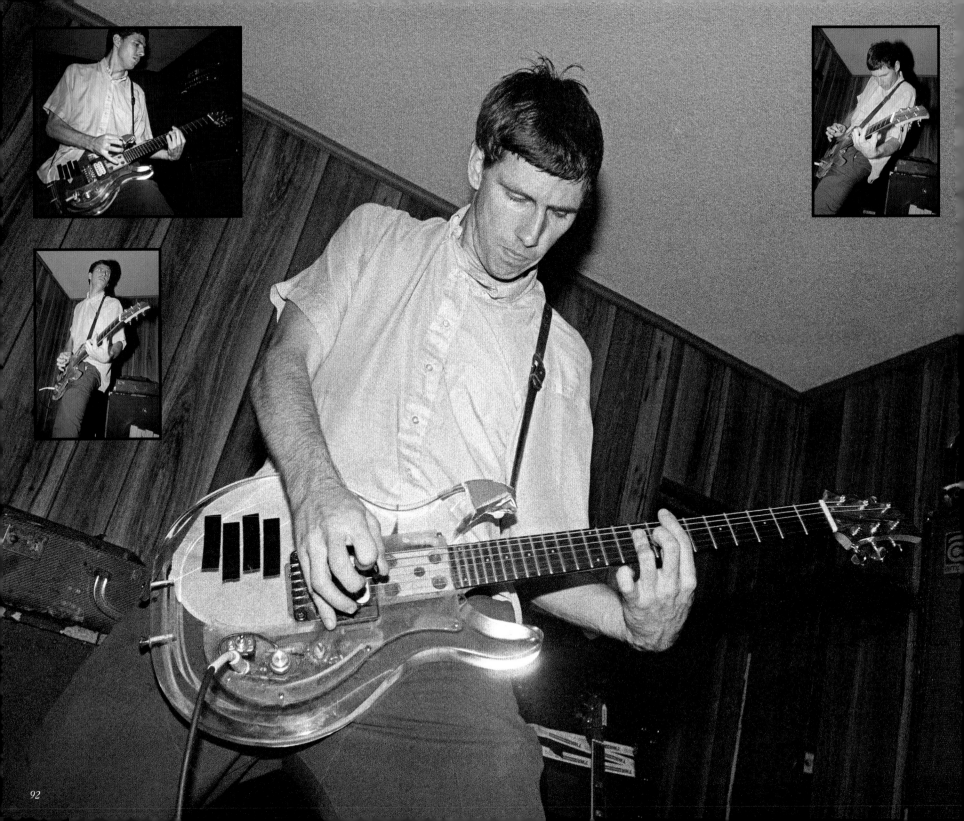

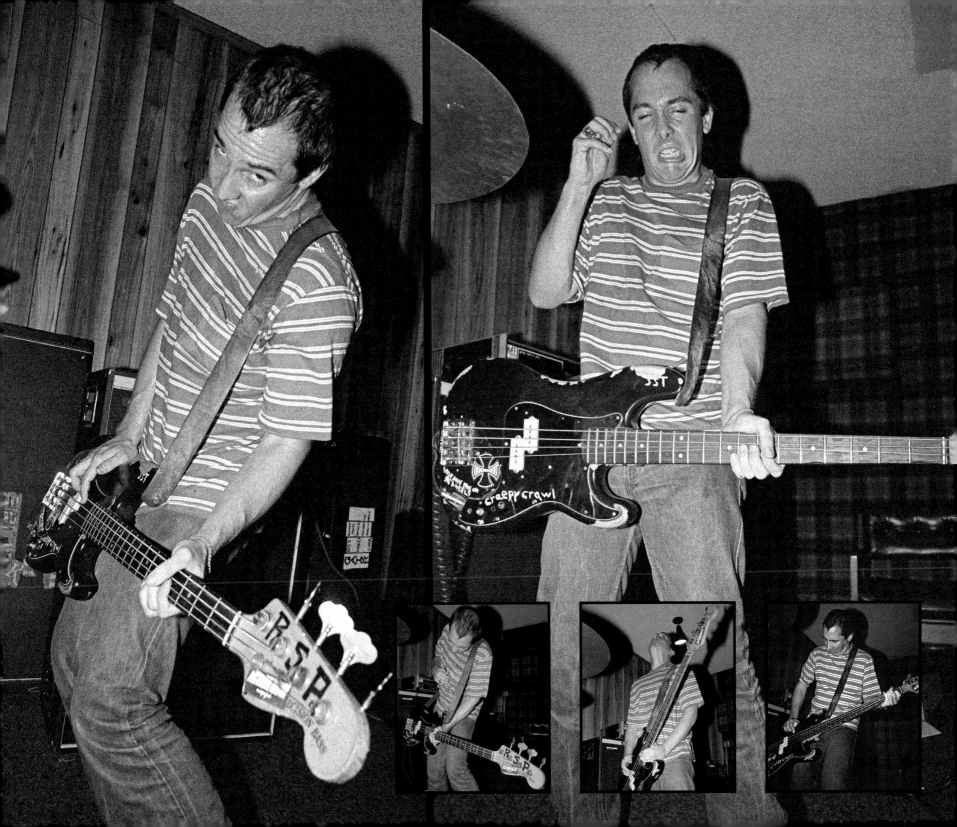

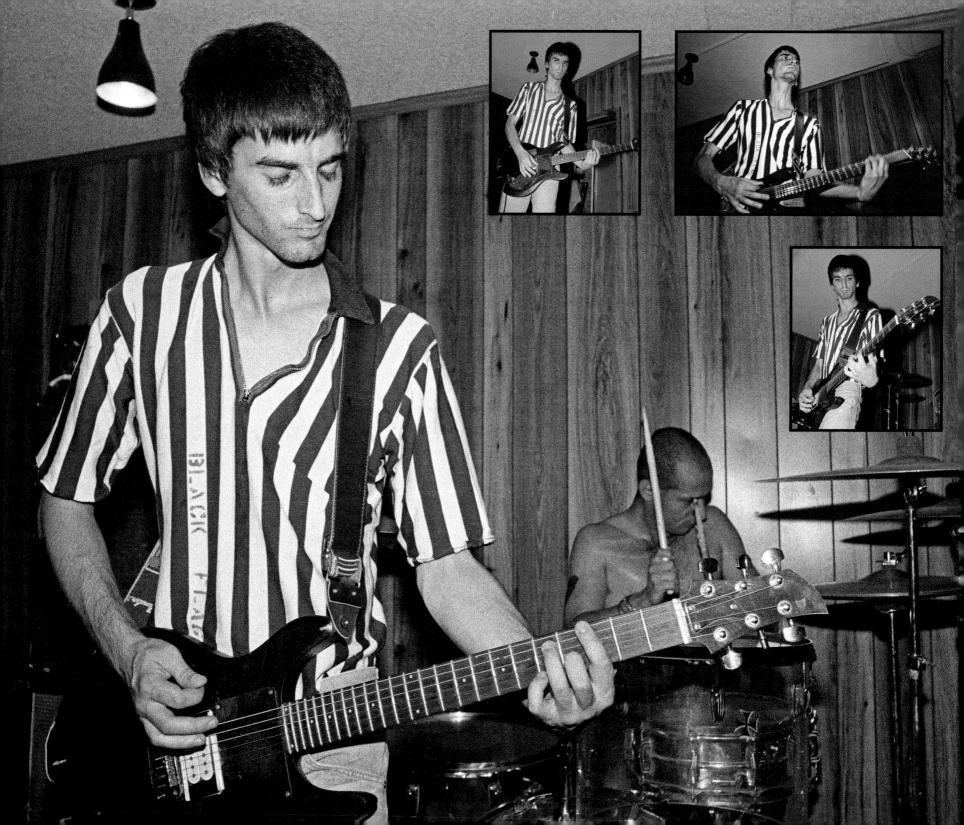

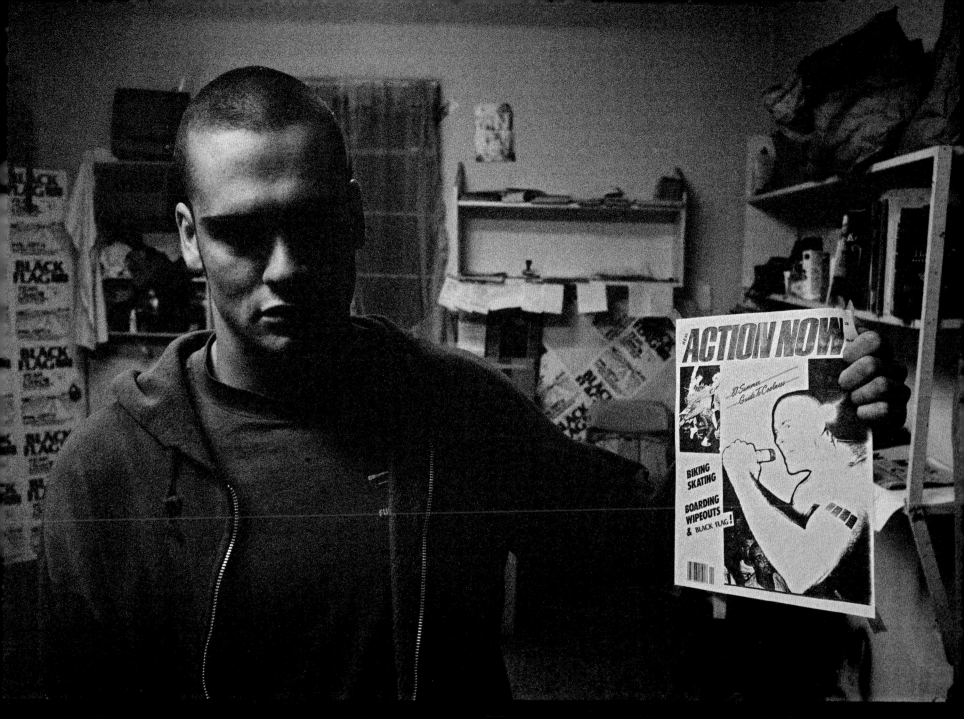

Henry in the makeshift office.

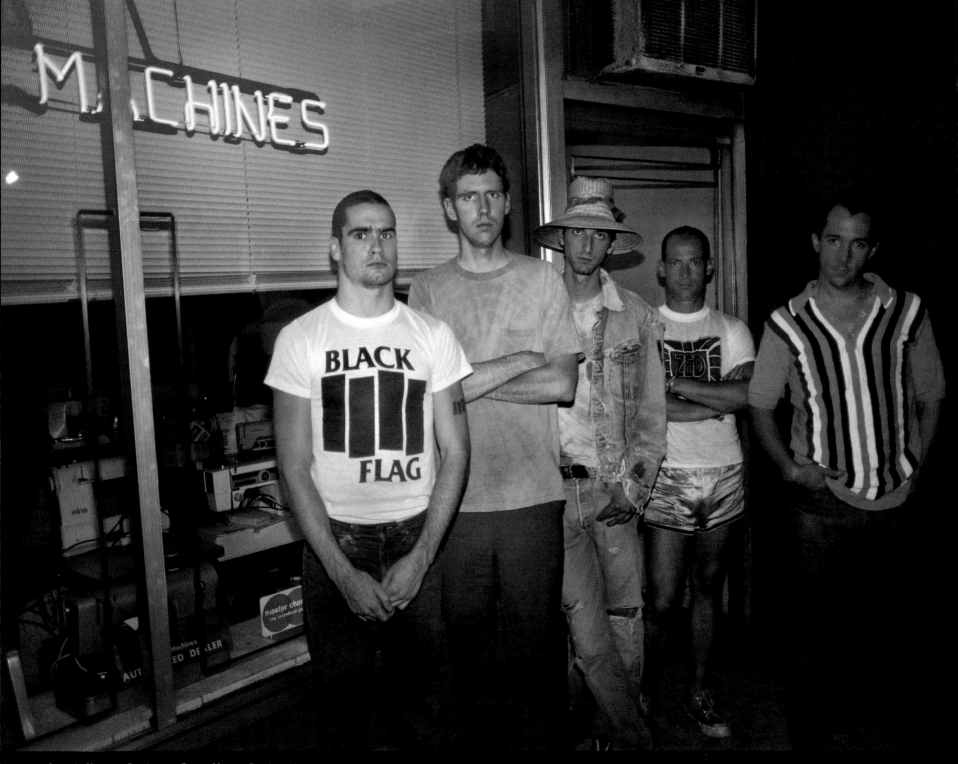

Outside Unicorn Studios on Santa Monica Boulevard.

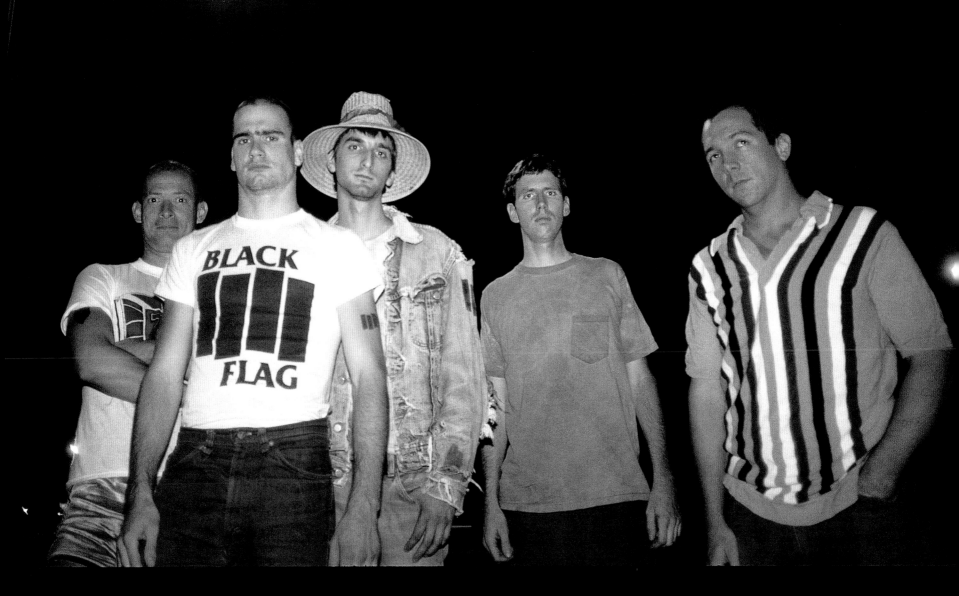

Dez Cadena, Chuck Dukowski, Greg Ginn, Robo, Henry Rollins

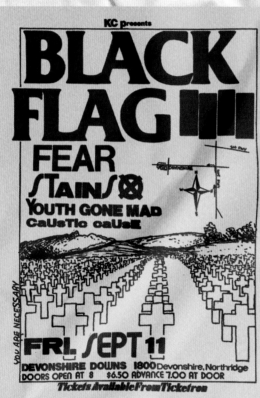

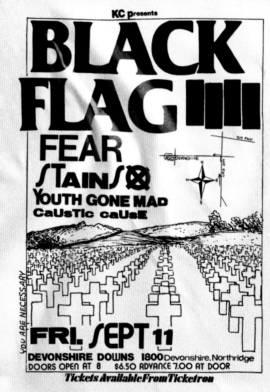

Devonshire Downs, Northridge (San Fernando Valley), September 11, 1981

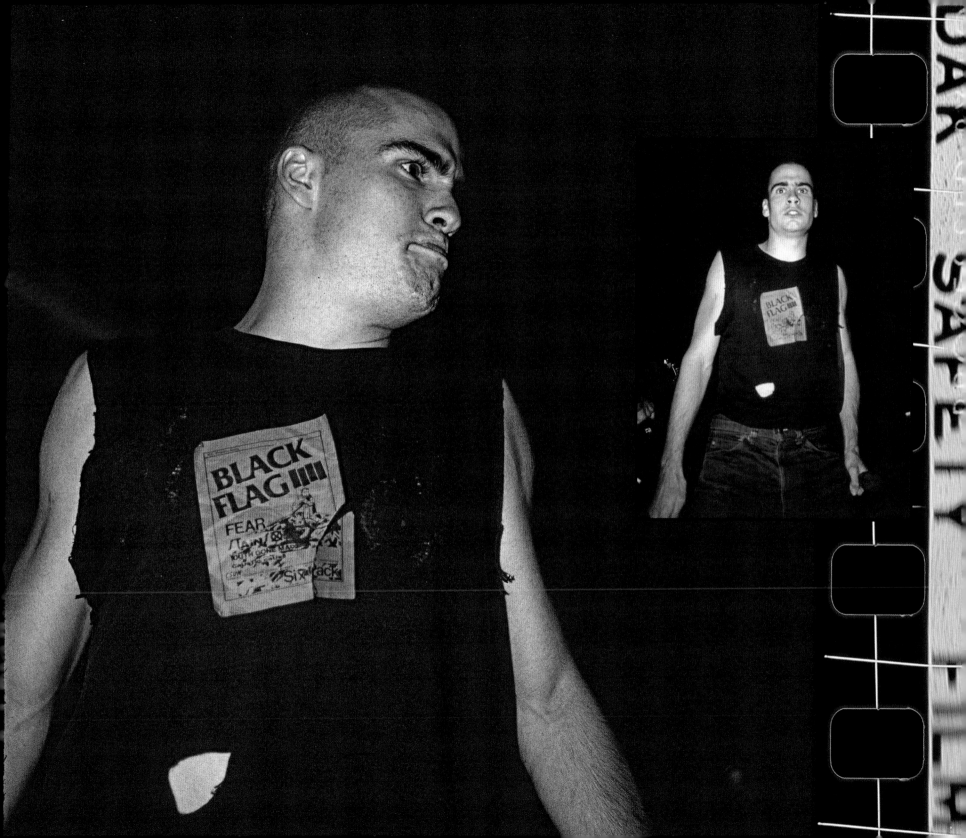

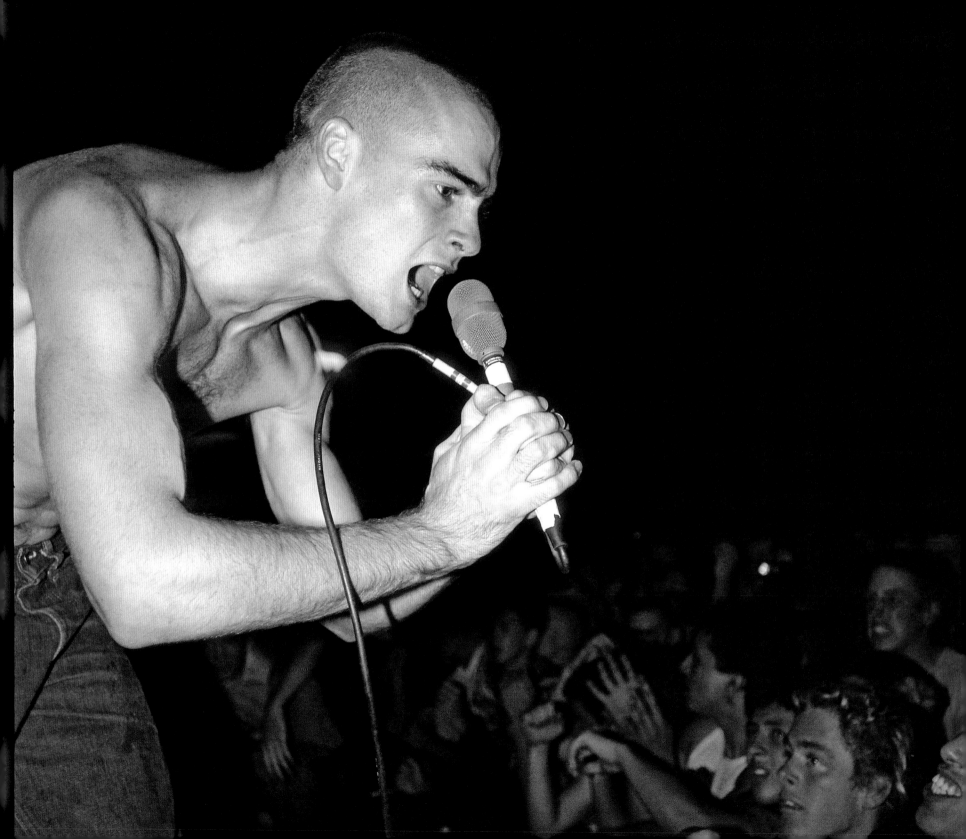

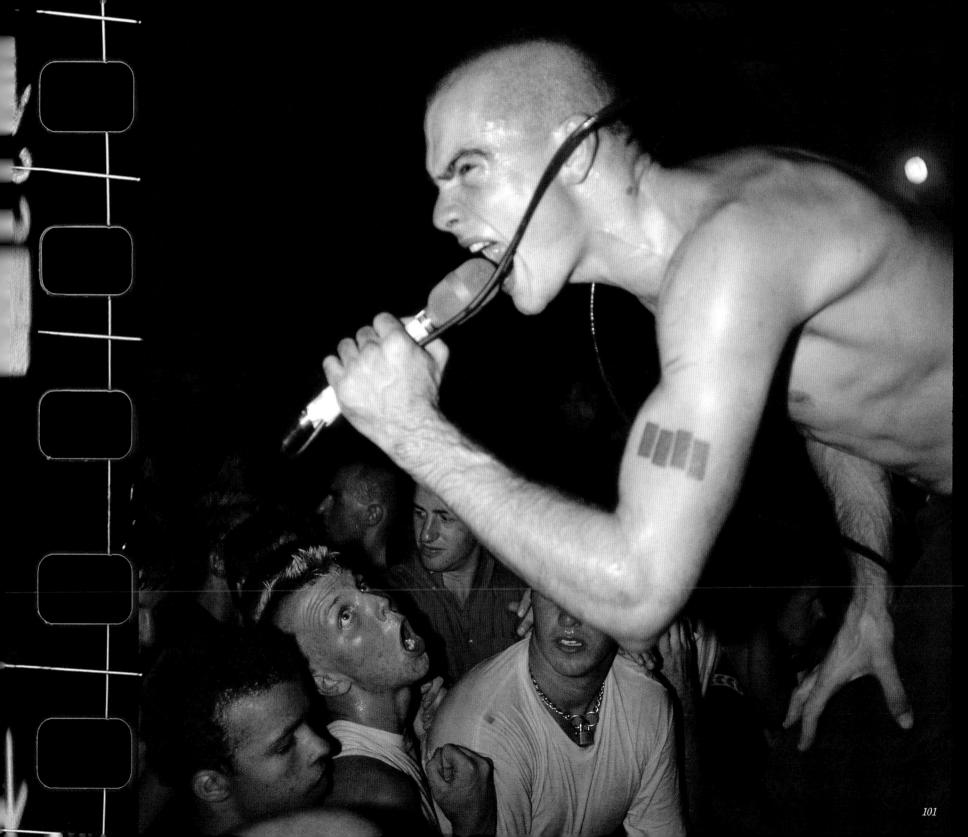

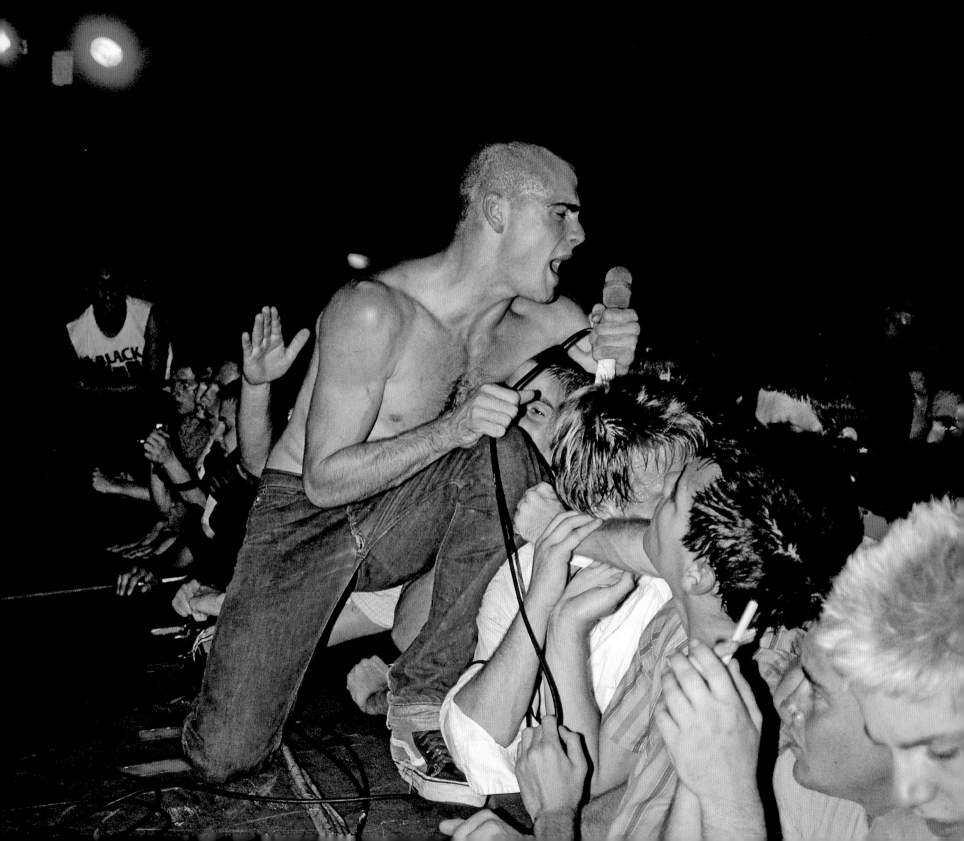

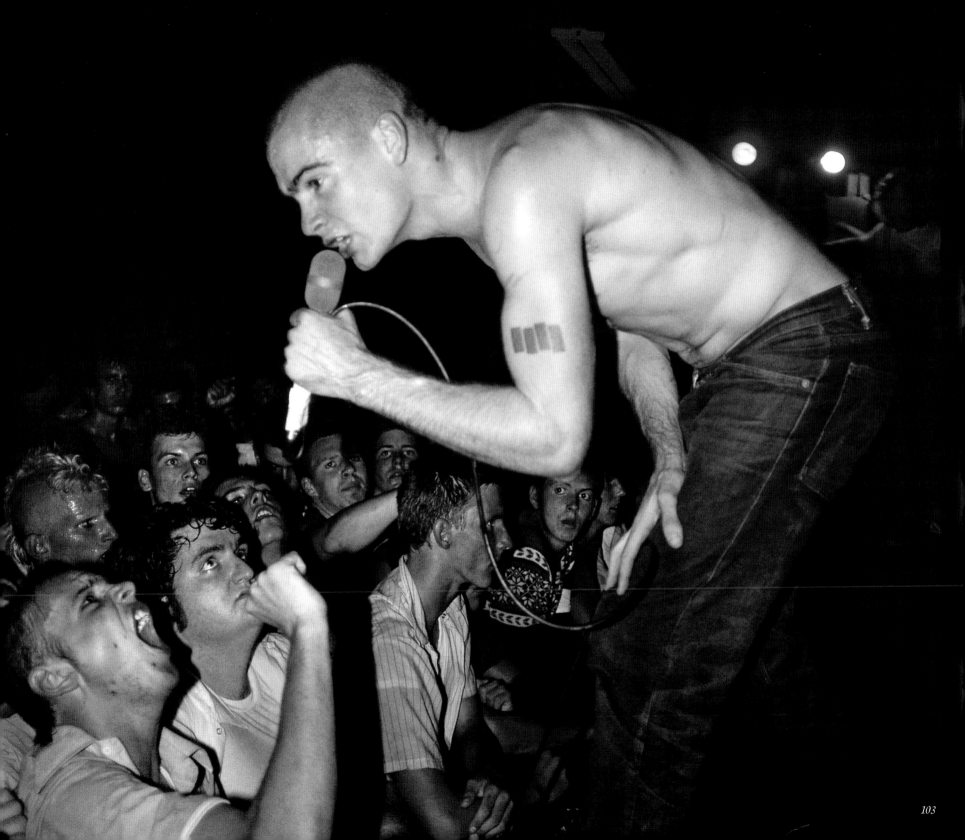

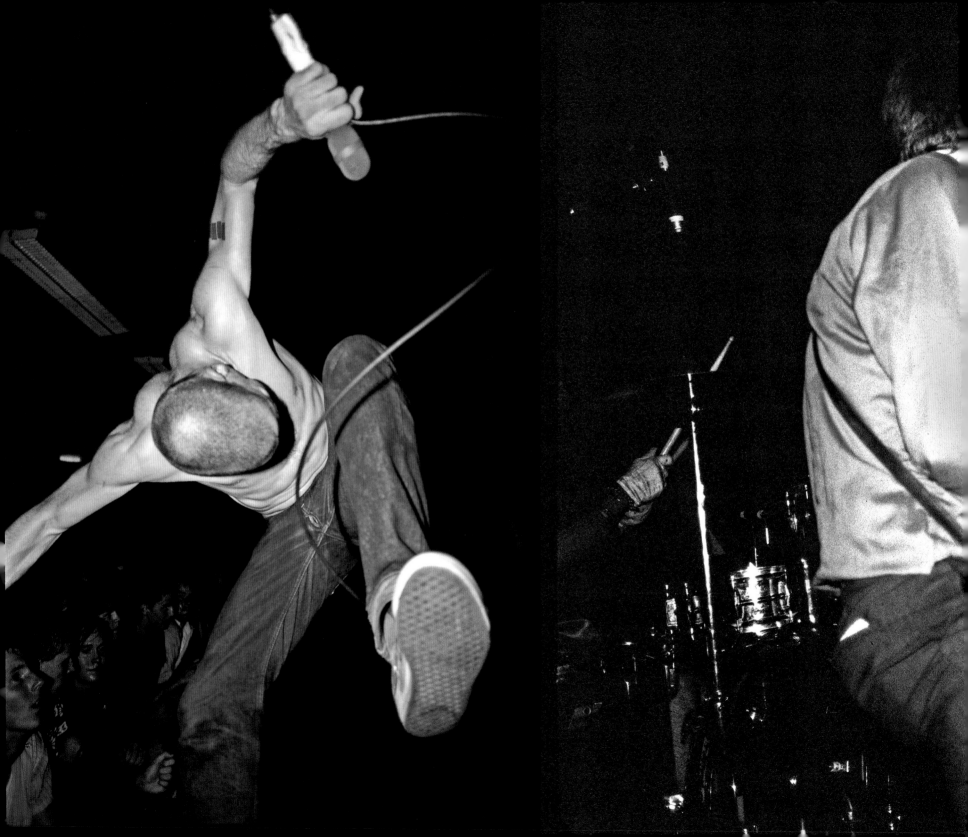

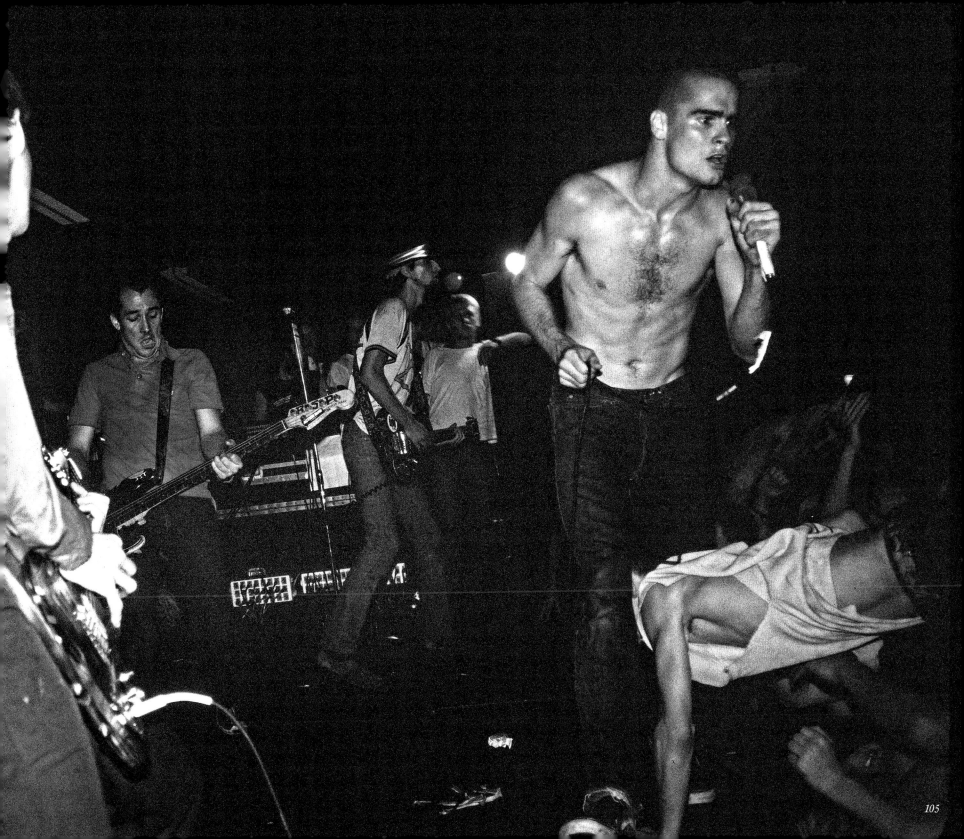

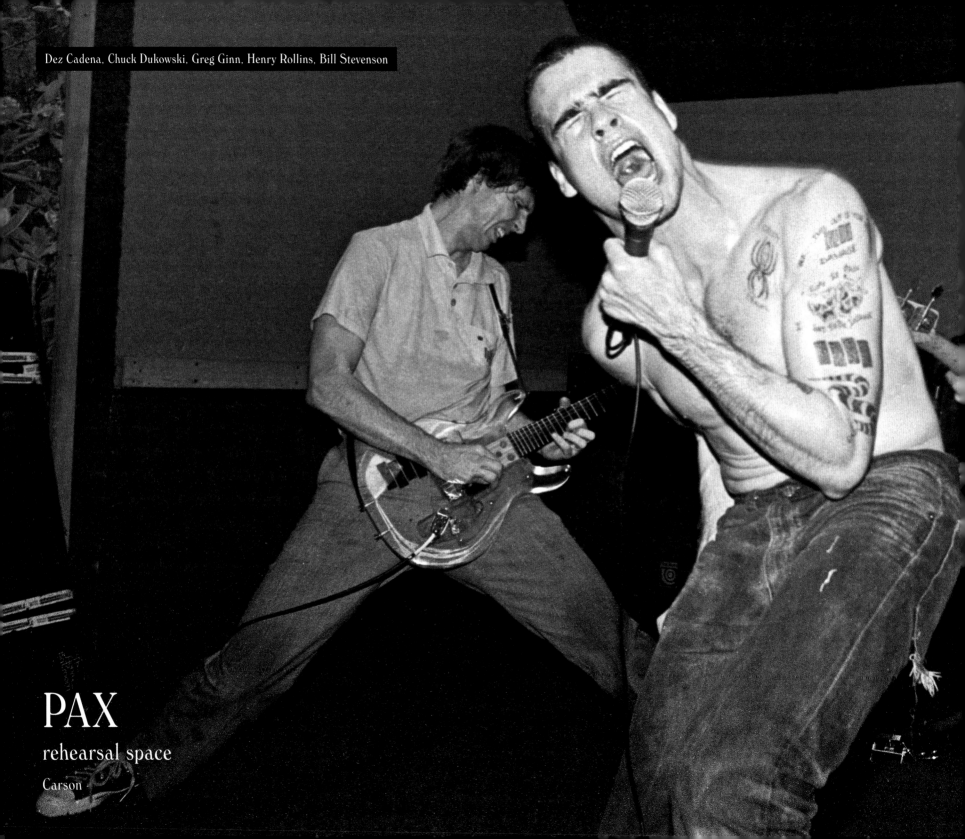

Dez Cadena, Chuck Dukowski, Greg Ginn, Henry Rollins, Bill Stevenson

PAX
rehearsal space

Carson

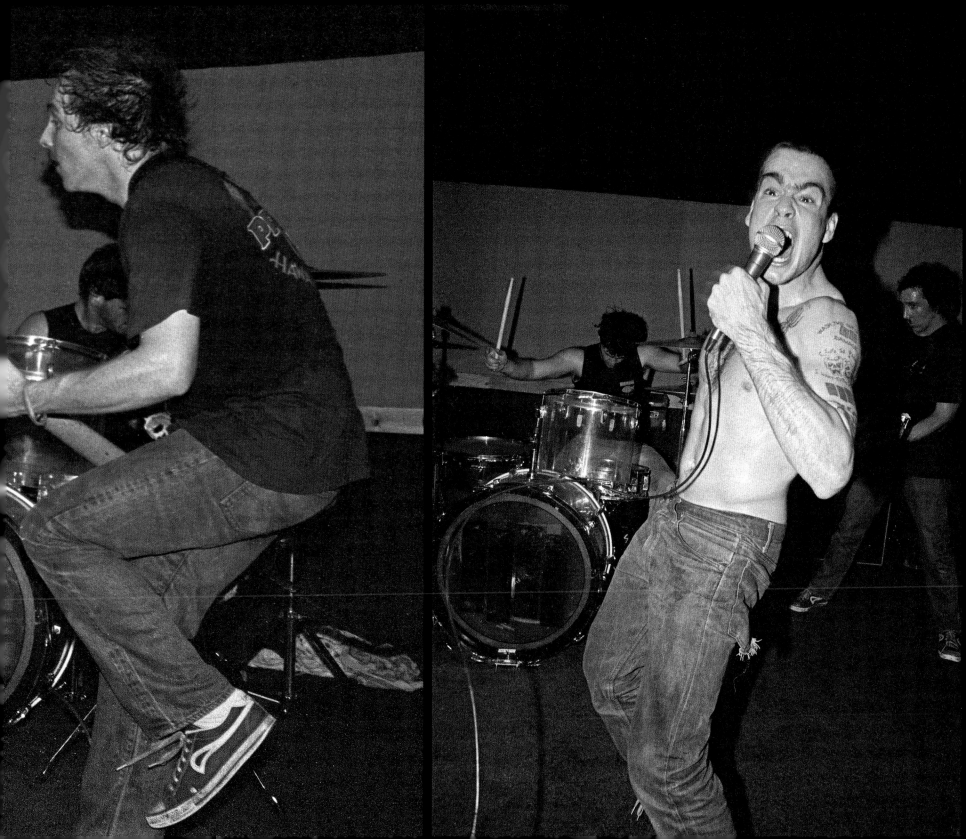

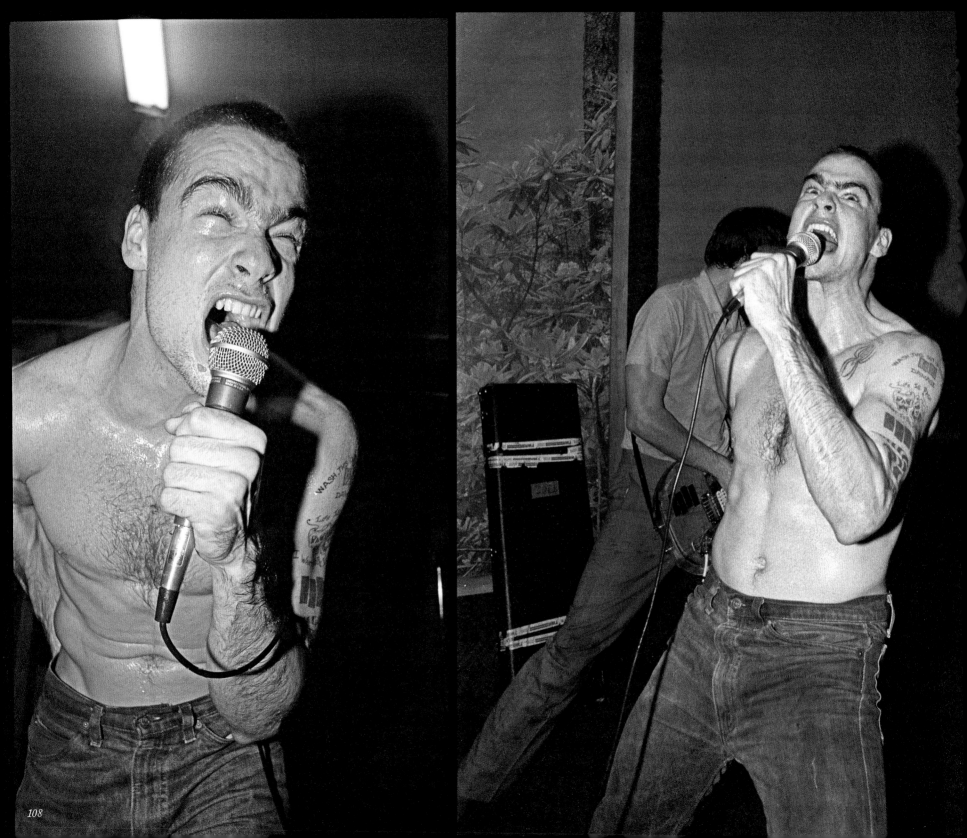

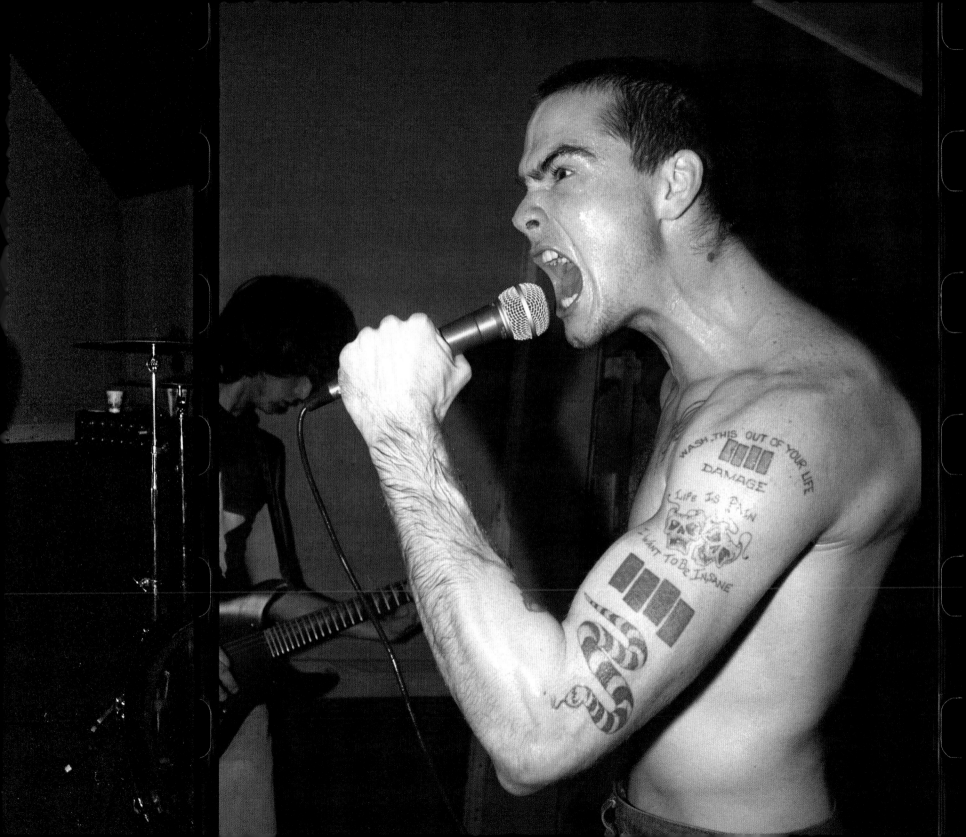

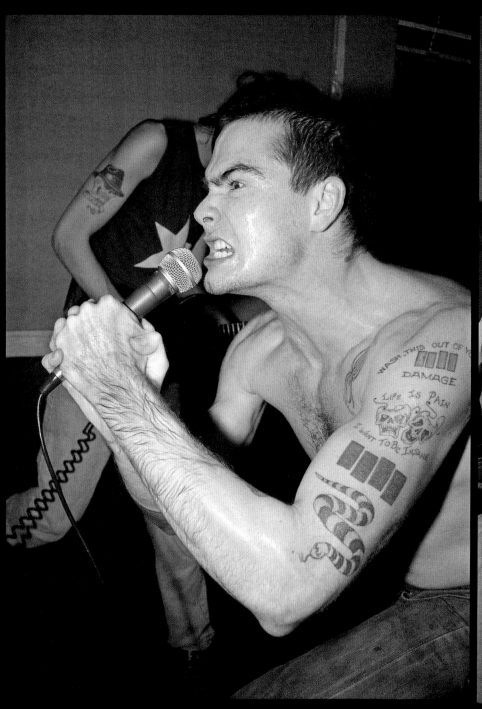
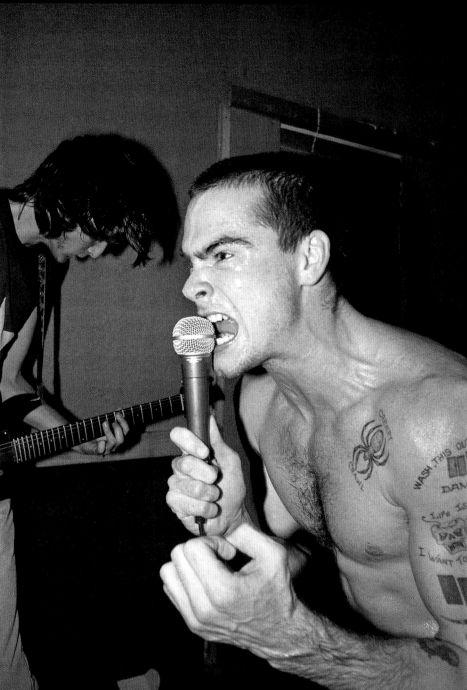

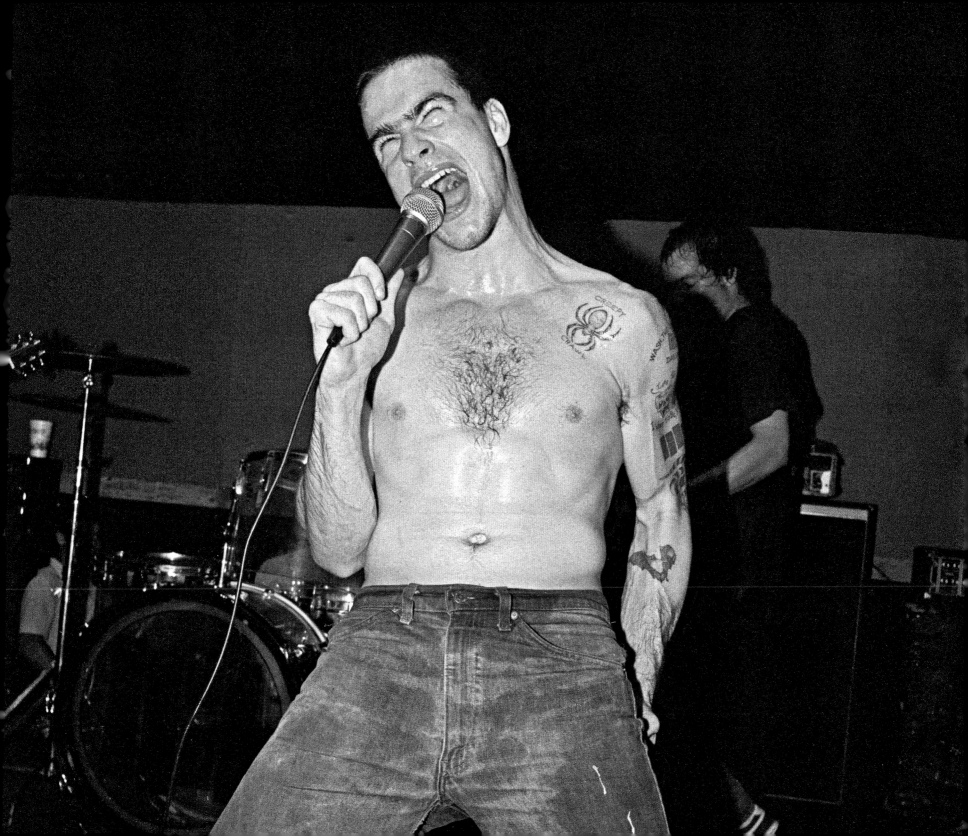

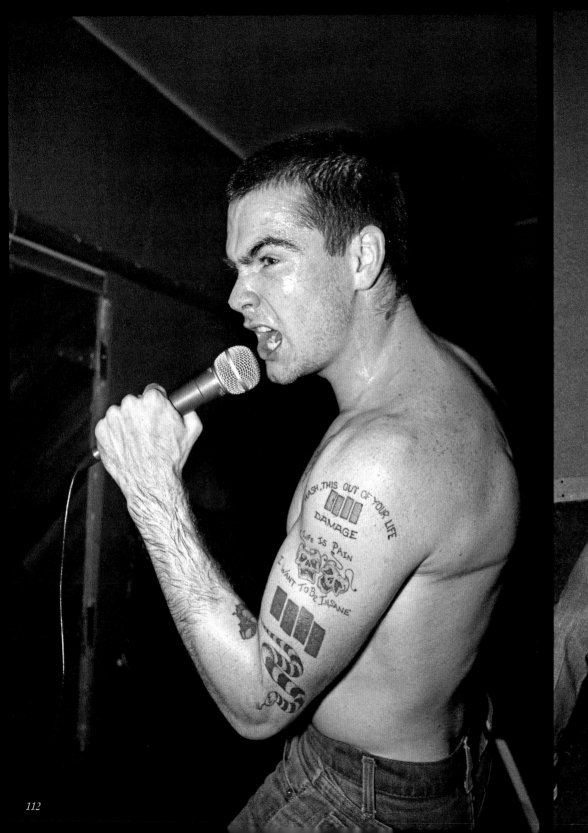
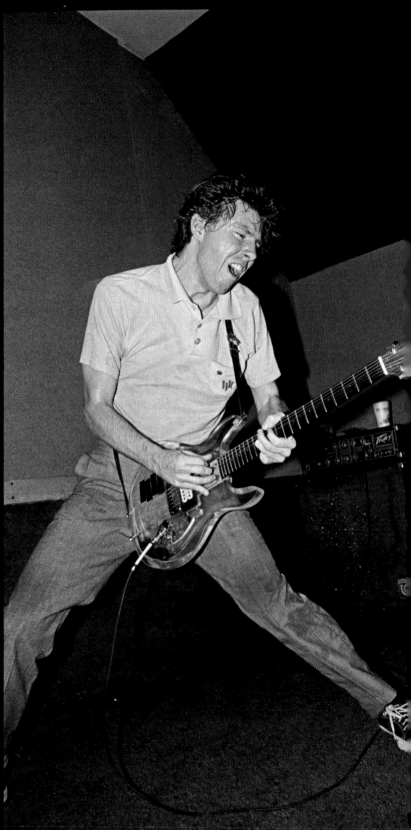

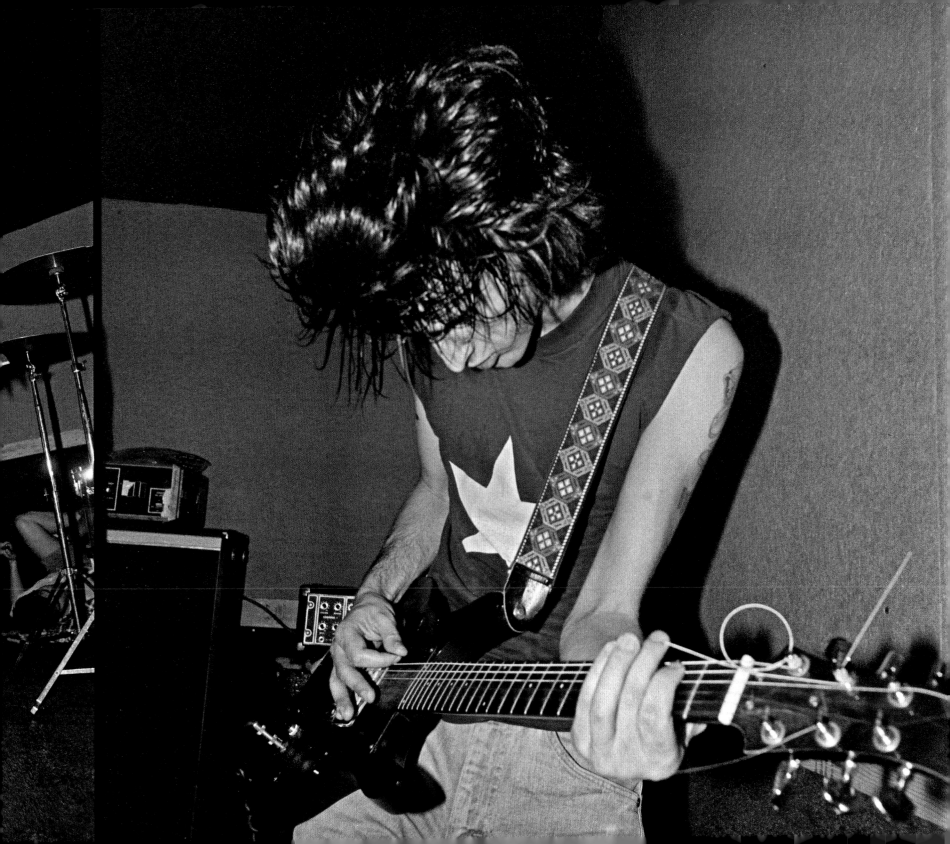

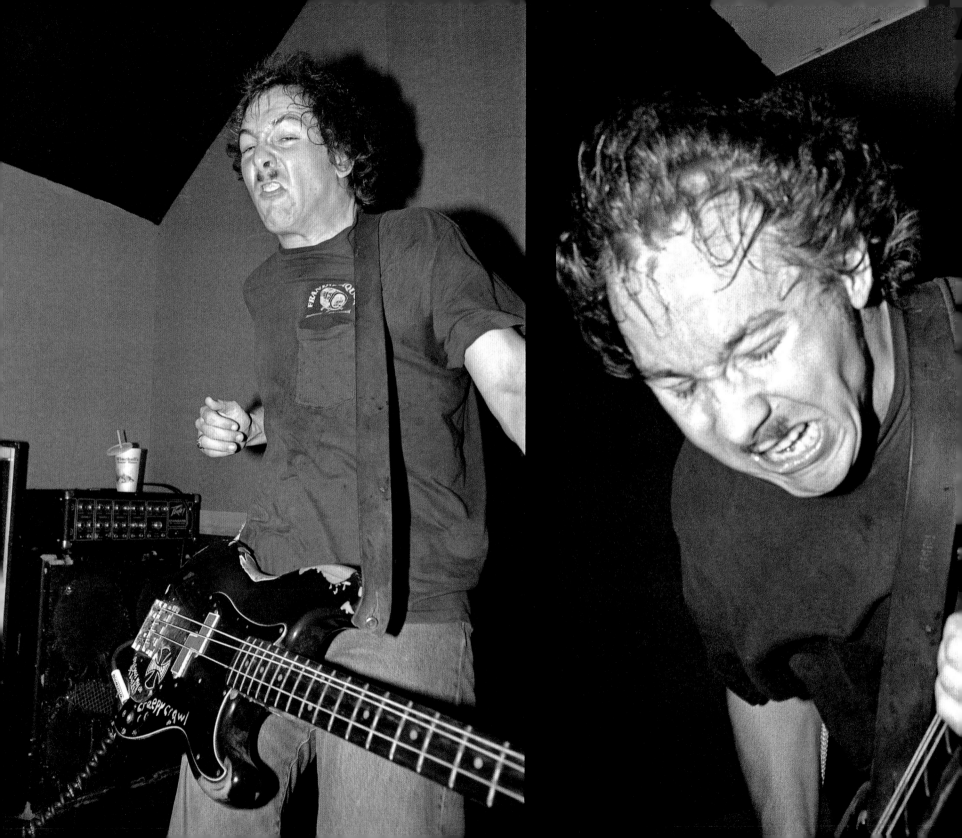

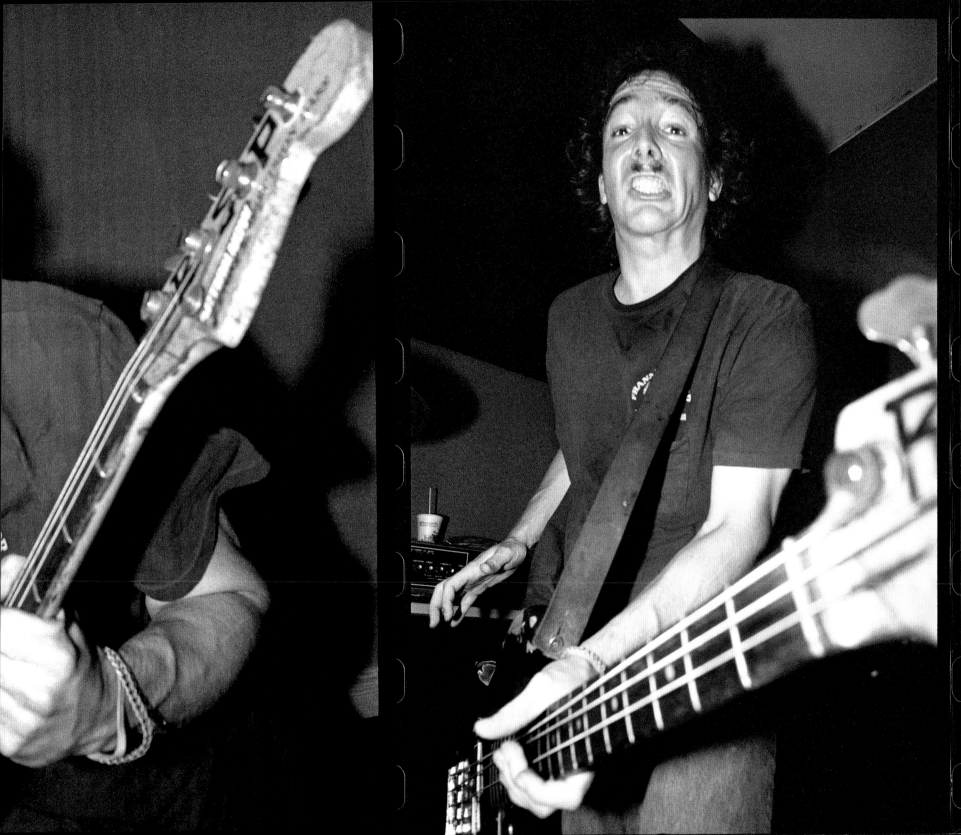

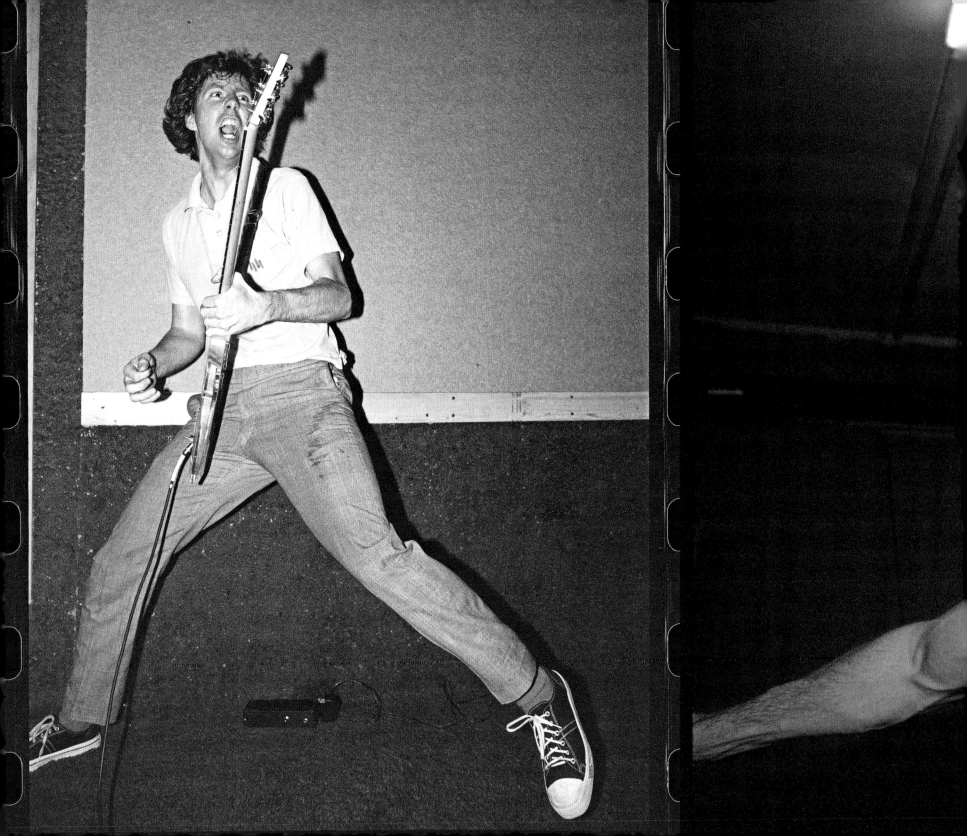

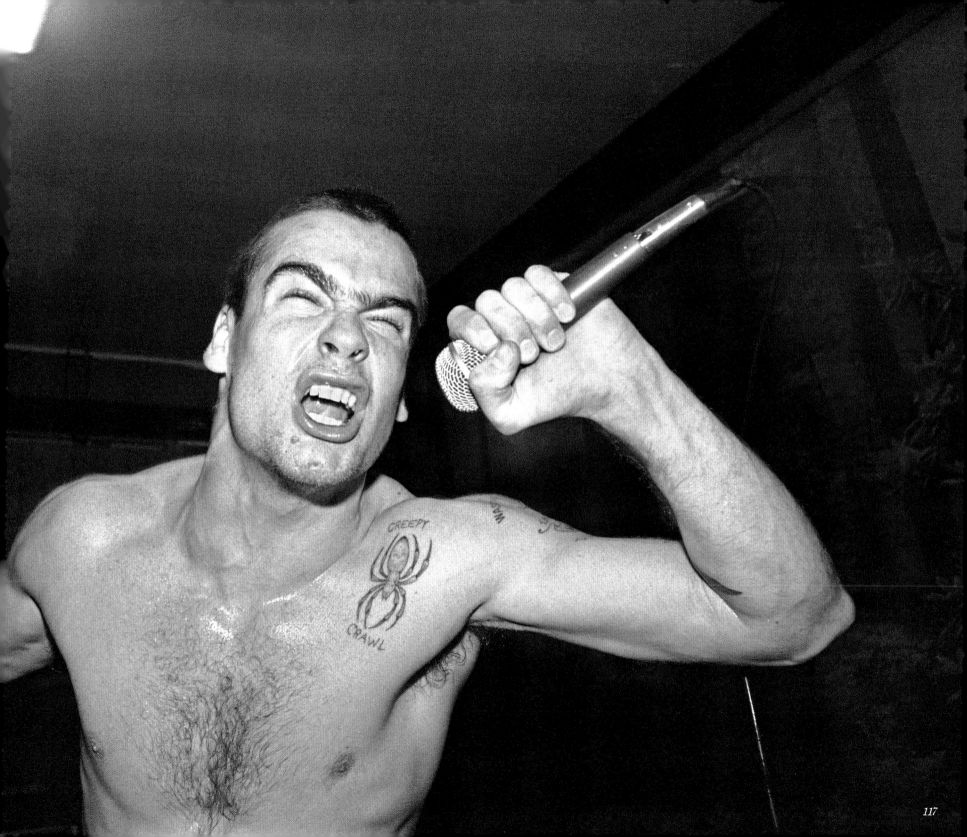

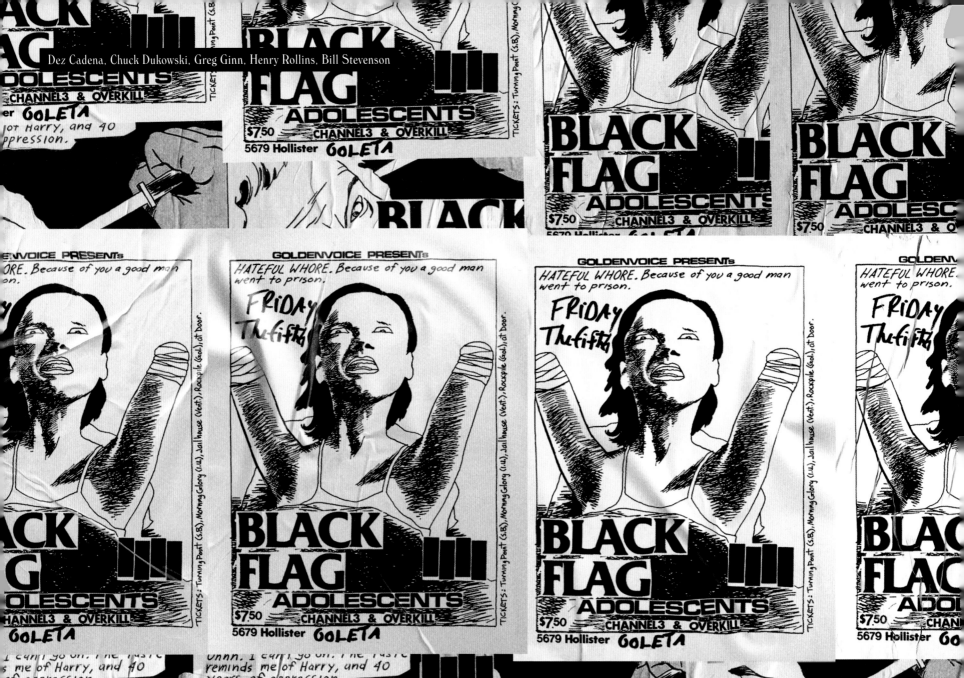

Dez Cadena, Chuck Dukowski, Greg Ginn, Henry Rollins, Bill Stevenson

Goleta Valley Community Center, Goleta, March 5, 1982

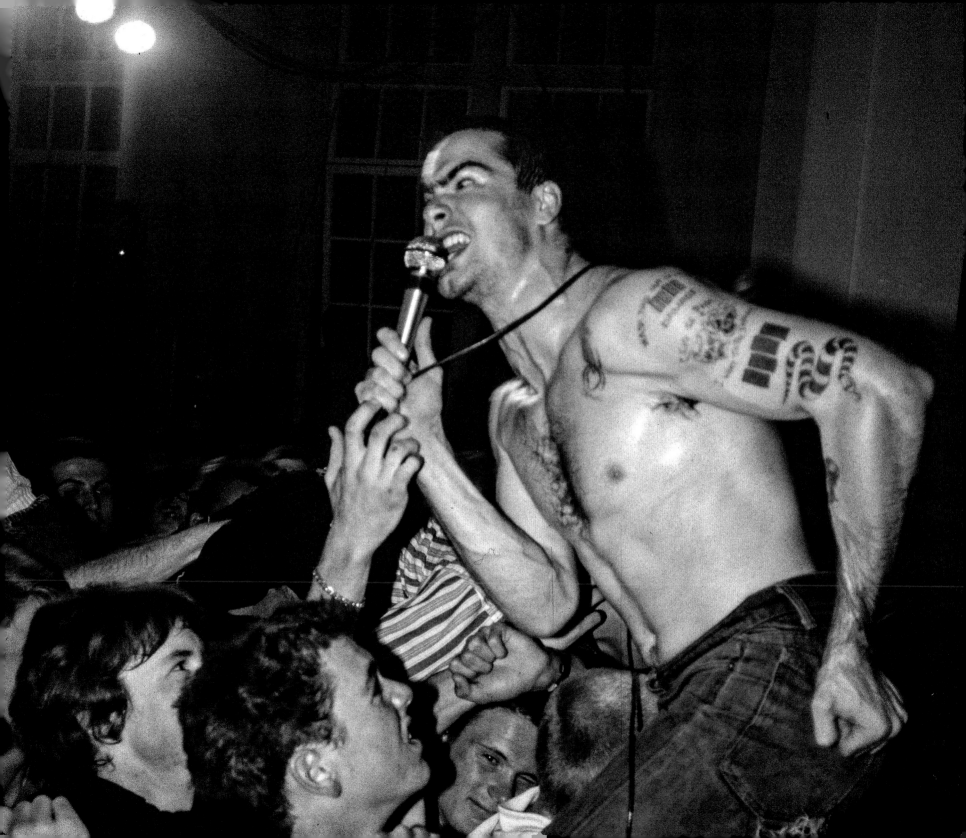

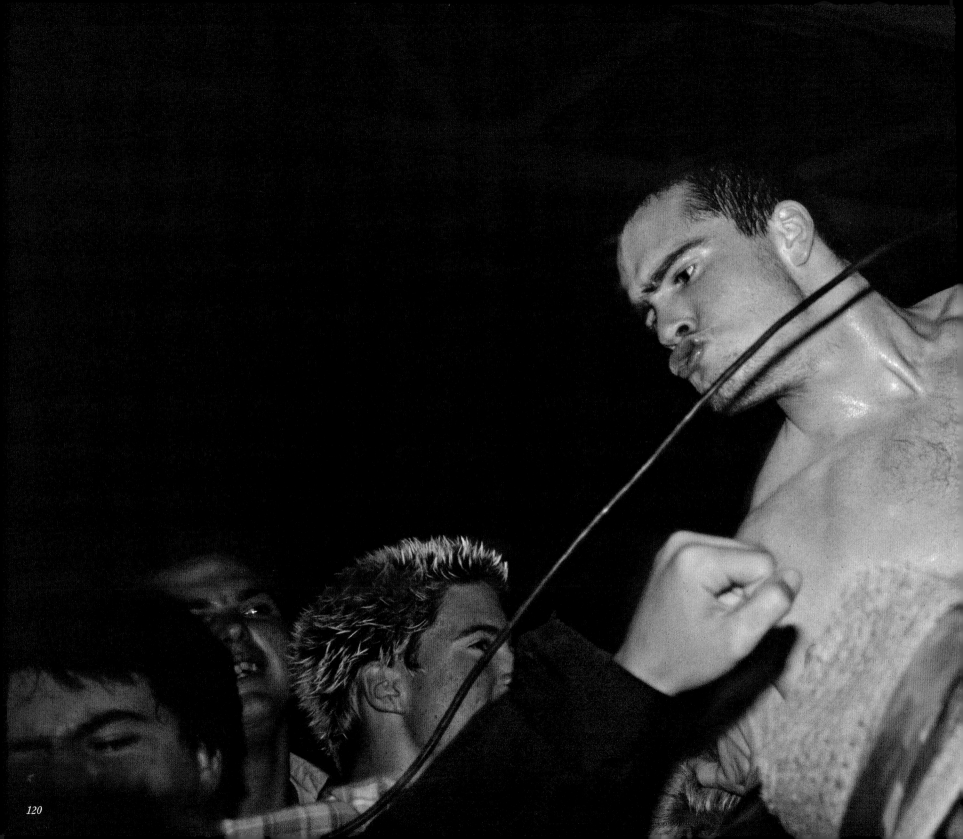

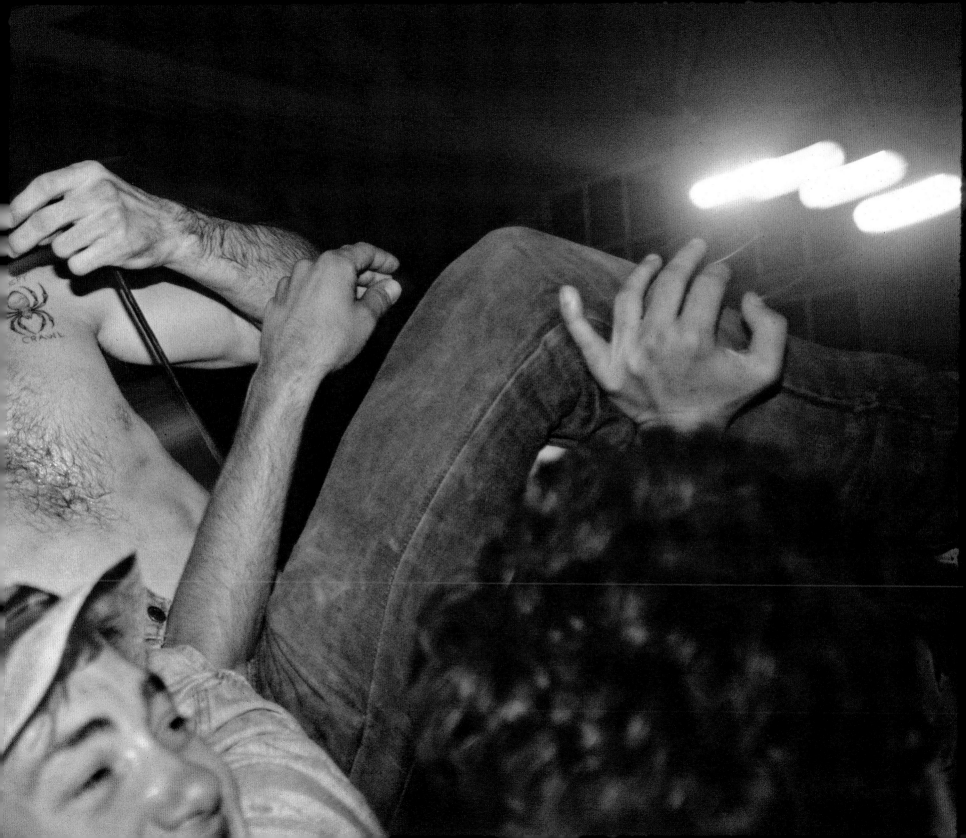

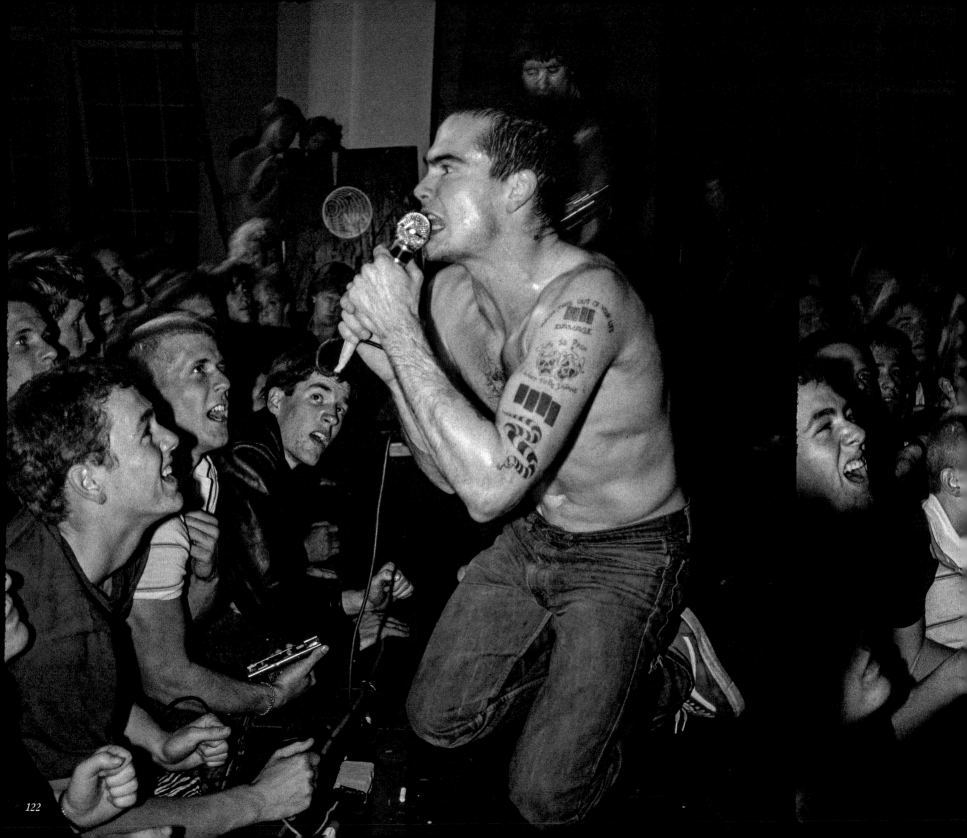

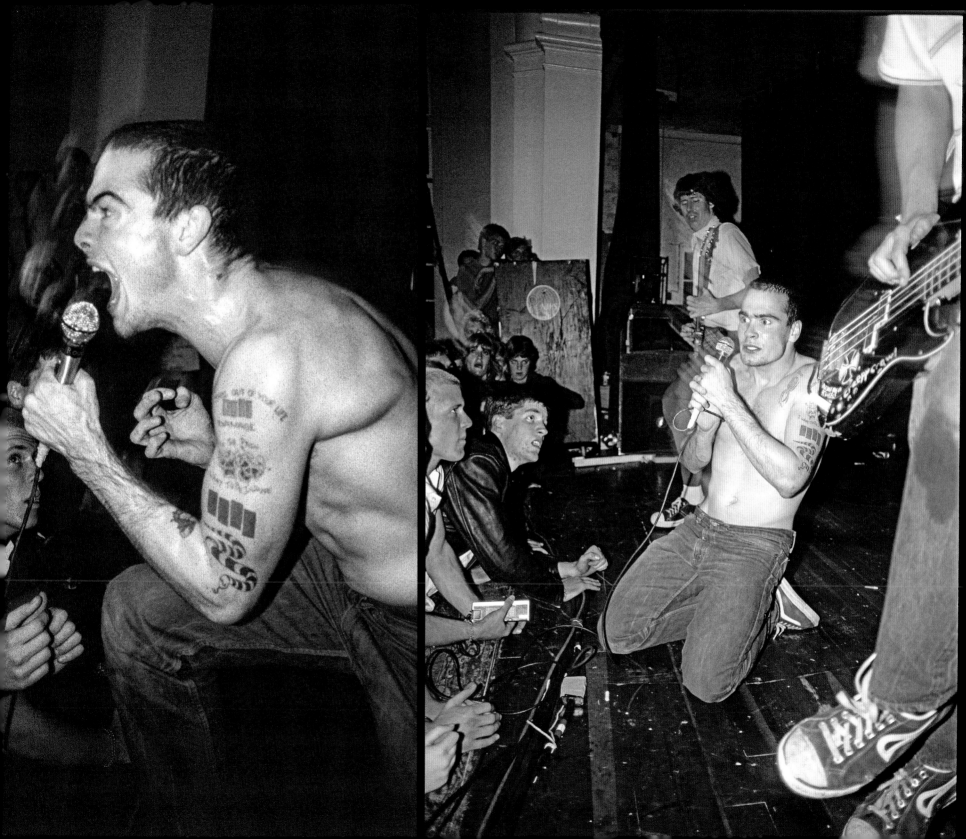

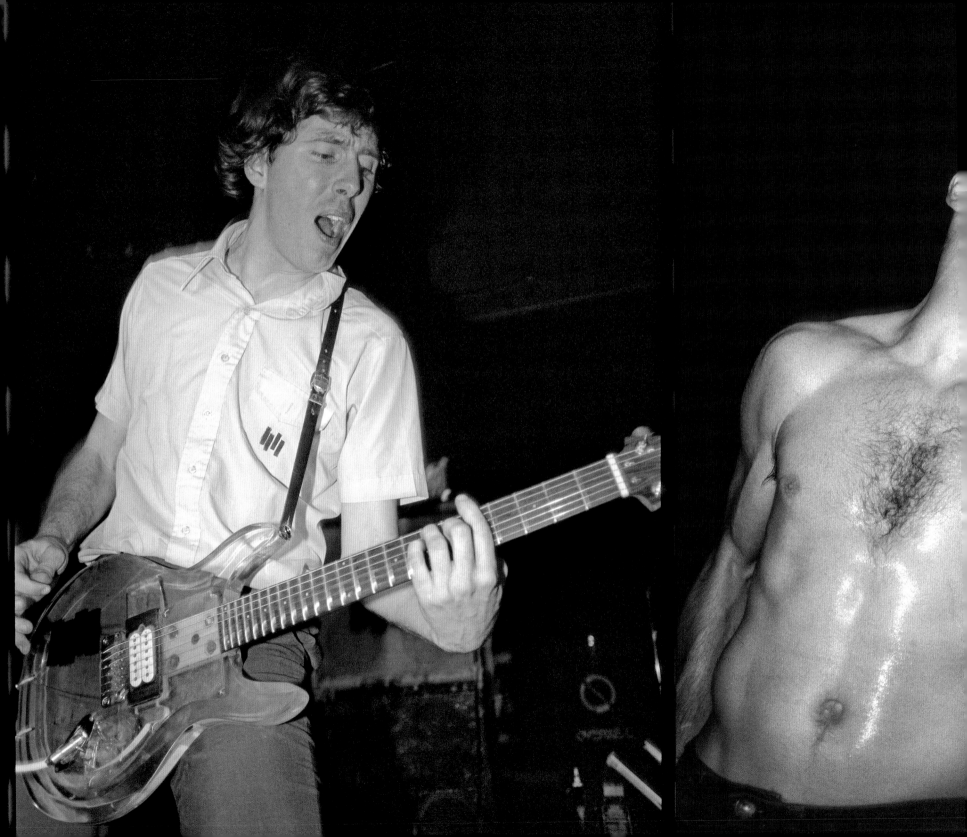

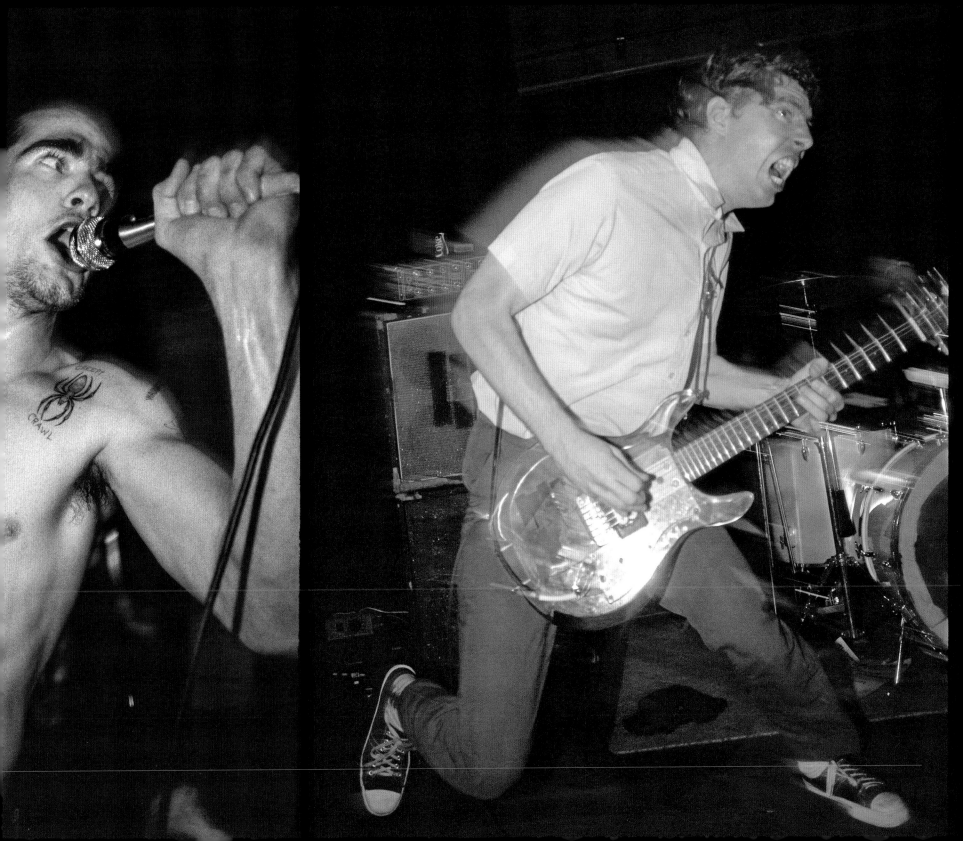

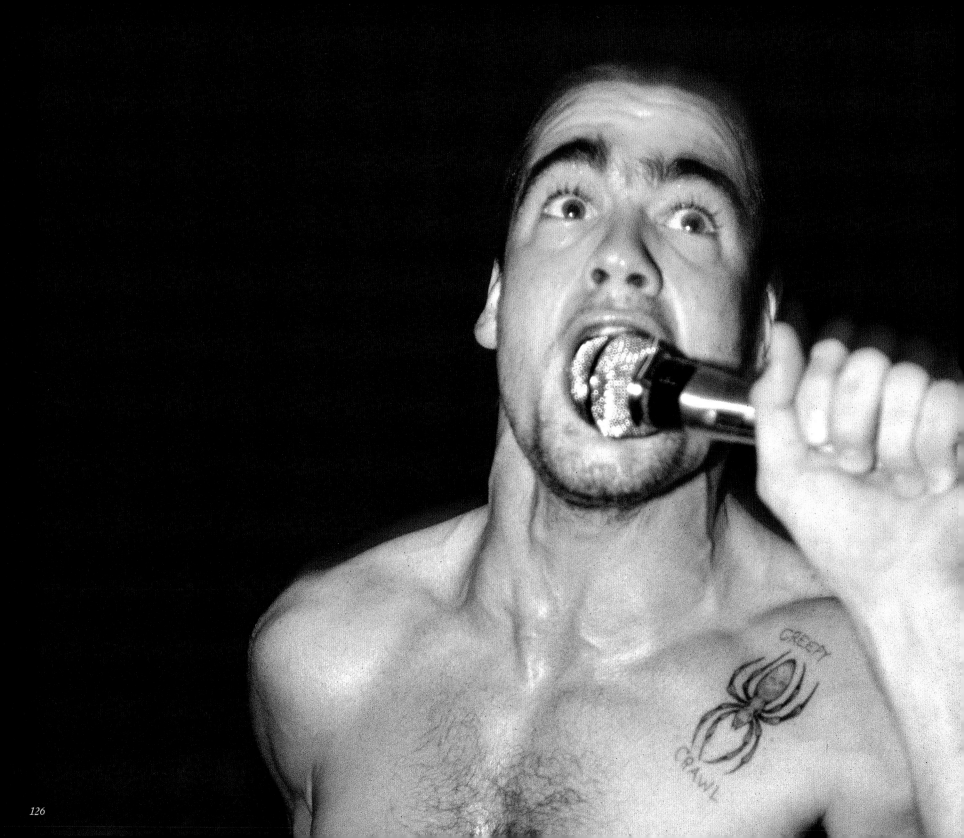

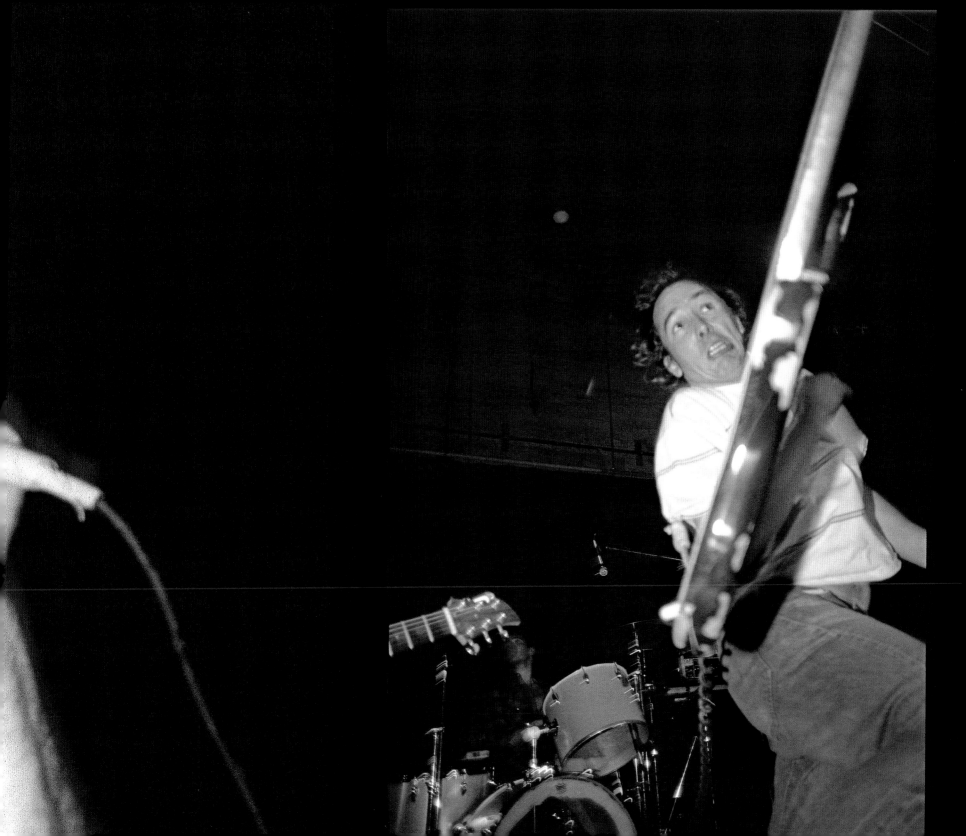

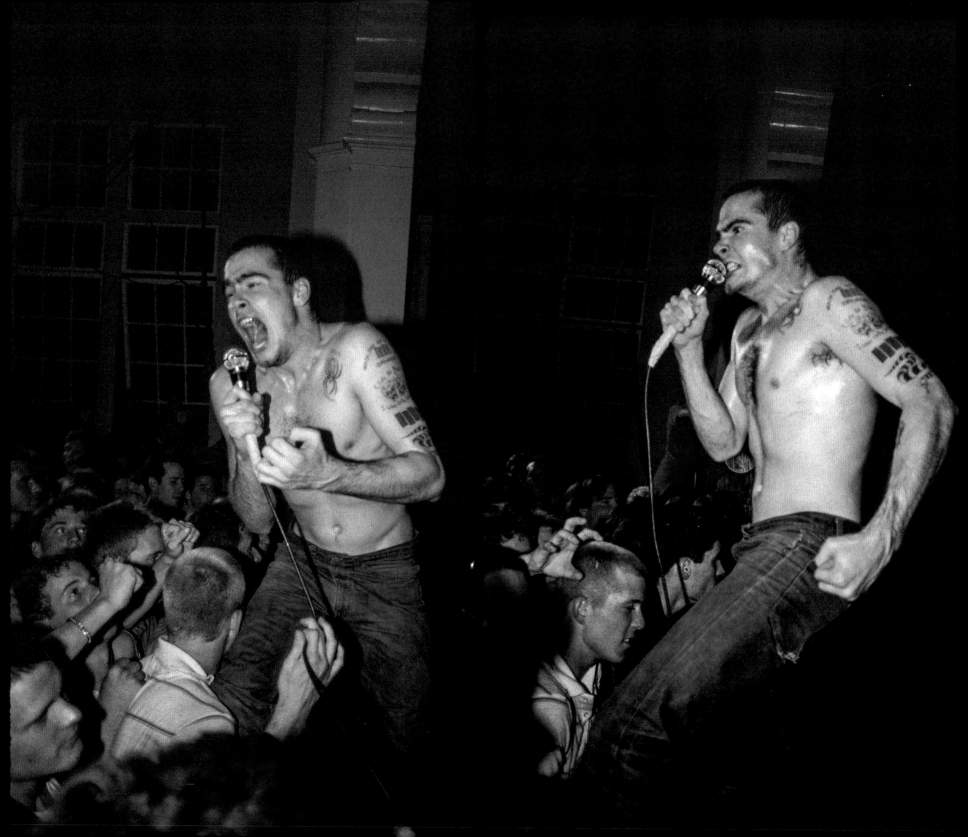

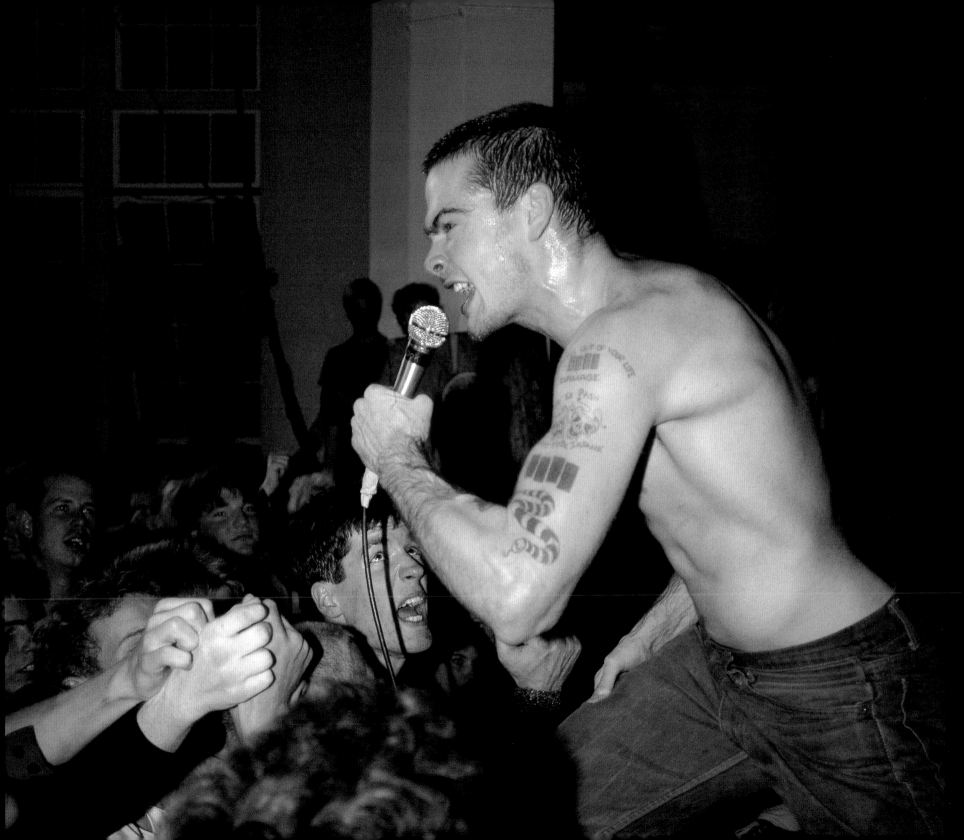

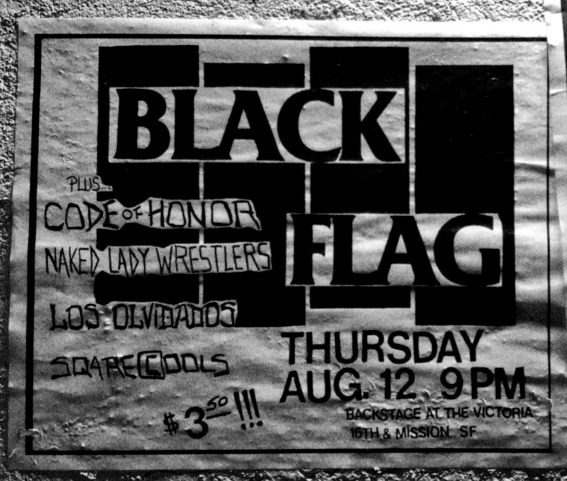

Chuck Biscuits, Dez Cadena, Chuck Dukowski, Greg Ginn, Henry Rollins

Victoria Theatre, San Francisco, August 12, 1982

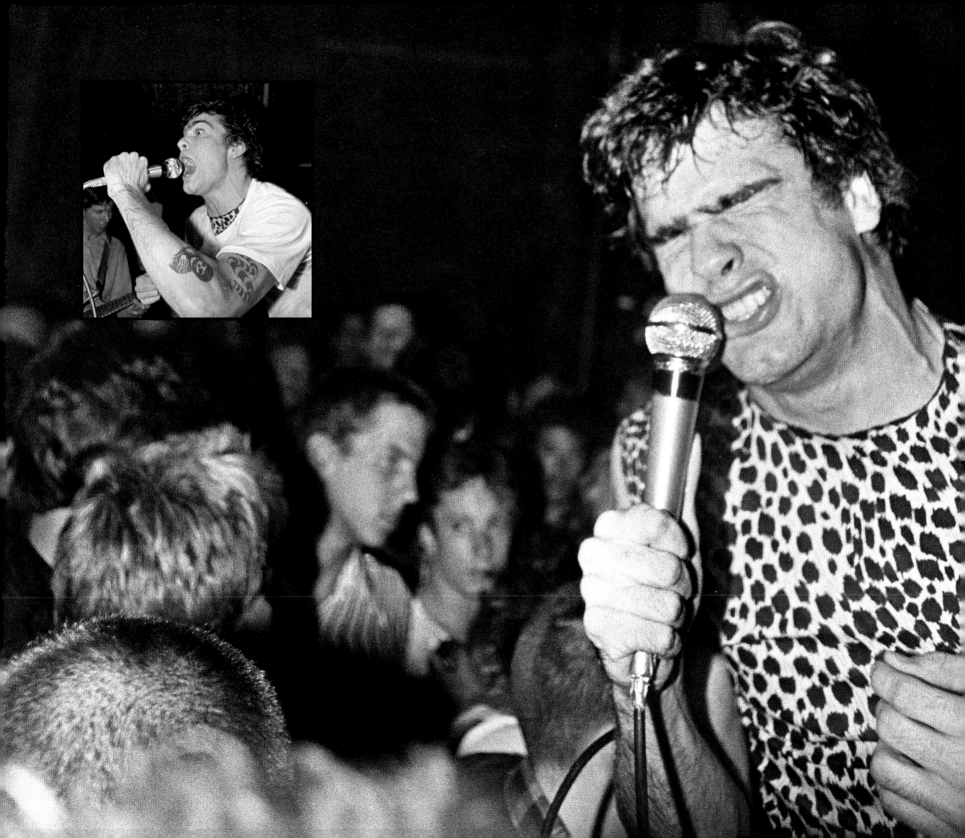

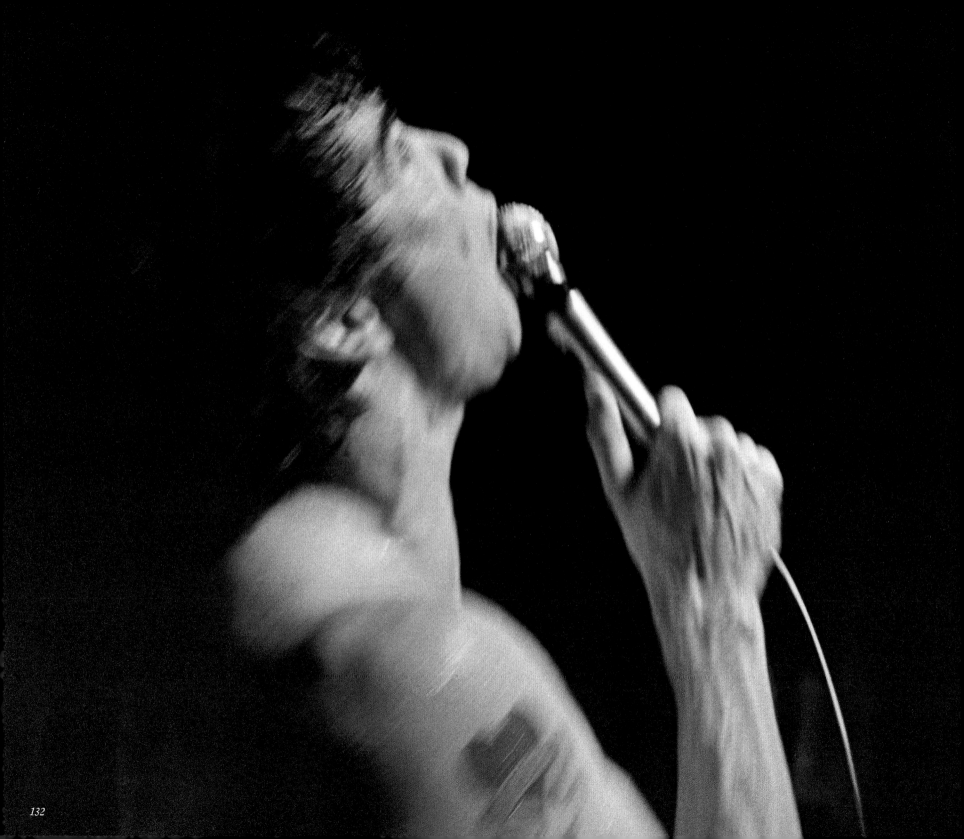

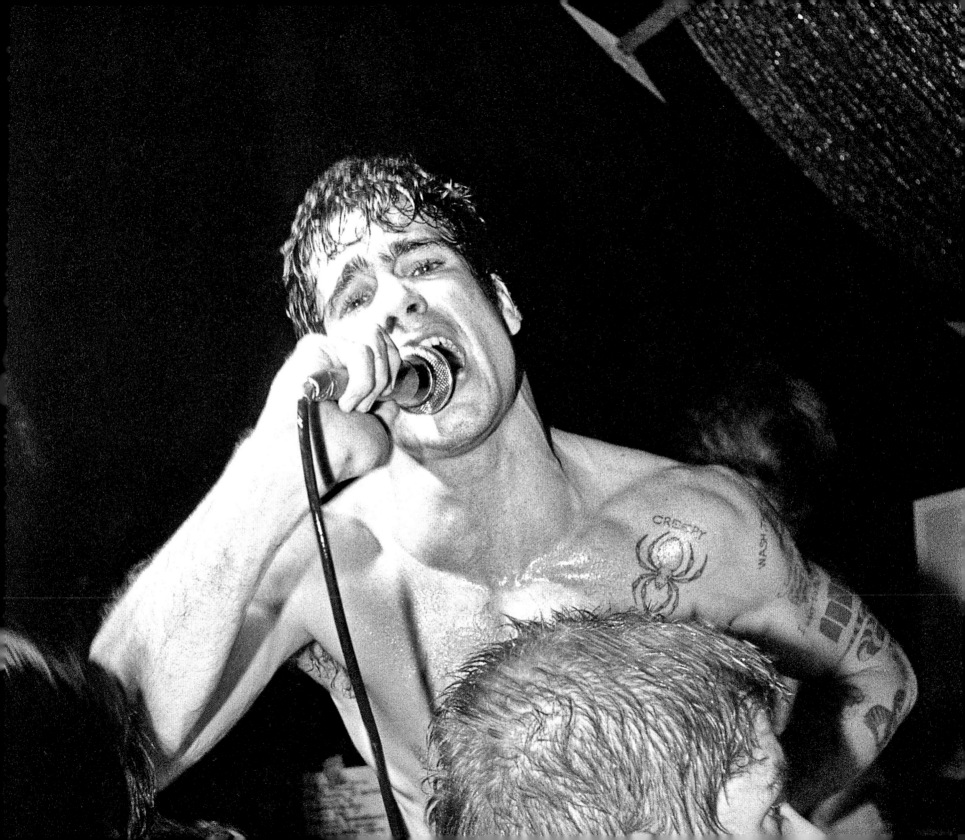

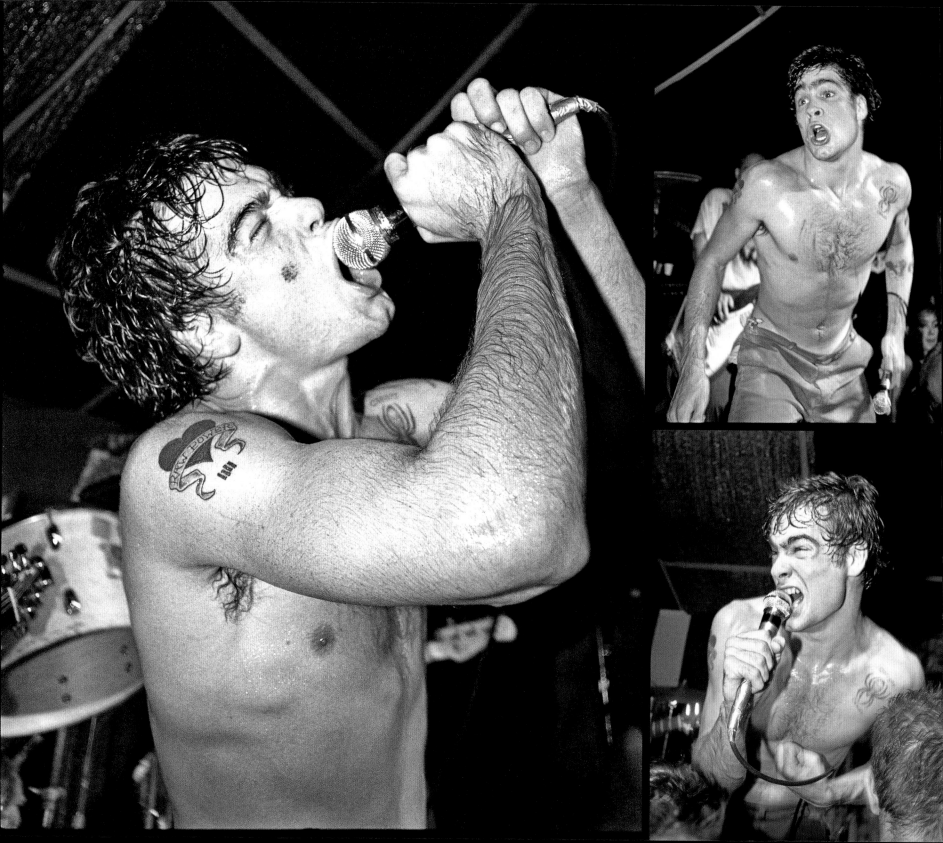

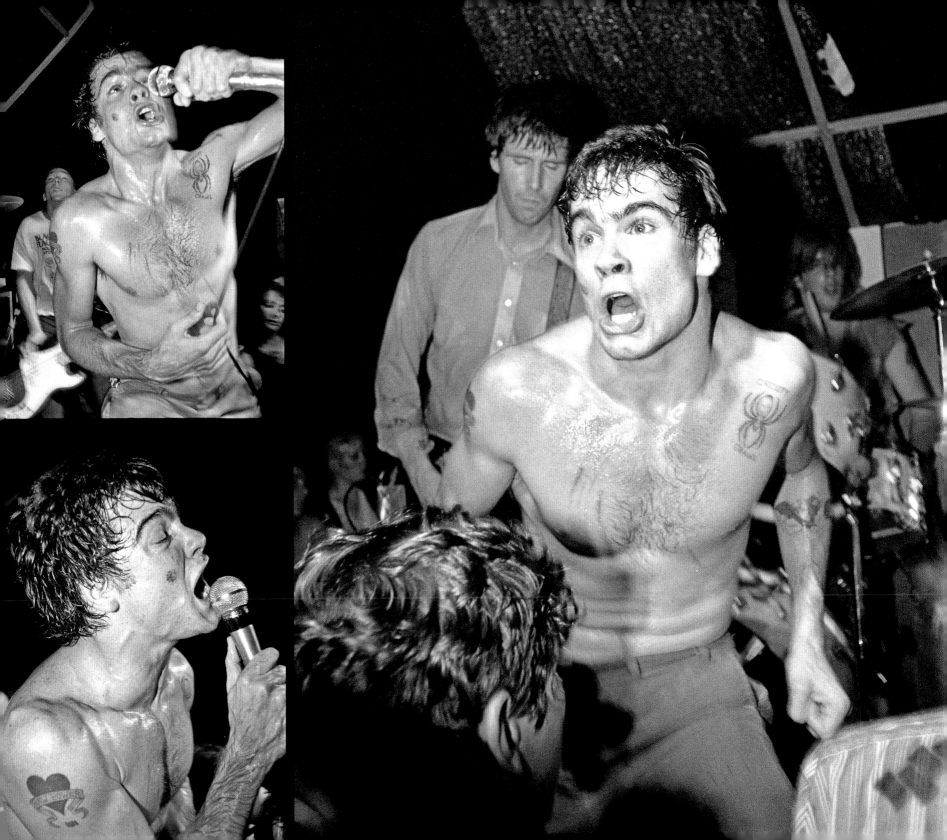

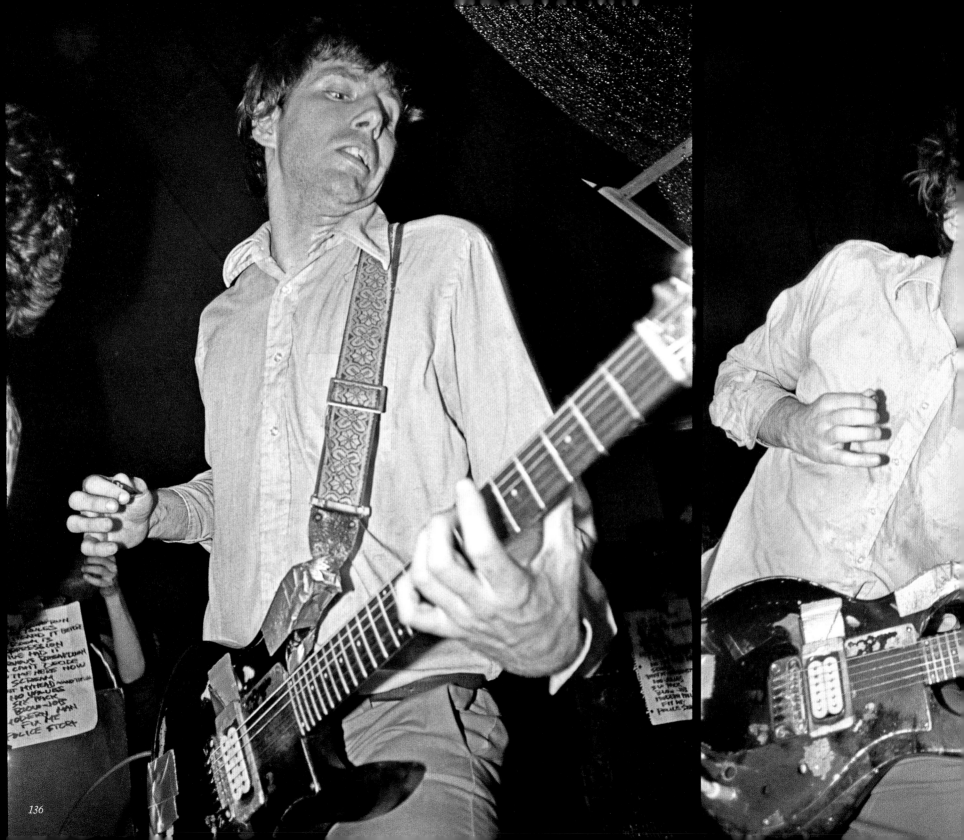

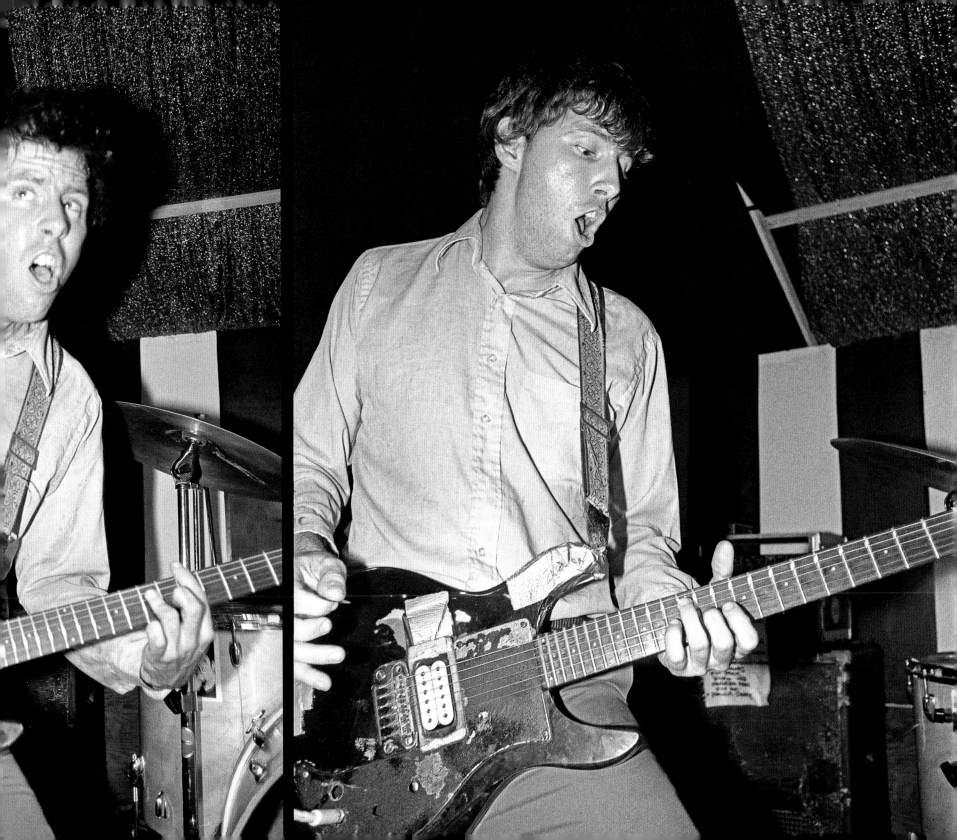

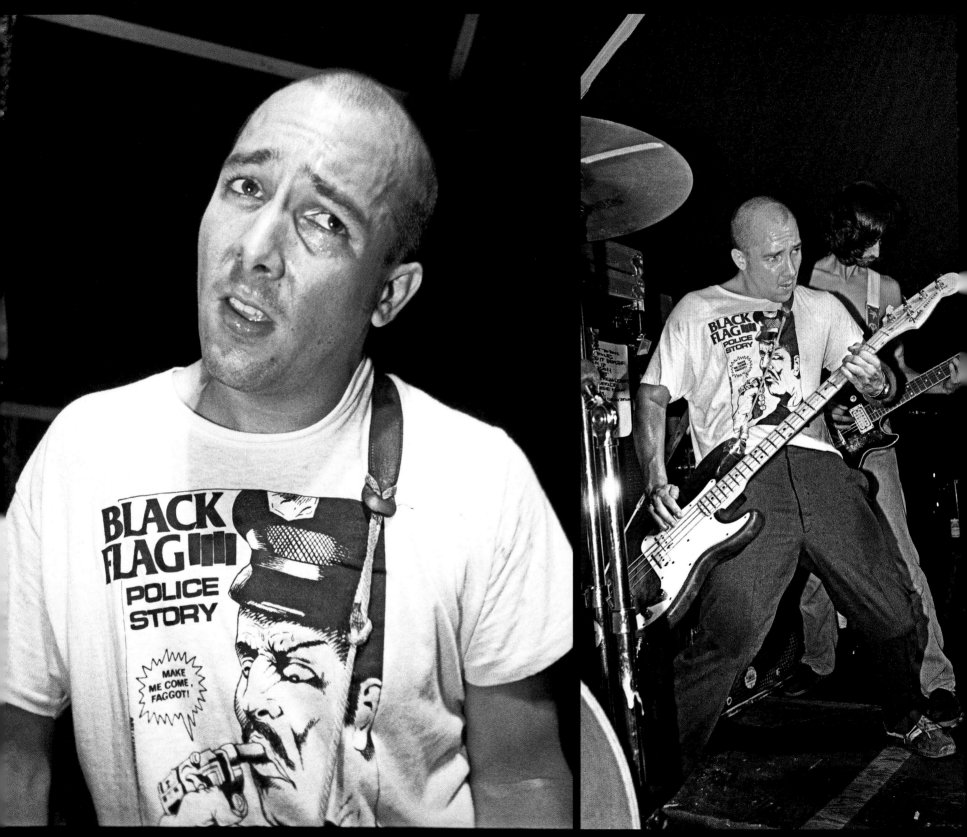

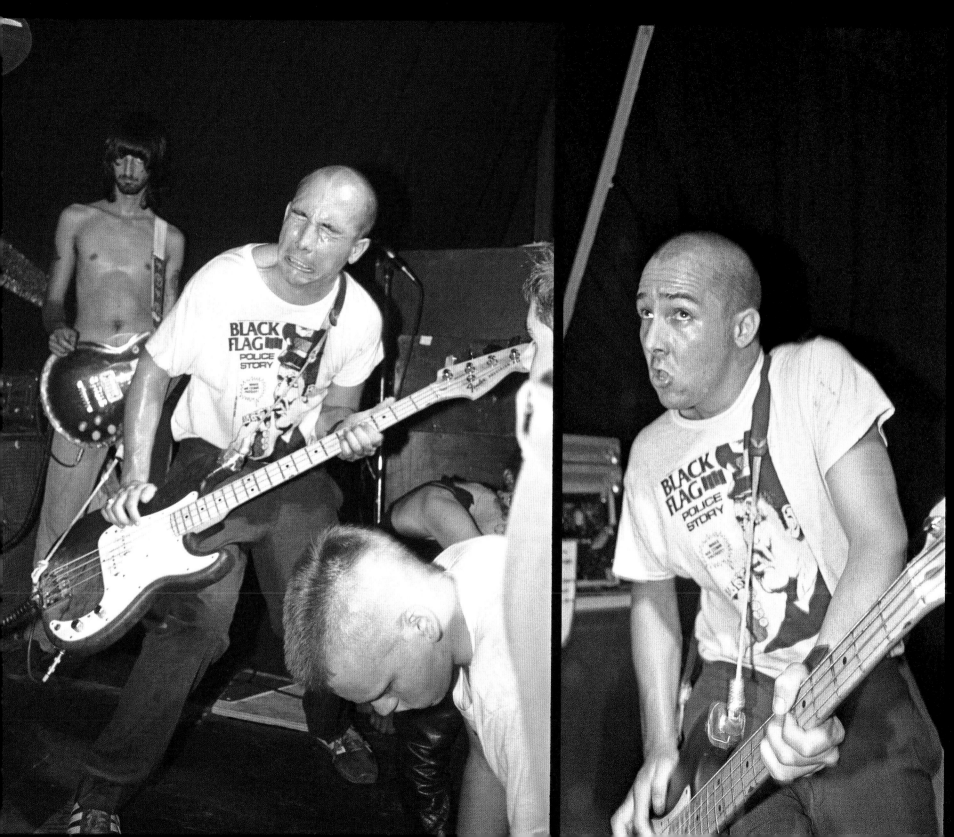

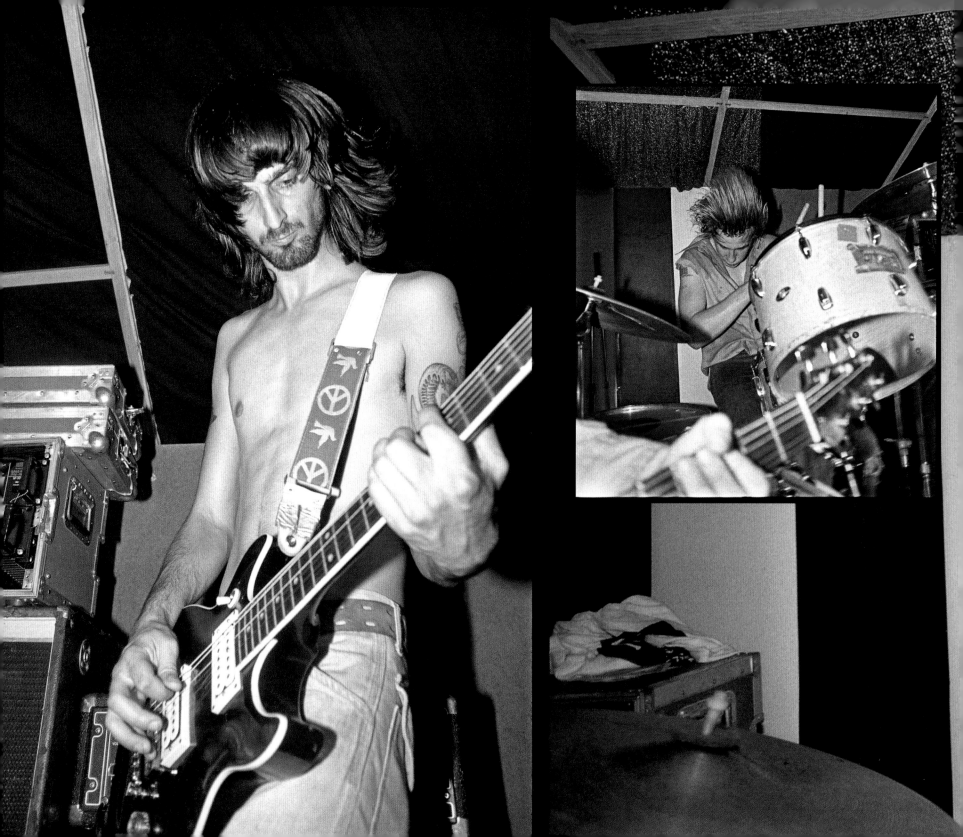

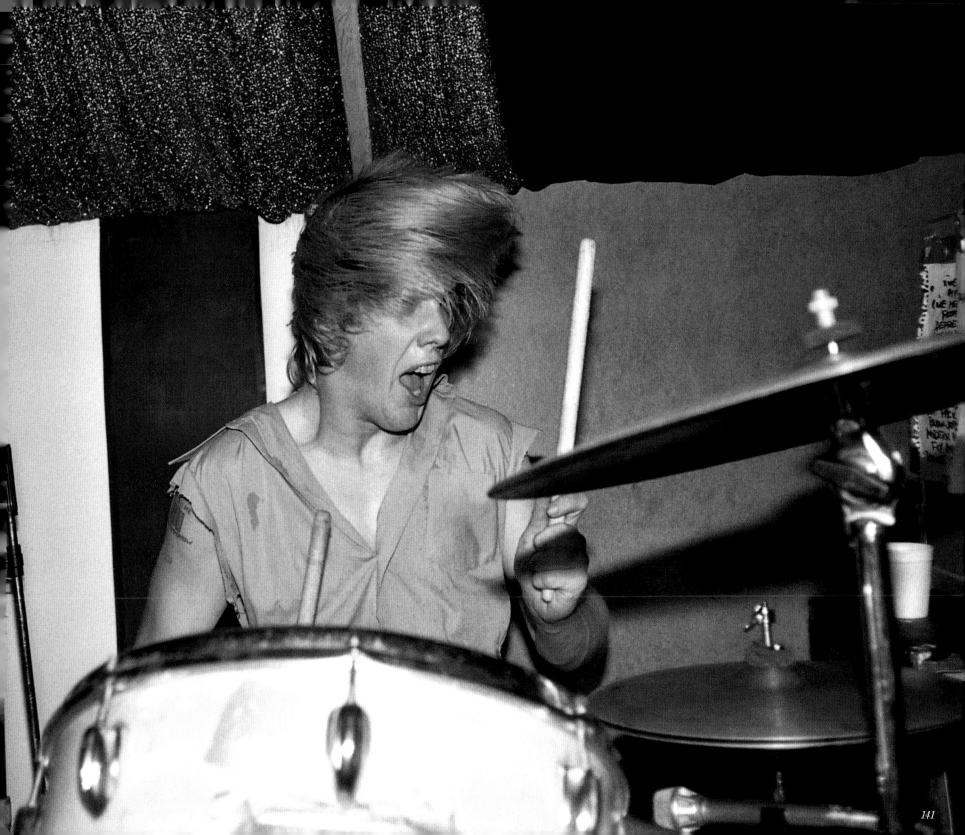

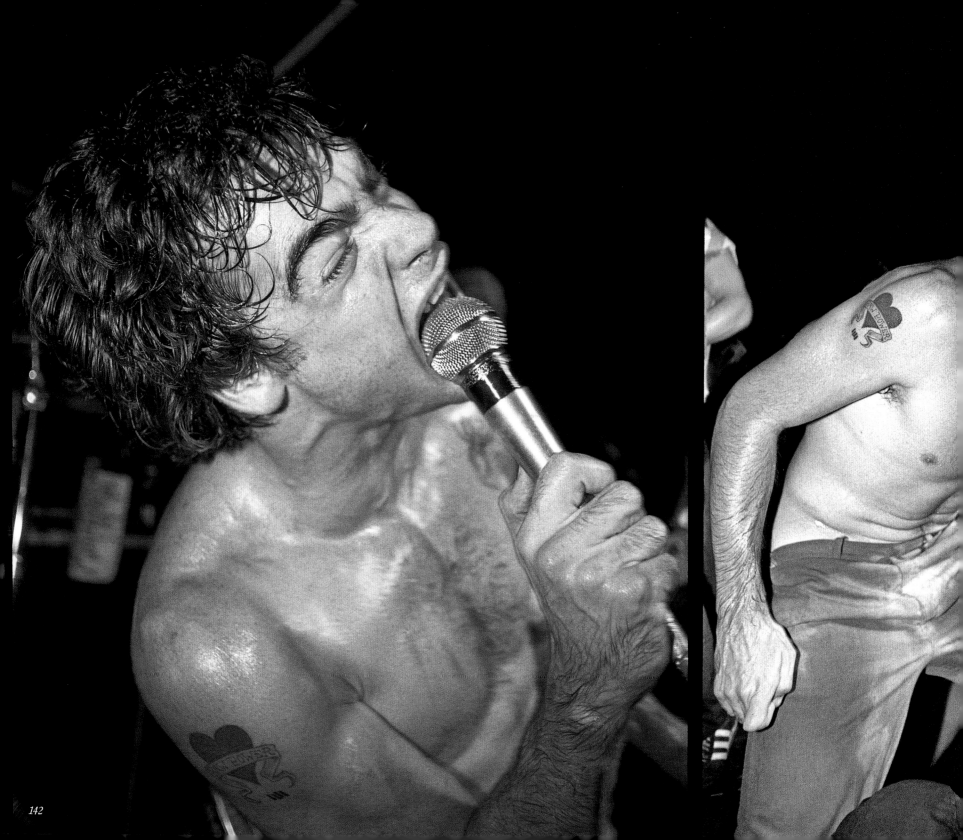

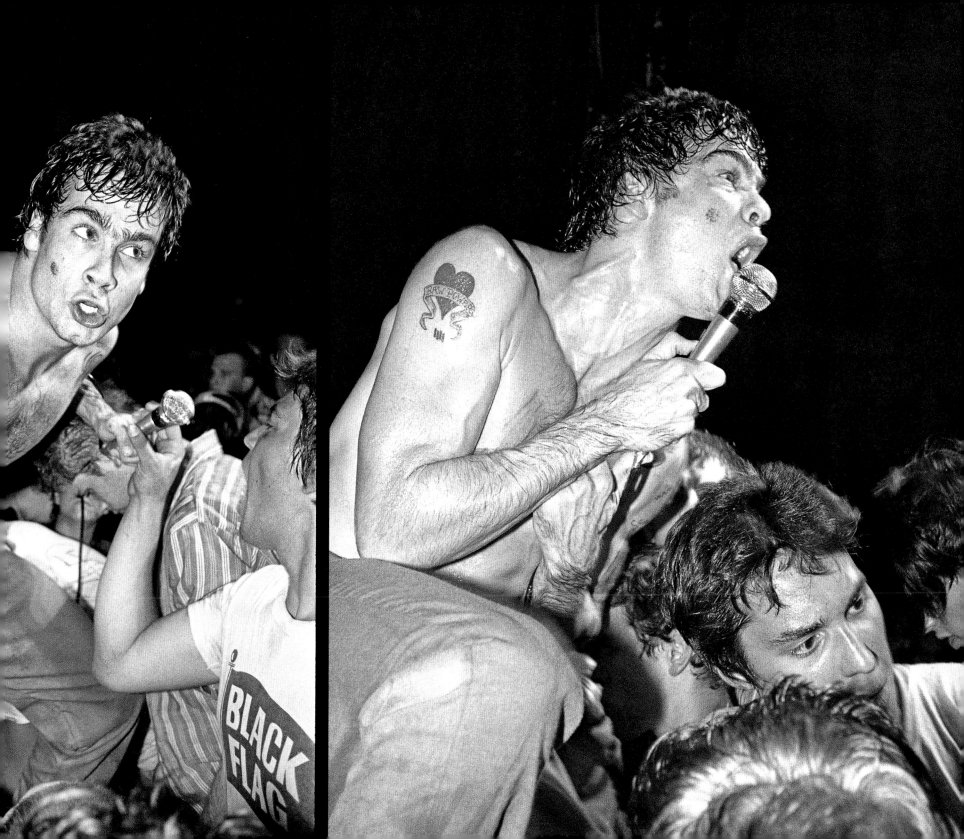

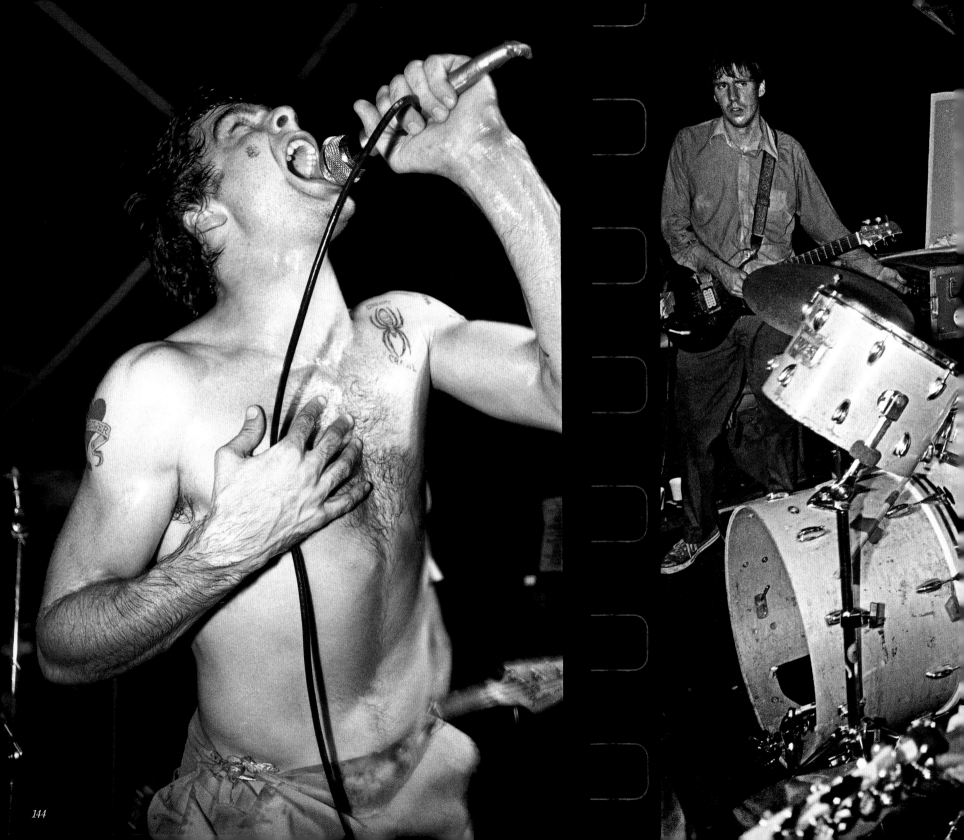

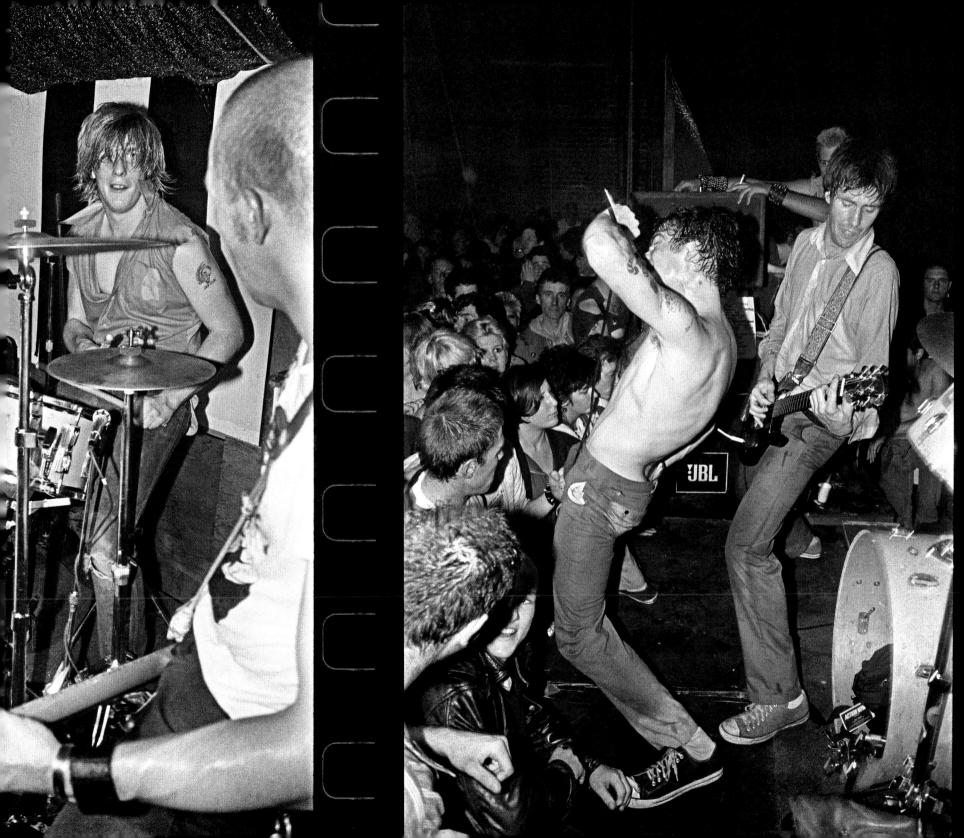

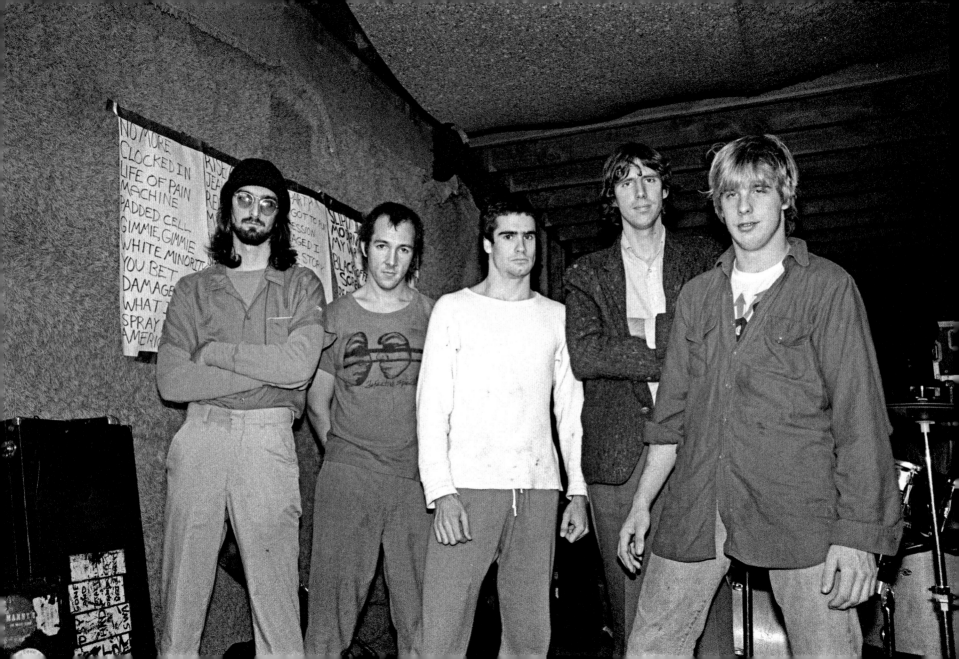

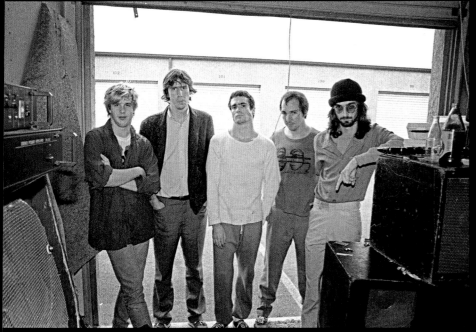
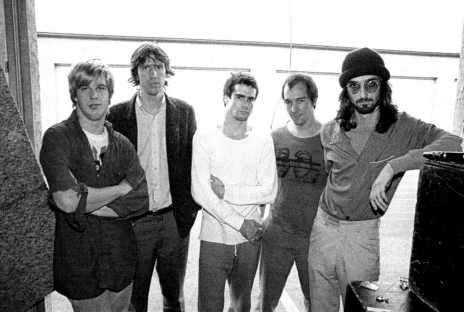
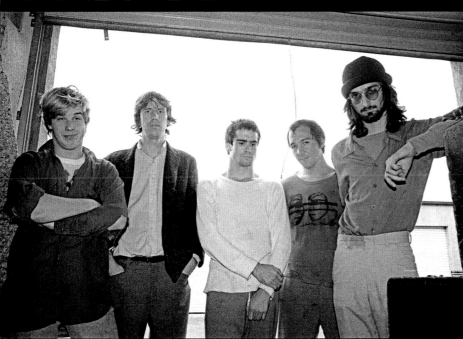
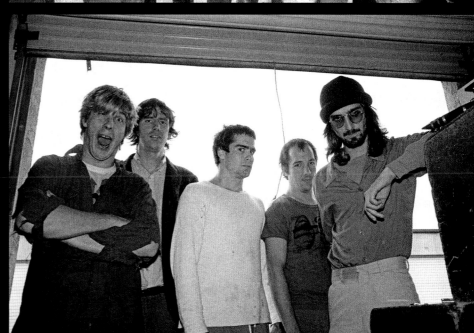

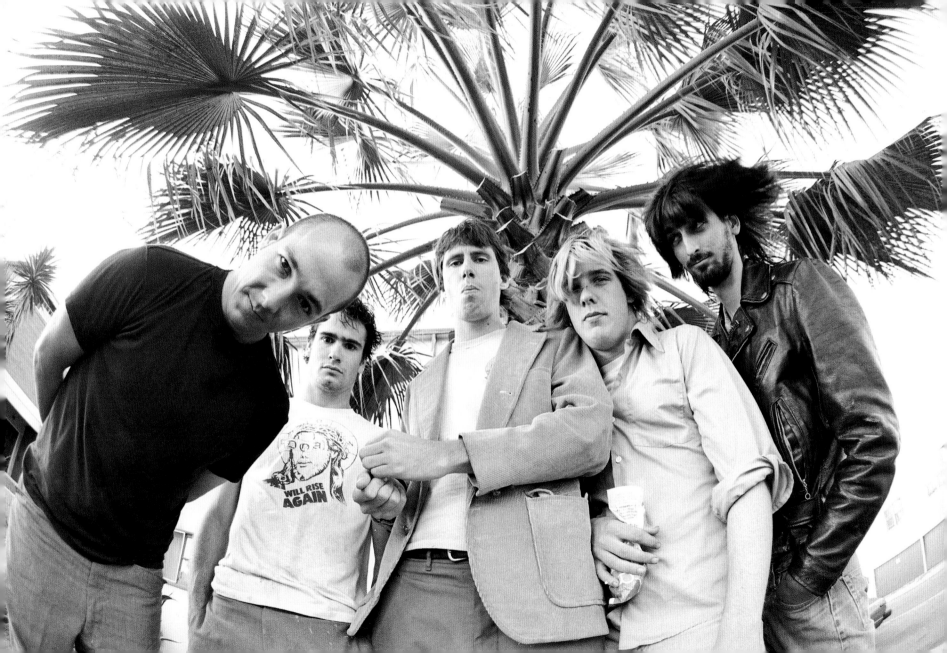

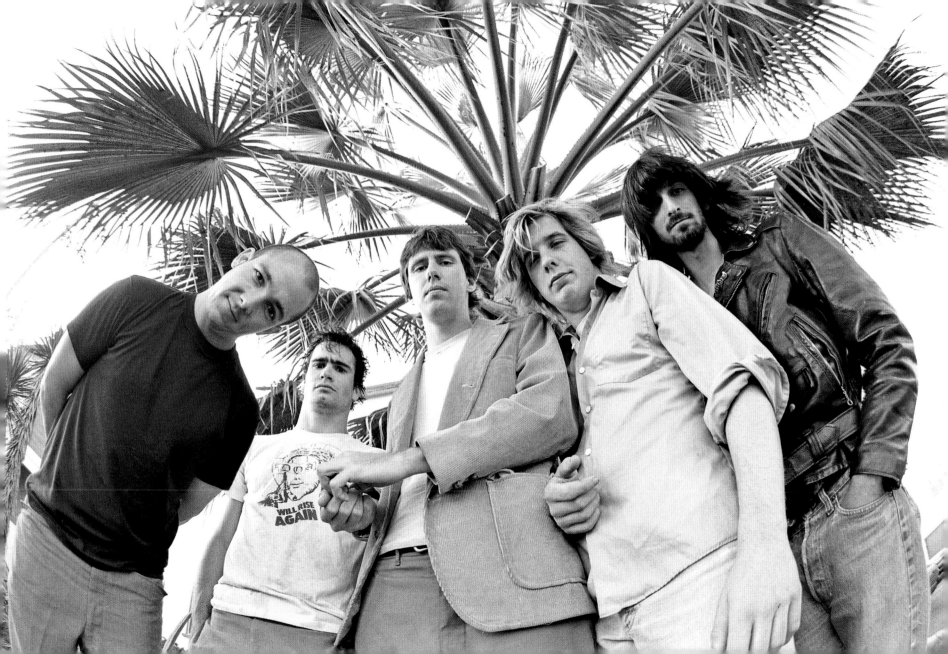

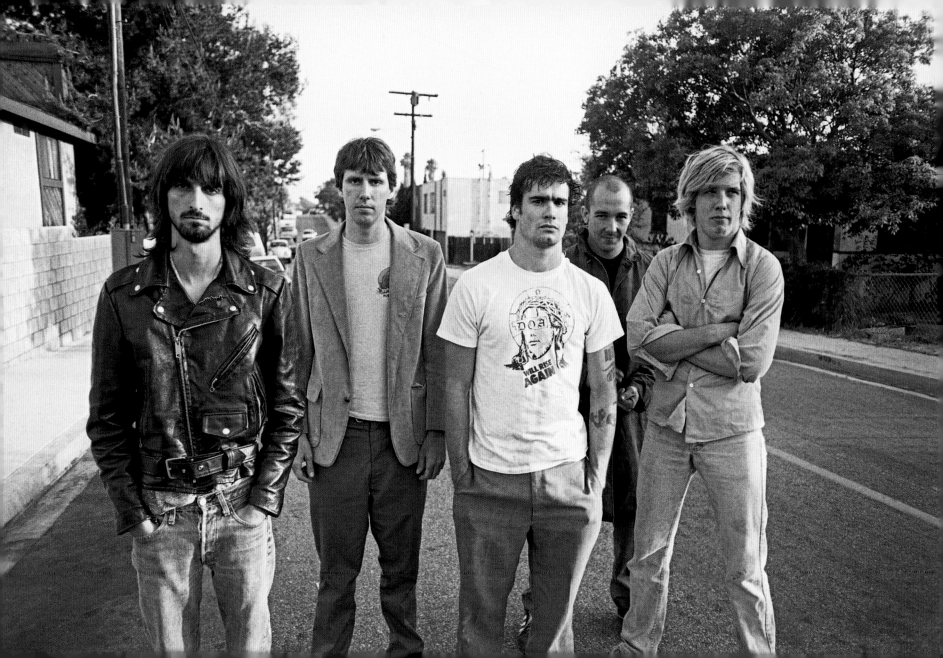

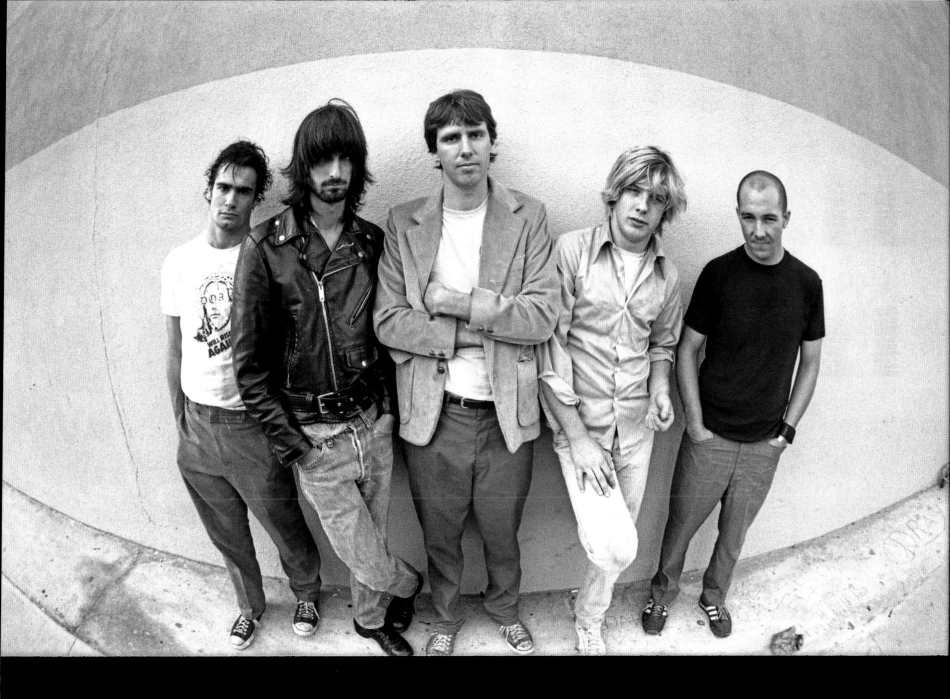

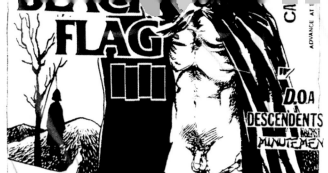

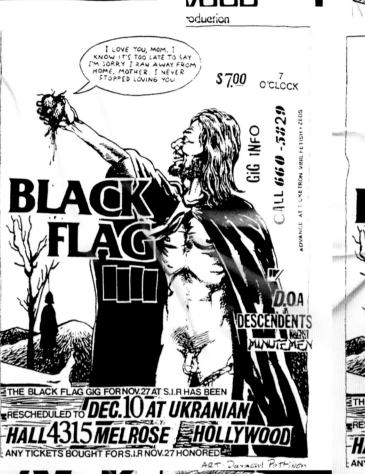

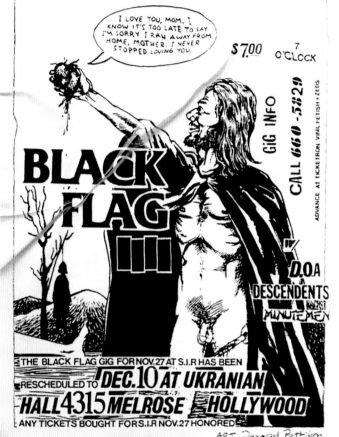

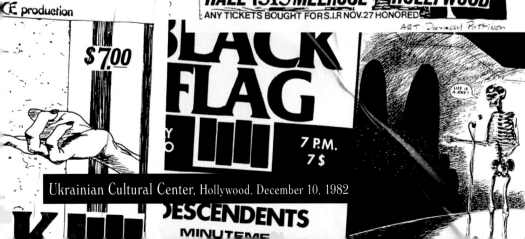

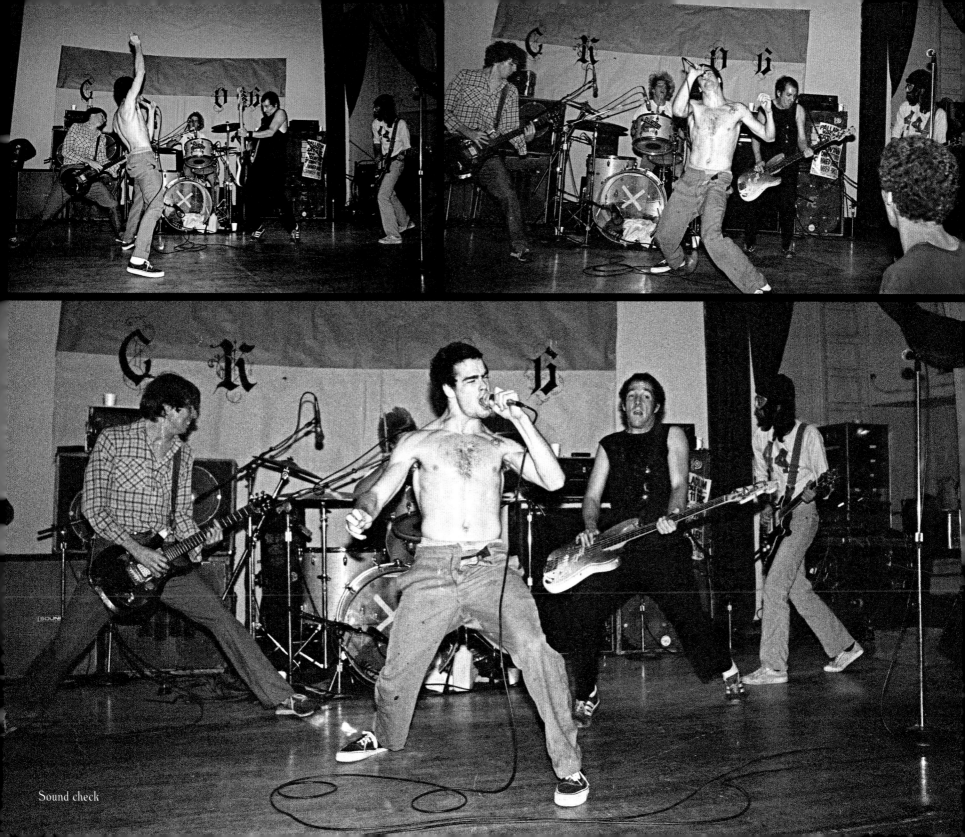

Sound check

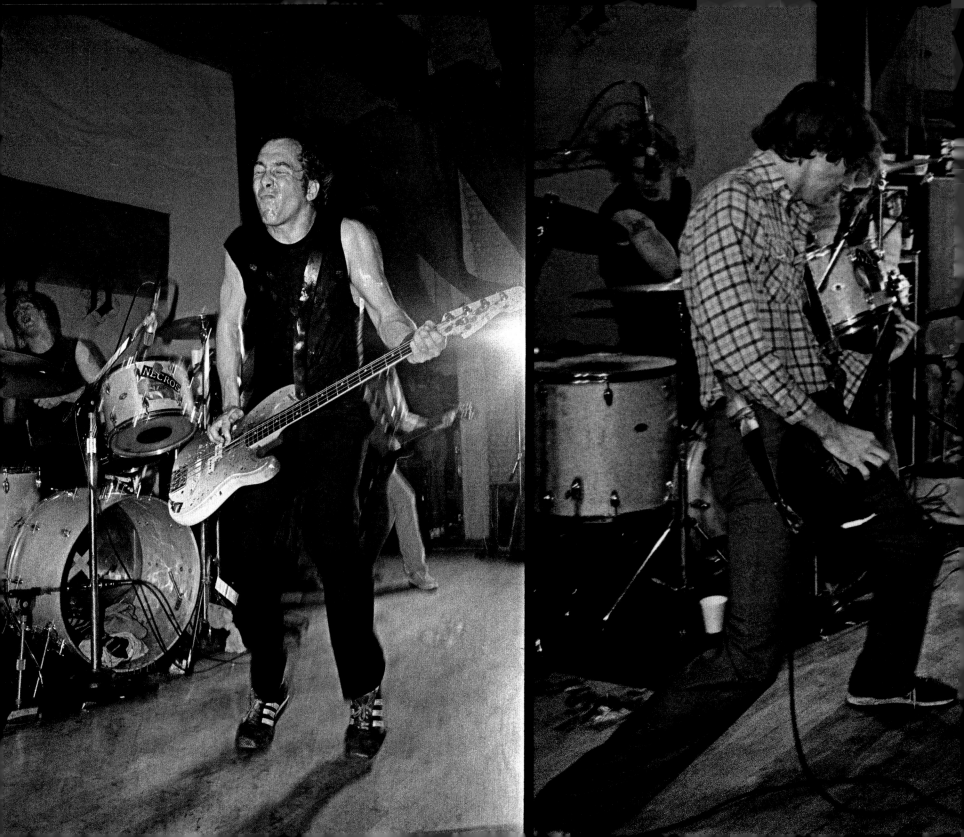

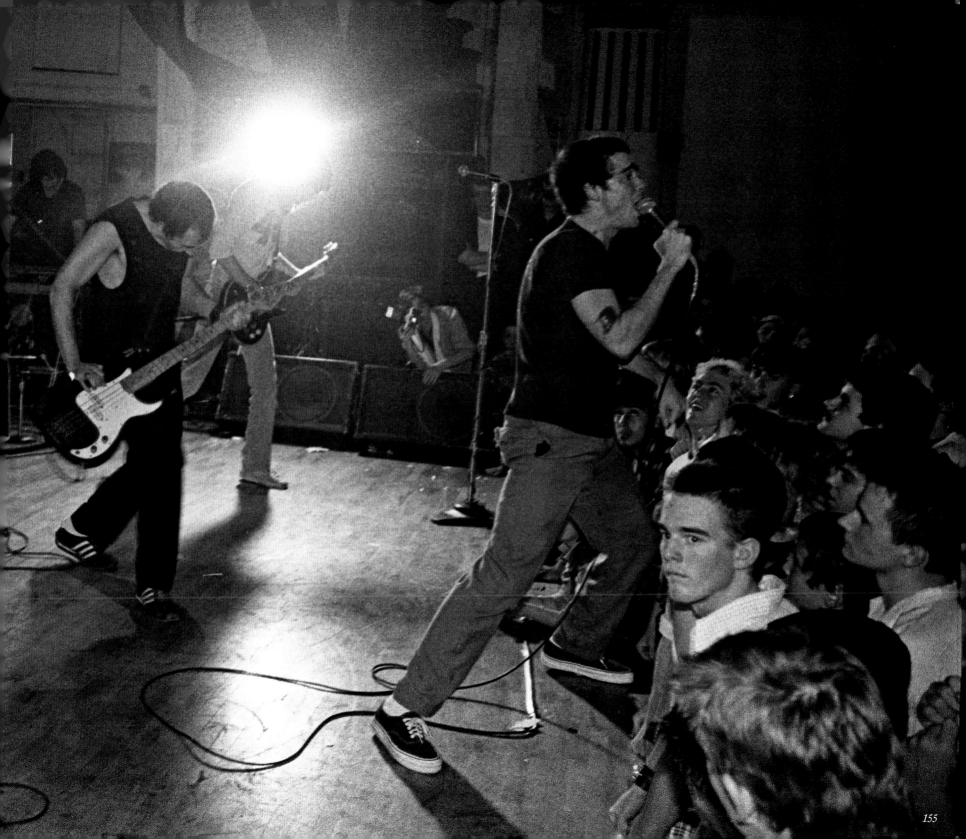

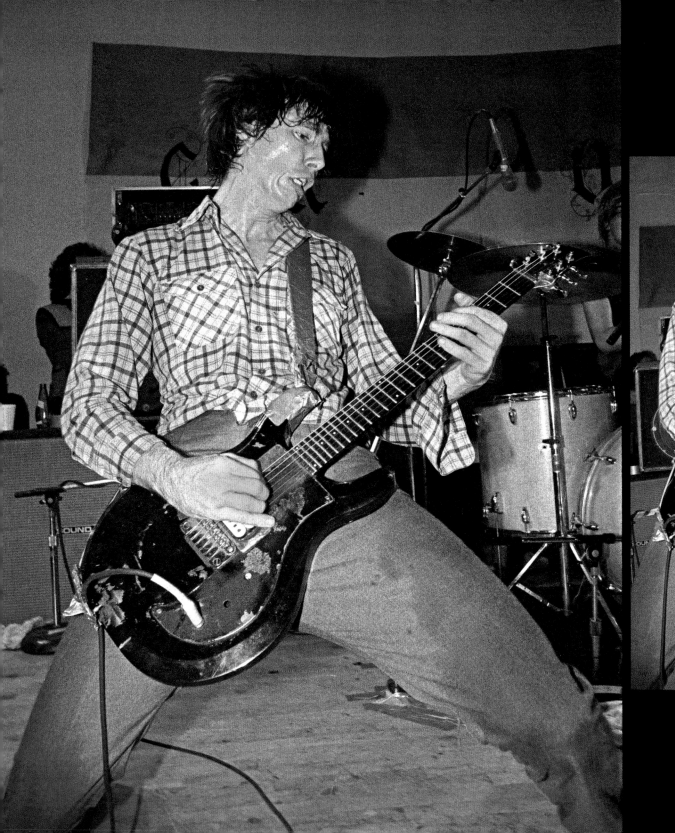
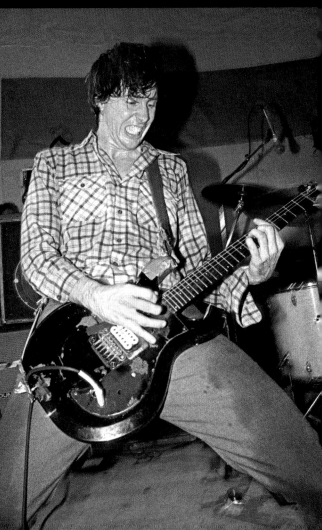

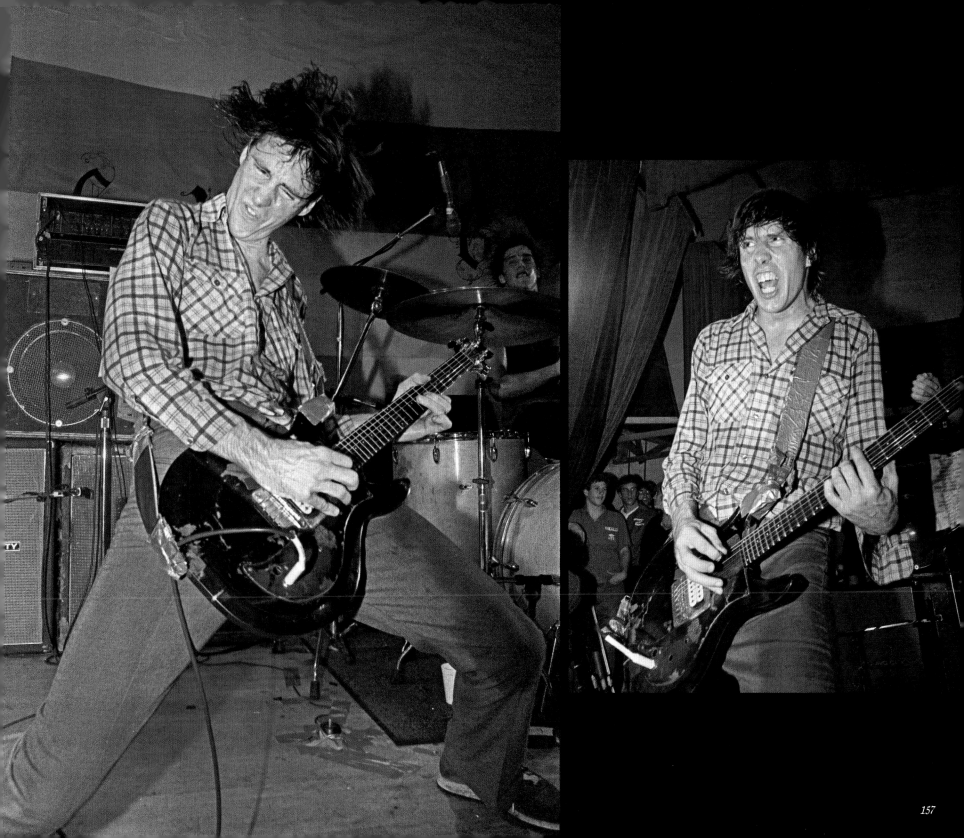

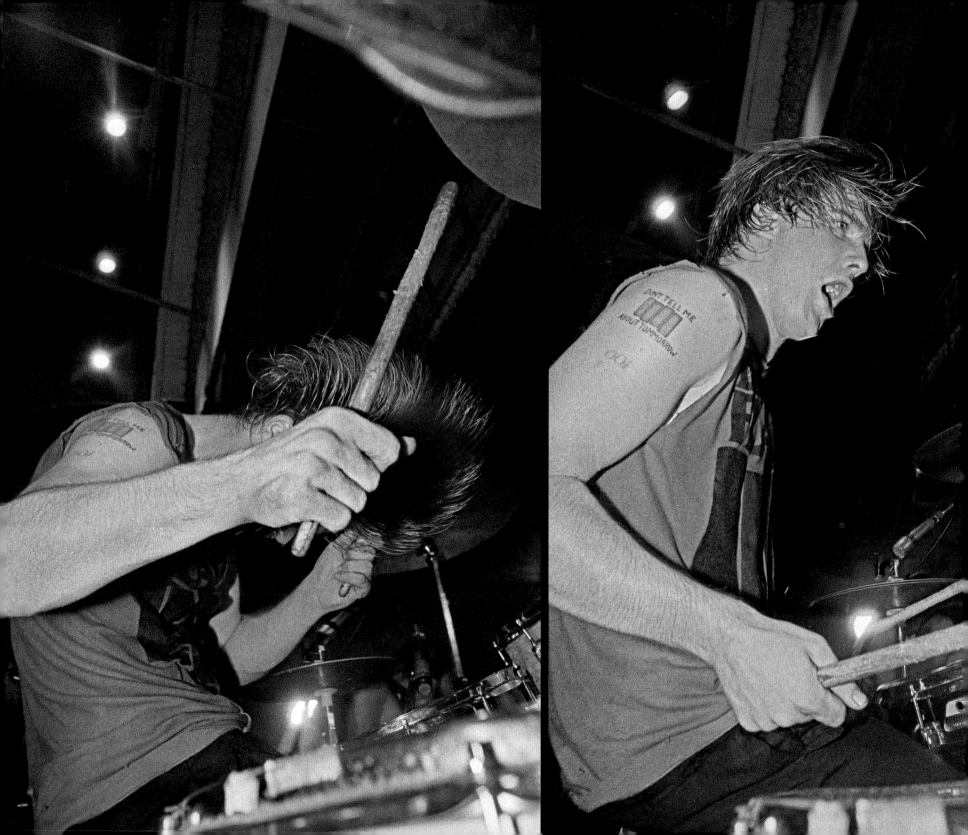

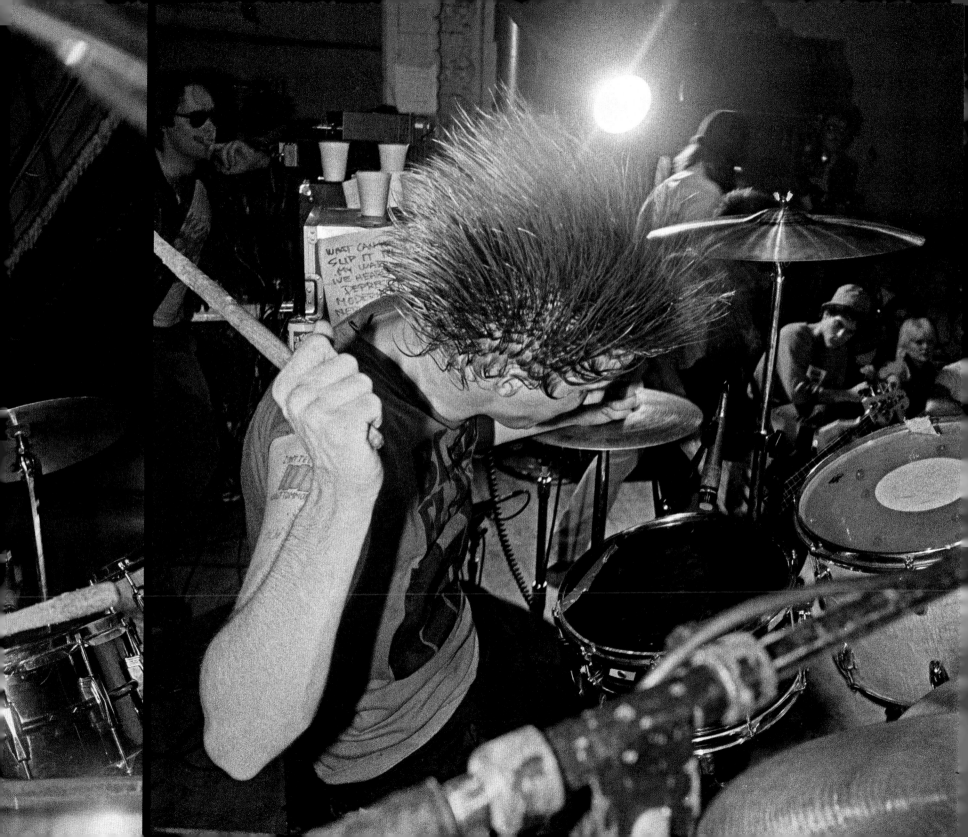

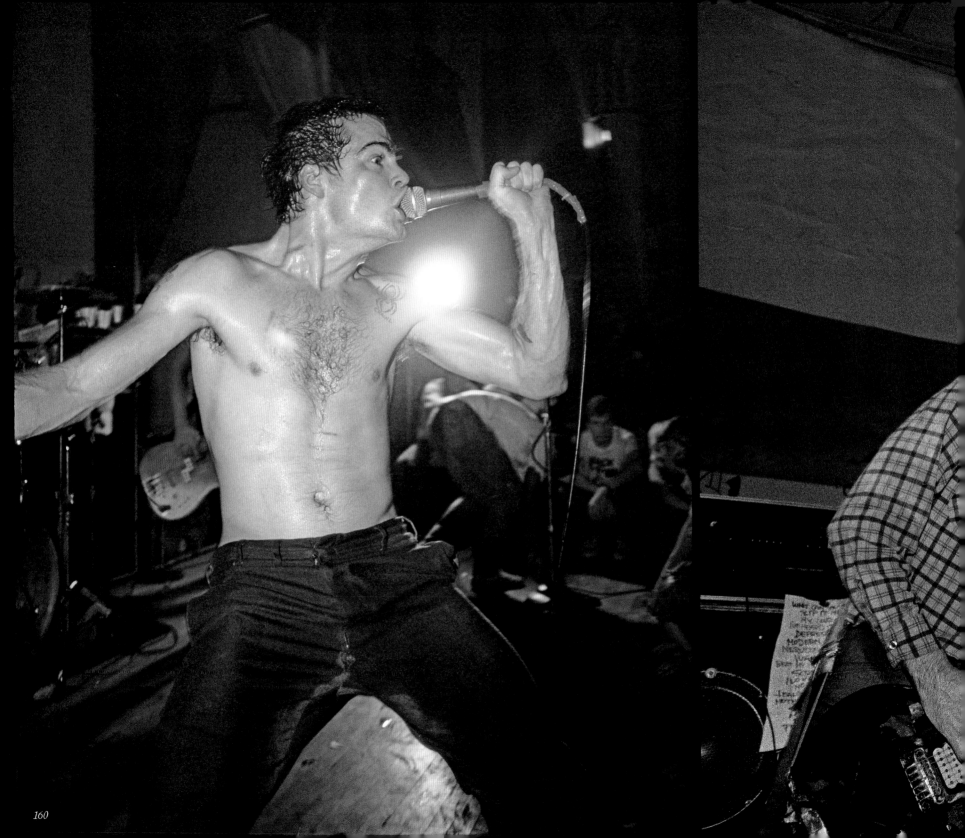

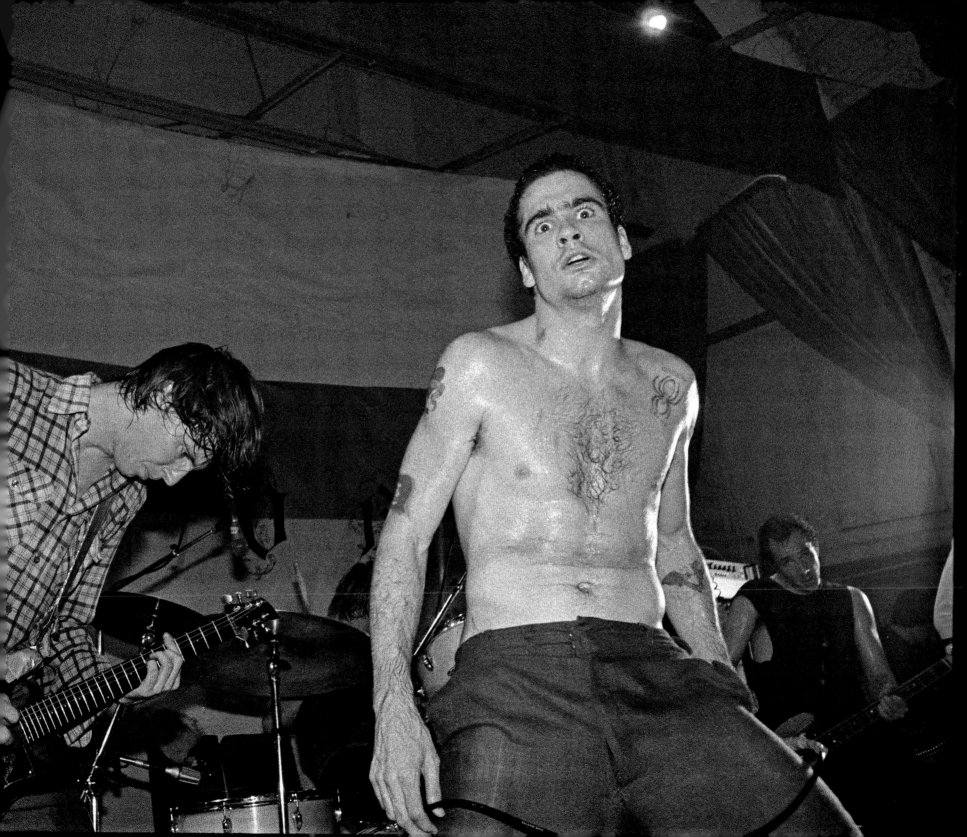

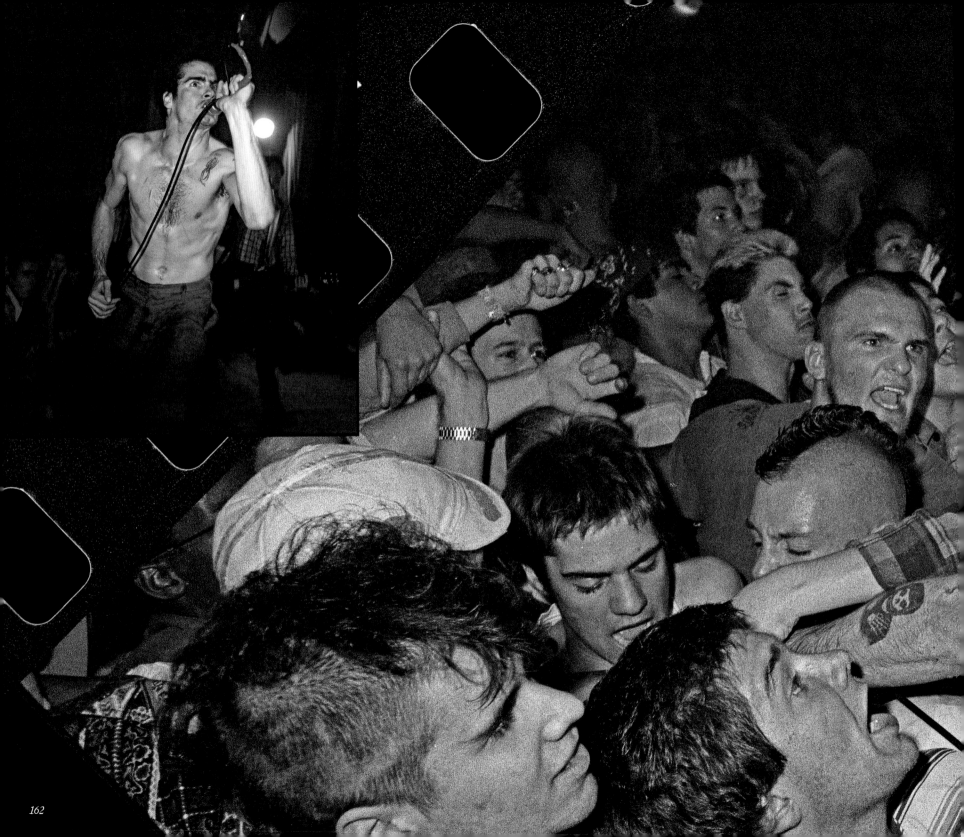

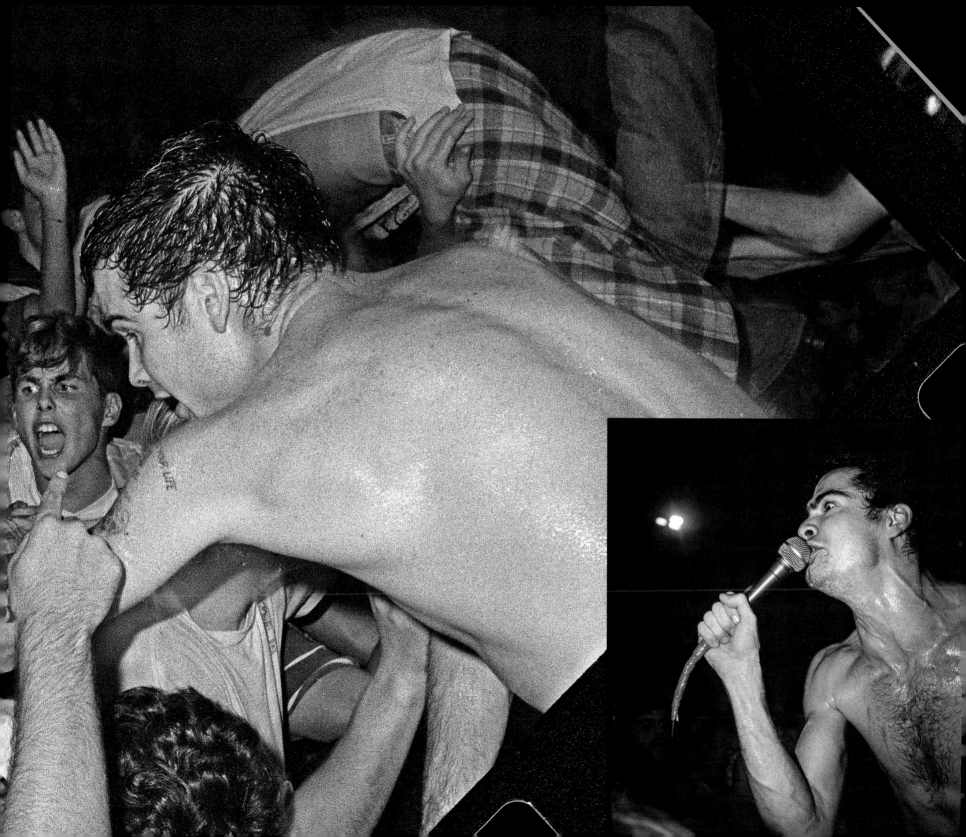

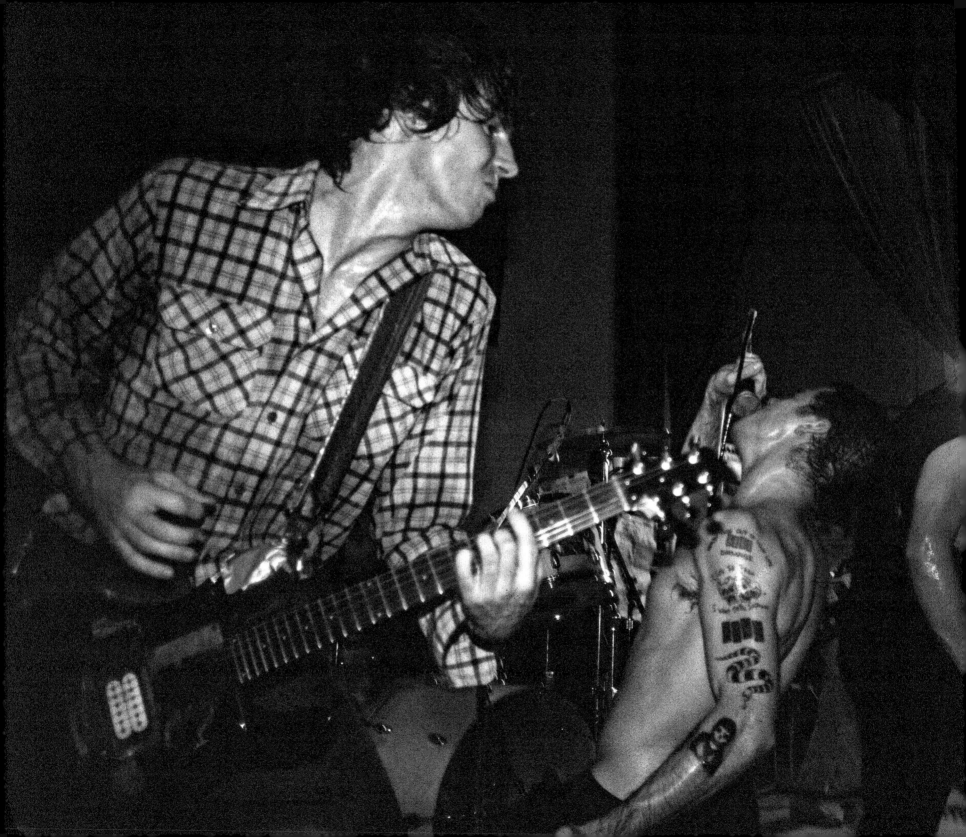

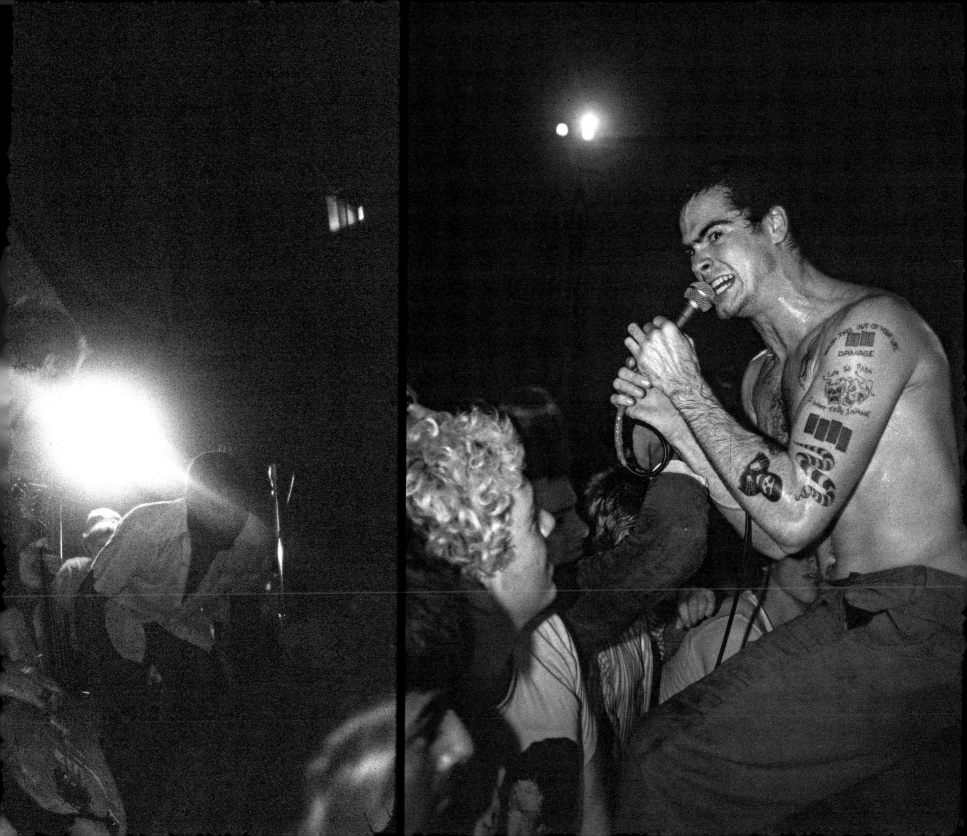

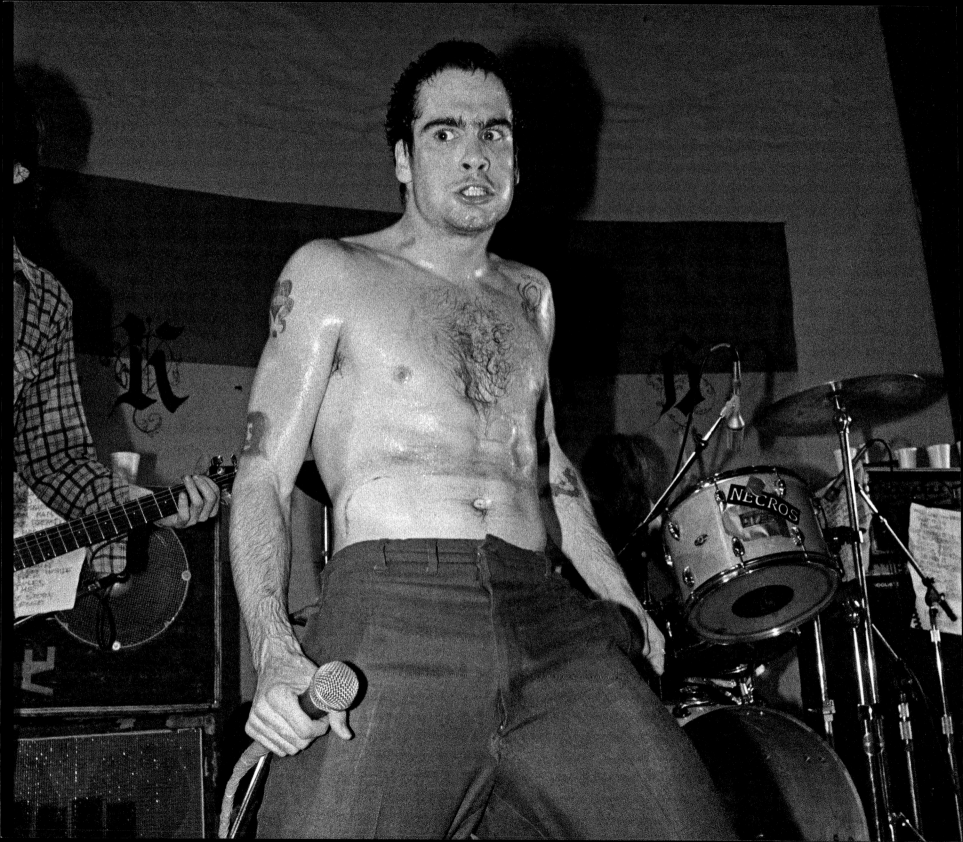

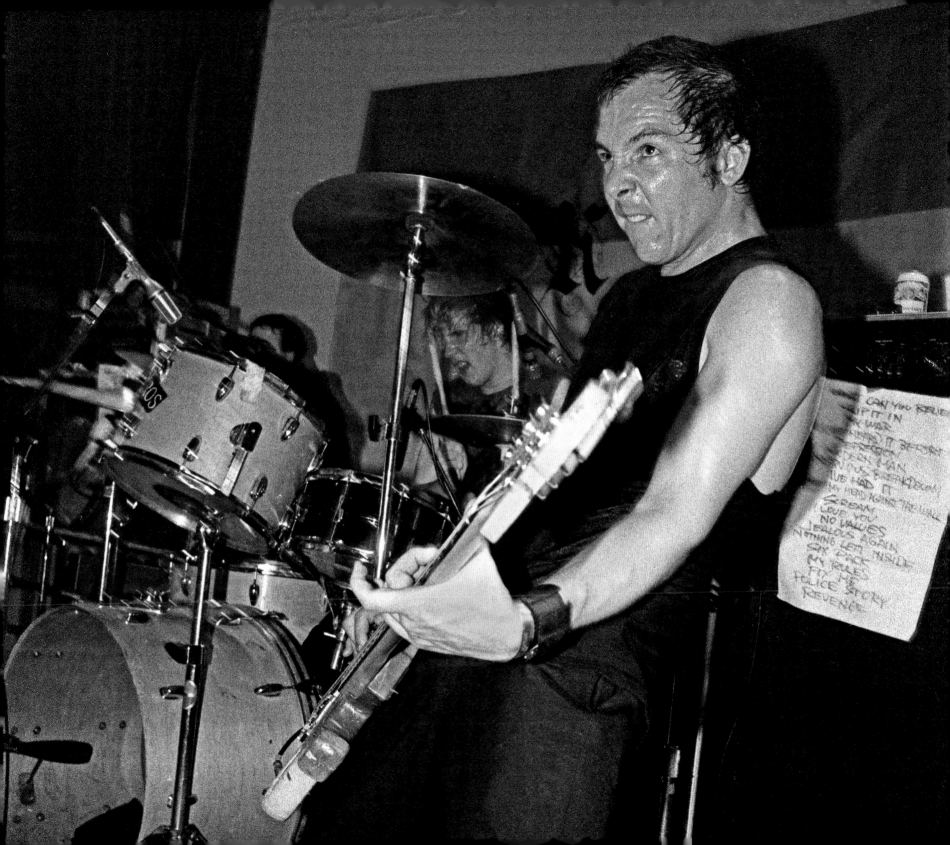

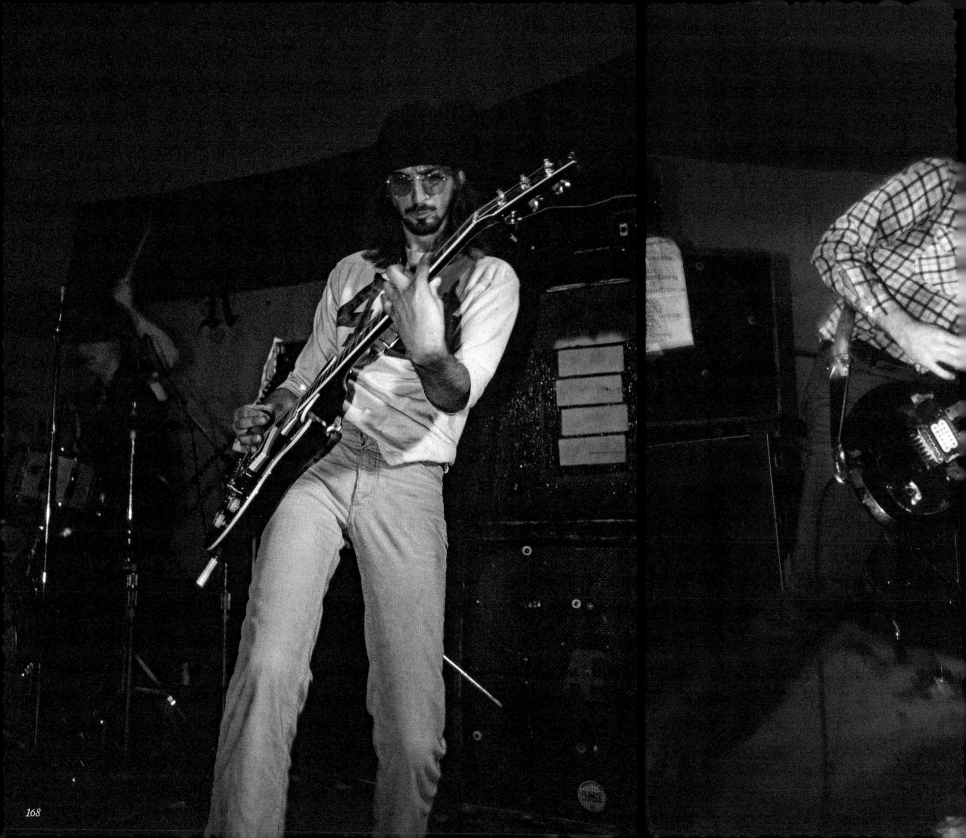

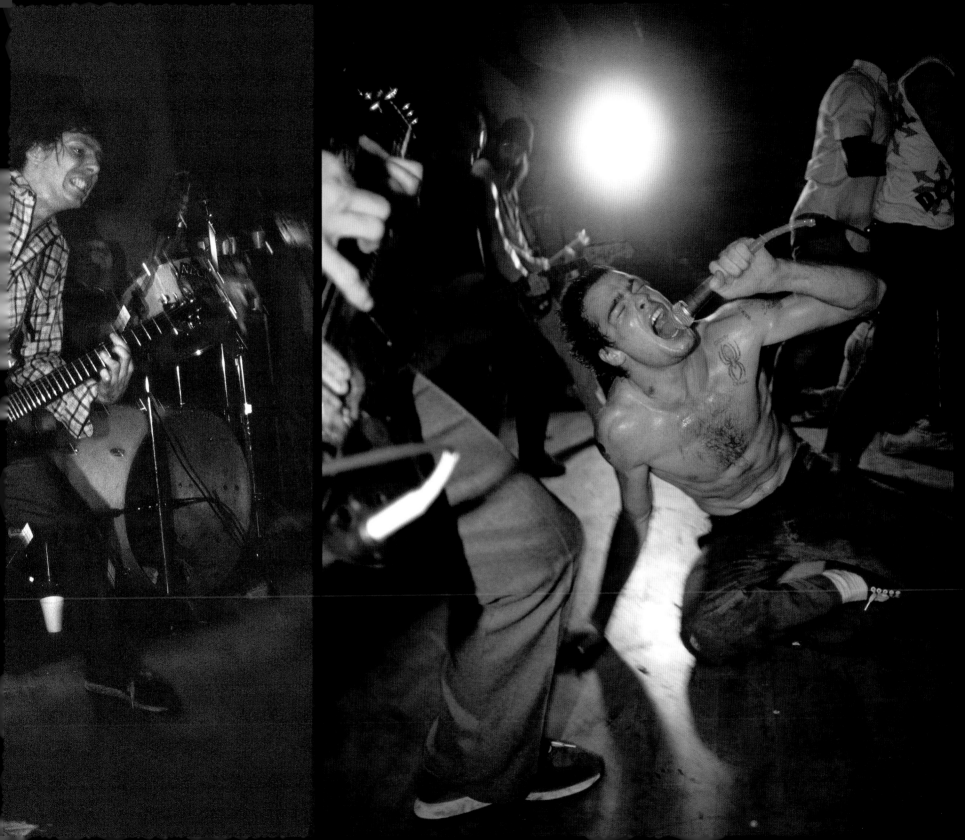

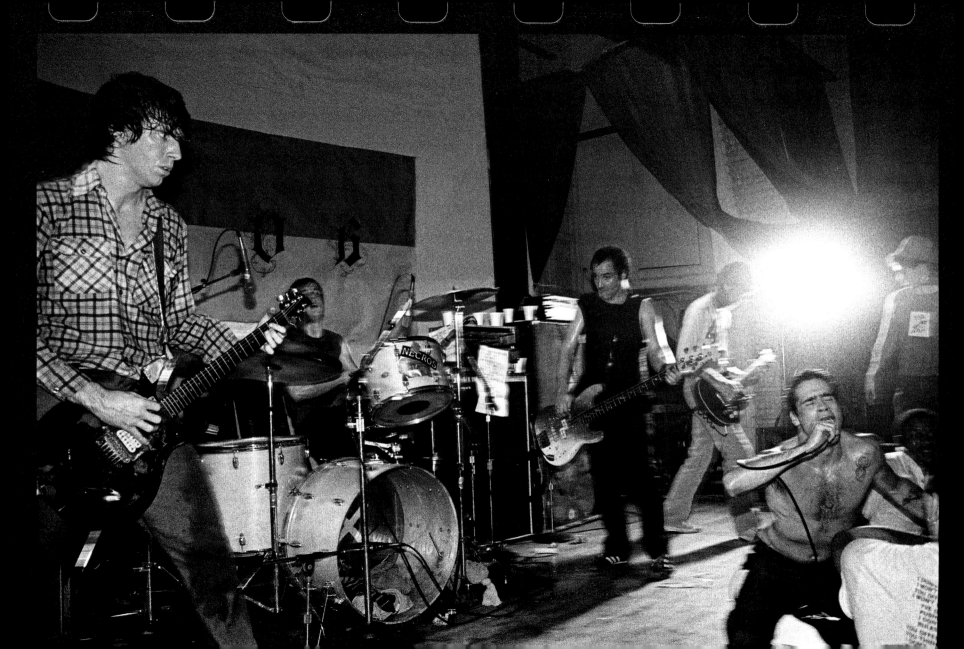

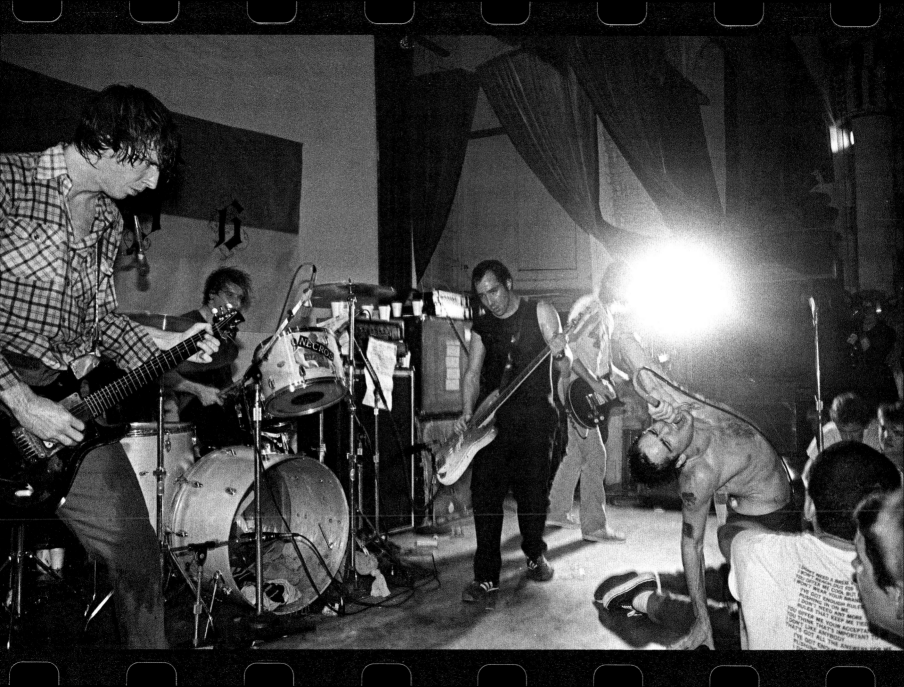

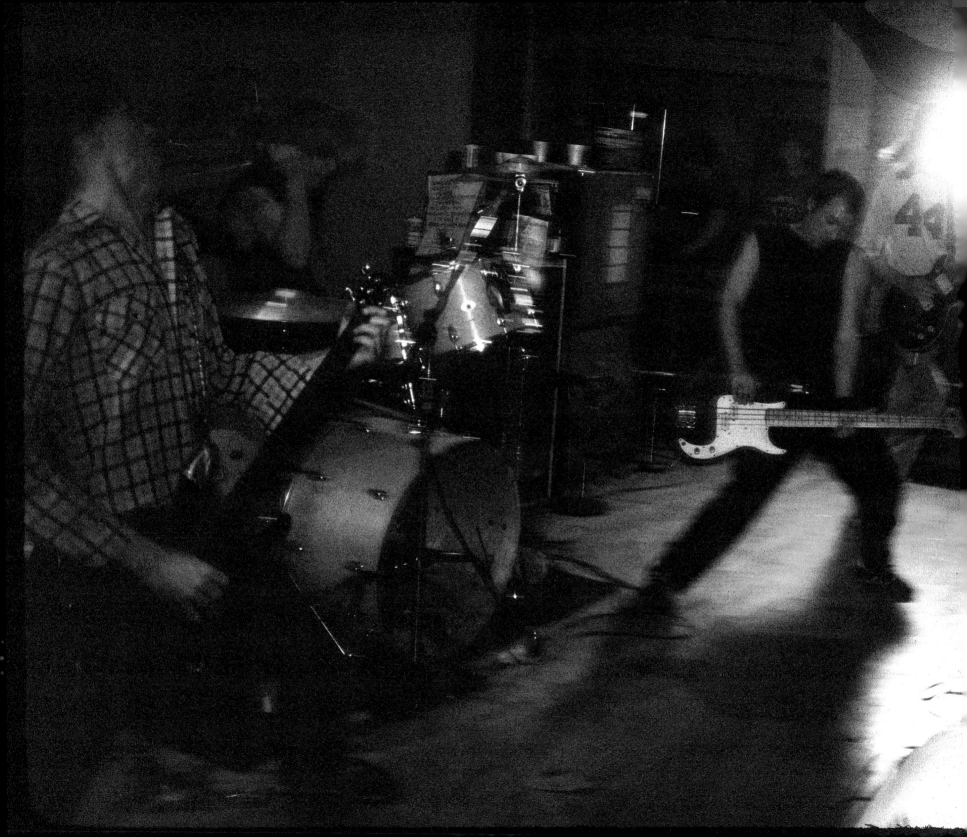

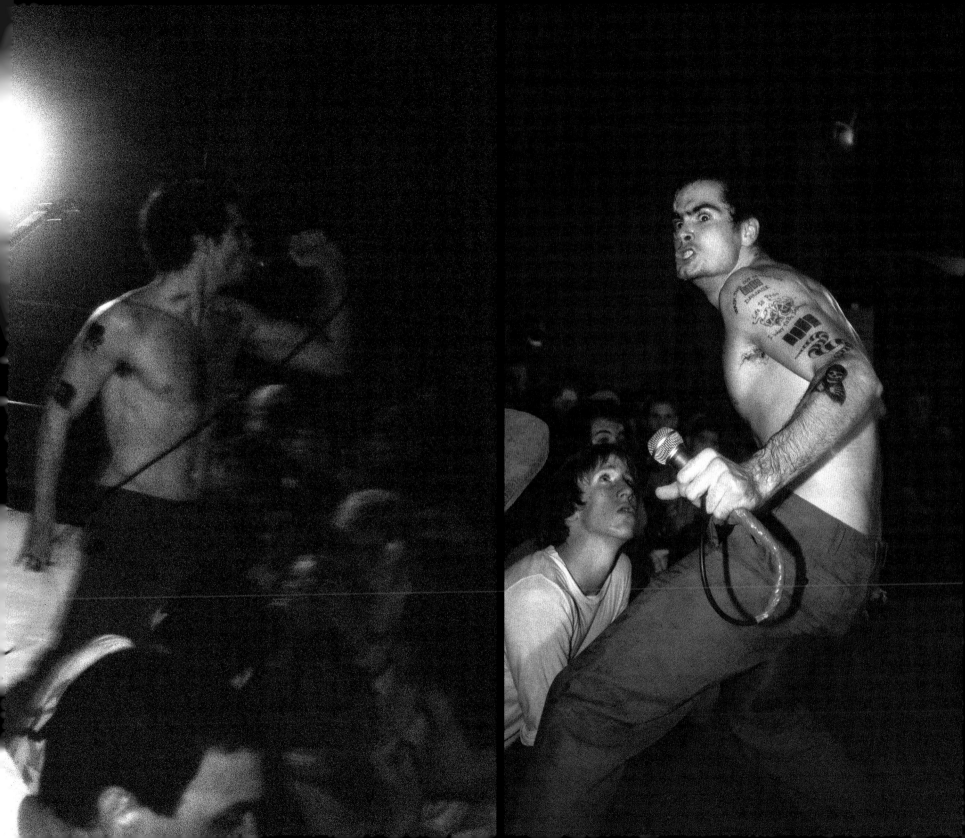

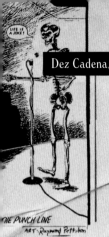

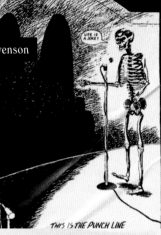
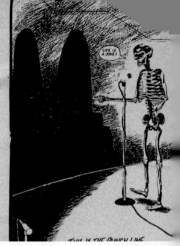

Dez Cadena, Chuck Dukowski, Greg Ginn, Henry Rollins, Bill Stevenson

La Casa de la Raza, Santa Barbara, January 7, 1983

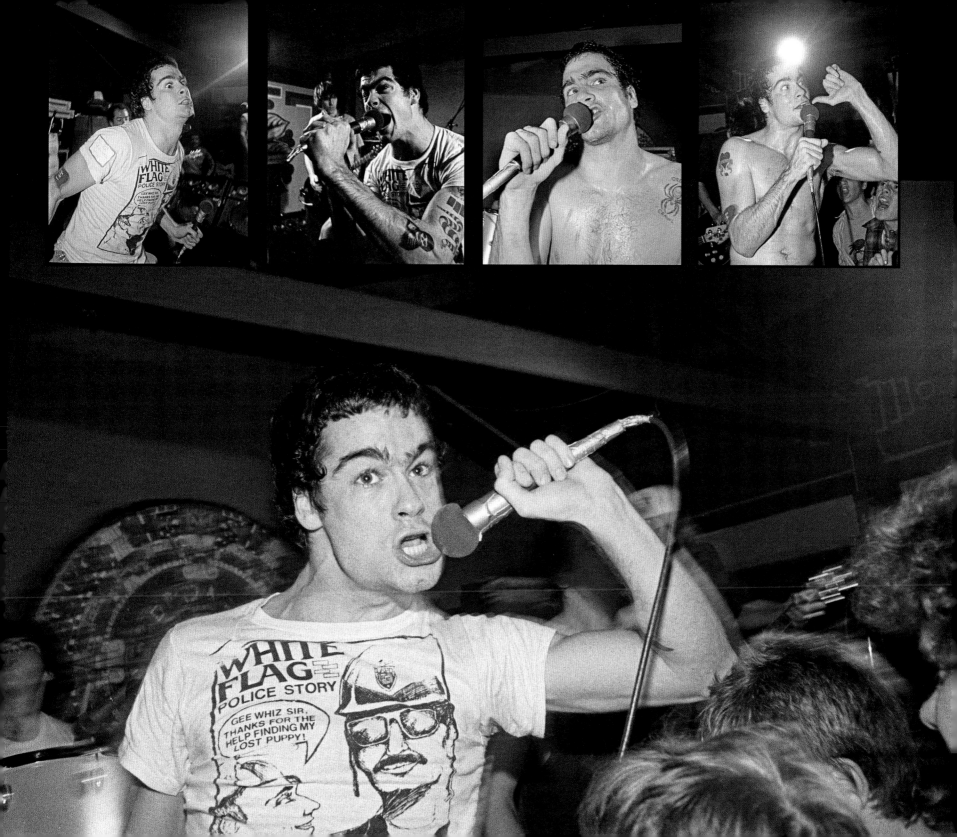

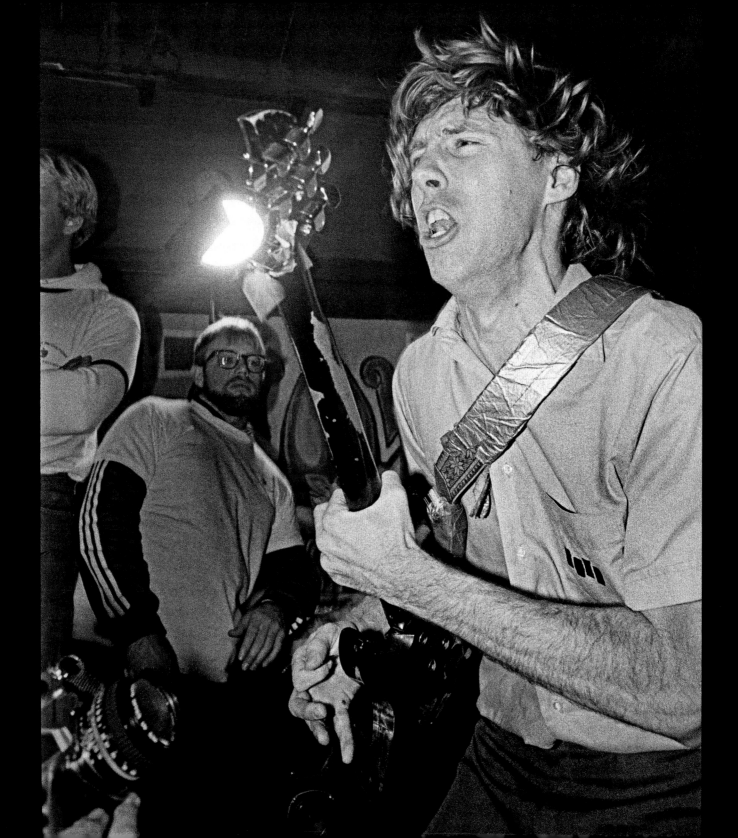

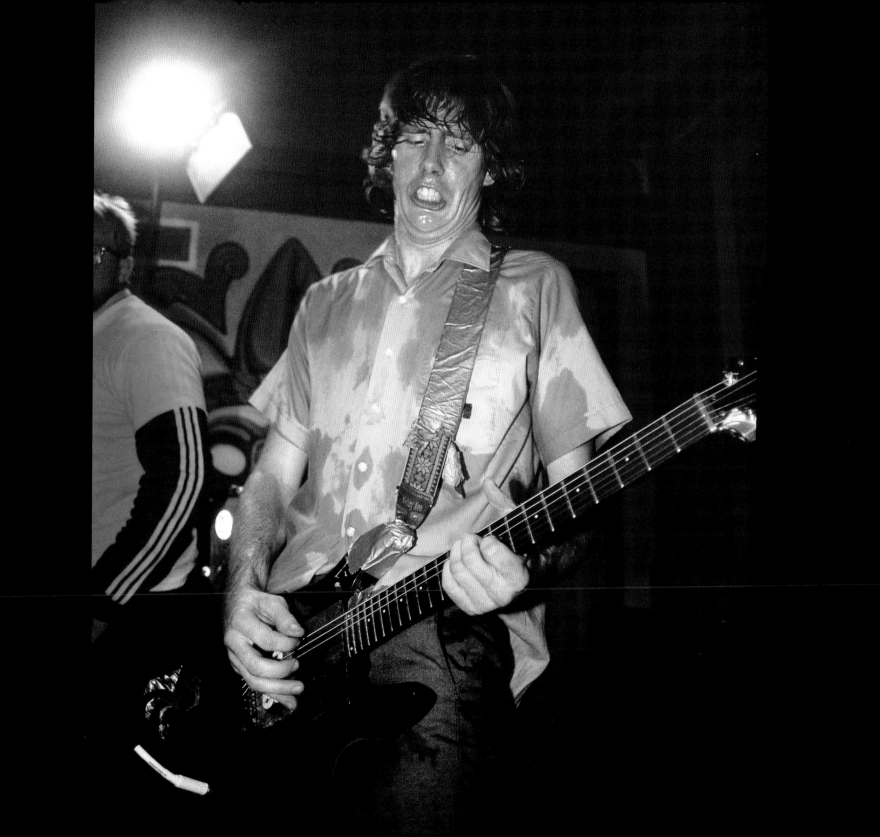

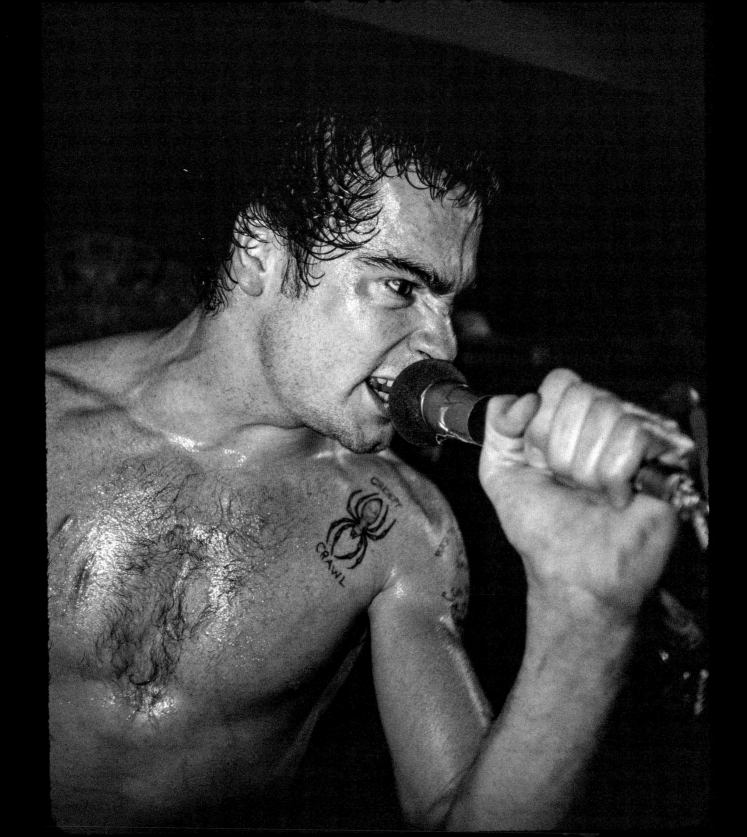

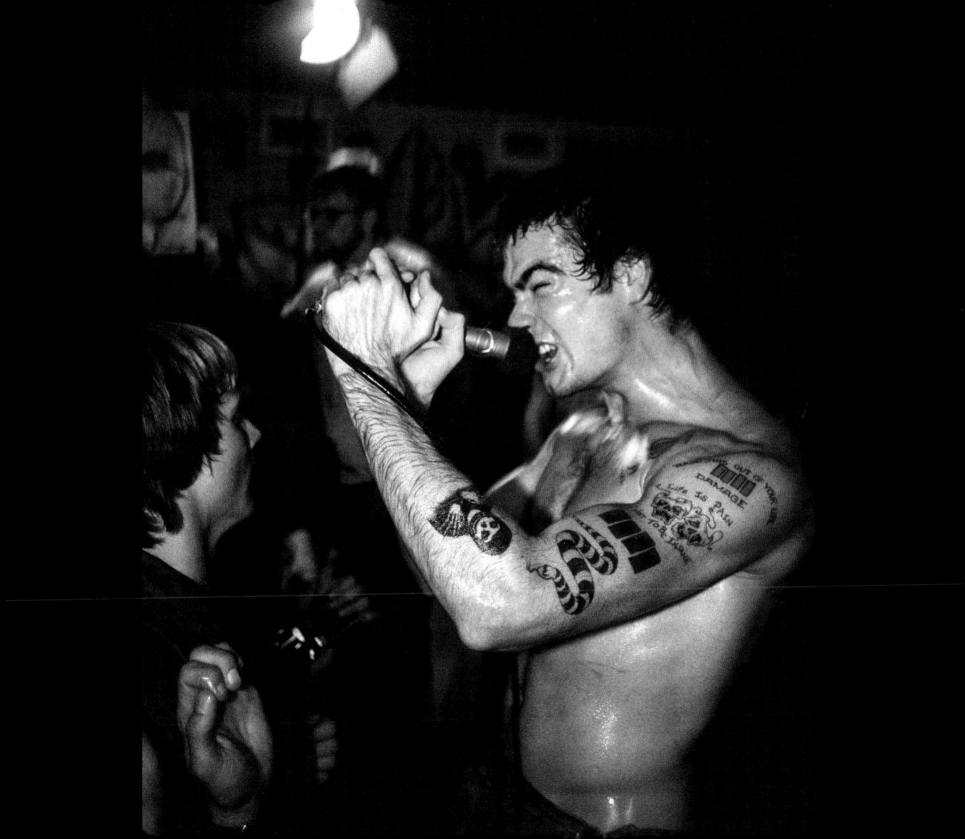

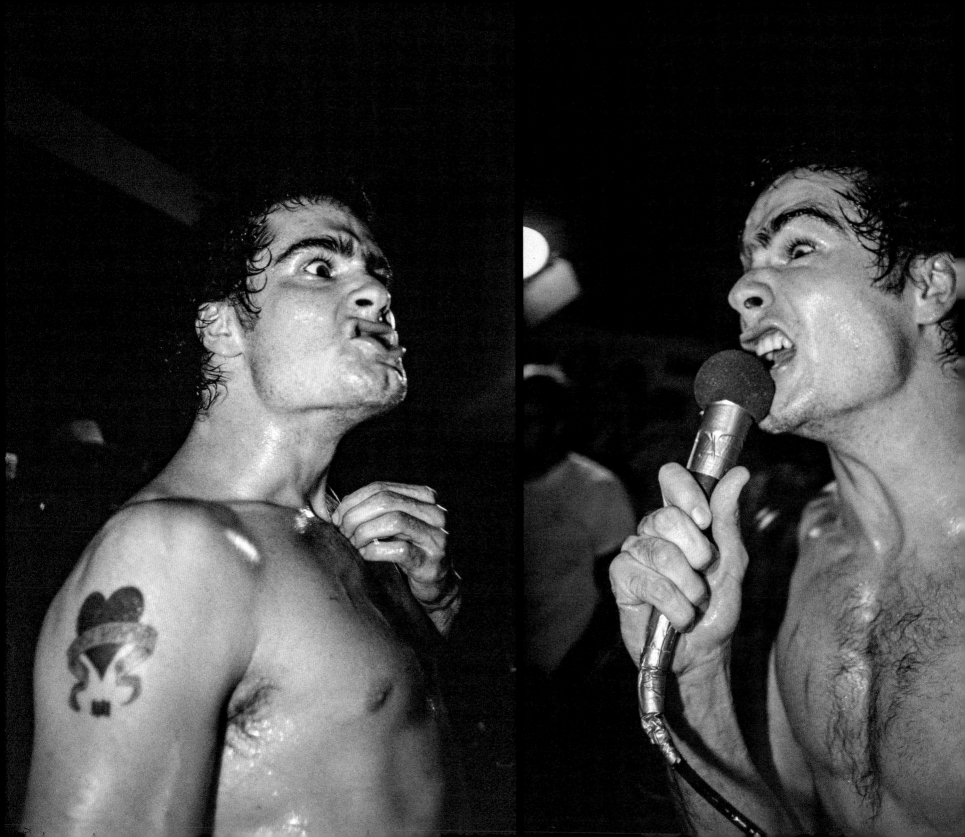

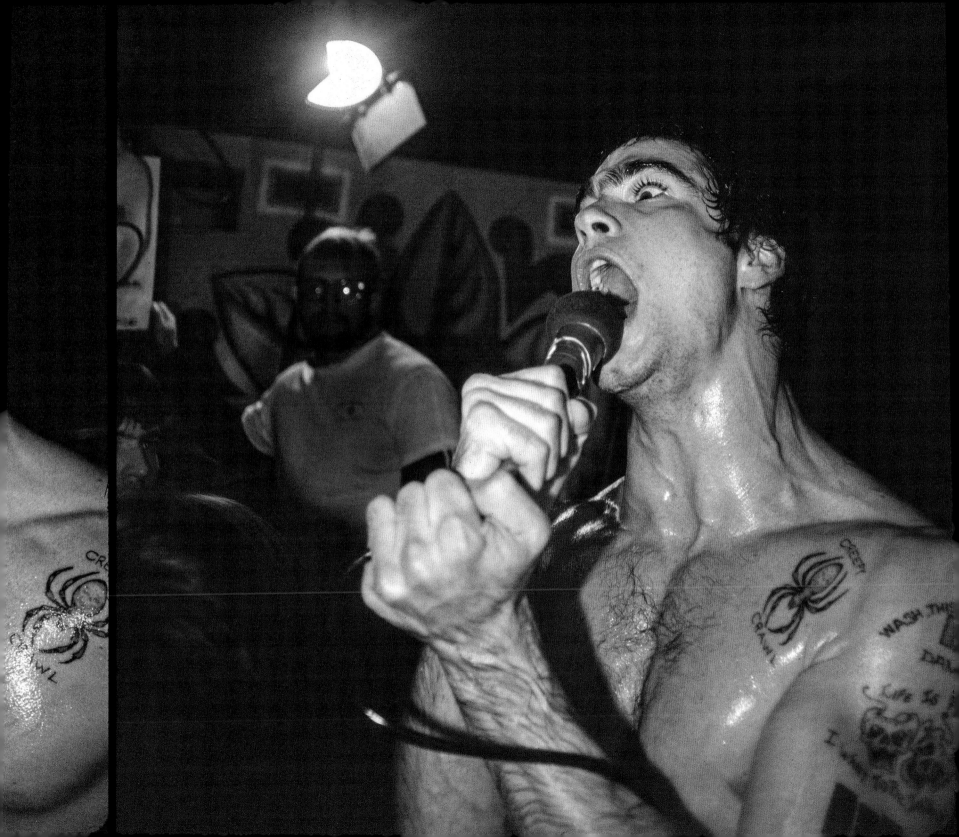

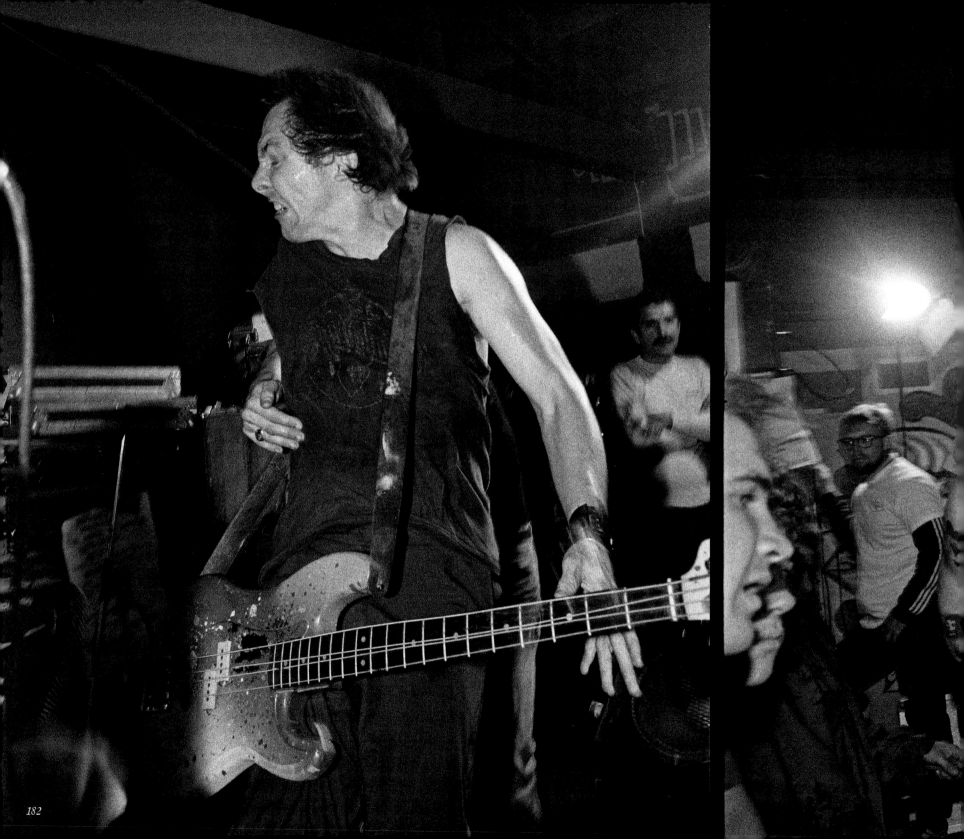

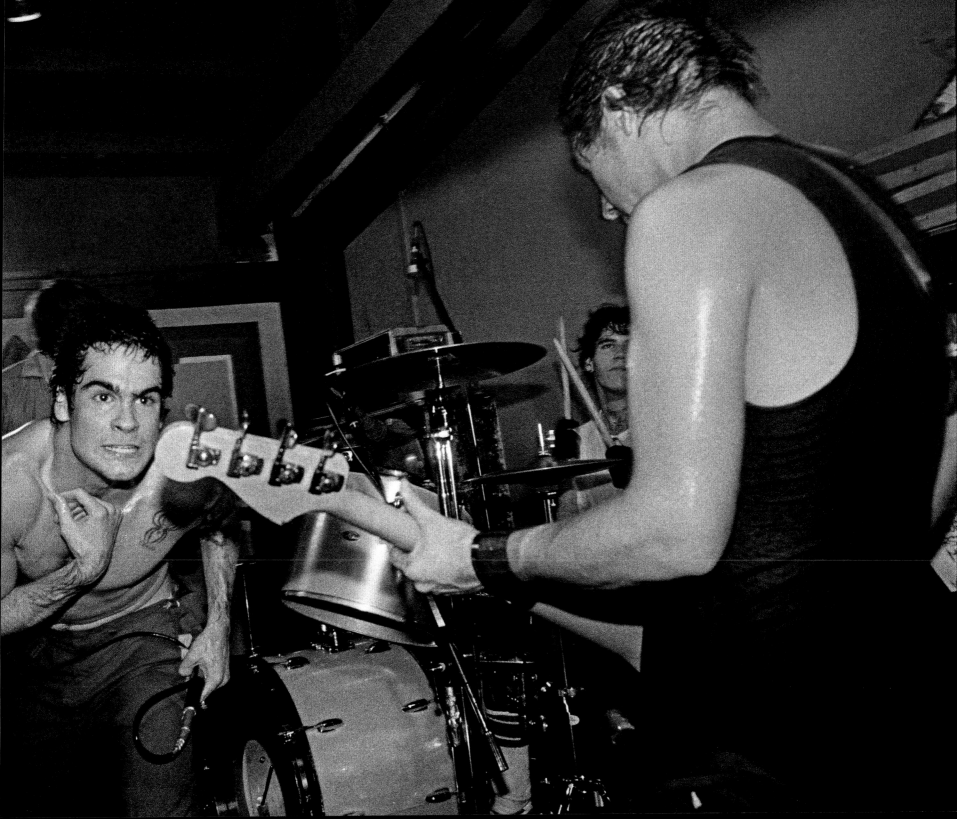

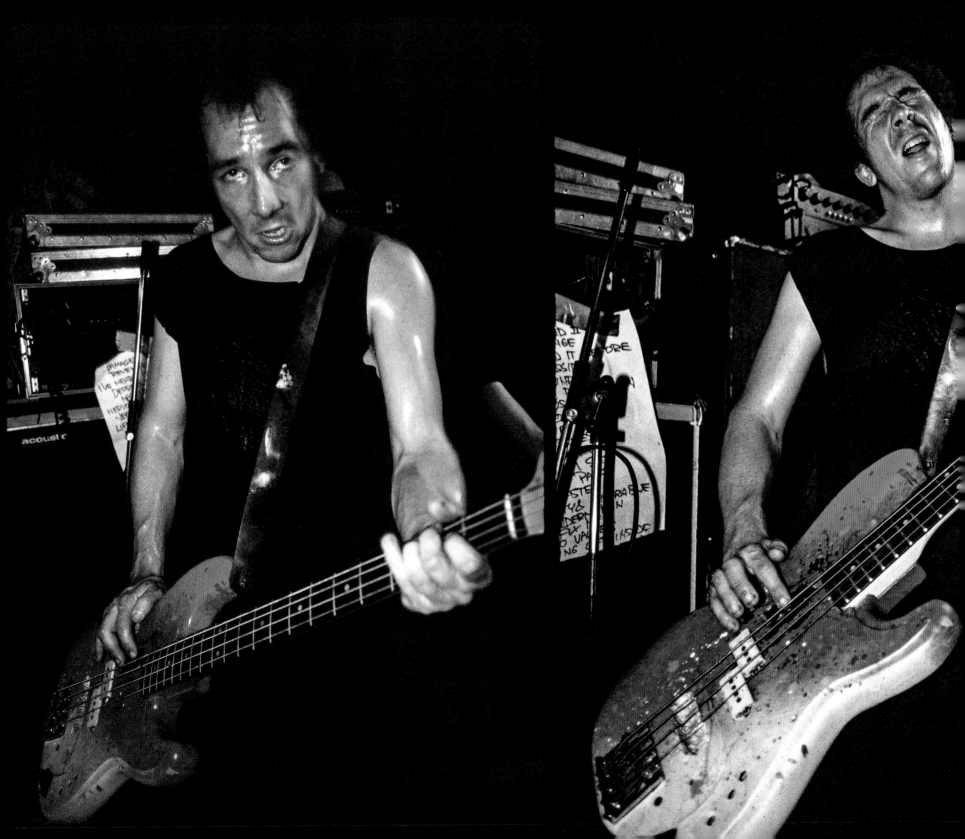

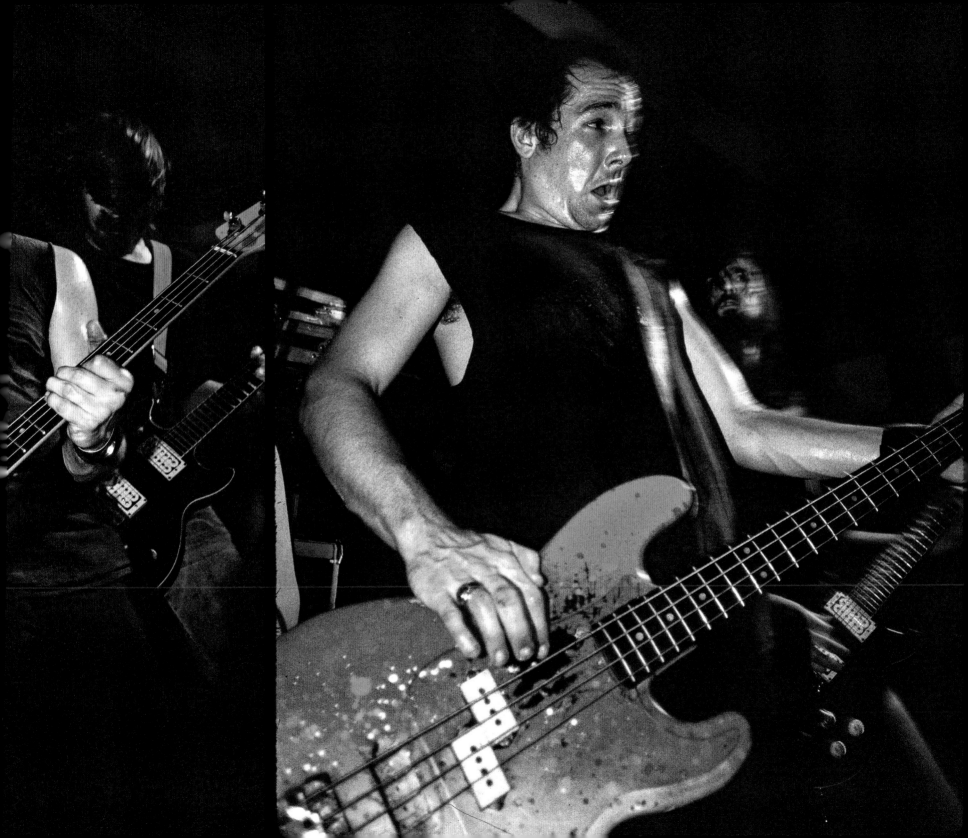

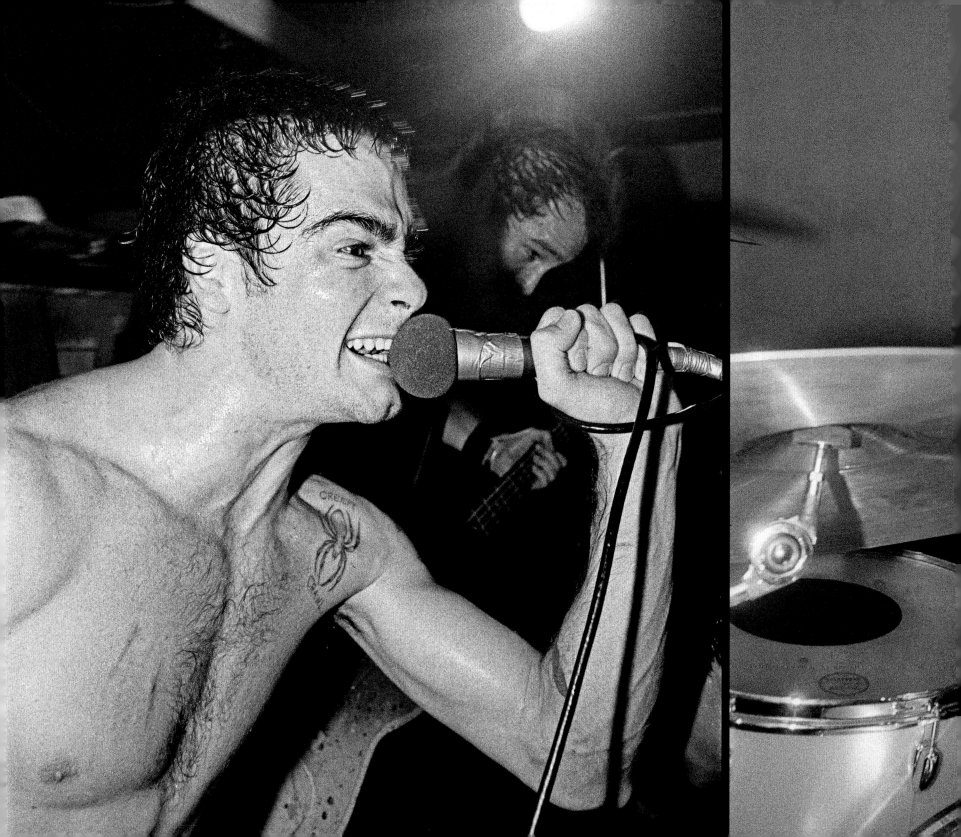

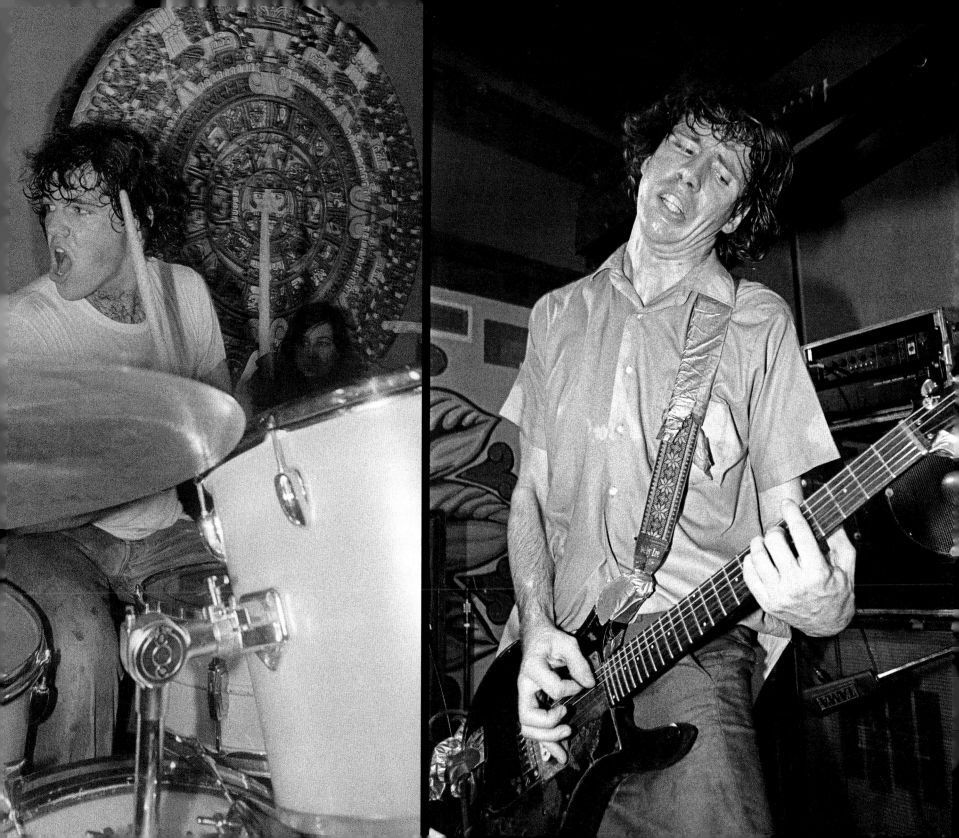

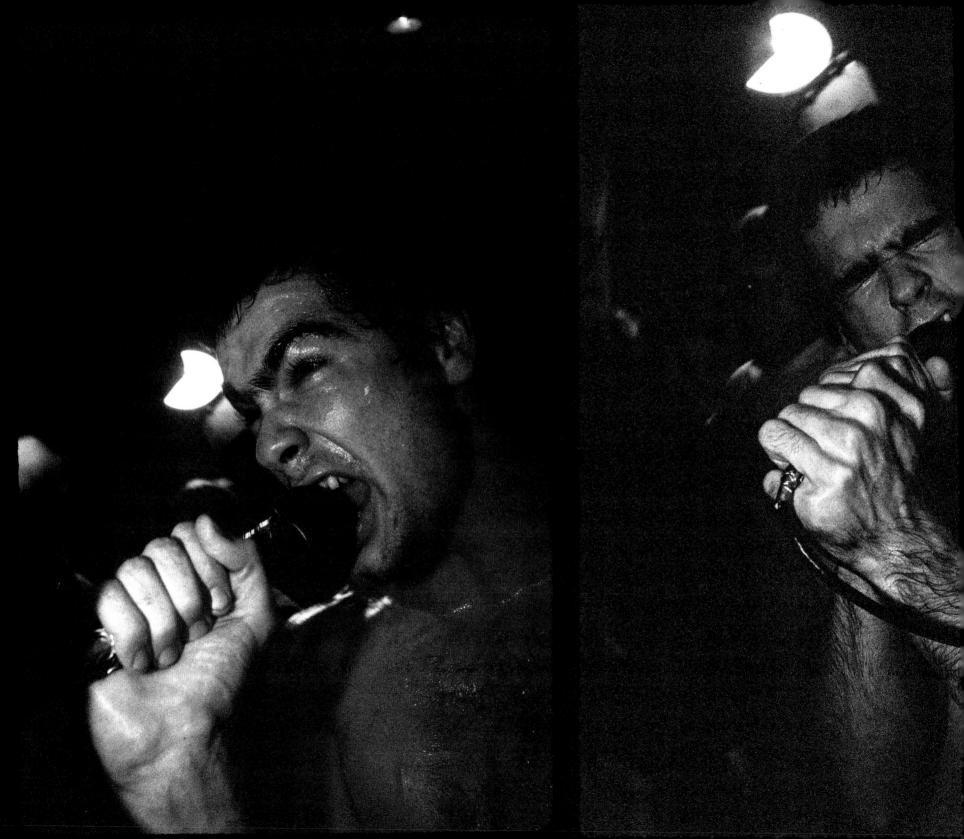

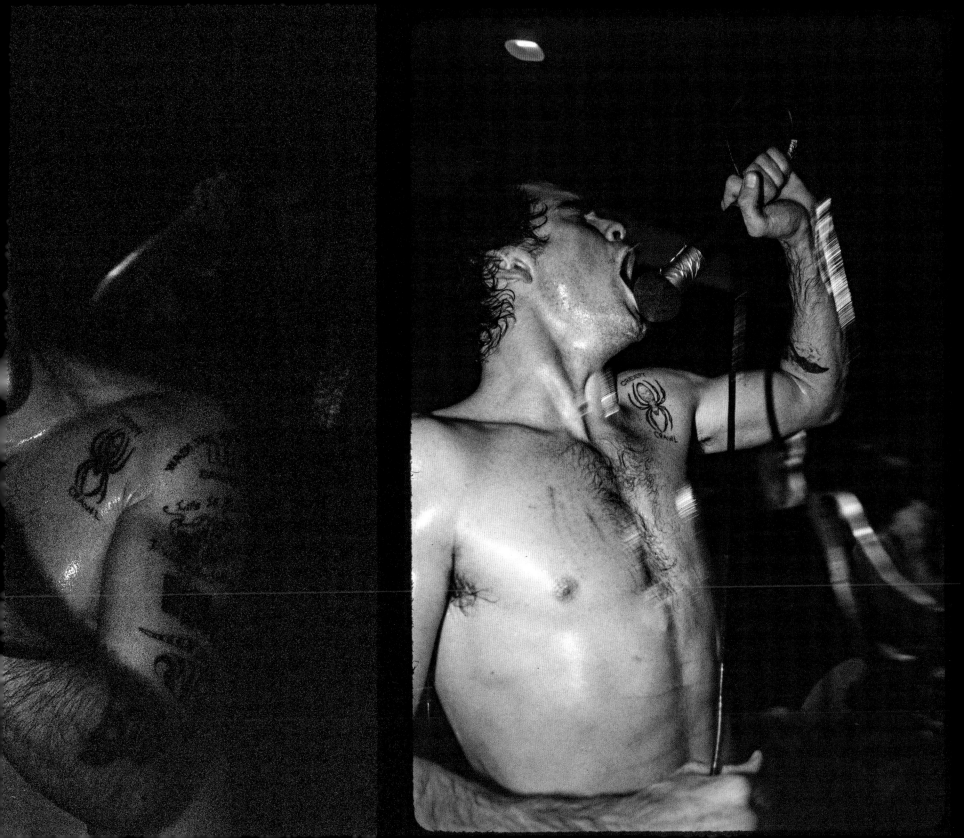

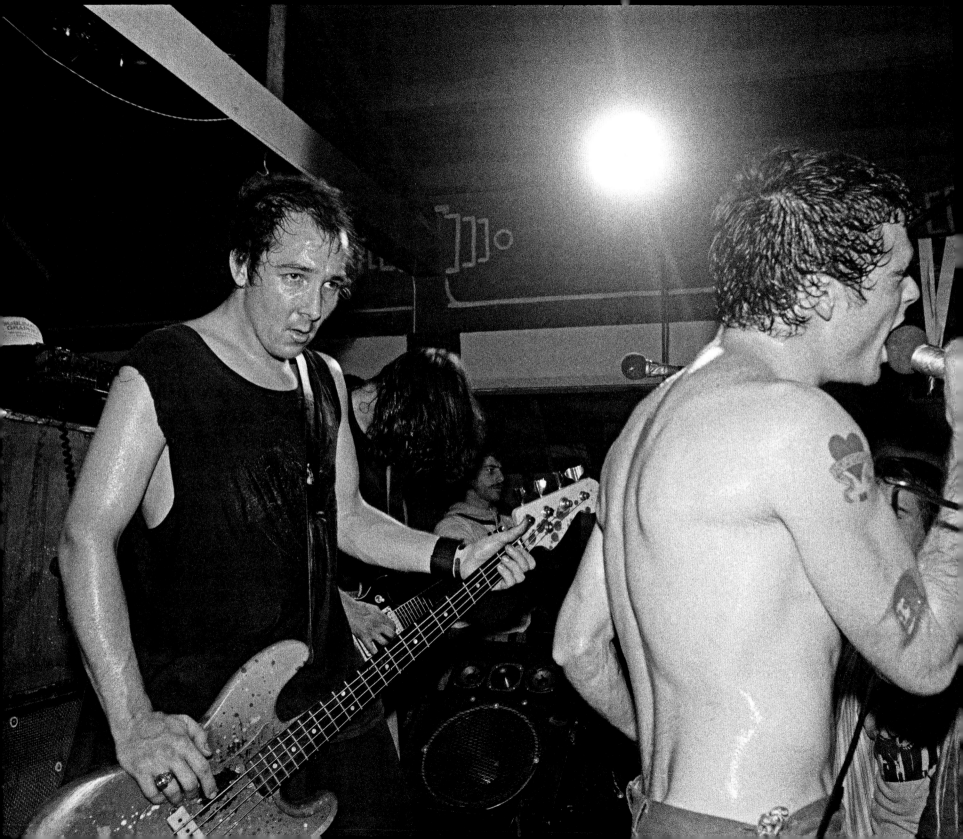

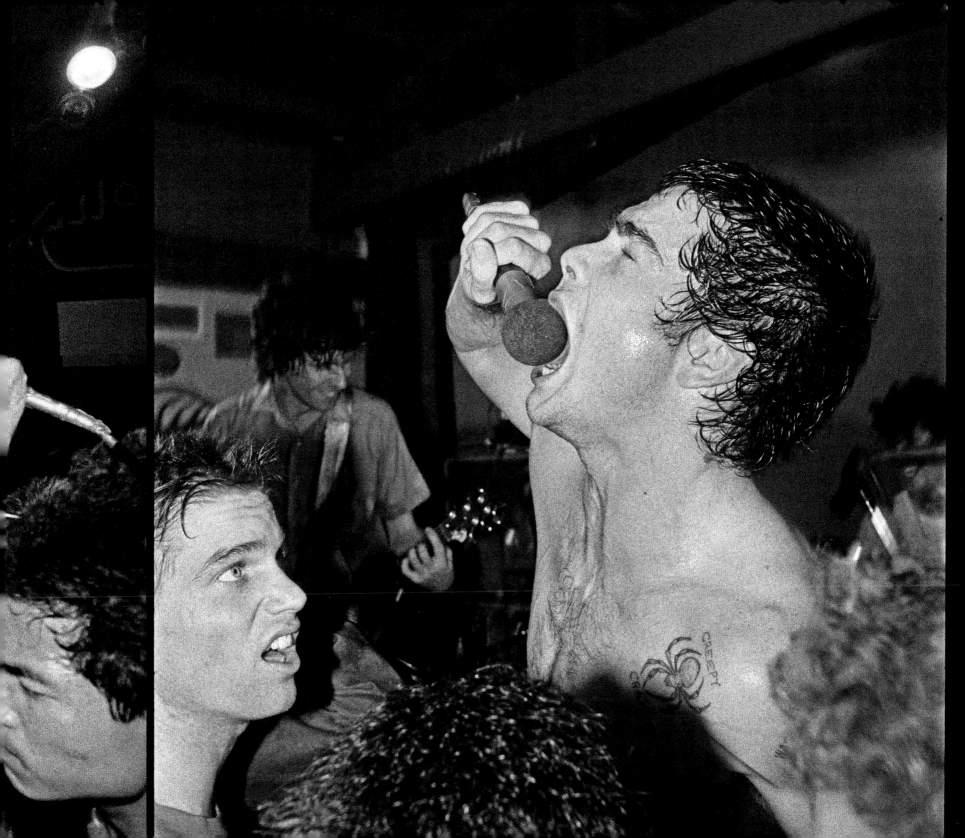

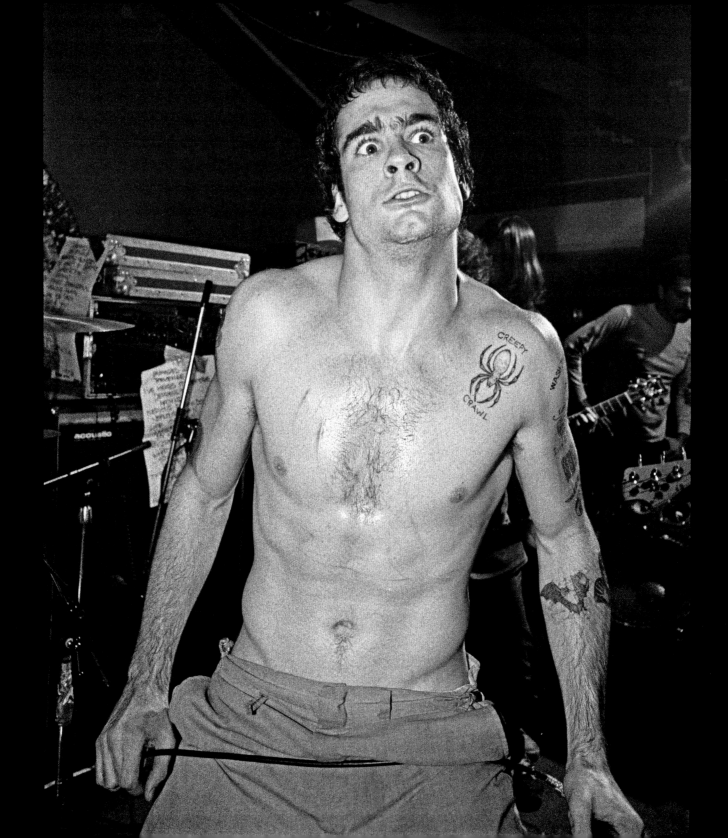

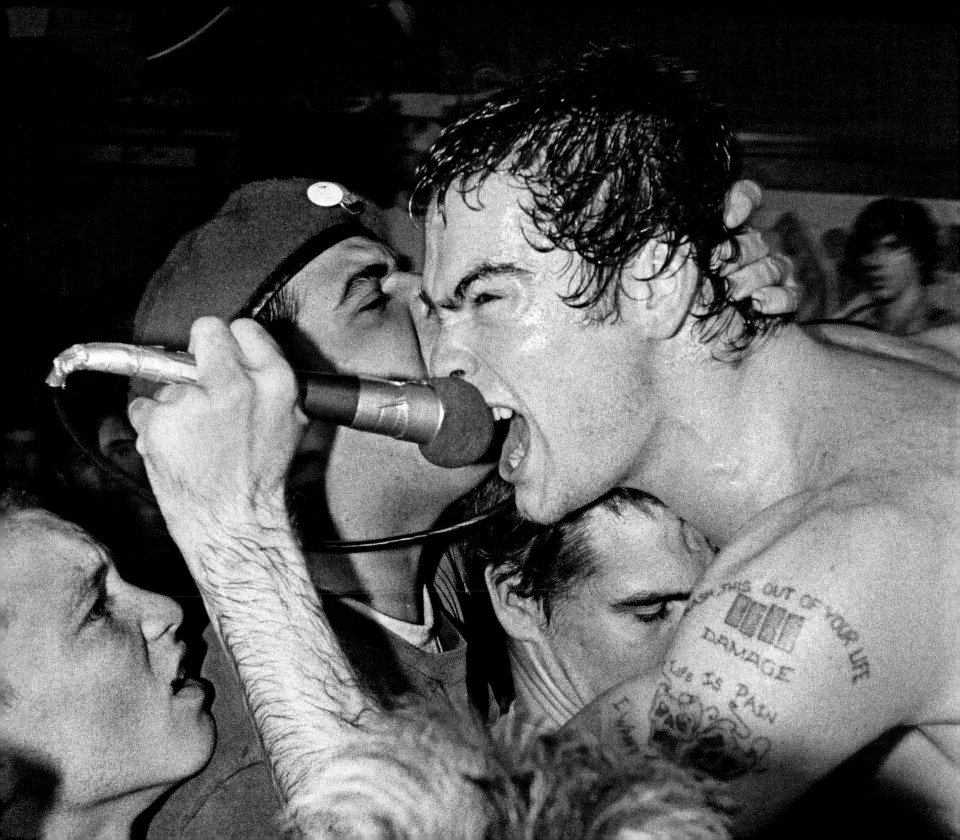

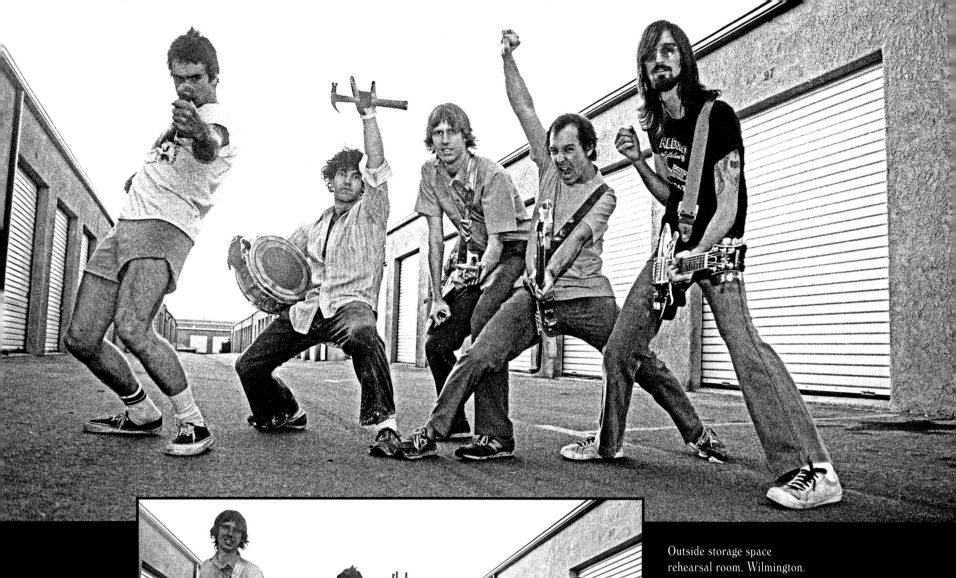

Outside storage space
rehearsal room, Wilmington.

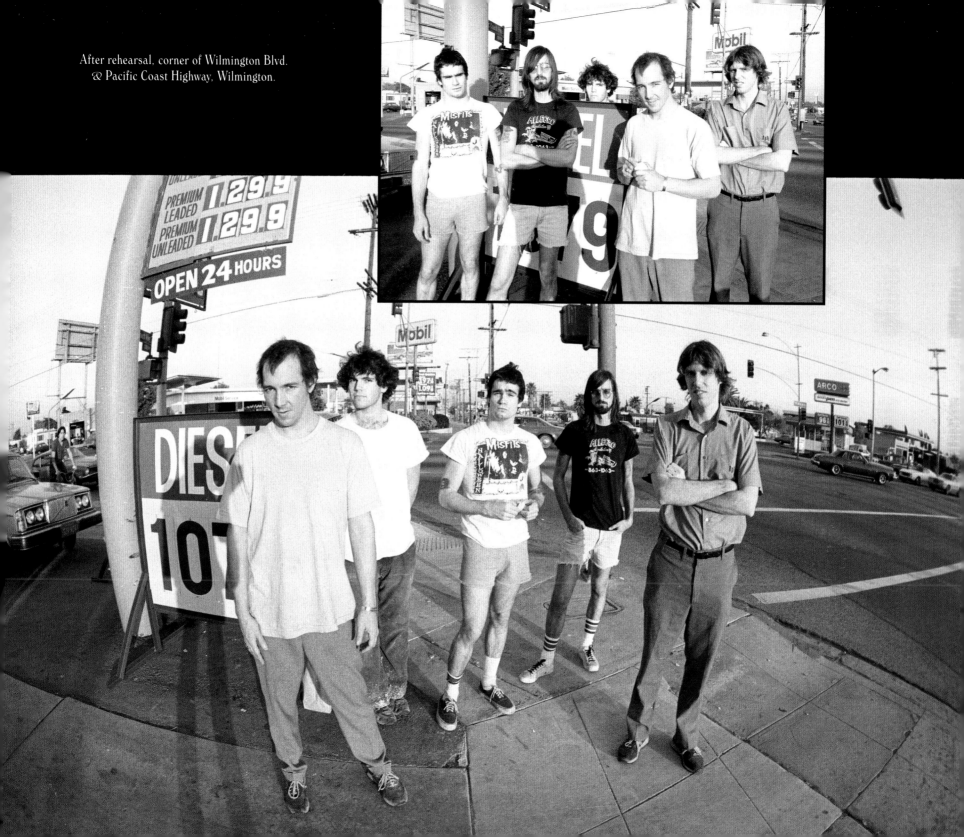

After rehearsal, corner of Wilmington Blvd.
& Pacific Coast Highway, Wilmington.

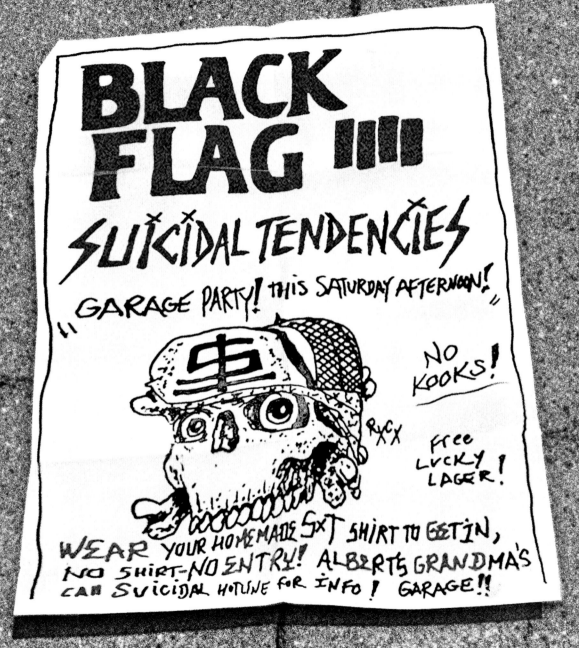

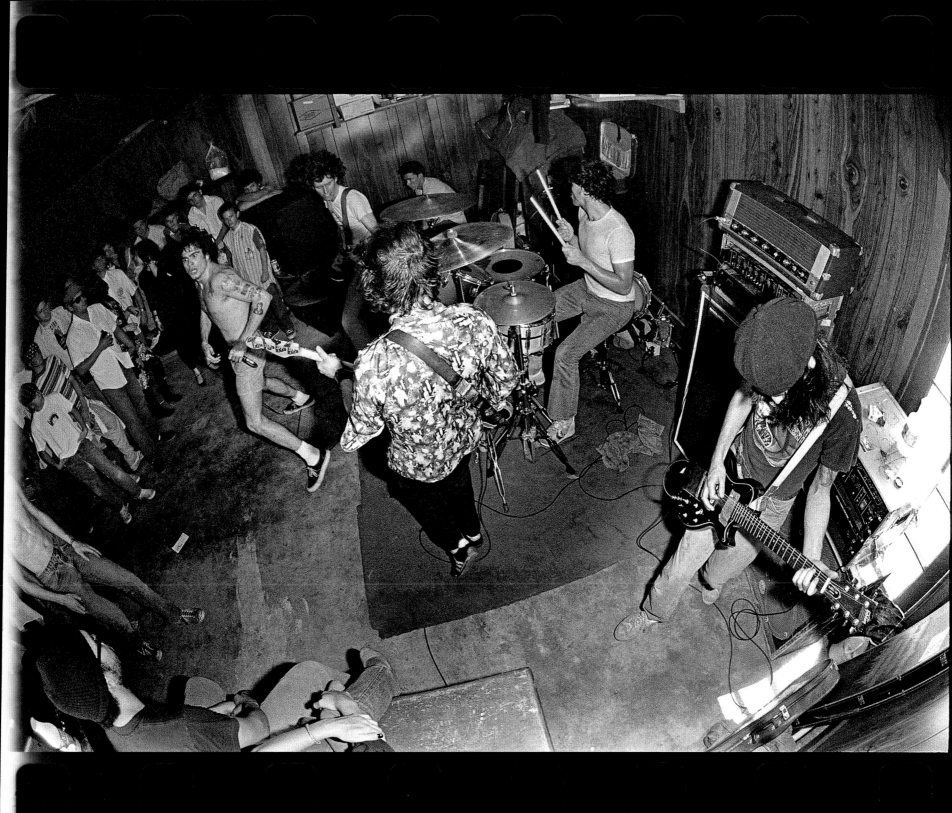

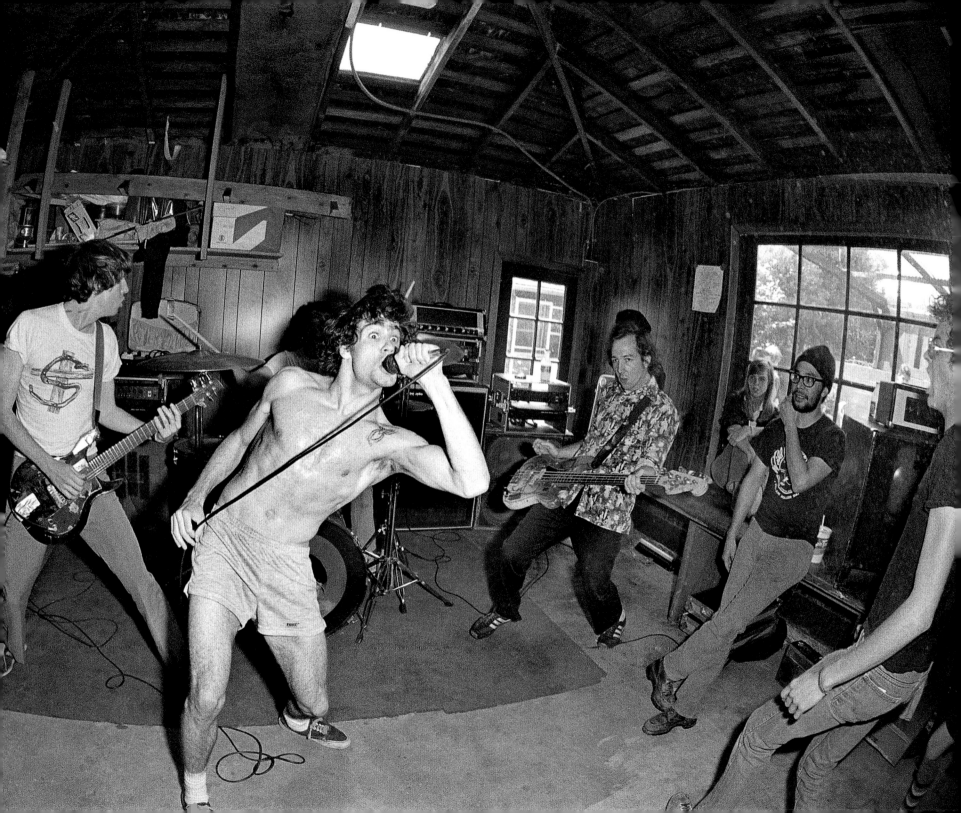

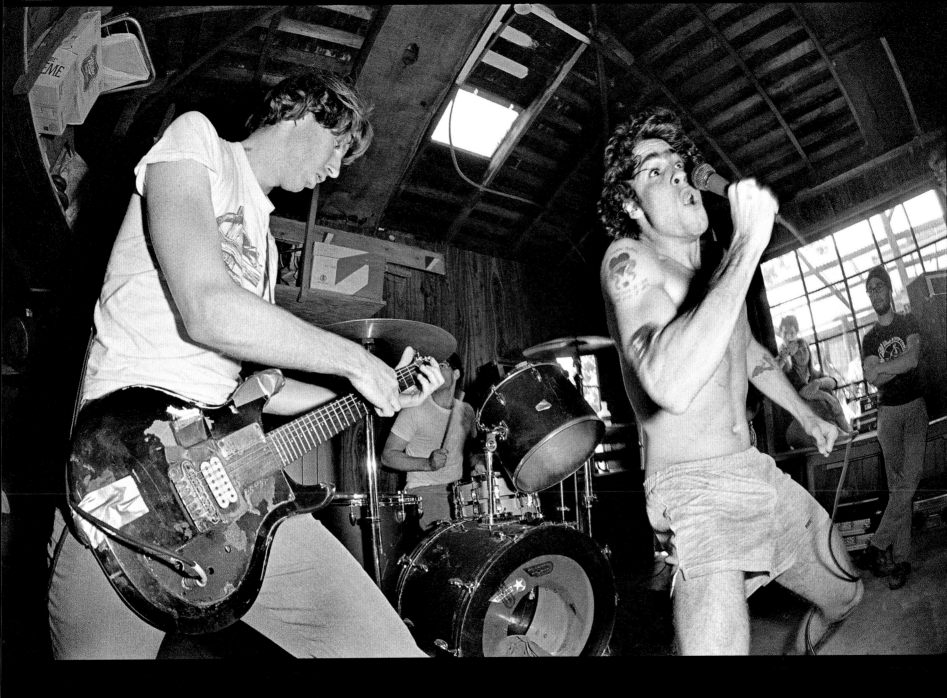

← Spot and Davo on right.

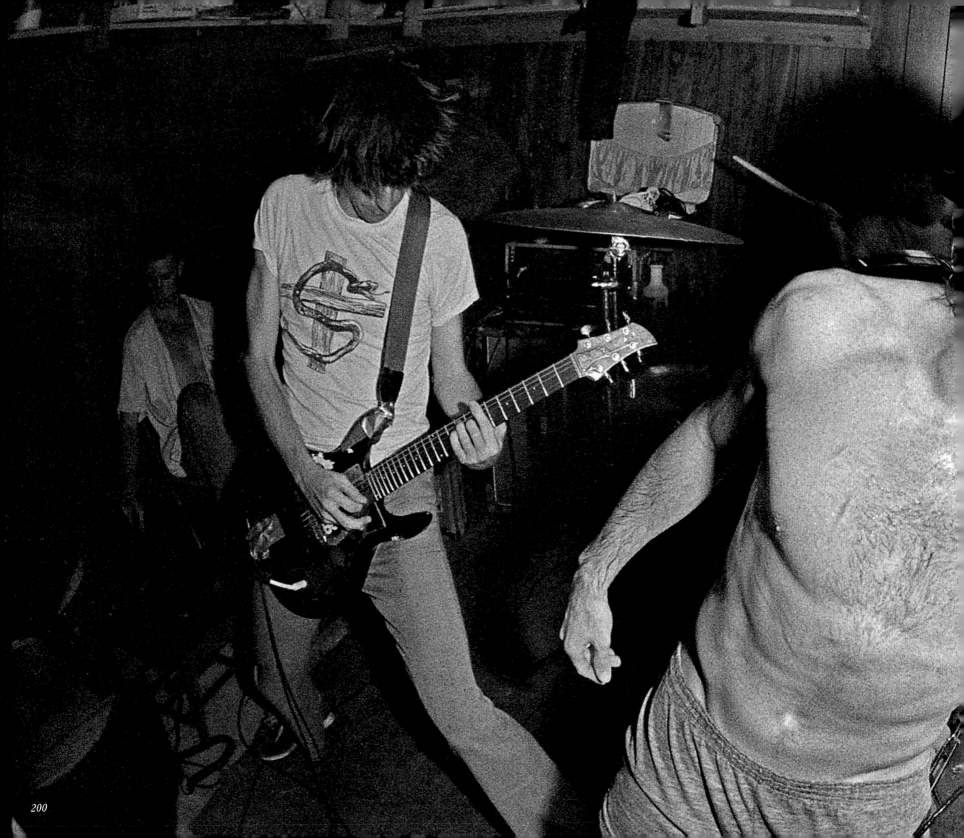

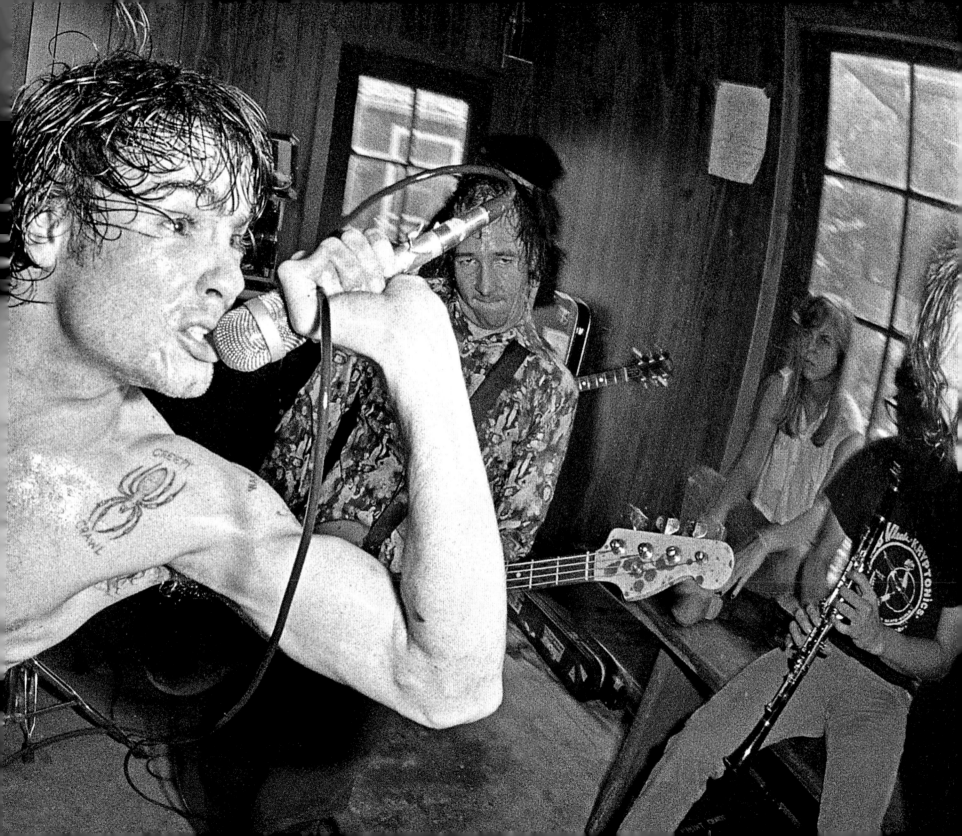

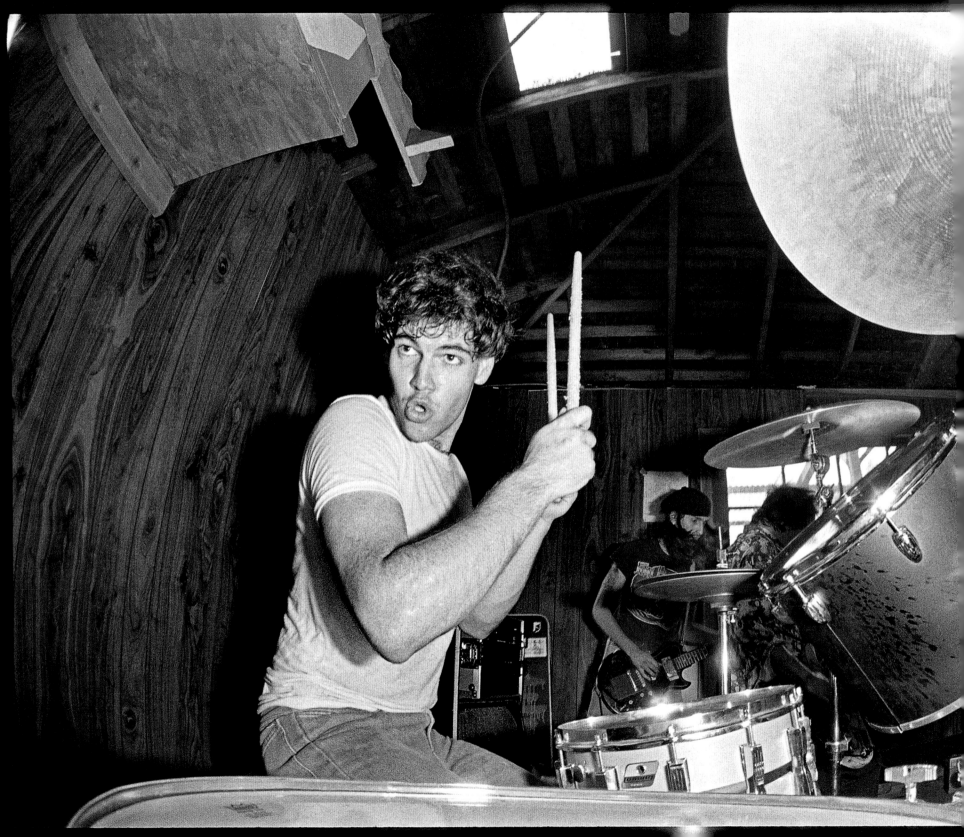

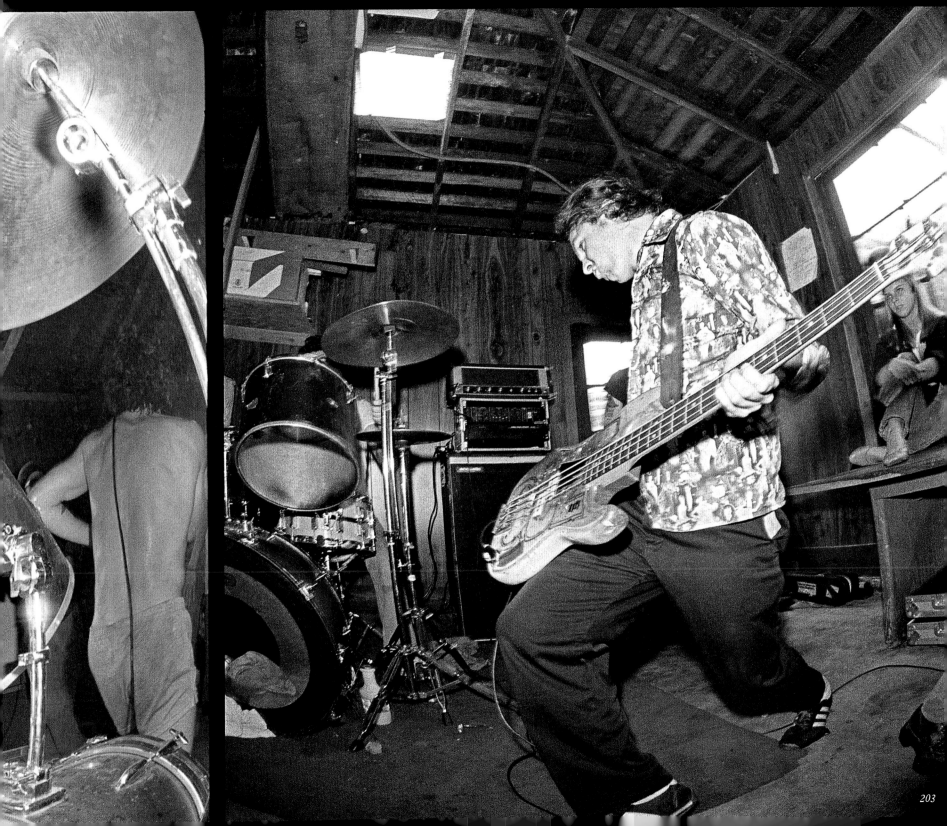

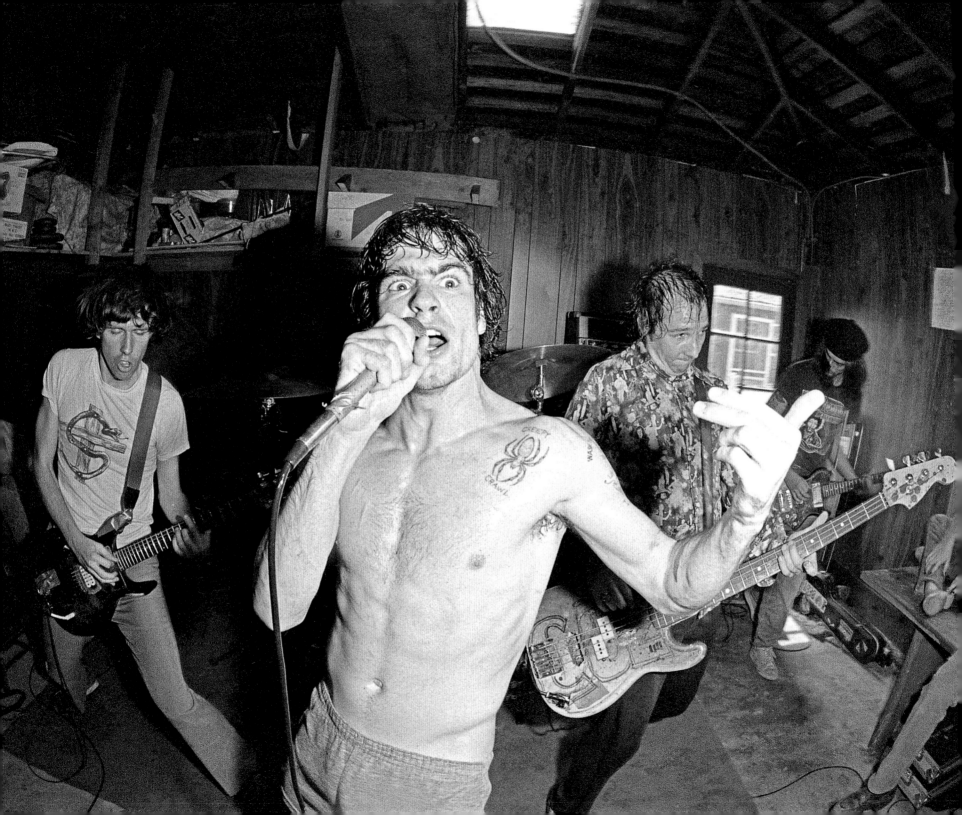

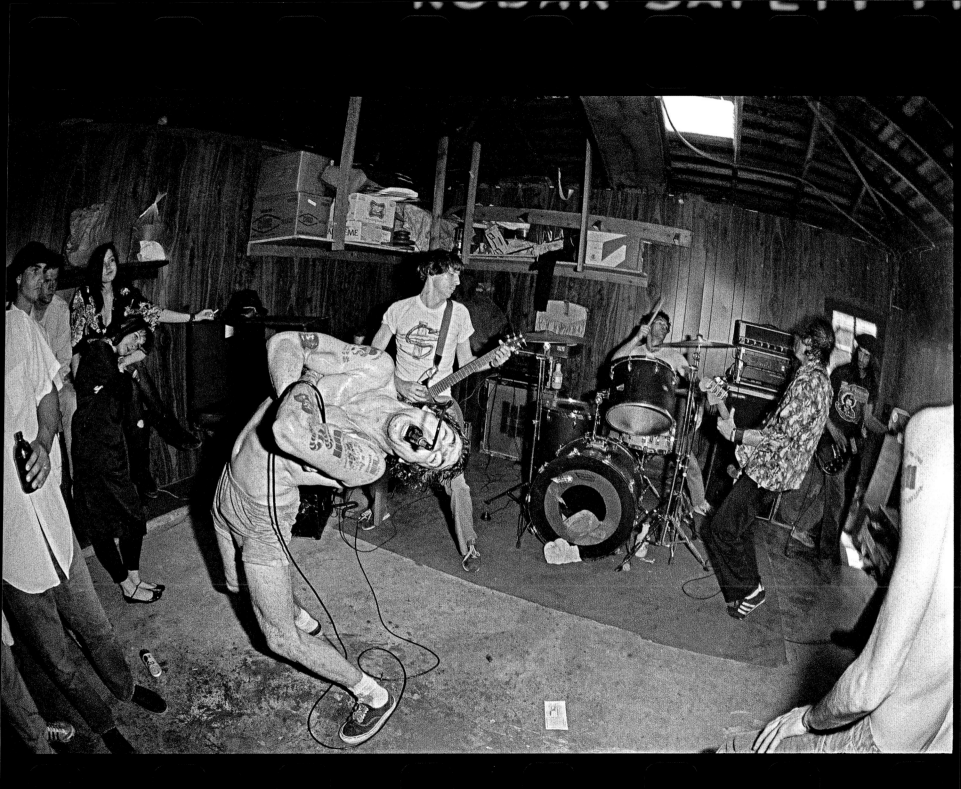

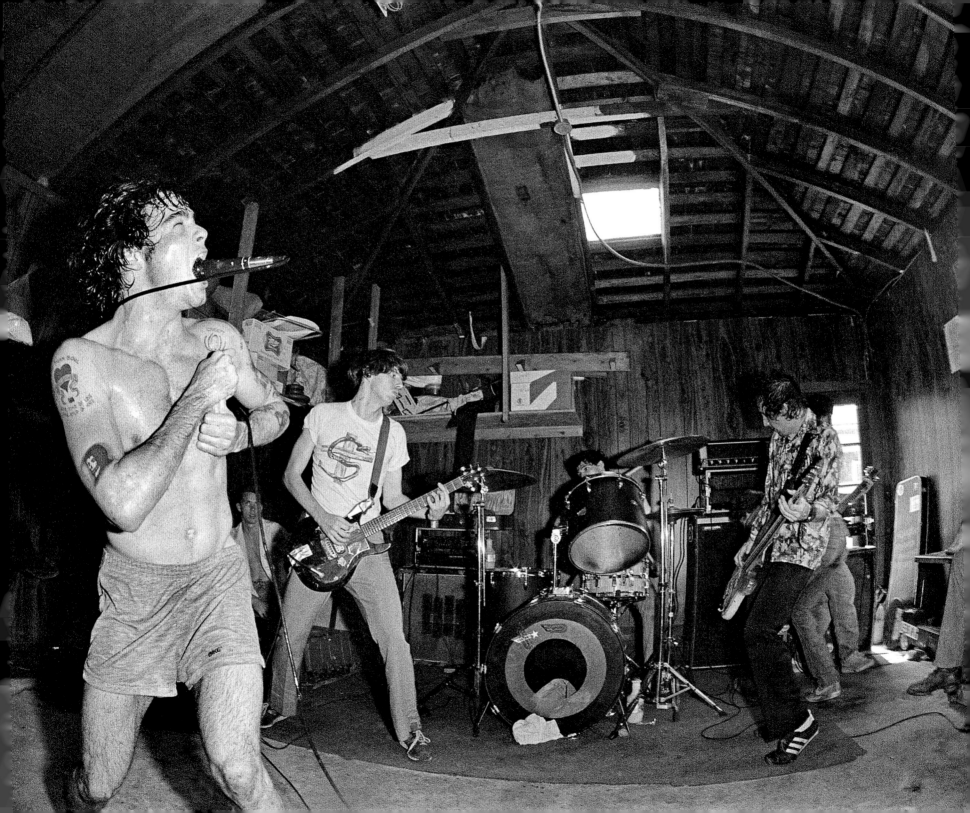

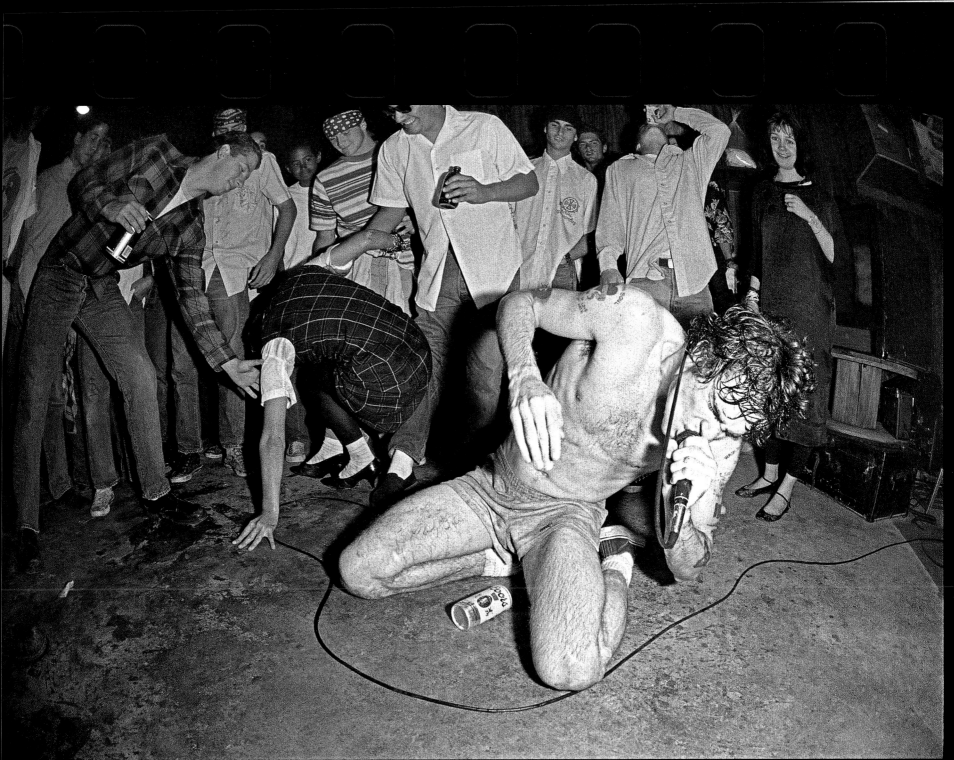

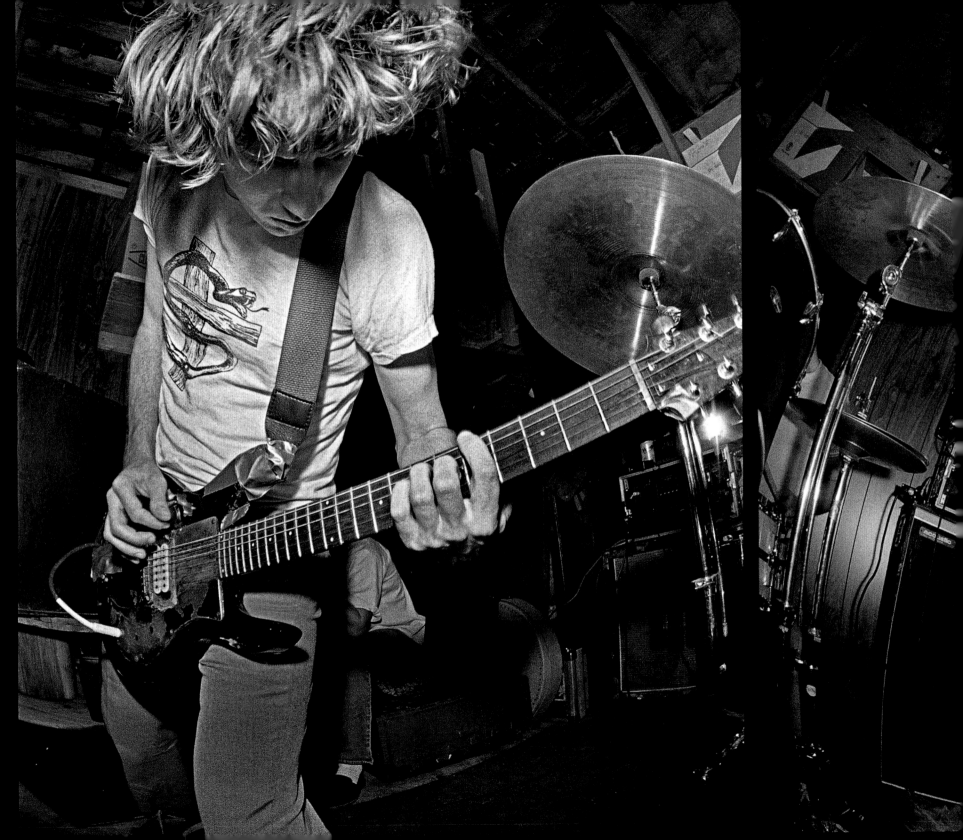

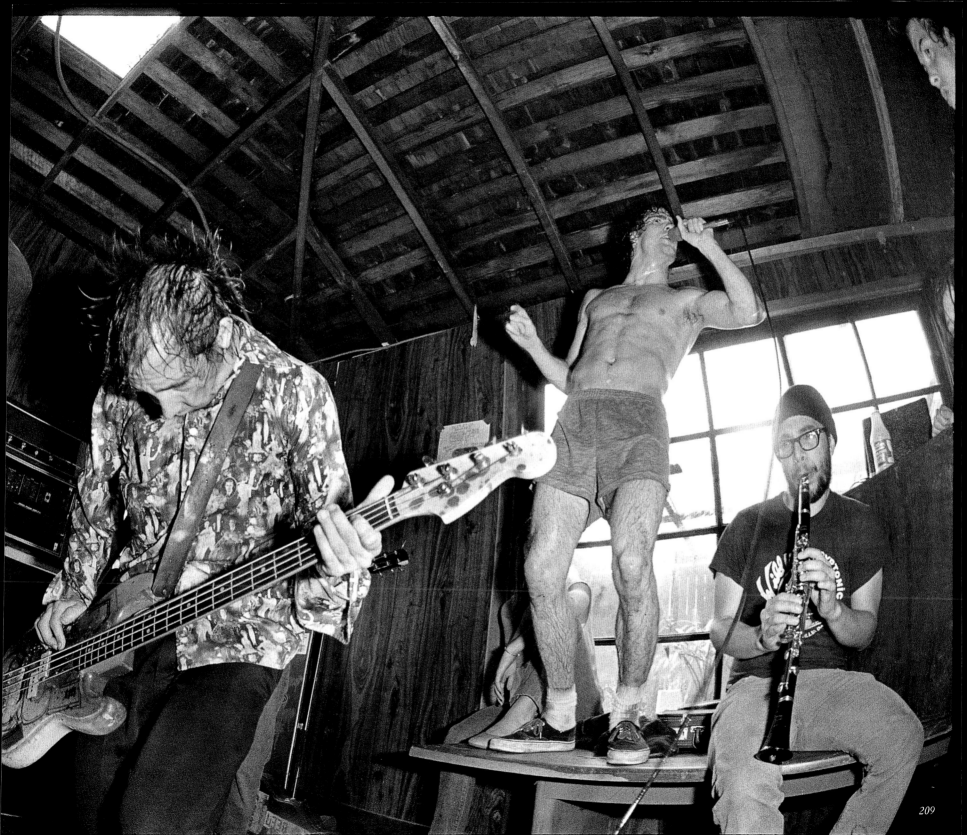

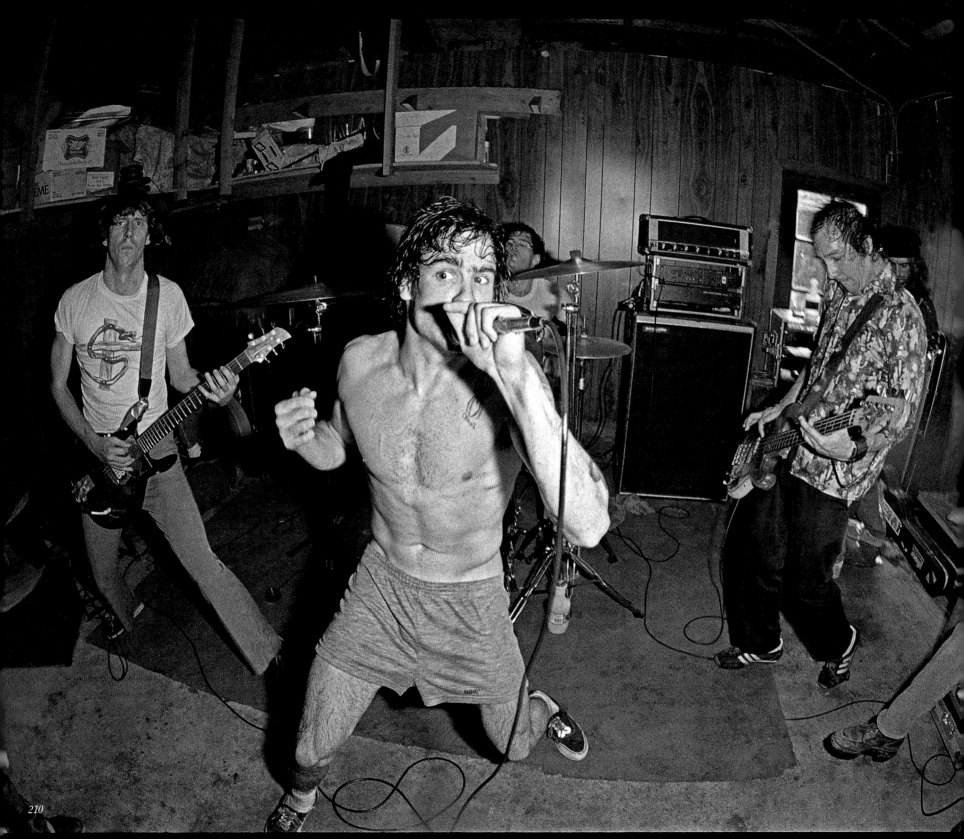

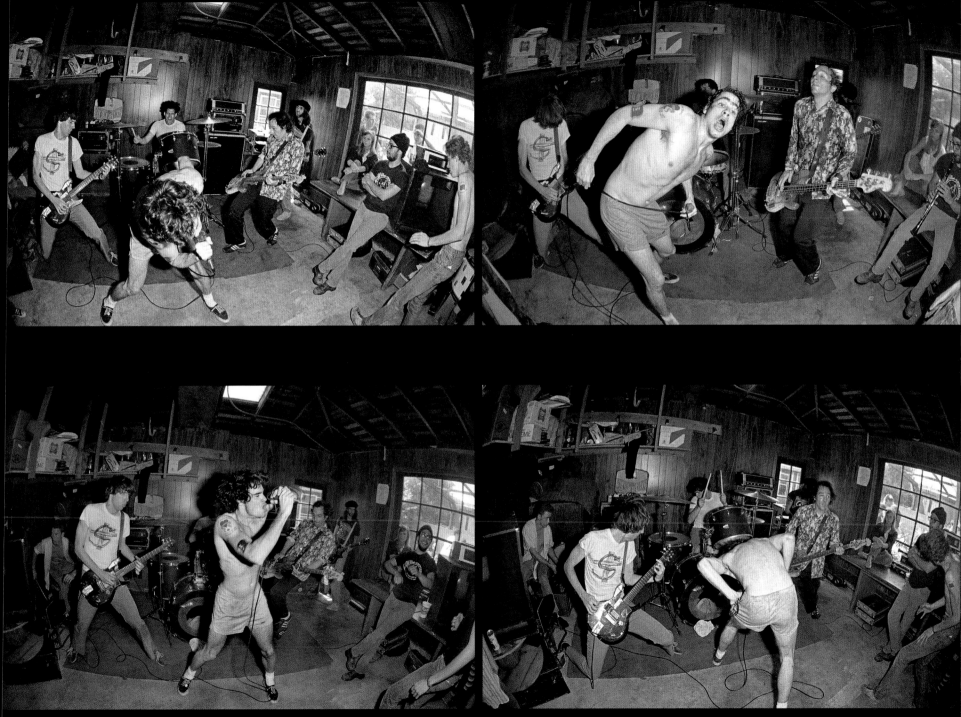

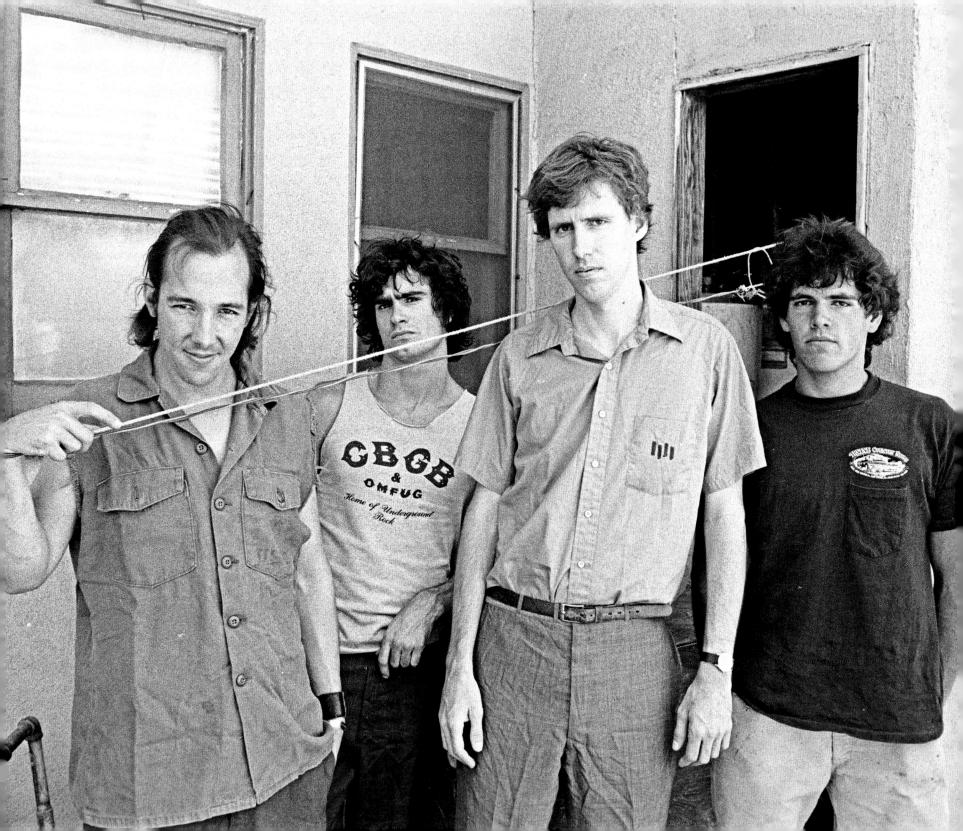

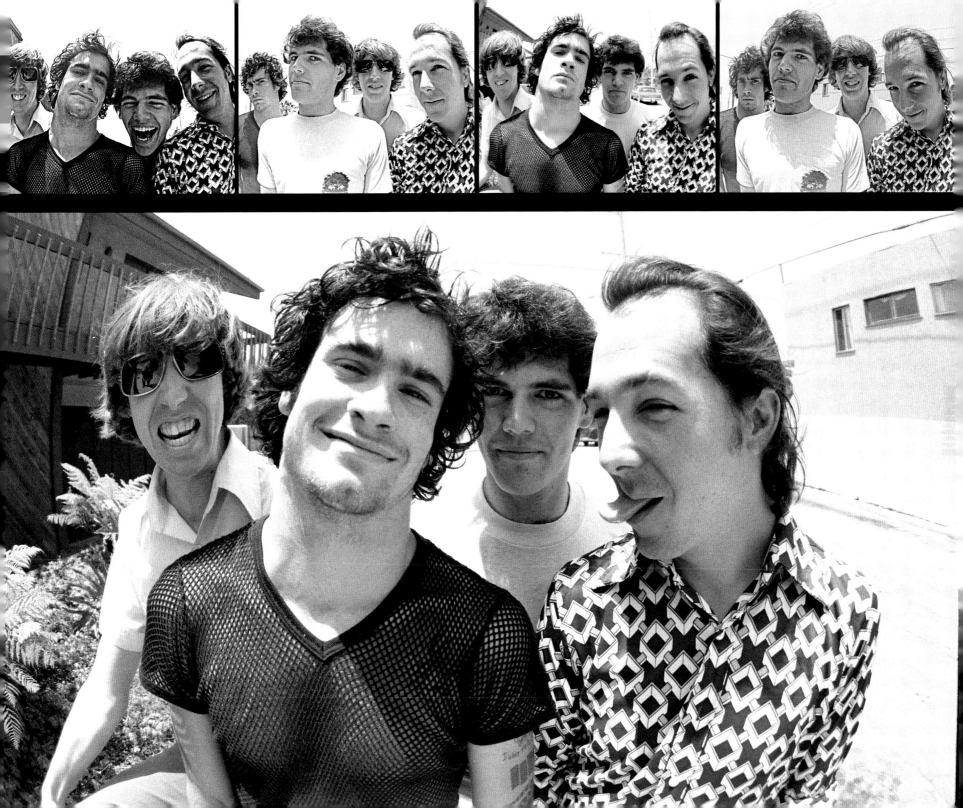

Chuck Dukowski, Greg Ginn, Henry Rollins, Bill Stevenson

Santa Monica Civic Auditorium, Santa Monica, June 11, 1983

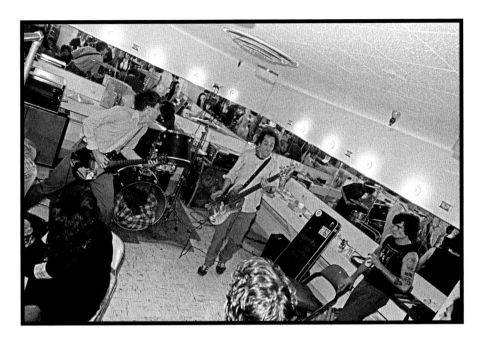
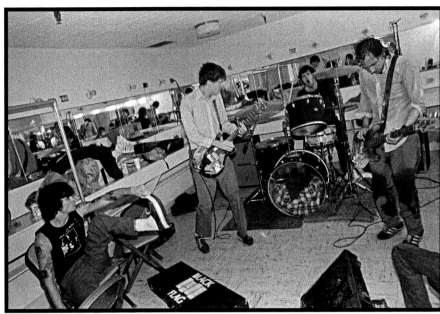
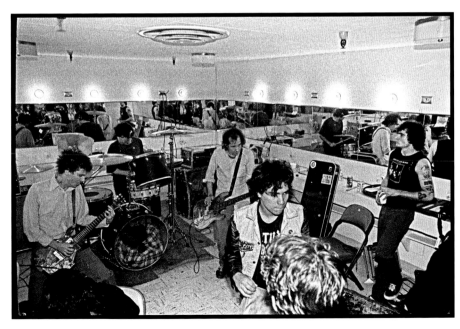
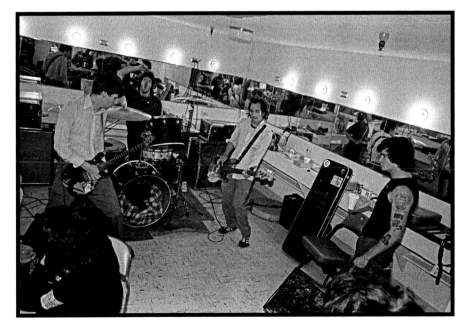

Pre-show rehearsal in dressing room.

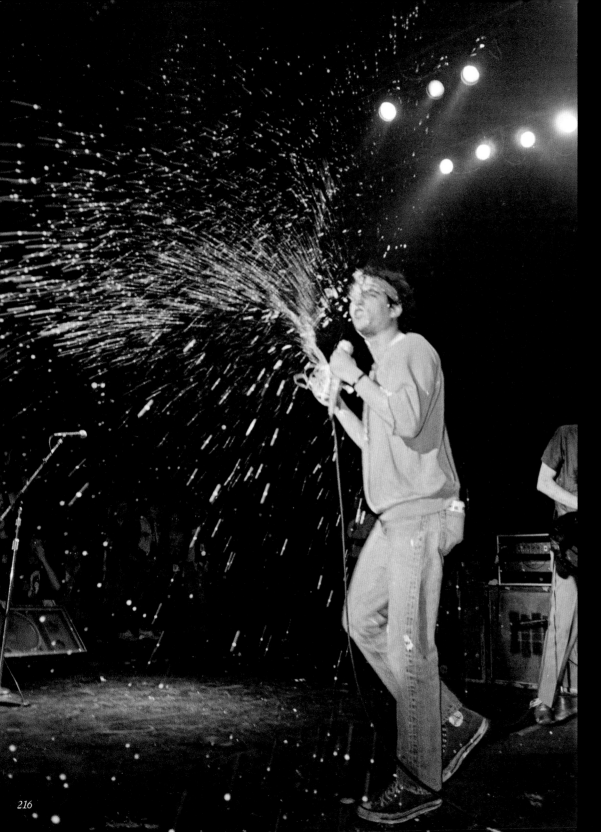

left:
Merrill Ward posing as
Keith Morris
(Johnny Bob Goldstein)

right:
Ron Reyes

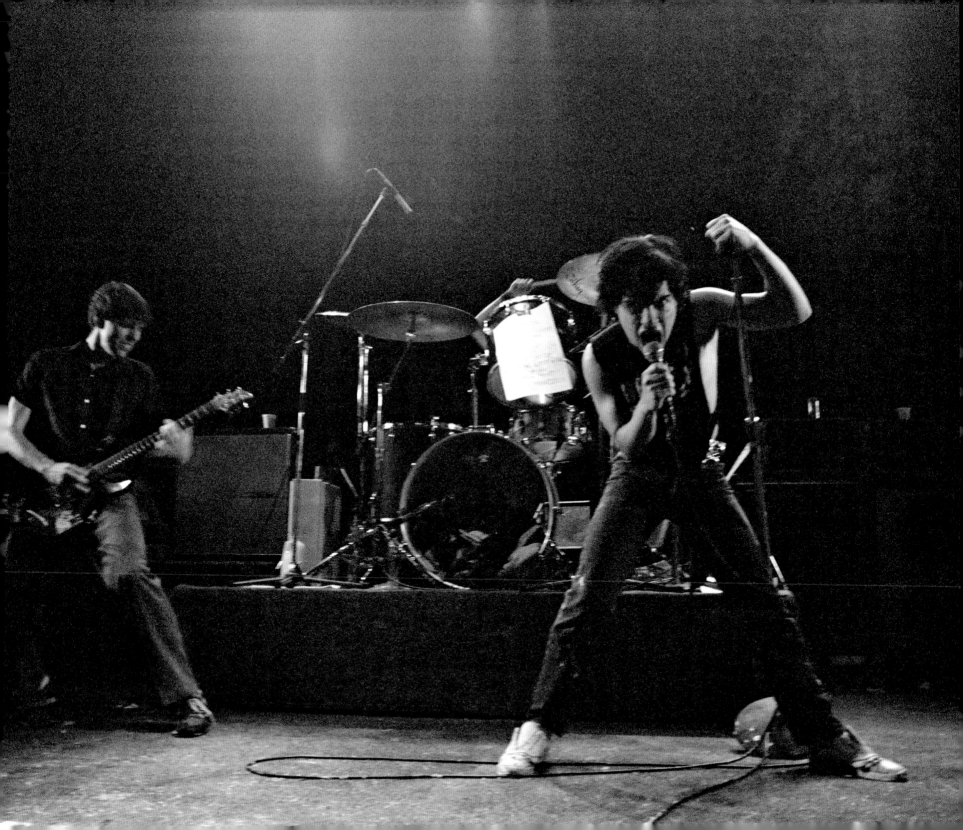

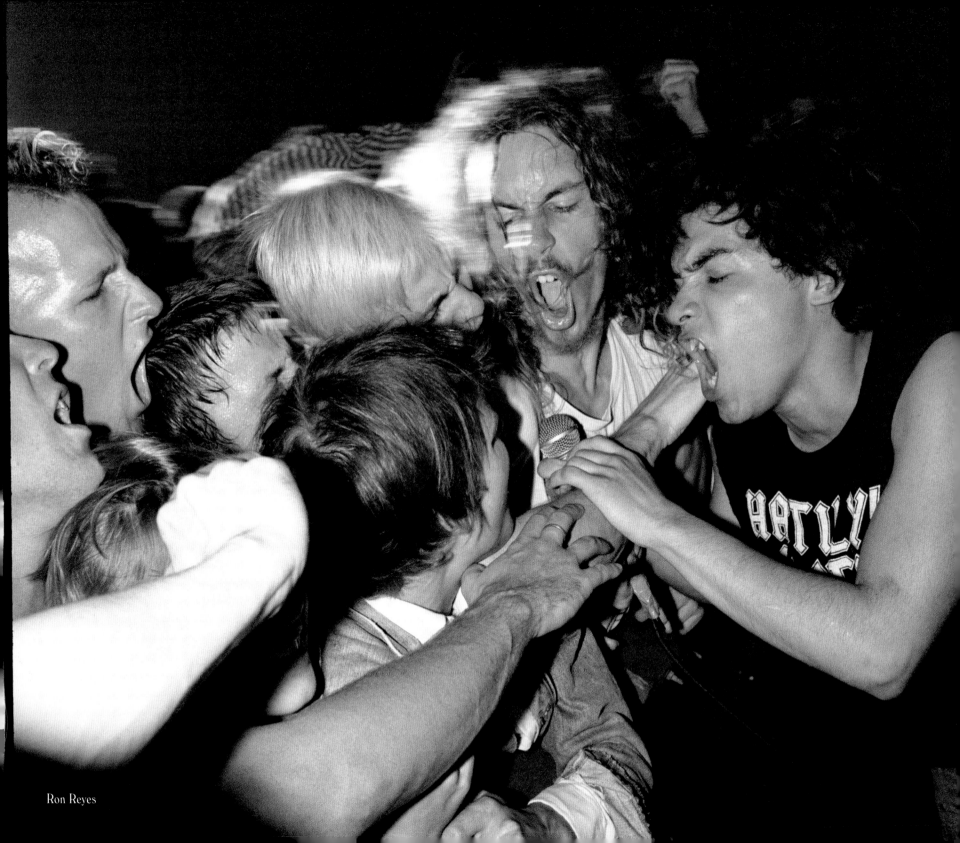

Ron Reyes

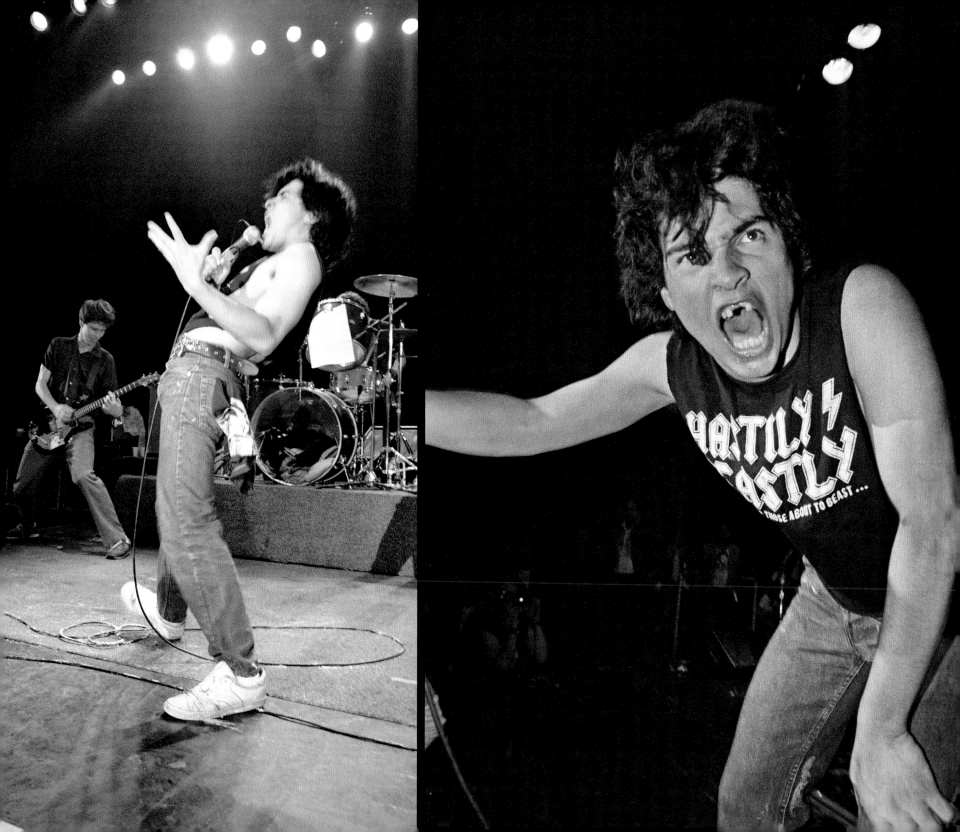

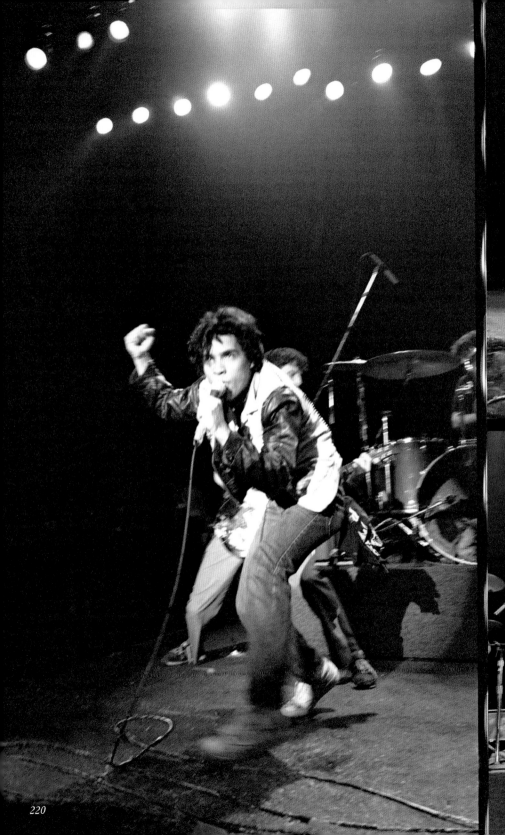
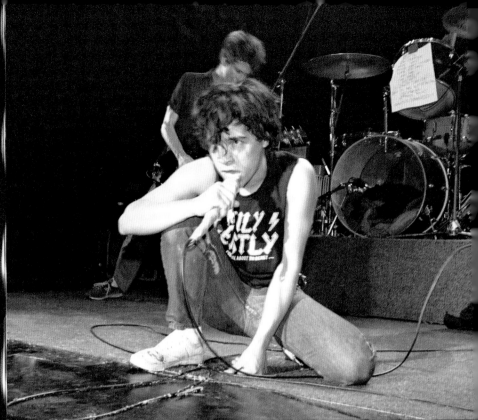
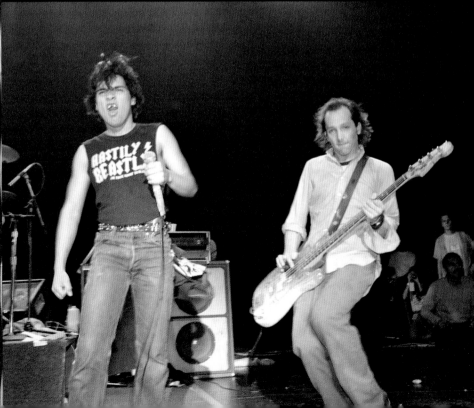

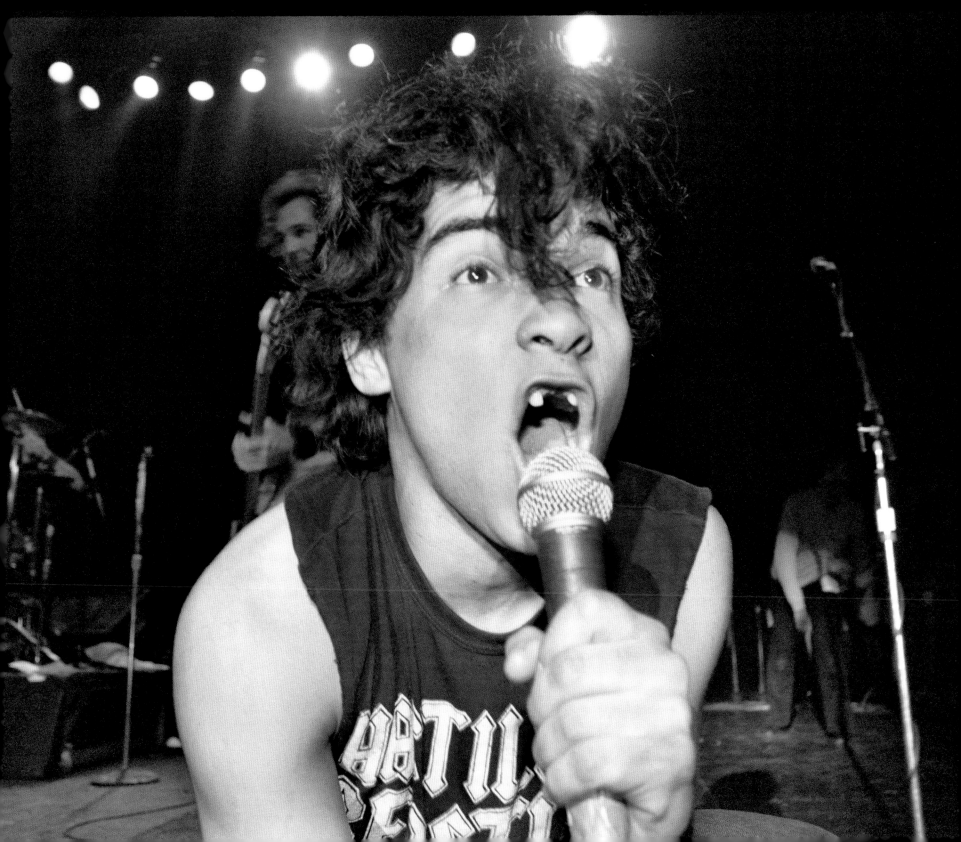

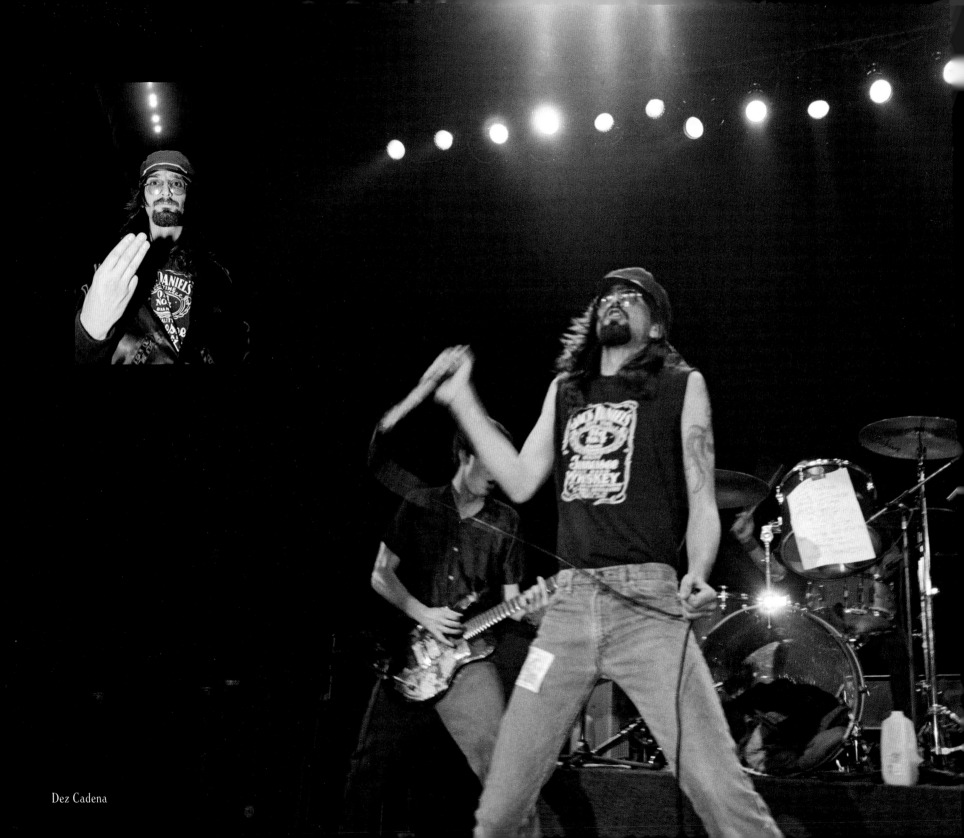

Dez Cadena

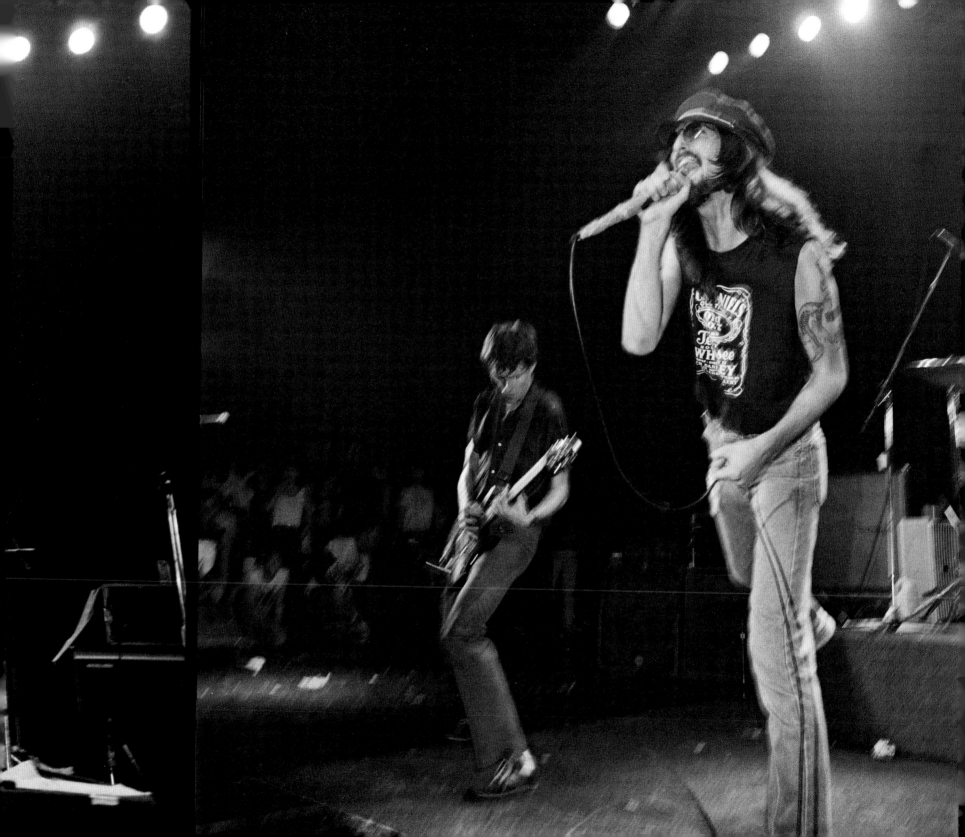

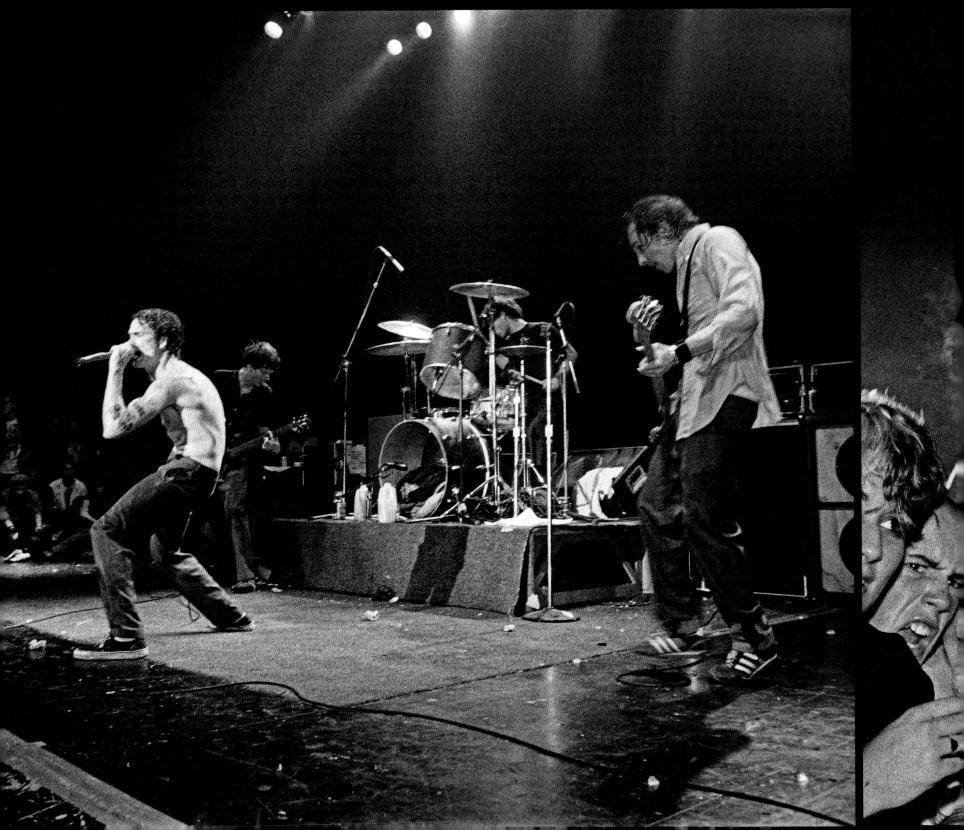

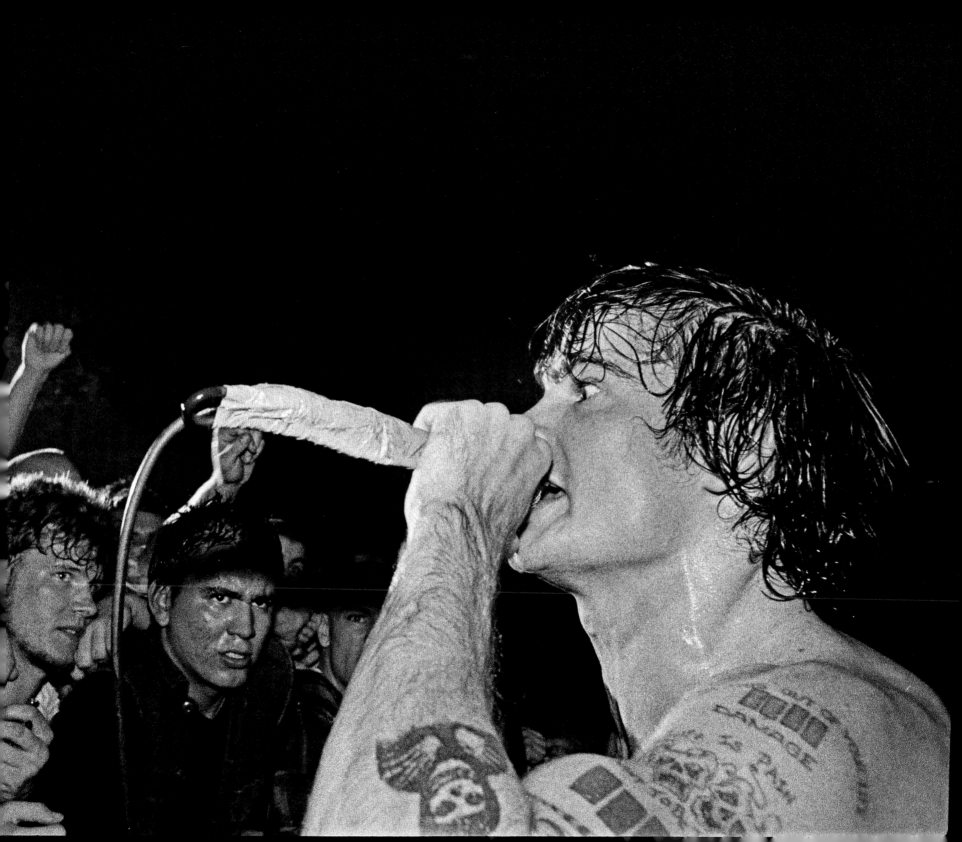

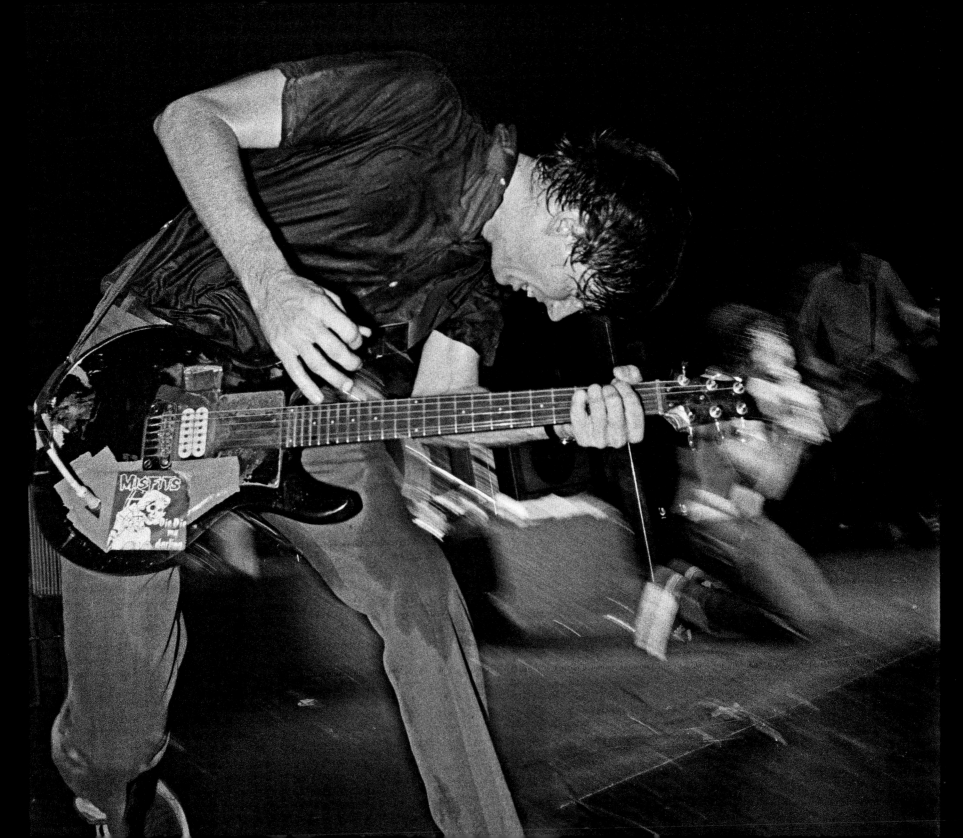

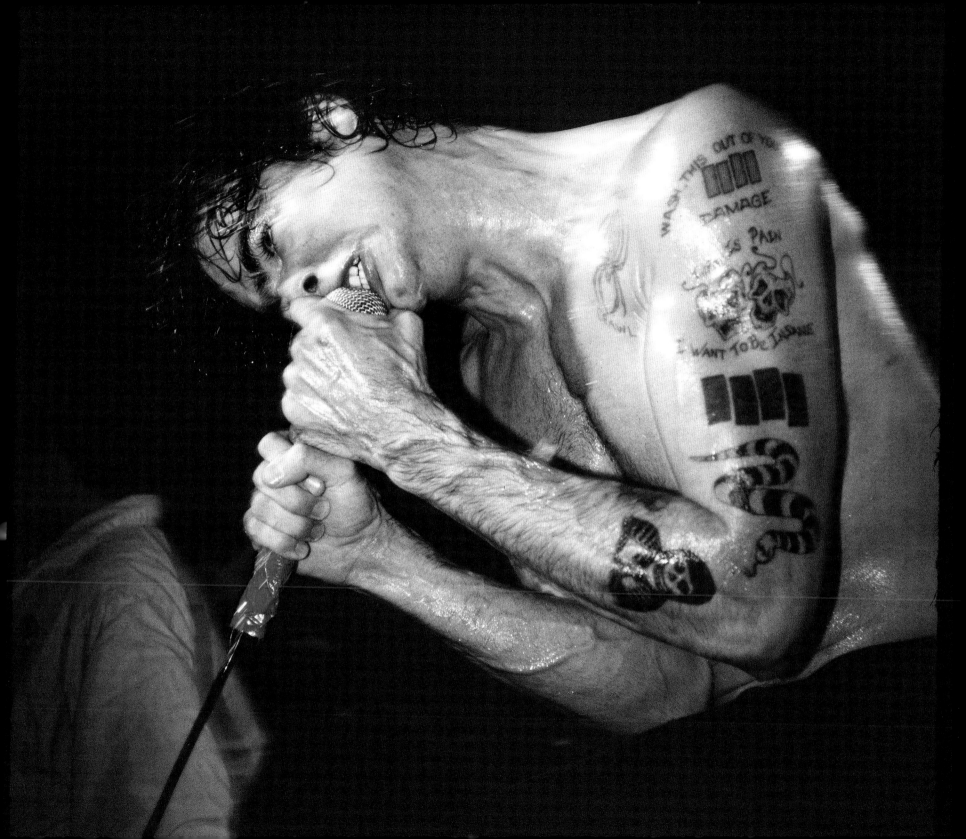

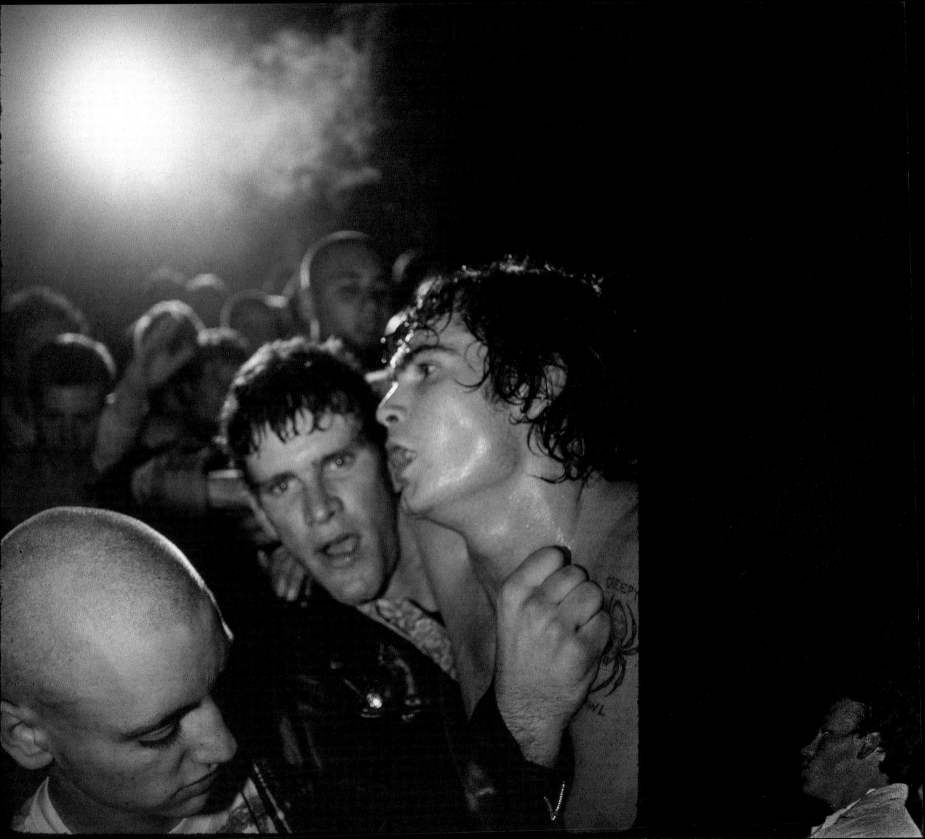

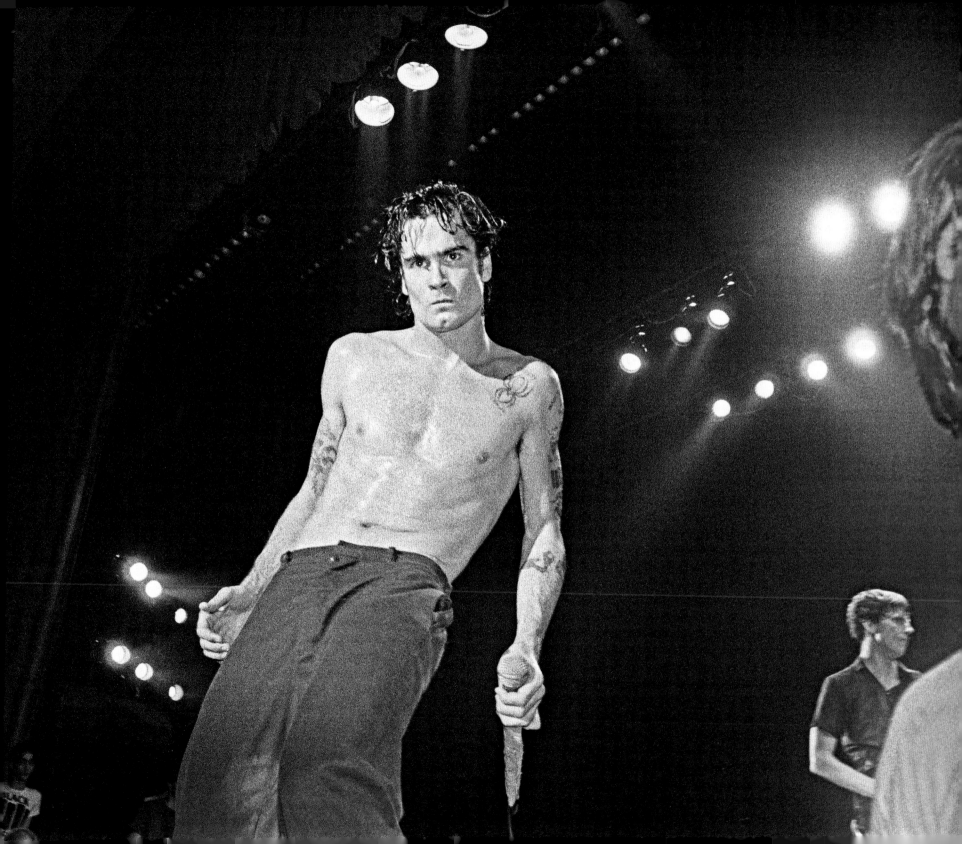

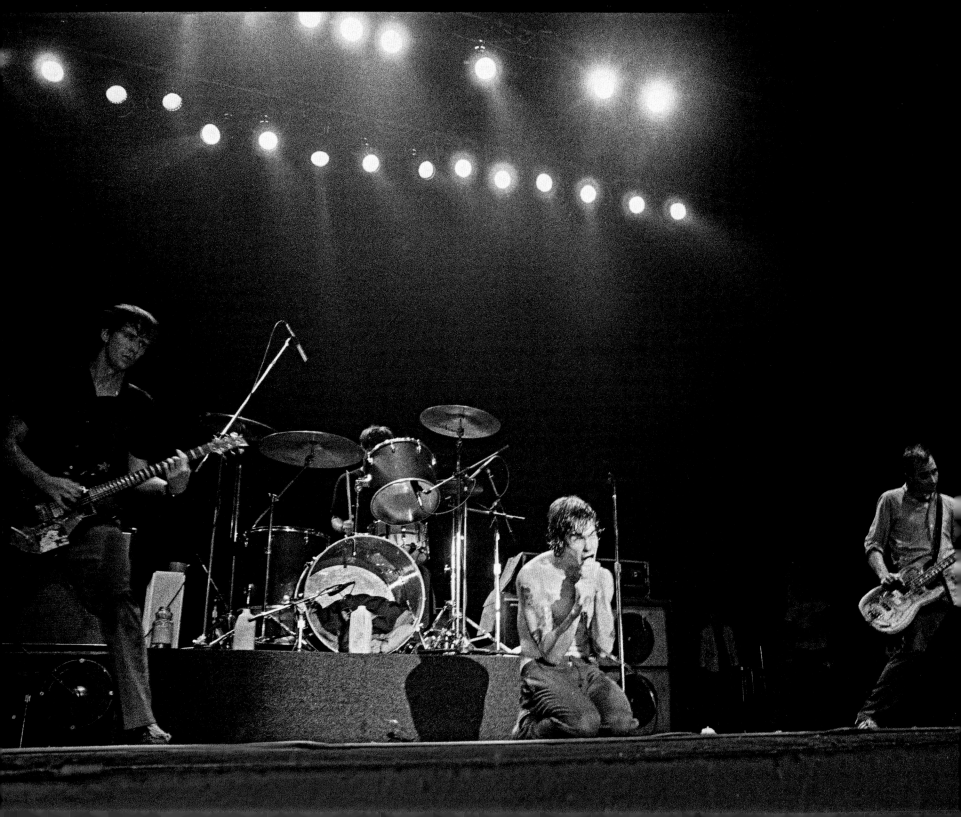

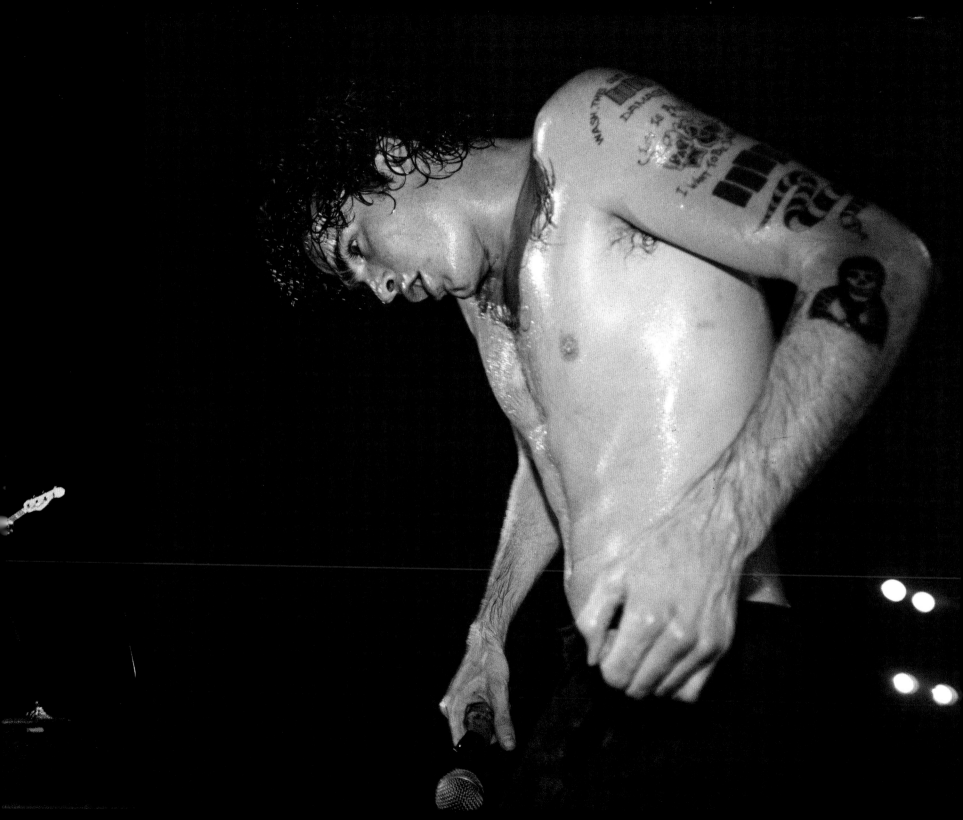

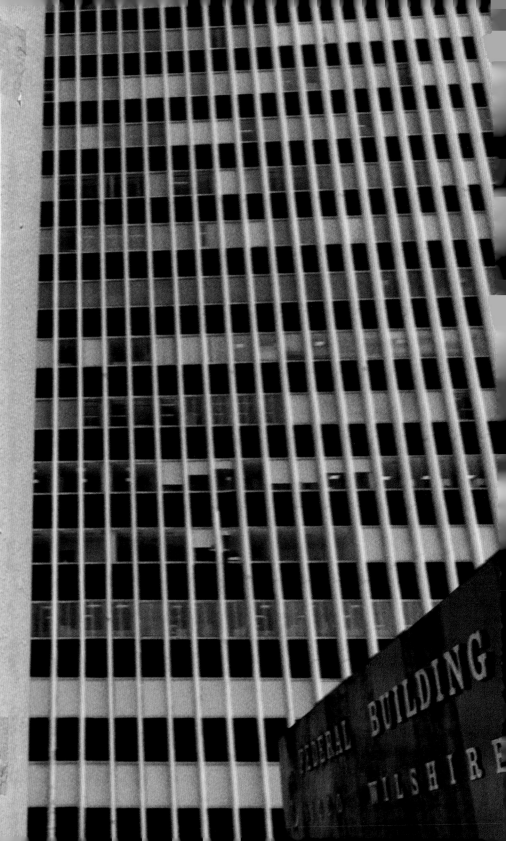

The California Marijuana Initiative presents

Independence Day Legalization Rally and

a FREE CONCERT

with

BLACK FLAG

PEACE CORPSE

WURM

BAD ACTOR

100TH MONKEY

many more!

JULY 4th NOON to 6pm

11000 Wilshire Blvd in Westwood
in front of the Federal Building.

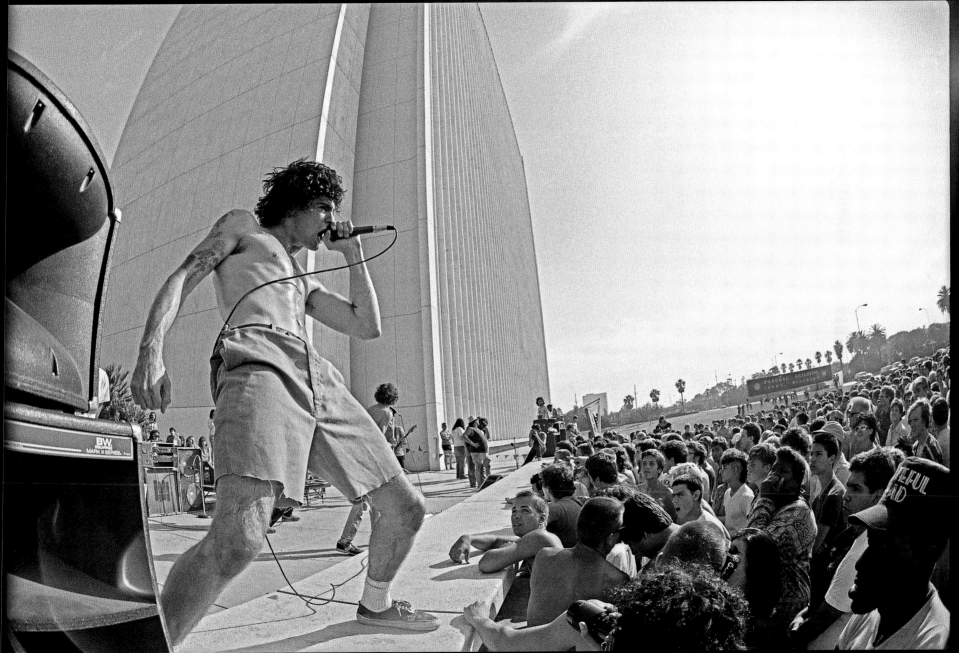

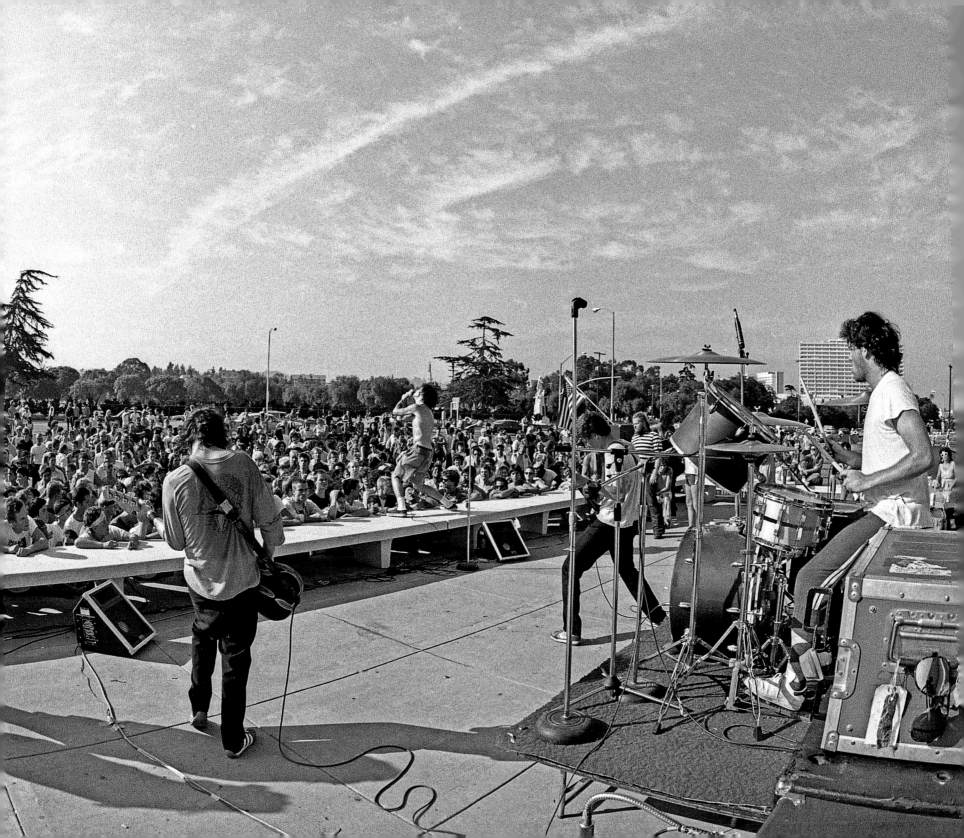

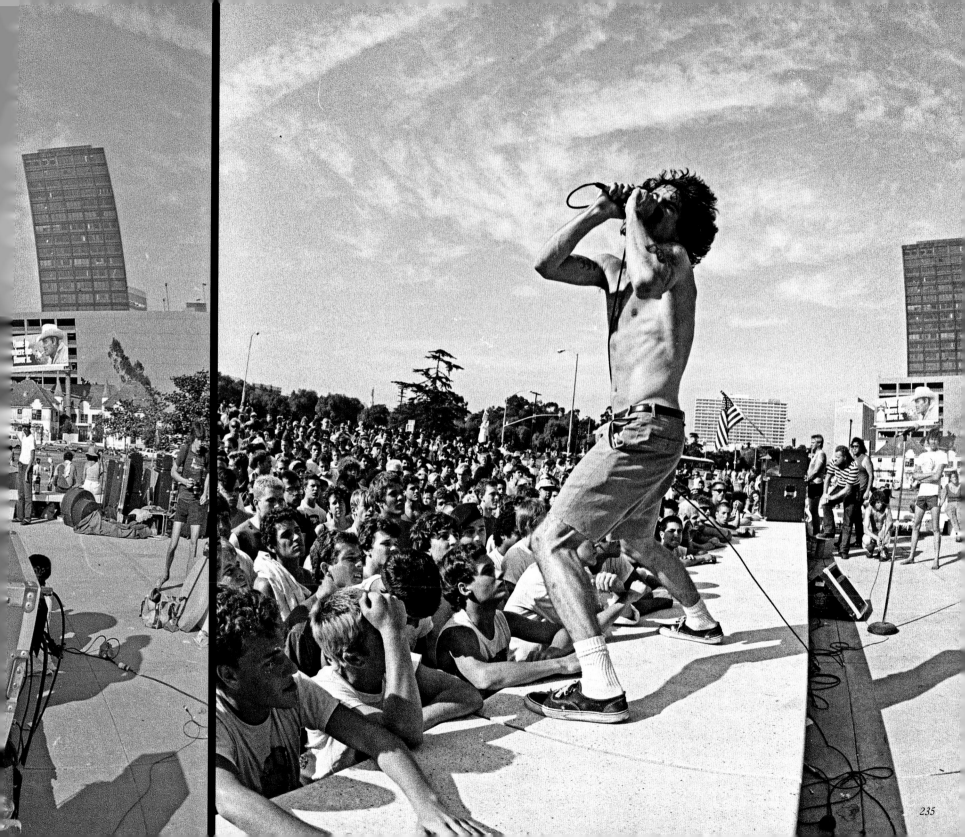

235

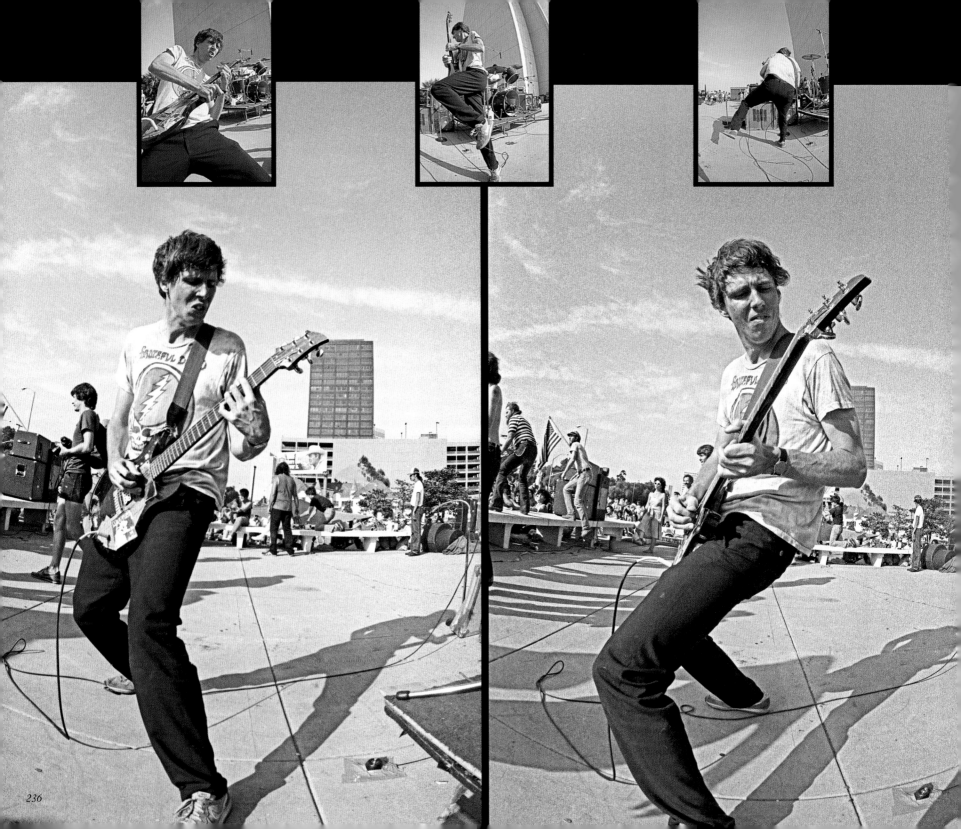

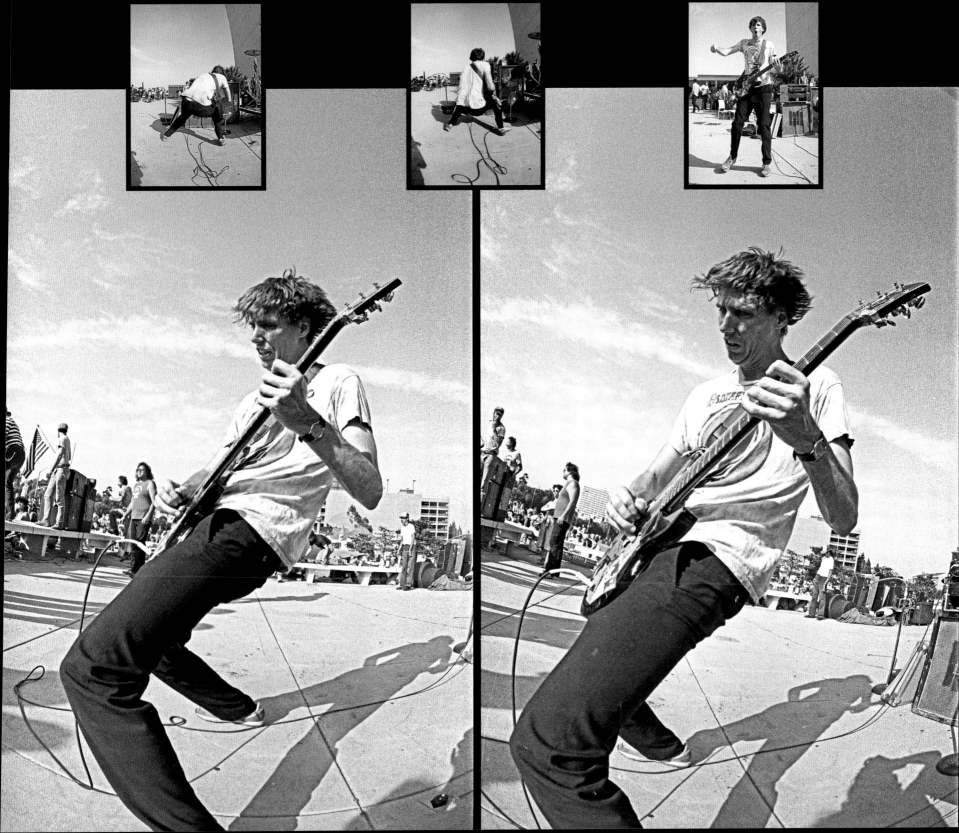

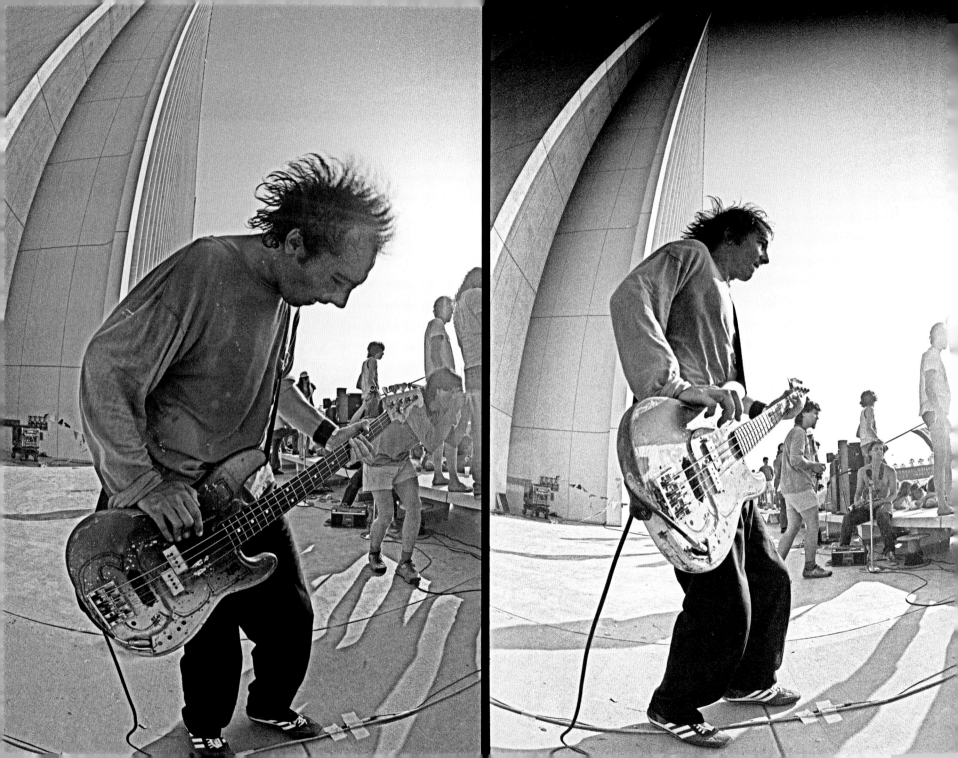

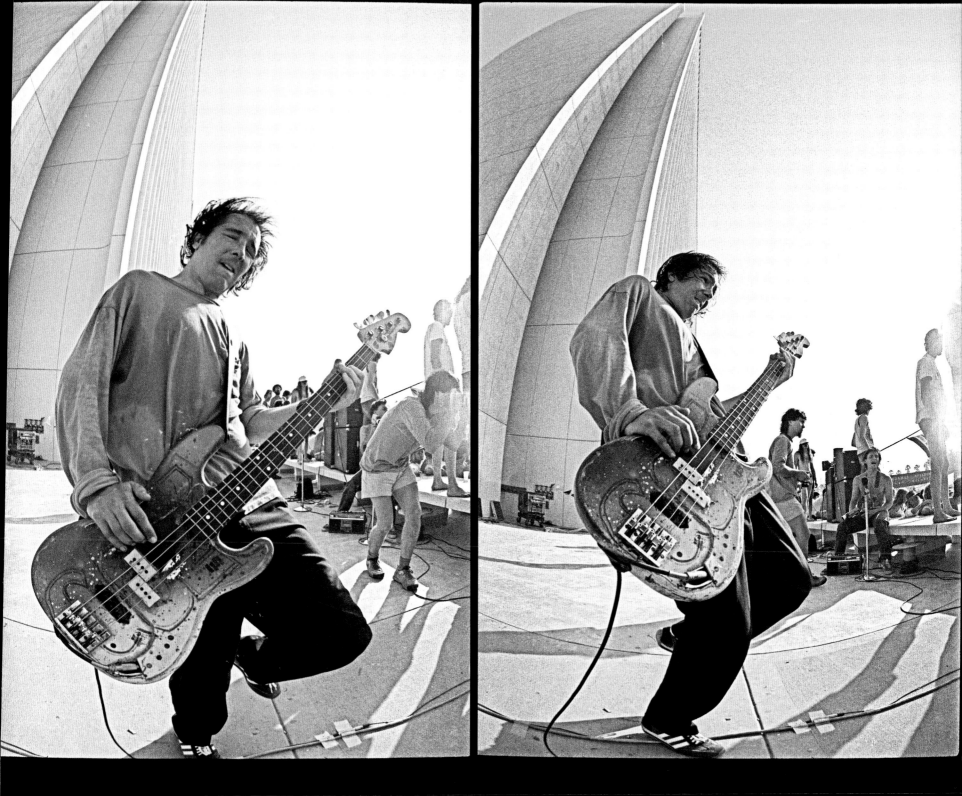

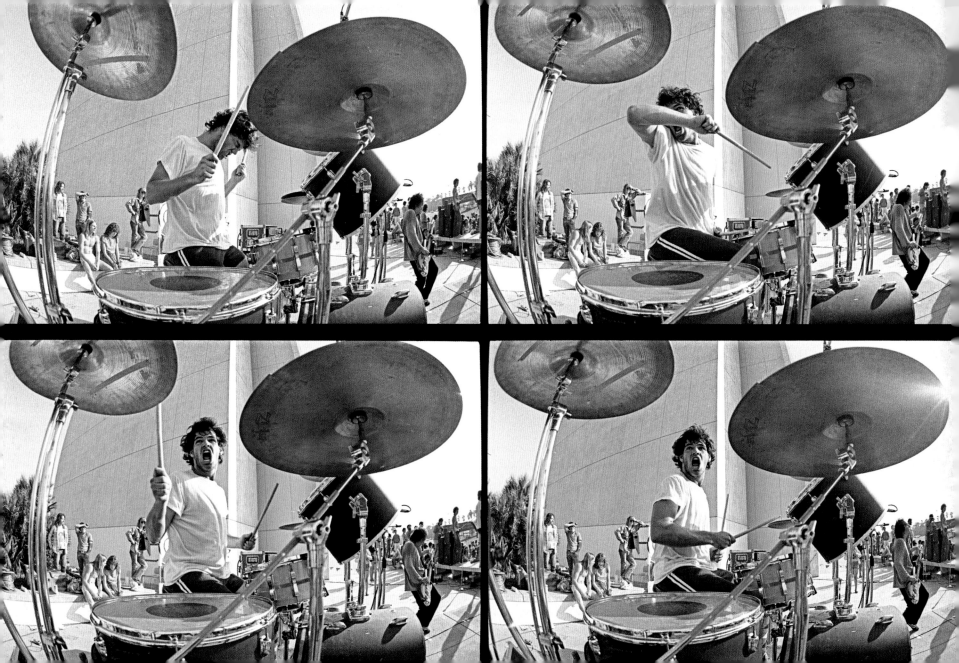

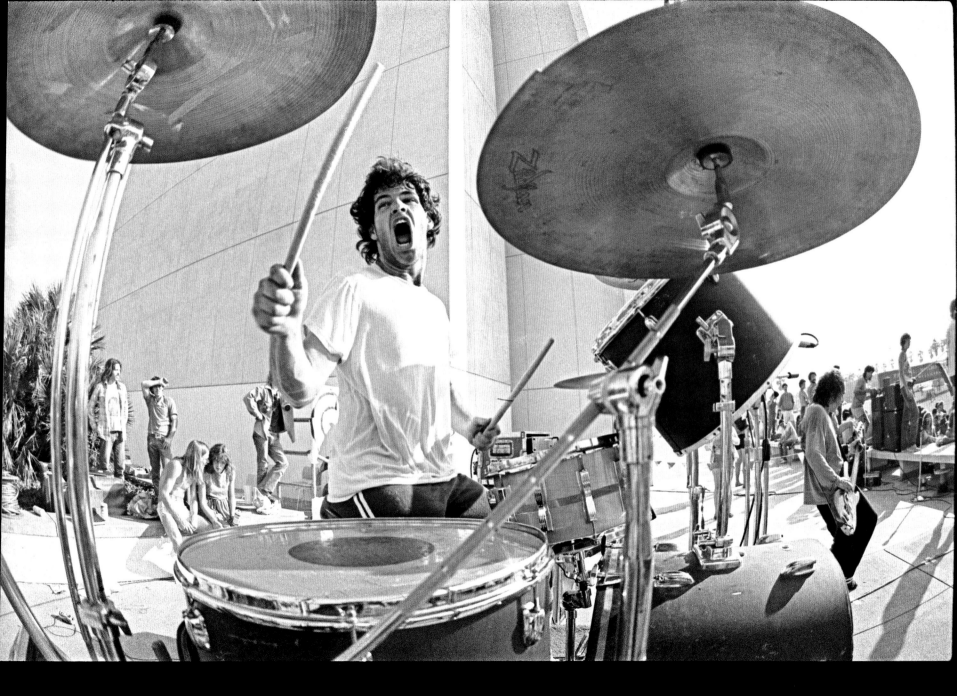

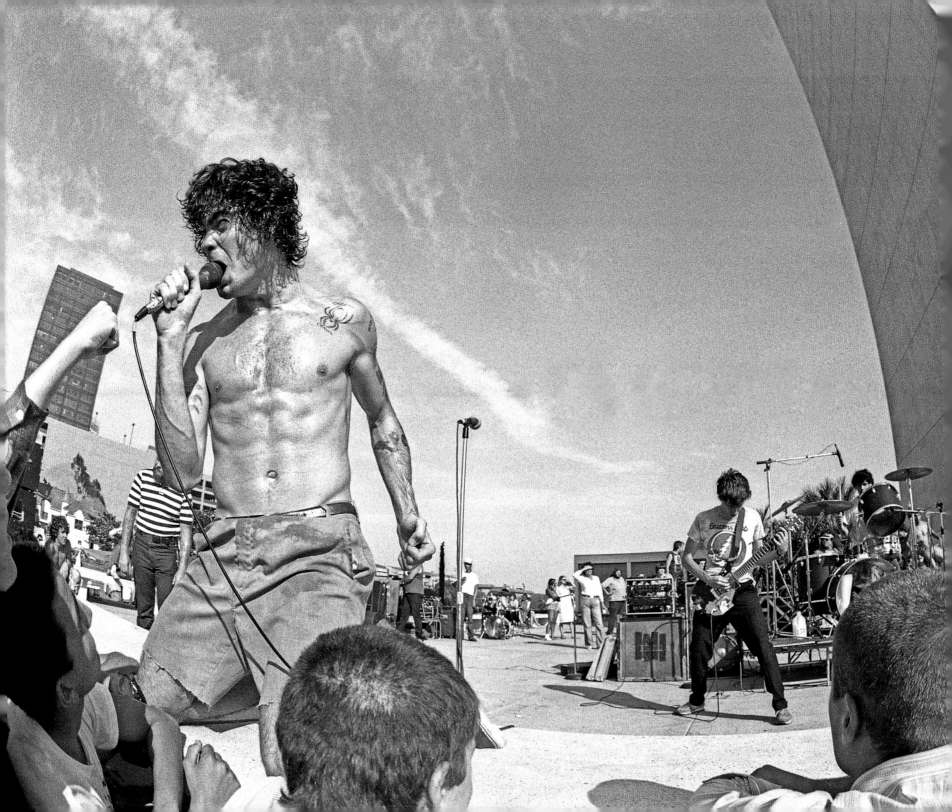

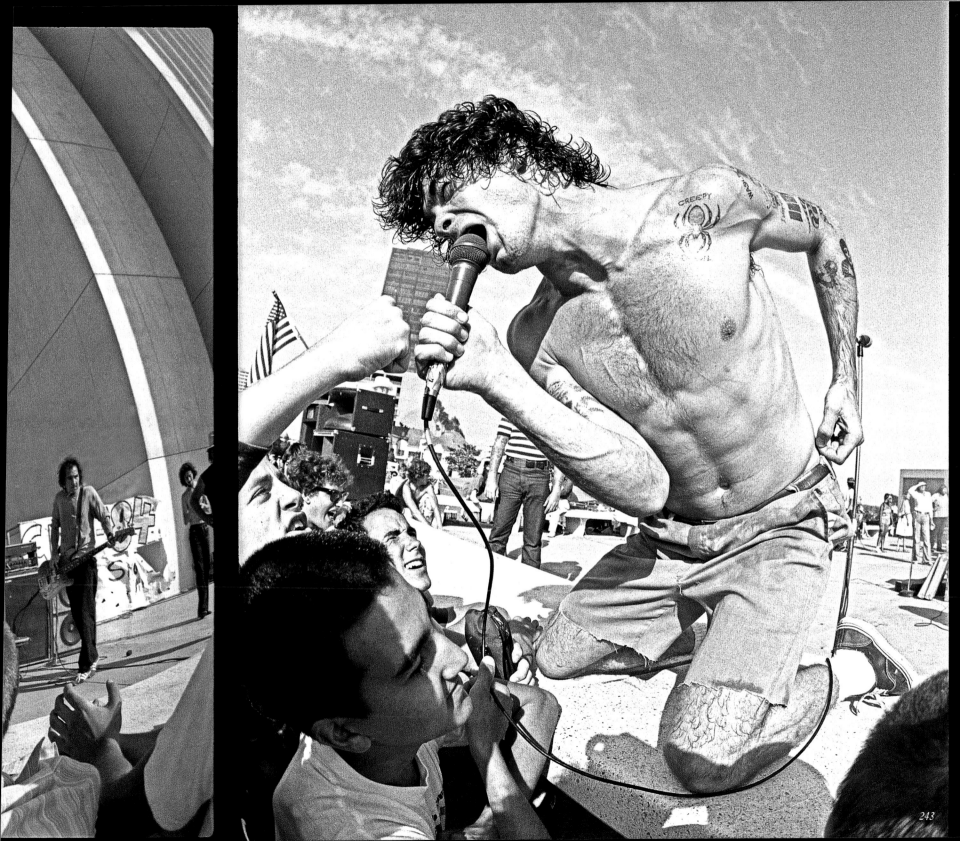

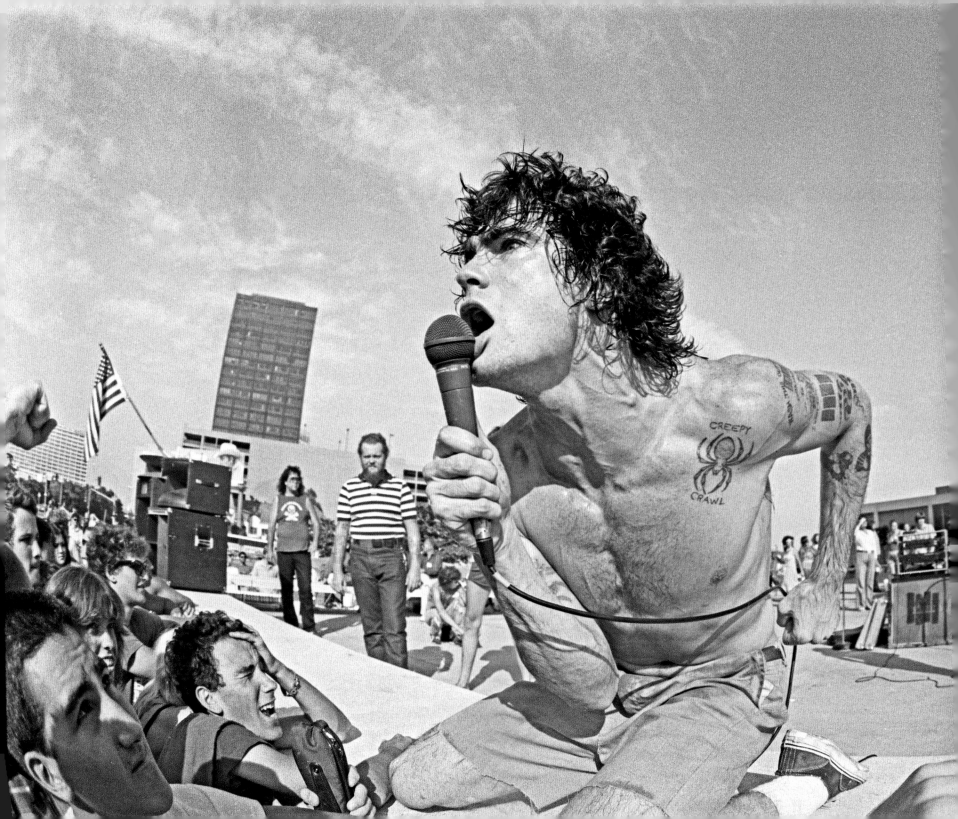

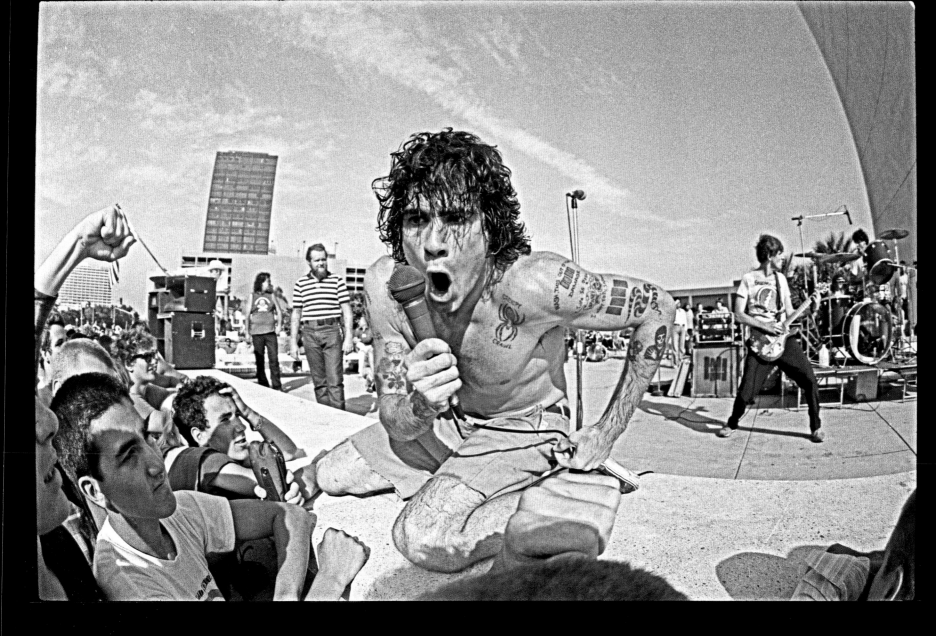

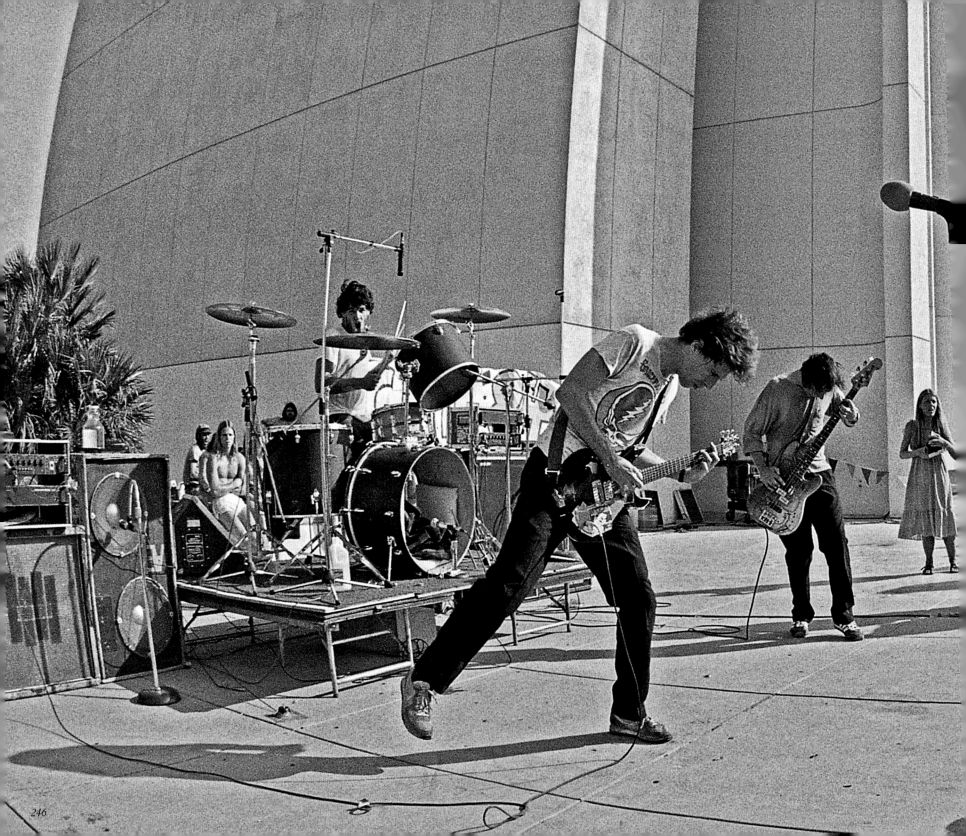

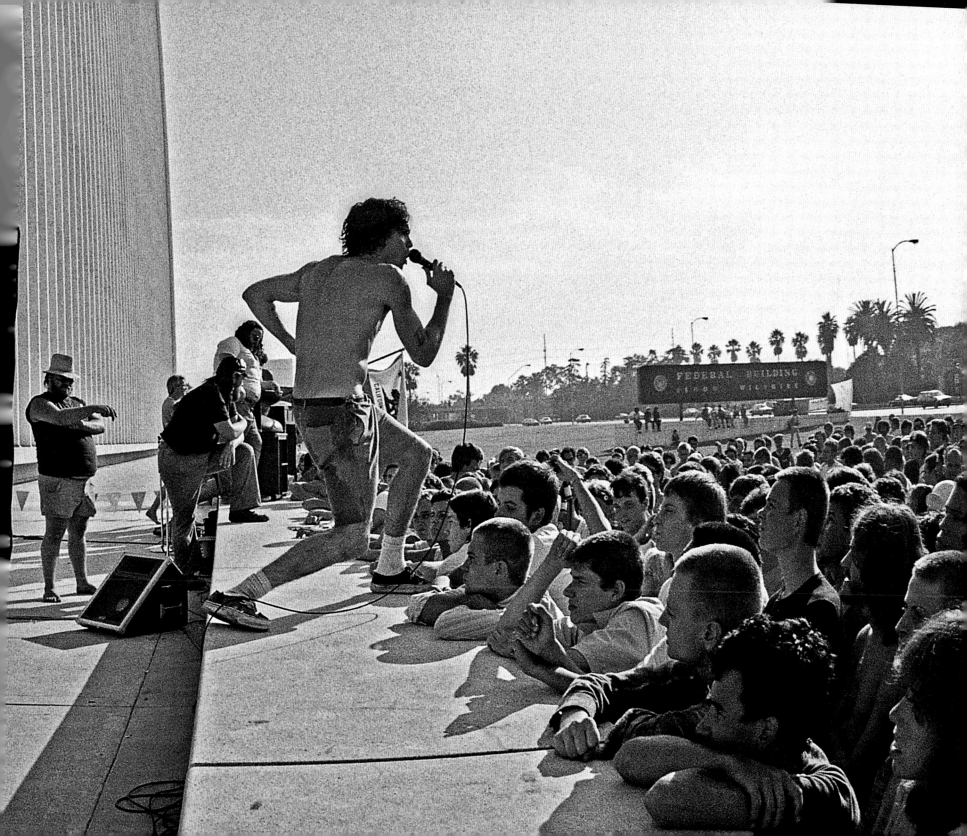

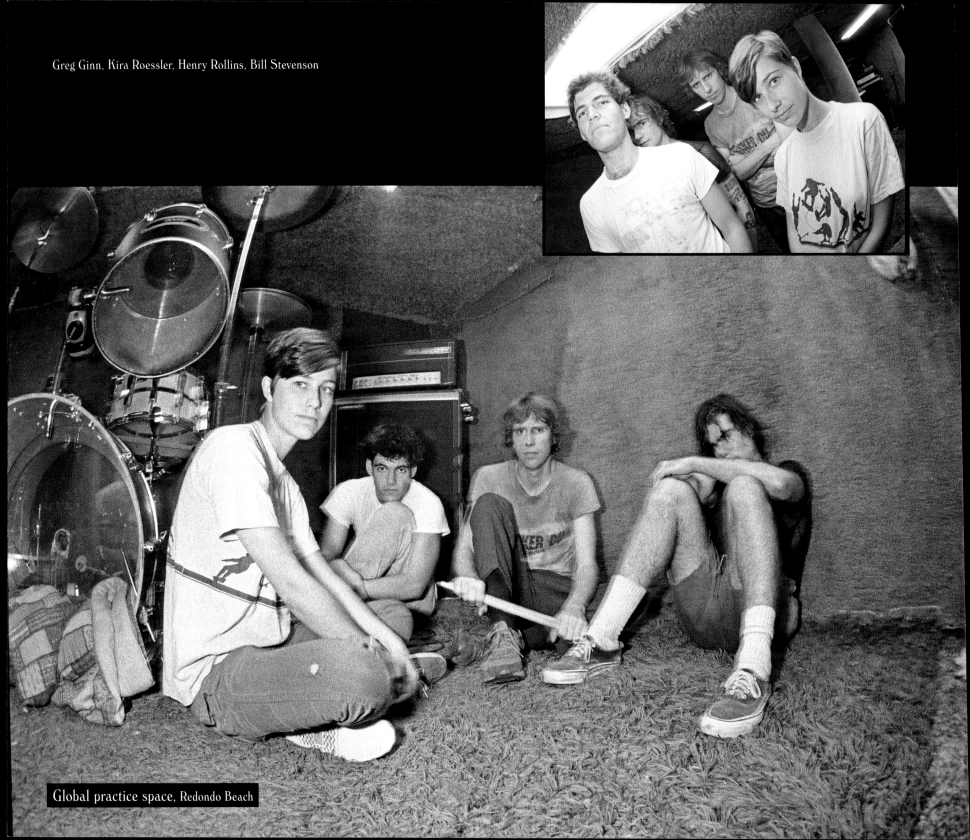

Greg Ginn, Kira Roessler, Henry Rollins, Bill Stevenson

Global practice space, Redondo Beach

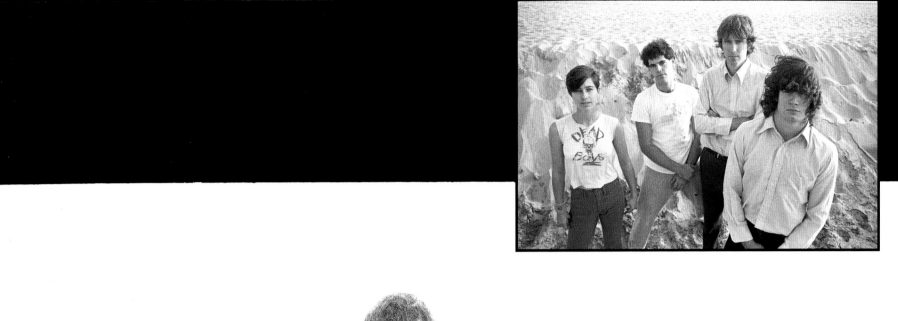
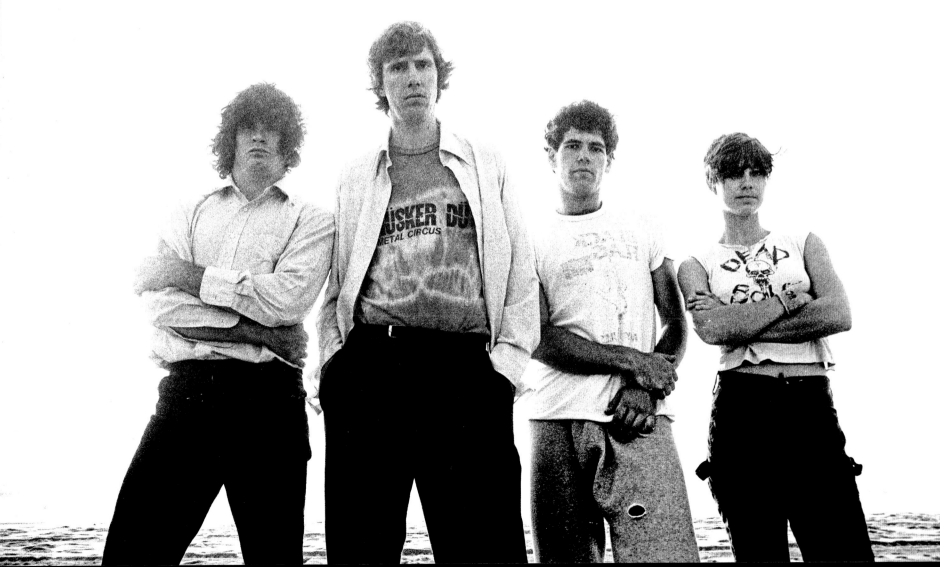

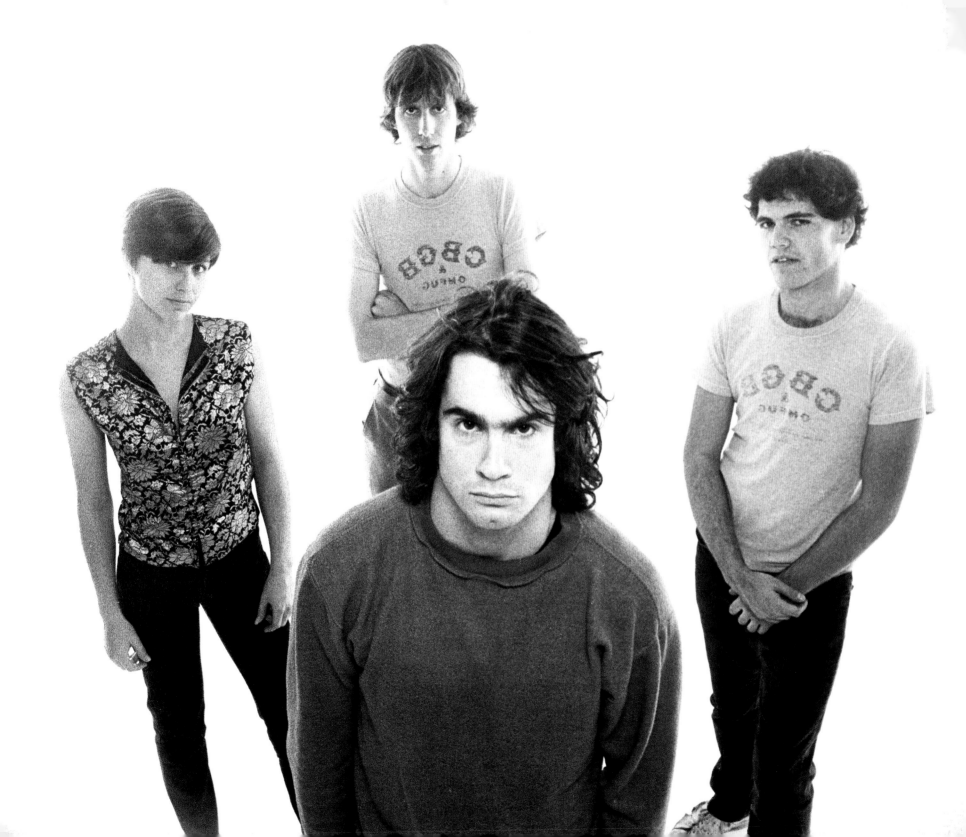

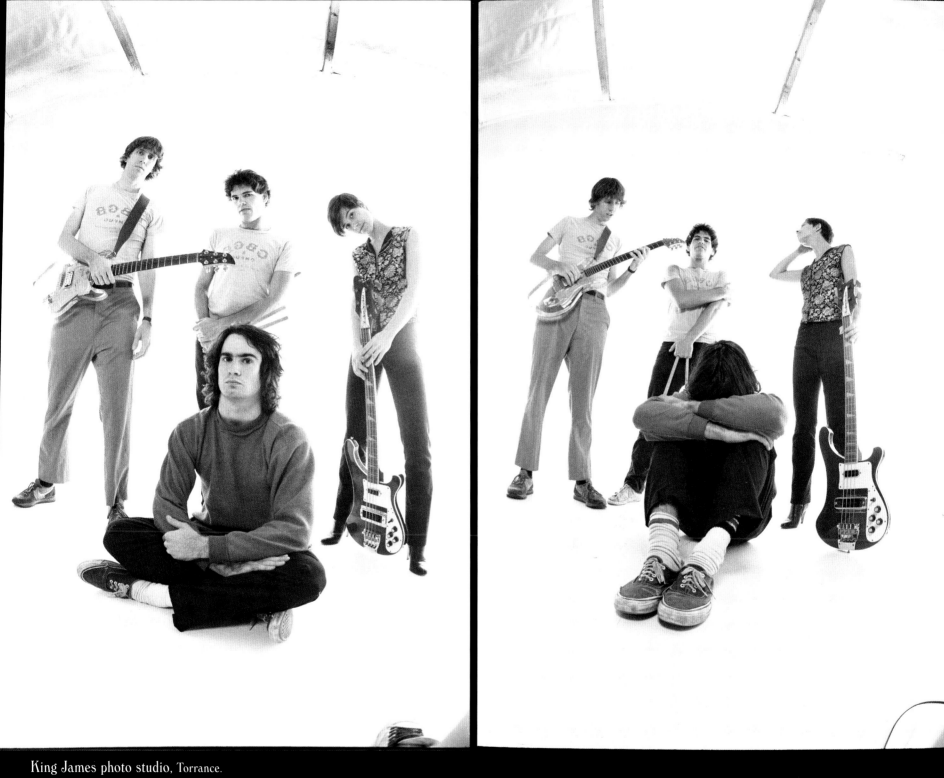

King James photo studio, Torrance.

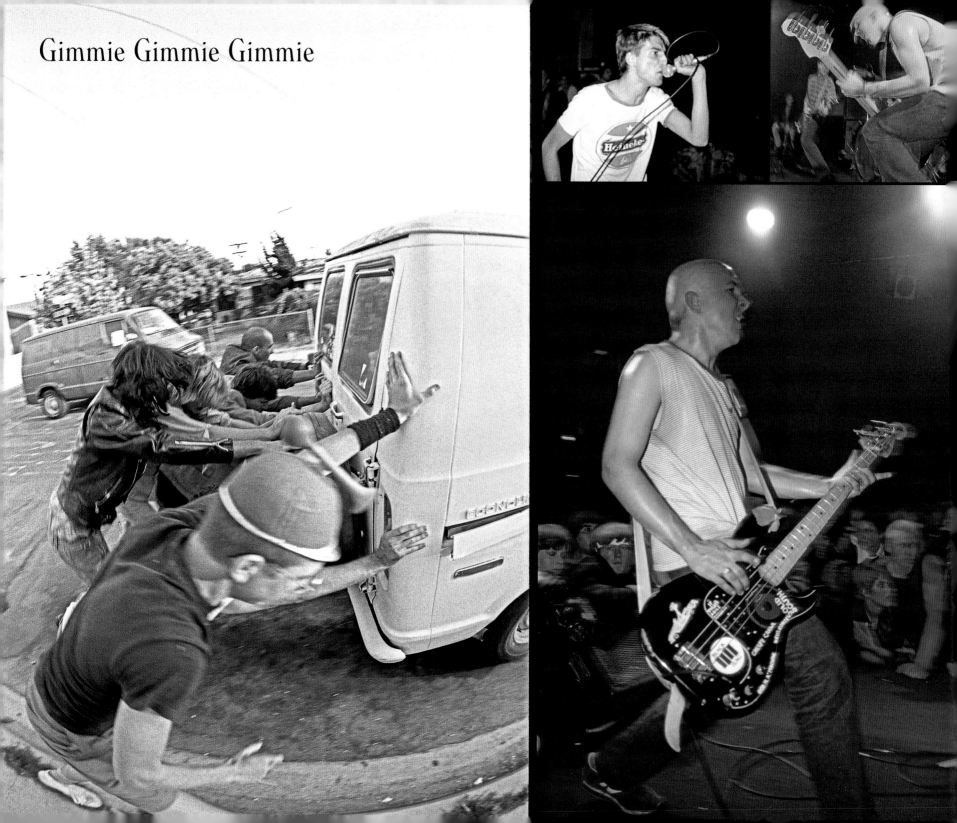

Gimmie Gimmie Gimmie

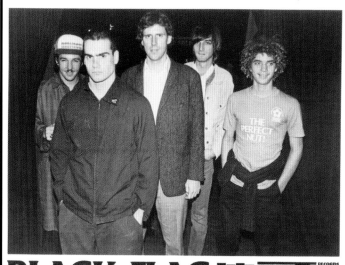

BLACK FLAG SST RECORDS

P.O. BOX 1 LAWNDALE CALIF. 90260 (213) 376 7313

Photo: Glen E. Friedman

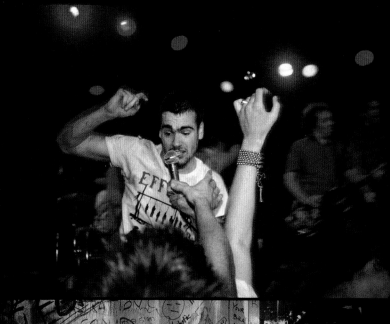

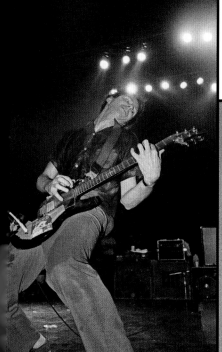

BLACK ◼◼◼◼ FLAG

BLACK ◼◼◼◼ FLAG

BLACK ◼◼◼◼ FLAG

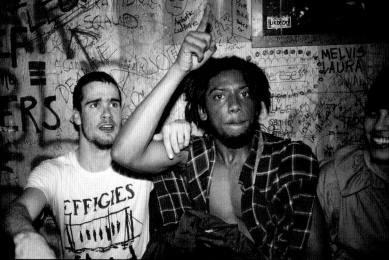

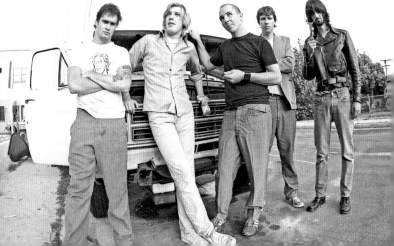

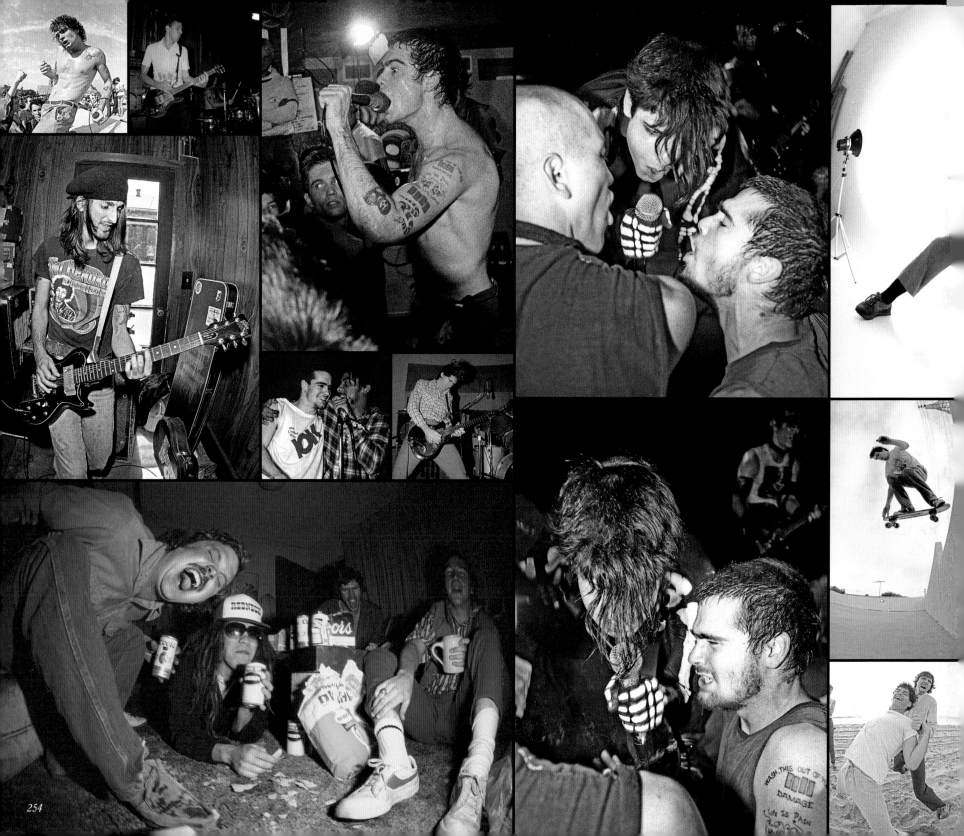

254

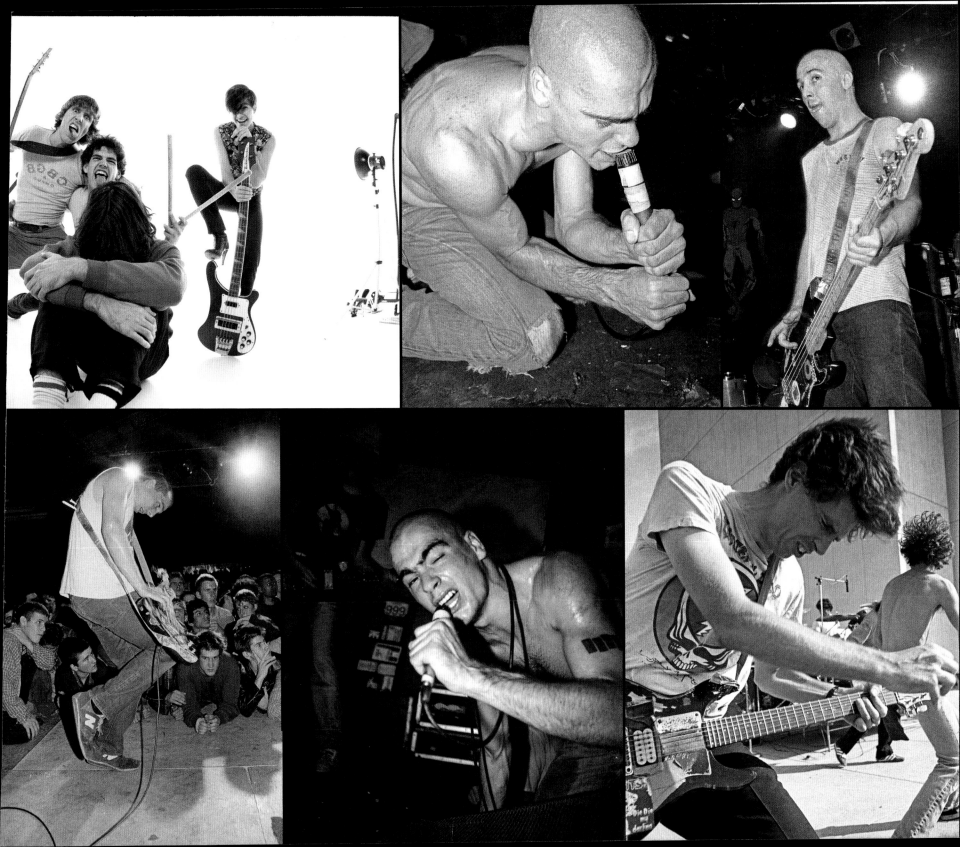

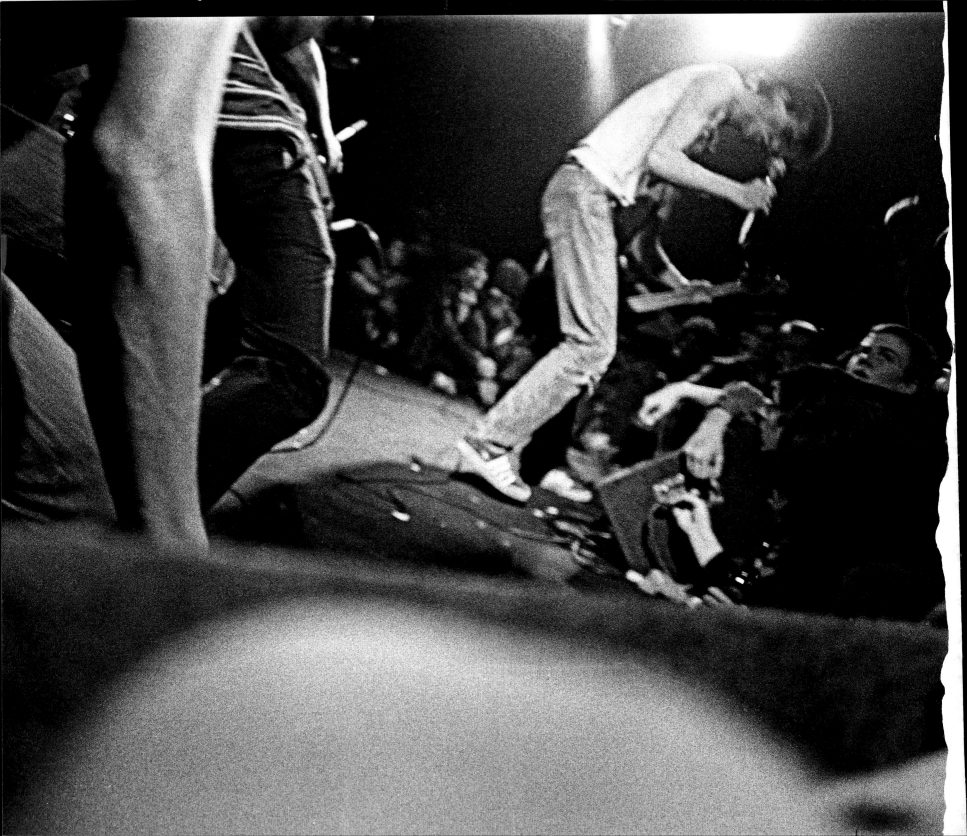

YOUR RULES - MY WAR

Tell me whats right
Tell me whats wrong
Sing me your egos song
Show me your weakness
Show me your fears
Tell me how I should live

C.D.

HALF A MAN · LET HIM DIE A MILLION